Seeing in Spanish

Seeing in Spanish:
From Don Quixote to Daddy Yankee—
22 Essays on Hispanic Visual Cultures

Edited by

Ryan Prout (Co-ordinating editor)
and Tilmann Altenberg (Co-editor)

CAMBRIDGE
SCHOLARS
P U B L I S H I N G

Seeing in Spanish:
From Don Quixote to Daddy Yankee—
22 Essays on Hispanic Visual Cultures,
Edited by Ryan Prout (Co-ordinating editor) and Tilmann Altenberg (Co-editor)

This book first published 2011

Cambridge Scholars Publishing

12 Back Chapman Street, Newcastle upon Tyne, NE6 2XX, UK

British Library Cataloguing in Publication Data
A catalogue record for this book is available from the British Library

ISBN (10): 1-4438-2935-8, ISBN (13): 978-1-4438-2935-9

For Alison Charles, Peter Judge, Liza Palmer, and Berwyn Rowlands

RP

"There is always the other side, always."
Jean Rhys, *Wide Sargasso Sea*

TABLE OF CONTENTS

LIST OF ILLUSTRATIONS

For illustrations please see the centrefold.

ACKNOWLEDGEMENTS

The germ of this book was the *Fractured Identities: Re-siting Hispanic Visual Cultures* conference which took place at Cardiff University in July 2009. For their support of the event thanks are due to the Histories Memories and Fictions Research Unit at Cardiff's School of European Studies, the Cardiff Humanities Research Institute (which supported the digitisation and enlargement of T. Ifor Rees's photographs), the Institut Ramon Llull, and the Olwen Reckert bequest. Many thanks to Craig Patterson for inviting Antón Reixa to give the Olwen Reckert lecture; to Montserrat Lunati for inviting Mariona Giner to give a keynote paper on photography, which was supported by the Institut Ramon Llull; to Frederick de Armas for encouraging the event from the outset and for giving a greatly appreciated keynote lecture on Francisco de Ribalta and Lope de Vega's *La viuda valenciana*; to Lona Mason from the National Library of Wales for giving a beautifully illustrated lecture on Sir Kyffin Williams's work in Argentina; and to María Dolores [Lola] Jiménez Blanco who got the conference off to a great start with a plenary lecture on the perception of Spanish art in the United States.

Very special thanks must go to Morfudd Rhys and to Osi and Hilary Rhys Osmond for allowing us to scan and copy the photographs taken in Spain, Mexico, Cuba, Peru, and Bolivia in the 1930s and 1940s by T. Ifor Rees and to mount them in the Viriamu Jones gallery as an exhibition to coincide with the conference. Morfudd Rhys gave a fascinating insight into her father's photography and her family's experiences in Latin America in a conversation with Diana Luft and we are very grateful to her for having made the trip to Cardiff and sharing with the conference delegates her memories of her father's role as the UK's first ambassador to Bolivia.

Many thanks to Caroline Rae, Mary Green, Rob Stone, and Andrew Dowling for chairing panels at the conference; to the Welsh Affairs Office of the United States Embassy for encouraging the event; to Catherine Davies, Nancy Vogeley, Margaret Topping, and Claire Gorrara for their encouragement both of the conference and of this volume; to Gemma Broadhurst and Mary Raschella who looked after the accounts; to Mark Cooper and Iris Winney who were very generous with their technical support; and to Jacob Wong for making sure the enlargements for the T. Ifor Rees exhibit were ready on time.

THE EDITORS

INTRODUCTION

The layout of this book has largely been structured around geopolitical boundaries, although the chapters which engage directly with conflicted identities on the internet and in cyberspace already query the sufficiency of these categories for a taxonomy of the fractured postmodern subject in the Spanish speaking world. To some extent all the chapters collected in the volume question the stability of identity and subject positions, not least with regard to the taxonomies of the nation state. For example, the Ana Mendieta read by Dolores Alcaide Ramírez in her chapter on the artist's silhouettes and on Nancy Morejón's poetry is a figure disputed by two polarised political geographies and was someone who could not *feel* at home in Iowa and who could not *be* at home in Cuba. The Cuban children Jill Ingham turns her attention to in her study of recent cinema are torn between their visceral attachment to the earth on which they are growing up and their parents' imaginary flights to other shores. In the images of Ana Belén used on the singer's albums from the 70s in transitional Spain, Esther Pérez-Villalba finds a moment in time where a newly aestheticised femininity vied for prominence as the legitimate expression of counter-cultural radicalism with a hippie look and dress code. Antonio Sánchez turns his attention to films from Spain which reveal the more recent correlations between fractured and rebuilt urban and rural landscapes and displaced subjectivities. Nasheli Jiménez del Val's study of representations of the fractured body in Mexico suggests a radical somatisation of societal and political disintegration. Elsewhere, fracture can be the harbinger of something beneficial, as in the alternative publishing industry in Argentina studied by Soledad Pereyra. Here we see a new art form, the handcrafted and decorated book, emerging from the breakdown following the economic crisis in the late 90s. Similarly, in her chapter on street art and graffiti Gudrun Rath identifies the role of apparently fragmentary and anonymous protest art in articulating post-dictatorial civil societies in Chile and Argentina.

A collection of essays on fragmentary and fractured identities will of necessity challenge attempts to coral the subject matter into a neatly cohesive unity. Having said that, there are consistent themes running through the chapters and, as well as briefly summarising the content of each contribution, this introduction also suggests other routes through the chapters besides those determined by chronology and geopolitics. What all the chapters share is a focus on some aspect of visual cultures from the Spanish speaking world and together they address film, photography, cover art, body art, television, architecture, ekphrasis, biography, murals,

posters, graffiti, and digital photo-montage. As an ensemble, the chapters give us a view of a world seen in Spanish, a world defined from the inside out where shared aspects of fragmentary and sometimes volatile subjectivities conjoin through an intermittently common perspective the shards of a whole no longer held together by empire, ideology, or the nation state. From Don Quixote to Daddy Yankee, and from Catalonia to Colombia, the chapters present subjects who see or are seen in (or against, or in addition to) Spanish and whose identities are being forged or being taken apart through a dialogue with visual cultures.

PUBLIC ART AND GRAFFITI

In her chapter on street art and graffiti, Gudrun Rath traces the fusion of sloganeering and urban tags from Paris and New York, via Mexico City and Los Angeles, to Buenos Aires and Santiago de Chile: "Along this pathway, graffiti assumed peculiarly Latin American idioms as it spread across big cities and fragmented into a diversity of styles and techniques" (232). Looking closely at the Siluetazo urban art protests in Argentina, and the "NO +" campaign in Chile (both 1983) as well as at the street installations of the Grupo de Arte Callejero, Rath suggests that from a form of anonymous protest and tribalism, graffiti and its street art offshoots have mutated in Latin America to an expression of dialogical and interactive political art which "no longer serves to delimit territories, as in the case of hip hop graffiti, but highlights and claims the visibility of the political past in urban spaces" (239).

Soledad Pereyra's focus is on publishing in Argentina during and after the economic crisis of 1999-2002. Her study of the emergence of alternative publishing houses which used materials salvaged by cardboard pickers to produce affordable books illustrates an overlap between a modified labour practice and public art. In the cardboard publishing house model, book production becomes a collaborative process and the same providers of the found materials are involved in the manufacture of unique hand crafted volumes. Pereyra's reflections on one publishing house in particular, Eloísa Cartonera, suggest that the model adapted to the economic crisis repositioned the book not so much as a monument to individual intellectual property but rather as an expression of public literary tastes and desires: "Arduous economic circumstances have fostered new and highly creative forms of the book that are produced outside the ambit of the publishing establishment" (229). The same adaptive fracturing of the process of literary production produced cohesion between sectors of society which had hitherto not worked in cooperation. Pereyra suggests that with the restitution of book manufacture to an

environment more clearly within the public sphere "The book ceases to be
a sacred object worshiped by a select group: instead it evolves and in
doing so it recalls the earliest moments in the history of the book as a
profane object" (228).

In his chapter on Diego Rivera's murals for Mexico City's Secretariat
of Public Education (1922-28), Mauricio Castillo recasts the muralist
project as "a complex set of ideological negotiations where artists, patrons
and the local and global political context of Mexico came into play" (143-
44). Through close analysis of four scenes from this extensive mural
Castillo articulates the paradoxical and contradictory demands on a public
art form that was expected to meet with a monumental and pedagogical
purpose by its government patrons whilst also serving as the medium of
avant-garde experimentation and provocation for its creators. In his
detailed reading of panels from the SEP commission, Castillo finds an
aesthetic caught between glorifying an institutionalised revolutionary past
and gesturing towards a future of radical socialist reorganisation of labour,
an impasse resolved through the use of an oneiric anachronistic dimension
where these competing demands can be blended together: "Understanding
the co-existence of these two visions of revolution is fundamental to
articulating the ontology of muralism as both monumental art and as an
avant-garde" (148). Castillo proposes that ultimately Rivera's attachment
to socialist revolution as an unrealisable fantasy won out over the
imperative to document a manifesto for tangible change: the SEP murals
therefore assume another layer of public meaning inasmuch as their
aestheticisation and institutionalisation of revolution can be read, as
Castillo indicates, as a harbinger of the fragmentation of modernity.

Alejandro Latinez's chapter on Abraham Ángel, the Mexican artist and
contemporary of Diego Rivera, can usefully be read in dialogue with
Castillo's chapter on the SEP mural. Latinez reads muralism and its
dominance within Mexican art history as itself constituting an orthodox
and institutionalising paradigm. In this reading, a medium associated with
revolution and with public participation in the arts is itself involved with
suppressing the expression of other perspectives, such as the androgynous
and queer artistic outlook captured in the few works completed by
Abraham Ángel during his very brief lifespan. Where is the revolutionary
capacity of gender alterity and of sexual dissidence in the muralist-
dominated art history of Mexico? This is a question which Latinez asks to
great effect by querying the sidelining of Ángel, within his lifetime, and
since, and by contextualising the reception of Ángel's work alongside the
greater visibility of gender queers made possible by Mexico's newly
emerging industrialised print medium which found in graphic stories about

homosexuals the scandalous content it needed to inflate circulation. Latinez detaches Ángel's work from this legacy and instead sees in the artist's oeuvre the key to another reading of Mexico's art history where a light shone briefly on possibilities for the artistic expression of an aesthetic which brought together national and indigenous traditions with a sensibility outside the binary of gender.

In her chapter on Jesús Ruiz Durand's poster art Talía Dajes examines the reworking by a Peruvian artist of pop art's aesthetic and ideals. A movement based on recycling itself becomes a source of material to be recycled and adapted to a specifically Peruvian frame of reference. In her analysis, Dajes demonstrates that Ruiz Durand's references to pop art are not only homage to artists like Roy Lichtenstein but also function as a means to articulate in aesthetic dialogue the resonances of earlier colonial episodes in Peru's history with the later influence of Untied States foreign policy in Latin America. Dajes suggests that Ruiz Durand redefines "The limits of what is considered to be authentically Peruvian in terms that include the indigenous, the rural, and, more generally, everything that had been marginalised by the dominant Criollo urban culture" (141).

Jaime Porras Ferreyra makes a synthesis between the politically engaged metaphorical films of Carlos Saura and the artistic movement which has grown up around the 2006 Oaxaca Protests. In both cases, Porras Ferreyra reads artistic labour as the expression and instrument of political transition and his juxtaposition of the metaphorical films which characterised transitional Spanish cinema with the plastic arts inspired by the events which developed around the teachers' strike in Oaxaca recasts the more recent period in Mexican history as one of potentially pivotal change. As sites of resistance to a hegemonic past, Porras Ferreyra points up the affinities between the two intervals he studies so that we can draw correspondences between them as well as between more self-consciously artistic endeavours and the more obviously demotic graffiti, "escrache", and silhouettes studied elsewhere in the book.

CHILDREN

Children, and the role they are afforded in films tackling social divisions, figure in a number of the chapters. In her contribution, Jill Ingham compares the child-centred Cuban film *Viva Cuba* (Juan Carlos Cremata, 2005) with Fernando Pérez's more sombre and adult focussed *Madrigal* (2007). Where the more recent film looks to internal migration through the imagination as a route out of Cuba's political and economic difficulties, *Viva Cuba* contrasts adult fixation on migration with a childish impulse to explore the island and to inhabit the present. In *Viva Cuba* and its playful

engagement with intertextual references, Ingham finds a film which "references and ironises in its diminutive would-be fugitives the clichés of the road movie genre" (214). In this analysis, children represent the insular continuity which migration threatens to interrupt, and thus embody both the past and the future, as well as "what the adults are leaving behind: friends, family, ancestral ties, and a much loved island landscape and its music and folklore" (217).

It is precisely the symbolic burden placed on childhood as a store of futurity to which Deborah Martin returns in her reading of Colombian director Víctor Gaviria's 1998 film *La vendedora de rosas*. Martin reads the film as one which tries to negotiate a position somewhere between a documentary view of the real hardships endured by many children in Latin America and another perspective which inherits cinema's tendency to romanticise childhood: "The film treads a wavering path between extreme radicalism in its bid to allow child agency, and a more conventional use of the child: as (national) allegory/symbol within the Latin American narrative tradition of mobilising the child-figure as a means of highlighting exploitation, marginalisation, and racism whilst denying the figure real agency" (270). Martin considers how the unusual circumstances of the film's production contribute to a sense of it being pulled in different directions. Like *Viva Cuba*, this film follows children who are on the move, though, as Martin underscores, the fragmented succession of places and perspectives in Gaviria's film is more about reflecting disconnections in Colombian society than it is about using journeys as a metaphor for self discovery: "Journeys in *La vendedora de rosas* reveal the incoherent, inconsequential and truncated nature of the children's street lives. They are a challenge to teleological views of history [...] and also to concepts of progress" (275). Martin looks in the film for instances where the attempt to reflect a childish perspective wins out over cinema's more familiar recourse to an instrumentalist use of the child to represent adult anxieties or aspirations.

In her chapter on Chilean cinema Verena Schmöller articulates a reading of Sergio Castilla's 1998 film *Gringuito* in which we clearly see how children are often charged with effecting reconciliation of adversaries in Latin American film. In this film, again, an errant child's adventures first serve to trace a linear progression through a Santiago de Chile otherwise divided along the lines of class and wealth, and then to provoke a returning exile family to reconsider their relationships both with authority figures and with relatives who were happy to stay and prosper in the Pinochet dictatorship: "By means of the visual POV as well as the film's mise-en-scène it becomes clear that a friendly co-existence of the

two elements of Chilean society represented by the previously fractured family is—in the film at least—not only possible, but worthy and desirable" (250).

In Ryan Prout's chapter on transnational adoption he also considers the meanings invested in childhood, by Asha Miró in her two volumes of autoethnography—*La hija del Ganges* and *Las dos caras de la luna*—and by Sara Barrena in *Venida de la lluvia*, her account of adopting her daughter from China. Prout contrasts the birth or roots narrative prepared in advance for her daughter by Barrena, and pursued across India by Miró, with the quest for identity undertaken by Carla Subirana in her autobiographical documentary film *Nadar*. Though the Catalan director was not adopted, Prout suggests that there are lacunae in Subirana's family biography which resonate with those addressed by Miró and Barrena. Transnational adoption has been read as a technology for suturing or reproducing cultures and in his chapter Prout asks with reference to three women's narratives if it also sets up a space where the polarities of identity read either as constructed or essentialised are in dialogue rather than opposition.

WOMEN

In her chapter on female *cantautores* from the late 60s and 70s, Esther Pérez-Villalba turns her attention to the visual aesthetics used to portray artists like Rosa León, Cecilia, María del Mar Bonet, and Elisa Serna on album sleeves. Pérez-Villalba's analysis discovers a style of representation strongly influenced by the particularities of Spanish party and gender politics of the time. Politically committed female musical artists wanted both to distance themselves from the fusty view of femininity prescribed by the Sección Femenina, and to be taken seriously as political activists. The chapter suggests that this led to the predominance of an aesthetic which privileged a kind of studied nonchalance framed by a graphic design evocative of political pamphleteering: "Politically-committed *cantautoras* wanted to escape their femininity and beauty in a traditional sense and to adopt the more masculine looks which would gain them credibility and influence in the male-dominated world of politics" (10). Within this context, Pérez-Villalba pays special attention to Ana Belén as an artist of the transition whose image, as reflected in LP cover art, also effected a transition between committed asceticism and the aesthetics of glamour. Where the conspicuous eschewal of sartorial femininity had become so codified, Ana Belén's "decision publicly to reassert a somewhat stereotypically feminine beauty seems a significant and considered political act in itself' (14). Peréz-Villalba shows us in Ana

Belén someone whose public image was a bridge between the radical asceticism of the late 60s and the newly acceptable glamour of the 80s: "She offered women fans a different model compared with other political female artists. Furthermore, she also showed men (and women) that progressive political activism, elegance, and the display of a 'feminine' femininity could go together" (15).

Lorna Dillon also focuses on a female political singer, Violeta Parra, though here the emphasis is not on visual representations of the singer but on Parra's work as a visual artist herself. Dillon looks at Parra's embroideries and her papier-collé and papier-mâché collages to suggest continuities between the well-known lyrics and the less studied appliqué work, and also to underscore the radical fusion of indigenous and colonial legacies throughout the distinct media in which the artist worked. Dillon sustains, furthermore, that Parra's representations of state violence are not only of aesthetic interest but that they were also conceived with an activist purpose in mind. The chapter's focus is on works which threw light on the abuse of human rights during Parra's lifetime and on her use of a visual as well as of a musical language to hold responsible for their actions the perpetrators of such abuses.

In her chapter on Saint Teresa, Celia Martín-Pérez considers the visionary mystic's cultural afterlives by looking in detail at three film and television treatments of her biography: Juan de Orduña's *Teresa de Jesús* (1961), the television drama series directed by Josefina Molina, *Teresa de Jesús* (1984), and Ray Loriga's *Teresa, el cuerpo de Cristo* (2007). The figure that emerges "is a constellation of identities, which vary from hysterical religious mystic, through feminist icon, to sex symbol [...] reflect[ing] different models of womanhood [and] marking shifts in gender attitudes across five decades of Spanish cultural history" (29). Martín-Pérez suggests that the TVE mini-series re-interpreted Teresa to create a character with a "de-radicalised, progressive quality which echoed the ideal picture the socialists aimed to promote" (25). Whereas state-funded or state-supported versions of the saint's life have inevitably reflected the orthodoxy of political incumbents, Martín-Pérez suggests that independent productions have not necessarily veered far from the established path. In Loriga's film, she reads an image of the saint which "supposedly belongs to post-feminist discourse [but which] in fact [...] only serves to reinforce the kind of neo-macho attitudes which usually appear camouflaged" (29). The chapter points towards Rafael Gordon's *Teresa Teresa* (in which an ectoplasmic saint returns to Spain to do the TV chat show circuit) as a text which begins meaningfully to renovate Teresa's image and to question women's roles in the post-feminist era.

In her chapter on Luis Buñuel's *Tristana*, M. Graziella Kirtland-Grech contrasts the director's off-screen conservatism with a story about radical re-invention of a female protagonist. By honing in on the metonymic value of Don Lope's slippers in Buñuel's adaptation of Galdós's novel, this chapter underscores the dramatic economy of the surrealist director's story-telling. Kirtland-Grech suggests that the metonymy of the slippers "Form[s] part of a complex metonymical braid [...] enabl[ing] us to delineate the stages through which [Tristana] passes in her journey from subjugation, to rebellion, and finally to power, when she takes control of her life and of Don Lope's household" (41). This chapter also reminds us of the price exacted by this transformation: in the process of shifting from ward to autonomous householder, Tristana's body, like her biography, is torn apart.

Whereas Jill Ingham's chapter looks at the prospect of emigration to the United States for a new generation of Cuban families, Dolores Alcaide Ramírez considers in her chapter on Nancy Morejón and Ana Mendieta the lasting effects of the exile forced on a previous generation of Cuban children by the Pedro Pan airlift. Alcaide Ramírez locates Mendieta's performance art within this history of radical displacement and finds in Morejón's poem about the artist an attempt to reunite a Cuban identity fractured by the torrid politics which has been driving parents and children apart from Pedro Pan to the Elián González affair: "Morejón uses Mendieta's tragic death to criticise the fragmentation of the identity of fourteen thousand children and teenagers who were relocated from Cuba to the United States through the ministrations of Operation Peter Pan" (178). This chapter describes a history of emigration where ideology and economics are constantly intertwined: if the *noventamillistas* left Cuba in 1961 as much to protect their assets as to flee communism on ideological grounds, the *balseros* who risked life and limb in the 90s to escape from Cuba left because of an absence of any assets, either in the bank or in the larder, victims of a dogmatic and intransigent ideology. While the two ideologies across which Mendieta's life was lived seem as far apart as ever, Alcaide Ramírez suggests that Morejón's poetry, at least, "recovers the involuntary exile as a piece of the Cuban mosaic, and as part of the artistic legacy which should be available to all Cubans" (189).

In his chapter on the 1990 Cuban portmanteau film *Mujer transparente*, Guy Baron describes a female Cuban identity fractured not only by division between insular and exile experience but also by a post-modern aesthetic which was beginning to site individual women's lives outside the paradigm of the Cuban national collective. Baron pieces together the five parts in which the story is told in a reading which illustrates the film's

resistance to a unified meaning: the whole is in fact "the erosion of the so-called socialist subject and the fragmentation of female subjectivity [...] seen in all of the short films" (194) which together make up *Mujer transparente*. Baron's chapter is especially attentive to the uniquely Cuban iteration of post-modernism and to the parallel crises of subjectivity and of Marxist consciousness which threw into disarray the assumption of a unified female subject. Baron suggests that Cuban cinema sought to work out its version of the post-modern aesthetic precisely through the representation of women so that "the modernist search for truth [...] is displaced by the knowledge that there is not one singular reality, but a series of fractured realities" (204), a series of syntagmatically connected disconnections set out in the analysis of *Mujer transparente*'s anthology of discrete yet partial short films.

CYBERSPACE AND DIPLOMACY

Several of the chapters collected here approach material which presents a clear challenge to interpretations based on the paradigm of the political nation state bounded by physical geography. For example, in her chapter on Catalan soap opera Silvia Grassi looks towards the re-purposing of gay storylines by Youtubers who are more interested in unifying a narrative around a common sexuality than a common language. Grassi's chapter first examines the emergence and evolution of long-running soap operas within the arena of regional television output designed with an explicit nation-building and normalisation process in mind before considering how viewers' re-editing of this content for participatory new media platforms has produced meanings and functions which exceed those foreseen by the original scriptwriters. Whereas cineaste and theorist Tomás Gutiérrez Alea's concept of the spectator's dialectic, and of cinema's radicalising potential, seemed always to fall short when faced with the question of how audiences could actually be involved with a film (as opposed to being moved by it, shocked by it, or outraged by it), in the digital universe where Grassi's chapter finds unscheduled mutations of television content re-ordered by viewers themselves, exactly the dialogue Alea envisaged (without being able to situate it) assumes potentiality. Collage has gone from the preserve of art house to the demotic arena of the home PC.

Similarly, in Michelle Rivera's chapter on internet expressions of reggaeton anti-fan sentiment we find de-territorialised possibilities of cyberspace being used to stage a debate over the situation of the hypothetical Latino/a music consumer. Whereas the music industry seeks to create an homogenised Latino audience by prescribing an ethnographically determined set of tastes, in Rivera's chapter we see that

on the one hand the national amorphousness of the web allows anti-fans of one particular music genre to deploy electronic avatars of this deracinated consumer to stage trans-national alliances against such an interpellation and, on the other, to insist on the heterogeneity of tastes and of national allegiances, and on the poly-faceted identities of the individuals who comprise the putatively uniform Latino consumer base. Rivera's chapter sets up a lively dialogue between attempts by the music industry to use genre to create a Latino market (and thereby bulldoze individuality and specificity) and resistance in the form of images on the web manipulated and queried by individuals interpellated or targeted by such marketing. In a web space increasingly monopolised by corporate activity, the forums Rivera's chapter explores "are a central location of identity negotiation and formation as well as an alternative public sphere where anti-fans speak back to, interact with, and produce images and text that resist the apparatus that seeks to define them" (296).

Diana Luft's chapter on T. Ifor Rees, the Welsh diplomat who was also a writer, photographer, and translator also deals with a subject who, while representing British national interests as a diplomat, lived between and beyond national frontiers.* Luft discovers in T. Ifor Rees a subject whose identity was deeply rooted in Wales, and in the Welsh language, and who also formed attachments in Spain and Latin America where he spent much of his diplomatic career. Rees took photographs in the form of a diary and the albums he created offer a unique view of a Welshman's perspective on the Spanish speaking world in the first half of the twentieth century. Luft weaves in to her portrait of Rees's life some of his official diplomatic reports which sometimes recall perspectives outlined in other chapters in the present volume. For example, Rees's account of the overthrow of President Gualberto Villarroel in Bolivia brings to mind Nasheli Jiménez del Val's focus on broken bodies in Latin American politics. The images he took are poised somewhere between colonial photography, family snaps, and anthropology, and Luft makes a convincing argument that the framing of the photographs reflects the sensibilities of a photographer who was in some ways himself an outsider.

RECONSTRUCTION AND DISINTEGRATION

In his chapter on two recent documentary films from Spain—Mercedes Álvarez's *El cielo gira* (2004) and José Luis Guerín's *En construcción* (2001)—Antonio Sánchez considers how the reordering of urban and rural

* T. Ifor Rees himself used the Anglicised spelling of his surname. His family now uses the Welsh spelling, i.e. Rhys.

space in Spain has been represented in cinema. While the pneumatic drills of the Spanish construction boom now lie idle (with devastating consequences for those who depended on it to make a living), Sánchez shows us in *En construcción* a film which was attentive even before the bubble burst to the speculative uses of capital and to the communities and histories brought sharply into focus by the threat of gentrification. The pairing of *En construcción* with *El cielo gira* also underscores the symbiosis between rural depopulation and urban regeneration. Between these two films, Sánchez's chapter opens up a vista which stretches from the dinosaurs to the nouveaux riches and uncovers space in rural and urban Spain not as something eternal and unchanging but as susceptible to and sometimes determining of history. The fragments of the past in the sites explored by these two films, and underscored by Sánchez's reading of them, reveal that "space is littered with historical, archaeological, and even biological vestiges" (56).

Where Antonio Sánchez examines a body politic pieced apart by the expediencies of urban regeneration and rural depopulation, Nasheli Jiménez del Val considers the social meanings ascribed to representations of broken Mexican bodies in a chapter that begins with the first European engravings of Mesoamerica and ends with images of assassinated drug barons: "For the Spanish conquistador, the spectacle of the pieced body was used as evidence of the savagery of a godless Mesoamerican society that thrived on violence. For the drug cartel boss, the broken body functions as a statement of purpose and as a visible threat to competitors" (107). Tracing the meme of the broken body across several centuries of Mexican history, Jiménez del Val suggests that the violence which inheres to the use of images of physical dismemberment is as constant as the recycling of the scenario itself. In the war on drugs in Mexico, Jiménez del Val sees an especially troubling one-upmanship of spectacular killings: "If the Mexican government has fed into the strategy of semiotic intimidation by presenting tortured bodies as cautionary tales, the war against drug cartels has already been lost; for by playing under the rules established by others, the government reveals a power void born of the illegitimacy of its ascent to power" (116).

In his chapter on *Don Quixote*, Keith Budner gives us a fictional character who is not only at loggerheads with the world outside but is also, in a prototypical fashion, torn inside, between the chivalrous gentleman and a red-blooded individual whose motivation is not only to put the world to rights but to satisfy pent-up sexual frustration. Budner illustrates the fragmentary interior of Don Quixote (and the added texture this gives him as a fictional creation) by linking three incorrect classical allusions made

by Cervantes's hero to Alfonso de Ferrara's picture gallery, and with it to memory as something conceived of in visual and pictorial terms. By tracing back Quixote's failed allusions to an architectural marriage of image and text which Cervantes knew of and may even have seen first hand, Budner unravels Don Quixote's lapses to show the recesses in the mind of a character whose knowledge of antiquity was built, at least in part, on familiarity with an illustrated recess. Budner suggests that Cervantes uses a visual conception of the mind to articulate the inner workings of a character torn between social niceties and desire: "It is the paintings that speak and give voice to these unspoken and repressed elements of the psyche" (88).

NOTE ON TRANSLATIONS

Wherever possible English translations of all quotes in languages other than English are provided in footnotes, and, for very brief quotes or individual words, in the main text. Except where indicated otherwise, translations are by the individual contributors and Ryan Prout. Kurt Hackbarth translated Jaime Porras Ferreyra's chapter into English.

PART I
SPAIN

CHAPTER ONE

ANA BELÉN AND THE CONSTRUCTION OF A NEW VISUAL PERSONA: FEMININITY AND AESTHETICS IN THE POLITICAL SINGING OF THE TRANSITION

ESTHER PÉREZ-VILLALBA

In the 1960s, an important left-wing, politically-committed musical genre was born in Spain, popularly known as *canción protesta* (protest song) or *canción de autor* (singer-songwriting). The authors and performers of the genre were known respectively as *cantautores* and *cantantes políticos* (Torrego Egido 1999: 42, 43; González Lucini 1998: 32). These *cantantes políticos* defied censorship in order to communicate their political messages in support of democracy and freedom through their musical work and they became crucial icons of cultural and socio-political resistance in the 1970s as Franco's regime approached its dying days (Boyle 1995: 291; Turtós and Bonet 1998: 22, 26). The arrival and consolidation of institutional democracy led this musical movement to lose much of its strength in 1982 (Barbáchano and Domínguez 2006: 61). Heavily influenced and inspired by French song, and by North American and Latin American folk music (Menéndez Flores 2001: 62; Gracia García and Ruiz Carnicer 2001: 360), Spanish *canción protesta* constituted a world largely orchestrated by men. However, some female *cantautoras* succeeded in making a space for themselves in this conspicuously male-centred universe. In Catalonia and Majorca, creative authors Guillermina Motta and María del Mar Bonet managed to become important and valuable members of Els Setze Jutges, a musical movement closely linked with a desire to reassert Catalan identity and language (Román 1994: 339, 340).[1] In the Basque country, Lourdes Iriondo became a well-known member of Ez Dok Amairu, while Castilian-based Canción del Pueblo counted Elisa Serna and Julia León among its number (Turtós and Bonet 1998: 25, 30). The list of popular female political singers could be

[1] Although her career began later, singer-songwriter Marina Rossell also became well-known, especially in Catalan circles.

completed by adding the names of Cecilia, Mari Trini, Rosa León, and Ana Belén, four unclassifiable, independent artists who became very popular during the final years of the regime (González Lucini 1998: 119; Turtós and Bonet 1998: 27).[2]

Out of all the singers mentioned, Ana Belén deserves special attention as she was one of the best-known *cantantes políticas* of the period, especially from the late 70s onwards.[3] As Jordi Sierra i Fabra notes (2000), the 70s generation had in Ana and her husband, Víctor Manuel—also a very popular *cantautor*—"its official couple." Born María Pilar Cuesta Acosta in Madrid in 1951, Ana Belén started her career as an actress at the age of thirteen. Although her first films were not successful, she continued to pursue her career as an entertainer, and became involved with political singing in 1973 with the release of *Tierra* (Philips). A year later, she became a militant member of the illegal PCE (Spanish Communist Party). By the mid 1970s, she had emerged as a fashionable actress featuring on front covers and was also a well-known political singer, dual roles which she has successfully maintained up to the present.[4] This double artistic dimension apparently shaped her public image—her femininity—which seemed markedly different from that exhibited by most other female political singers. This chapter thus considers aesthetics in the world of *cantautoras*, the ways in which Ana Belén's femininity deviated from those aesthetics, and the possible meanings her new femininity may have had during the Transition. To this end, the chapter focuses on looks in two different senses: it examines different *cantautoras'* physical appearances

[2] Singer-songwriter María Ostiz also achieved popularity at the time of the Transition, especially with her song "Un pueblo es." She is not included in this discussion, however, because unlike all the other artists mentioned above, she adopted a rather conservative ideological position.

[3] Ana Belén was not a singer-songwriter in the strict dictionary definition of the term: that is, she did not compose her own songs, but sang other people's. However, this should not be seen as problematic: some of the singer-songwriters who were described as epitomising the genre were not always best-known for songs that they wrote themselves, but for their versions of poems put to music, or for singing other authors' songs (for example, Paco Ibáñez and many of his songs on the 1969 album *Paco Ibáñez en el Olympia,* Emen-SGAE). It should also be noted that many of Ana Belén's songs were written expressly for her. Moreover, she was the author—or at least co-author—of her songs in the sense that she performed them and by so doing provided them with specific meanings and interpretative nuances.

[4] See, for example, the front covers of *Miss* (10 July 1970), *Dígame* (20 March 1971), *Garbo* (13 October 1971, and 31 May 1972), *Lecturas* (29 October 1971), *Nuevo Fotogramas* (7 April 1972).

and clothing styles, and also considers issues of the gaze as captured on album covers. LP sleeves are chosen here as appropriate visual documents because they may be read as texts that directed not only how the singers should be seen by audiences, but also how their images related to their own musical work as committed artists. I will also briefly explore how the particular pioneering (postmodern) femininity which Ana Belén aimed to articulate visually relates to her musical repertoire and to those aspects of her life which extend beyond her musical career.

In terms of style, most *cantantes políticas* of the Transition usually displayed the type of femininity that was fashionable in the streets among left-wing circles. Influenced by American and British hippie trends, this style emphasised long, tousled hair and a natural female beauty unenhanced by cosmetics. These trends were clear to see in many of the photos used on protest singers' album covers. Such visual documents repay attention, for we rarely remain indifferent to visual input; either consciously or unconsciously, we tend to interpret visual stimuli, and these induce and shape what Patrick Maynard calls our "imaginings" (1997: 97). In fact, photographs especially have the power to "involve thought and feeling, stirring will and desire" (Maynard 1997: 68). Moreover, images are important "because they are indicators of social position and power [and] powerful framers of self-image, social identity, and public values" (Korsmeyer 2004: 1), and are central in "producing meanings, establishing and maintaining aesthetic values, gender stereotypes and power relations within culture" (Rogoff 1998: 14).

We turn first to Rosa León, the first performer to record Luis Eduardo Aute's "Al alba" (1975 Ariola-Eurodisc), a milestone of anti-Francoist political singing.[5] The cover of León's 1973 album, *De alguna manera* (EMI-Odeón), illustrates the template used for several of the artist's releases in the 70s. A photo of the singer appears within a brown, square frame, in the middle of the sleeve, against a plain, greyish background. León's name appears in big, bold, brown letters above her framed photo (Fig. 1-1). The names of the authors whose repertoire she is interpreting— Aute, Benedetti and Krahe—appear below her photo, also in a sober, bold, brown typeface, although smaller than that in which the singer's name is written. The titles of four songs from the LP are also visible at the bottom. This layout, which stresses the importance of authorship and of the lyrics, apparently emphasises the content of the album over the singer's visual persona, and it appears with relative frequency on the covers of other

[5] Here as throughout the chapter the year in which an album or single was released and the name of the record label on which it appeared are given in parenthesis in the course of the main text.

albums by *cantautoras*, for example Mari Trini's *Mari Trini* (1969 RCA), León's single "Las cuatro y diez" (EMI), Motta's *A un amic del país basc* (1968 Concèntric), Bonet's *L'aguila negra/No voldria res més ara* (1971 Boccacio Records), or Serna's *Choca la mano* (1977 Movieplay). In the case of *De alguna manera*, it should be remembered that Aute and Krahe were very popular singer-songwriters associated with left-wing political circles. Thus, for audiences in the 70s, these names triggered connotations of political engagement and the layout of the album accordingly reflects the expectations consumers at the time brought to it. In fact, such a layout may even have guided consumers' interpretations of the songs; a priori they may have been led to pay *special* attention to the political content of the lyrics. The photo of the singer also deserves attention. It shows a medium close-up portrait of her face, which is shot slightly in profile, with León looking out of frame and downwards, suggesting absent-mindedness or even submissiveness. She is wearing large, round glasses, which give her the intellectual look that was greatly appreciated by left-wing circles. These spectacles frame her apparently melancholic and thoughtful eyes, which gaze into the middle distance. León's long, brown, straight hair is parted hippy fashion, in the middle of her brow, and her subtle make-up (some eyeliner and lipstick) is nearly unnoticeable within a design whose colour scheme already has the quality of a sepia photo. In fact, the portrait's colour scheme echoes the browns used for the album's lettering. Again, León's visual persona seems designed to go almost unnoticed, to become integrated within the cover's focus on committed lyrics. Her image here is that of an average, ordinary, young woman, and corresponds with the description given by Fabuel Cava of León's public persona:

> Era como la vecina de la escalera, algo bonita, progre y 'engagé', ligeramente obstinada en los temas de parejas modernas y el reparto de las tareas domésticas, en realidad toda ella era un arquetipo de las chicas progres de la época (las tías "concienciás", que decían) su pelo, sus gafas, sus faldas largas, sus tics. (1998:109)[6]

Some of the features found on the cover of *De alguna manera* are also to be seen on Cecilia's albums. The front sleeve of *Cecilia* (1972 CBS), designed by Daniel Gil, included a photo of the artist taken by well-known

[6] "She was like your next door neighbour, somehow beautiful, lefty and 'engagé', very attached to the idea of the modern couple and the sharing of domestic chores; in fact everything about her responded to the archetype of lefty women of the time (*committed* girls, as they used to say): her hair, her glasses, her long skirts, her mannerisms."

photographer Francisco Ontañón (Fig 1-2).[7] This album, which included the popular socio-political satirical song "Dama, dama", shows on its front sleeve a so-called three quarters portrait or American shot of the singer with the image cut off at the knees.[8] Cecilia is shown standing up and looking face on against a plain, brown background which does not form a very strong contrast with her silhouette. Following the left-wing fashion of the times, she is wearing a tight, plain, cream-coloured top, and jeans. Her name, written in large, black and white embossed typography with a three dimensional effect, horizontally crosses the full width of the sleeve. The fact that her name is printed over the image seems to suggest, as in the case of León, that the artist's name, and by extension her song-writing, are most important while her visual persona is perhaps intended to remain conceptually as well as visually in the background. Moreover, the name covers a significant part of Cecilia's torso, from just beneath her bosom to her waist, thus concealing the tapering of her slim waist, which somehow desexualises the portrait and de-feminises Cecilia, making her body look more vertical and less curvaceous. This de-feminisation is also suggested by her apparently belligerent posture: with her left arm she is grabbing one of her belt loops in a rather masculine Cowboy fashion while on her right hand she is wearing a boxing glove. The choice for her portrait of an American shot is also significant, as this was typical of the Western, a traditionally masculine genre.

With regard to her face and her expression, this picture of Cecilia does not conform to what John Garrett terms "a cosmetic portrait [...] intended to show the sitter in a flattering fashion" (2001: 205). If she is wearing any make-up, it cannot be discerned, rendering her face average since no particular feature is enhanced. Her mouth is open and reveals rather prominent front teeth. While she seems to be looking at the viewer, her eyes and facial expression suggest shyness and a lack of self-confidence, as does the hunching of her shoulders. It is thus noteworthy that, in spite of the partly de-feminised depiction of her body, her face and aspects of her posture evoke fragility and shyness so that in some other respects she remains traditionally feminine.

Similar features of Cecilia's public persona were often used in compilation records released after her tragically early death. *Señor y dueño* (1991 CBS), for instance, presents record buyers with a photo taken by her

[7] Photos taken by Ontañón (who died in 2008) have often been used in *flamenco* musical works.

[8] "American shot" is a term borrowed from the field of film studies and refers to a 'three quarters' image or picture which shows subjects cut off at the knees. This type of shot is frequently found in American cinematic texts.

friend and popular photographer Pablo Pérez-Mínguez; it is a close-up of her face which fills the LP sleeve, as she looks down and to the left (Fig.1-3).[9] Again, her gesture suggests fragility, absent-mindedness, and even perhaps virginal purity, all of it accompanied by an existentialist and almost mystical touch. As with *Cecilia* (1972), the posthumously released album depicts the artist's skin unadorned by any make up. Due to the extreme close-up nature of the shot and to low illumination, large shadowy areas are created, which reveal the circles under her eyes, her freckles, and the imperfections of her skin. Her long black hair is parted in the middle and the locks near her forehead appear slightly greasy. In fact, it seems that the image that record companies wanted to project of Cecilia after her death was still that of the socially-aware artist who was more worried about existentialism and politics than about herself and her image, although some more sexy and sophisticated photos of the artist also existed. This suggests that her visual persona was anything but unmediated, as the seemingly spontaneous naturalness and casualness of the femininity depicted on Cecilia's album covers was in fact a studied aesthetic style in vogue among many left-wing women.

The use of low-key lighting, which creates interesting chiaroscuro effects—at times enhanced by the inclusion of black and white pictures— is relatively frequent on other LP sleeves of the period. It can be seen on Cecilia's *Cecilia 2* (1973 CBS), Motta's *Recital Guillermina Motta* (1965 Concèntric), Serna's *Este tiempo ha de acabar* (1974 Edigsa), Iriondo's *Lurdes Iriondo* (1969 Herri Gogoa-Edigsa), and Bonet's *María del Mar Bonet* (1969 Concèntric), among others. This particular use of lighting often creates sharp contrasts between illuminated spaces and shadowy areas, the latter becoming especially prominent and therefore significant, "if only for their environmental and representational importance to visual perception" (Maynard 1997: 188). In this respect, the sleeve design for *María del Mar Bonet* (1969) deserves closer attention. Like most of the LPs mentioned above, but in a more extreme fashion, this cover suggests literal—and, by extension, metaphorical—effacement of the artist's visual/physical persona. In the close-up head on shot, Bonet's face is illuminated frontally by a low key light. There is no fill light and the back light is almost non-existent, which means her silhouette hardly stands out from the black background. Her long, black hair also adds strongly to this contour-softening effect. Black, very dark grey, and green tones dominate the sleeve. Furthermore, two almost identical photos of Bonet's face are

[9] Pablo Pérez-Mínguez, an influential photographer in Spain since the 70s, was especially well known in the 80s for his pictures of the *Movida Madrileña* artists.

partly superimposed on one another, which creates a foggy effect and, again, blurs both contours and facial details: her vivid eyes and attentive gaze seem to be diminished through the physical self-effacement suggested by the image's blurriness.

Bonet's LP *Alenar* (1977 Ariola) also features a noteworthy sleeve portrait where an extreme close-up photo of the singer has been cropped to include only the upper left corner of the face (Fig. 1-4). We are shown half of her forehead, her thick, bushy eyebrow—which has been left to look natural and has not been plucked—, her left eye—only slightly highlighted by some eyeliner—and part of her dark, long hair, which seems to curl rebelliously at the edges of the forehead. All these features evoke the hippy aesthetic, suggesting sincerity and extolling a natural and uncontrived beauty. The fact that her eye does not seem to be looking at the camera, but rather out of frame, is also noticeable. Her line of sight, directed to the viewer's left (typical of other photos of *cantautoras*), suggests political direction. More importantly, this distracted gaze of the artist, which often seems lost in space and rarely looks back at the viewer, is a surprisingly common feature on the LP sleeve portraits of female Spanish singer-songwriters. We see it not only on the covers discussed in detail above but also on many others: for example, on Mari Trini's *El alma no venderé/Mi guitarra* (1967 RCA) and *Amores* (1970 Hispavox), Motta's *Recital Guillermina Motta* (1965) and *Cançons que estimo* (1974, Edigsa), Iriondo's *Lurdes Iriondo-Xabier Lete* (1969 Herri Gogoa) and *Lurdes Iriondo* (1969), and Serna's *Este tiempo ha de acabar* (1974). These artists' absent-minded gaze may signal the voyeuristic position that consumers were supposed to adopt, and also points to the subsequent potential objectification of the artists. In the case of *Alenar*, this reification seems especially clear: the photo has been taken from above the subject, suggesting the viewer's superiority and a belittling and objectification of the subject's visual persona. Moreover, while conventions of artistic photography allow almost any type of shot for human faces—cropping frames to show only part of a face is acceptable—the fact that the LP sleeve for *Alenar* shows only a quarter of Bonet's face could nevertheless be interpreted as a fragmented, fetishising and therefore objectifying image of her visual persona.

Elisa Serna's visual persona is also interesting in many respects. Through her visual persona, the performer of the anthemic anti-Francoist song "No nos moverán" seemed to radicalise some of the characteristics of the femininity espoused by many *cantautoras*. In fact, she could perhaps be said to embody the gender confusion look that was in vogue at the time not only in Spain but also in some British and American musical circles

(Kelley 2000: 1, 7).[10] A declared feminist and former girlfriend of singer-songwriter Hilario Camacho (Niño 1996), Serna displayed a rather masculine image. *¡Choca la mano!* (1977), for example, includes a medium, black and white portrait of her: it shows her body up to her shoulders and leaves out her voluptuous breast. The feminine quality of some of her facial features (mainly her lips and thin eyebrows) seems partly displaced by her hair style and the use of light: this picture shows Serna's usual hair style, her very short hair and a short fringe which grows longer on the sides almost resembling sideburns. The use of a strong, main light which creates large overexposed and other extremely underexposed areas blurs certain facial details on the one hand—mainly the lips and eyebrows—and on the other hardens features less specifically associated with femininity—especially her chin. Likewise, her attire is overtly masculine: she is wearing a loose, long-sleeved shirt with a stiff collar which is partly unbuttoned and reveals what seems to be a cravat tied around her neck. She is also wearing a sleeveless sweater over her shirt thus completing a style which evokes male *cantaores* (flamenco singers) and, looking further back, nineteenth century outlaws of the Curro Jiménez type.[11]

For her earlier album *Este tiempo ha de acabar* (1974), the cover of which was designed by Jordi Fornas, Serna likewise displays a notably masculine style (Fig. 1-5).[12] A middle shot of the type found in *¡Choca la mano!* shows her in profile as she plays the guitar, sings, and looks at an audience out of view. The artist's image occupies the bottom part of the cover and appears below her name which, on this occasion, is presented in huge, black letters on a plain, reddish background. Serna's image here has been deliberately underexposed to the extent that we can only just make out her silhouette against the background and those unfamiliar with her looks may even find it difficult to discern whether the image depicts a man

[10] Kelley refers to progressive rock (mainly glam and punk) in his article, rather than to singer-songwriting, and mainly to a certain "progressive aesthetic", with "some link to the notion of the feminine" (Kelley 2000: 2). Nonetheless, his notion of gender confusion seems appropriate here, although for a different purpose: to refer to a certain masculinisation of the feminine in the circle of Spanish singer-songwriting of the Transition.

[11] *Curro Jiménez*, a very popular Spanish series broadcast in the late 70s, told the story of a band of outlaws led by Jiménez, an imaginary nineteenth century Robin Hood style Andalusian bandit who fought French invaders and fed the poor. This character seems to have been inspired by a real nineteenth century outlaw figure, namely, Andrés López, "el Barquero de Cantillana", who lived in southern Spain.

[12] Jordi Fornas also designed the covers for other LPs recorded by *cantautores* (e.g. Joan Manuel Serrat's *Ara que tinc vint anys*).

or a woman. This particular layout seems to suggest, yet again, the importance of the singing persona above that of the physical one. In fact, on *¡Choca la mano!* and, even more pointedly, on the cover of *Este tiempo ha de acabar*, the image of the artist has lost much of its studio shot photographic detail to become, deliberately, like a low-quality newsprint image that would look just as much at home in political propaganda and on leaflets. Like the imagery, the blocky and slightly ragged typeface employed on the sleeve of *Este tiempo ha de acabar* suggests pamphleteering and proselytising.

The analysis presented above suggests that while most female *cantautoras* embraced an image that drew on British and American hippie fashion, they also gave this look their own twist to signal breaking free from Francoist aesthetics, and, by extension from Francoist socio-political, economic, cultural, and religious codes of femininity. Such codes, mainly dictated by the Falangist Sección Femenina and illustrated in officially sanctioned magazines like *Teresa*, encouraged a contained and moral yet nevertheless feminine femininity: plucked eyebrows and some evidence of make-up to enhance women's most attractive facial features were welcomed by the official arbiters. Impeccable hair styles and neat, respectable—but not too revealing—clothing styles which nevertheless hinted at women's natural curves seemed likewise to be well considered (Otero 1999: 95). In other words, the officially sanctioned style was far removed from the baggy clothes, spontaneity, wildness, and the physically carefree attitude embodied by many *cantantes políticas*. Besides this desire to be very different from women influenced by Francoist trends, there was a further political reason for the partial physical masculinisation of female singer-songwriters. Paying attention to one's physical aspect and to beauty was considered feminine and thus a sign of frivolity in leftist circles. And the Transition, a crucial phase of harsh socio-political unrest and ultimately a period of huge changes, could do without frivolities. Ultimately, this pervasive neglect of the physical could be traced back to the Platonic dualism which equates the female body with beauty, and the masculine mind with the superior critical faculty, which could even be threatened by beauty (Korsmeyer 2004: 22, 132). It is not surprising, then, that politically-committed *cantautoras* wanted to escape their femininity and beauty in a traditional sense and to adopt the more masculine looks which would gain them credibility and influence in the male-dominated world of politics.

Yet, in this rather Spartan scenario, some dissident images were seen. For example, those of Motta on the covers of *Guillermotta en el país de las Guillerminas* (1970 Ariola) and *Cançons que estimo* (1974), where she

appears very feminine, playful, and seductive.[13] Ana Belén is especially important in this respect due to a level of success which has seen her become a household name. She managed to deconstruct the aforementioned Platonic dualism in very interesting ways. She often adopted some of the fashionable hippy looks of the 70s, but added some very personal elements to these: she combined them syncretically with more formal and tidy manners which did not fully neglect the lessons on beauty and elegance taught by La Sección Femenina—while subversively incorporating a very sexy touch full of eroticism. She always used cosmetics and appeared as a very feminine and slightly vain woman who looked after her physical appearance and style with pride. This is not to say that this type of femininity was totally absent in the singers examined earlier—for example, León and Bonet play the sexy role in images on the covers of *De alguna manera/Canción consumo* (1973 EMI) and *Cançons de Menorca* (1967 Concèntric), respectively. Nor is this to say that Ana never revealed the more moderate and shy dimensions of her character, as she did, for example, in *La paloma de vuelo popular* (1976 Philips).[14] However, these are exceptions. The majority of *cantautoras* were represented on album sleeves as detailed previously, and Ana Belén's most common public image, as we shall go on to see next, was that shown on the LP sleeves for *Tierra* (1973), *Calle del Oso* (1975 Philips), and *De paso* (1976 Philips).

Tierra's cover includes a very large photo of Ana Belén sitting on her haunches (Fig. 1-6). Filling most of the sleeve, the photo, which was taken by the well-known photographer Martín J. Louis, depicts her in a natural, outdoor setting.[15] Interestingly, although Ana is squatting, the shot is

[13] Motta's case, like that of Ana Belén, is interesting: although politically committed in her work, Motta maintained a casual and playful *pop* style which seemed close to the *chica ye-ye* aesthetics. Her musical biography is likewise interesting as she was courageous enough to sing both in Catalan and Spanish. This dual option, which might have suggested a double identity as a Catalan and Spanish citizen was adopted by number of singer-songwriters, and was criticised by some radical Catalan sectors at the time (Labordeta, 2001: 160). Some of Motta's LP covers include photographs of the artist taken by the feminist Catalan photographer Colita (Isabel Steva Hernández).

[14] She was visibly pregnant then, so perhaps that was the reason for her modest appearance.

[15] Martin J. Louis is the artistic name of photographer (and painter) Martín Frías. Author of numerous LP covers, in the 70s he was a well-known photographer who also worked for other very popular singers such as Nino Bravo. In the 80s and 90s, he was especially involved in photographing rock singers and became known internationally. The LP cover for *Tierra* was designed by M. Castán and J.I. Barea,

almost at eye-level, a neutral type of image which often symbolically suggests power equality between the sitter and the spectator. Ana's figure clearly stands out from the background, due to a combination of light and colour: the golden, apparently natural light that surrounds her clearly defines her slim silhouette while the different, prominently green tones of the background make her light clothes especially noticeable. She is wearing a large, immaculately white cape over a tight, flesh-coloured top which is sensually revealed around her left shoulder suggesting partial nakedness. Her long, dark, straight hair is parted in the middle, hippy fashion, but is also very neatly combed. Her soft-coloured but nevertheless visible lipstick makes her lips look fuller, while her marked black eye-liner and eye-shadow highlight her eyes and intensify her gaze. Ana Belén's name and the album title appear in a large, white, serif font which is italicised to match the folds of the cape and thus to pick up details of the sitter's physical presence. Although, as Susan McClary suggests, "Women's bodies in Western culture have almost always been viewed as objects of display" (1991: 137-8), other scholars, such as Carolyn Korsmeyer, point out that "The use of 'the body' on the part of artists does not always signify the same thing" (2004: 124). We can see the friction between these two stances on the cover sleeve of *Tierra* where Ana Belén, clothed in white, is also surrounded by nature, a scenario traditionally associated with femininity and with conquest and domination. However, all these ideas of potential servility, shyness, naivety, and virginal innocence seem rather playfully challenged by Ana's inviting, sexy, even daring gaze: she is staring back at the viewer so confidently that she seems to acquire full subject status. This idea of contestation mirrors the LP's contents, which include songs with an important feminist dimension like "Te besaba la arena en la playa", "Lady Laura", and "Soy yo, mi amor" in which Ana Belén ironically articulates the voice of a Spanish woman who enumerates all the virtues that would make her a perfect wife. An embodiment of a middle-class femininity shaped to suit men, as advocated by La Sección Femenina, the subject of "Soy yo, mi amor" is mocked by Ana's playful and ironic performance.

Turning to *Calle del Oso*, Ana Belén's gaze is the most striking aspect of this LP's cover, although other features also deserve attention (Fig. 1-7). On the right, the sleeve presents a close-up of the singer's face in two thirds profile, and part of her slim neck. This portrait, taken by Antonio Molina, Ramón Rodríguez and Duarte, fills more than half of the sleeve

artists who also contributed to the creation of LP sleeves for other celebrated Spanish artists like Paco de Lucía.

and, as with *Tierra* and *De paso*, the frame of the image extends to the edges of the actual LP cover.[16] Unlike other artists, Ana Belén does not appear confined within internal frames. Her sophisticated but subtle make-up makes her skin look totally even and of a perfectly smooth, transparent, and glossy texture; it also clearly enhances the natural beauty of her most outstanding facial features, especially her full lips, black, penetrating eyes, and prominent cheek bones. She has thinly plucked and nicely arched eyebrows and an impeccable hair style. She is seen against a plain, greyish background behind transparent glass which apparently simulates a window pane. This glass is wet on its exterior aspect: there are drops of water on it to suggest rain and this gives the sleeve an aesthetic value, among others. This window pane (with no frame to suggest confinement) also shows us the reflection of a man in the lower left quadrant of the sleeve. This man is closing one of his eyes and seems to be the photographer taking Ana's picture. Only half of his reflected and partly blurred face is seen and his mirror image does not obscure that of Ana Belén, who unequivocally remains the protagonist. The reflection also reveals that the singer's shot has been taken from a slightly low-angle, which magnifies the sitter's visual persona and suggests her strength, resolution, and perhaps some superiority over the photographer and viewers. While Ana Belén's face is turned to the left, her eyes are looking to the front, staring at the photographer and potential viewers. If anyone is being objectified in this composition, it may be the male photographer who we can observe but who cannot return our gaze. Ana's expression here is particularly defiant and offers a daring mixture of uninhibited sensuality, self-confidence, and awareness of her own beauty and attractiveness.

Self-confidence is also a feature of the cover illustration for *De paso* where Ana Belén's image is reproduced in art work, the lines, lighting, and angles of which recall Dalí (Fig. 1-8). Ana's face is a faithful likeness, reproduced in a very flattering fashion, but her long, straight hair seems surrealistically to be floating on the plain, blue-grey background.[17] Her look is penetrating and serious and suggests strength, which perfectly suits the overt political commitment of the songs collected on the LP, such as "Tengo", based on a poem by Nicolás Guillén and praising Fidel Castro's

[16] This LP cover was also designed by M. Castán and J.I. Barea.

[17] It should be remembered that one of the tenets of surrealism is that, apart from the world we see, there is a hidden and invisible reality. Thus, this LP sleeve could perhaps be interpreted as an invitation for viewers to go beyond Ana Belén's physical beauty and to discover fully her more politically-committed dimension, which are not incompatible facets but rather complementary ones.

socialist revolution, or "Julián Grimau", which pays homage to a member
of the PCE Central Committee who was tortured by Francoist forces.

Ana Belén's concern with her own physical beauty and looks was
perhaps conditioned by her commercially oriented image as a popular
actress, or even by some personal vanity. But it seems unlikely that her
decision to perform her particular and special brand of femininity
responded only to commercial or narcissistic interests. It is noteworthy
that while her visual persona may have been partly shaped by marketing
experts from the world of cinema and music, Ana is known to be a strong
and determined individual who has always exercised significant control
over her own image and artistic repertoire (Villena 2002: 71). As critic
Rodríguez Marchante points out, she was a committed artist who was well
aware of the on-going theoretical debates regarding politics, and of how
these interacted with particular ideas on gender roles, femininity, and style
(1993: 77). Thus, being fully conscious of the patriarchal bent of left-wing
politics, she willingly became a public figure whose combination of
glamour and political activism made her stand out from many other left-
wing women (Villena 2002: 77). In fact, her decision publicly to reassert a
somewhat stereotypically feminine beauty seems a significant and
considered political act in itself.

In her journeys to Italy Ana Belén realised that communists there
combined social claims with domestic revolutions, and that a new type of
woman activist was coming into being who reconciled an elegant or bold
clothing style with radical ideas (Villena 2002: 78). Nobody in the Italian
Communist Party was told off for wearing a mini-skirt, as often happened
in meetings of their Spanish counterparts: "Desde luego, mi modelo era el
PCI por esa actitud global ante el mundo que exigía las libertades
colectivas pero también, faltaría más, las individuales" (quoted in Villena
2002: 78-9).[18]

In this context, the potentially subversive content of many of her
numerous love songs acquires special significance: they could be read as
attempts to politicise the world of love, relationships, and emotions, and as
trying to open up the rather narrow, masculinised scope of an important
current of left-wing singer-song-writing.[19] Politics is not only achieving a
democratic government through an election. It should also involve the

[18] "Without a doubt, the model that I followed was that of the Italian Communist
Party, because of its global attitude towards the world, which demanded collective
freedoms but also, of course, individual ones."
[19] As I hope the text makes also clear, Rosa León, María del Mar Bonet, and
Guillermina Motta, among others, also contributed to this extension of what was
understood to be political.

implementation of laws that accept differences between the sexes but also encourage gender equality and sexual freedom for both men and women. Politics is singing "La muralla", perhaps the best-known politically charged song interpreted by Ana Belén, and other pieces by Nicolas Guillén, but it should also entail the performance of the aforementioned "Soy yo, mi amor" and "Los amores de Ana".[20] In other words, Ana Belén seemed to suggest through her work, her public visual persona, and her biography—she often stated publically that it was *she* who asked Víctor Manuel to marry *her*, something very unusual at the time when propriety, decorum, and tradition required of men to approach women, rather than vice versa (Vázquez Azpiri 1974: 70)—that a more comprehensive, open-minded, and less male-centred approach to politics was needed.[21]

Ana Belén was a "feminist playing feminine", a "communist with make-up making the personal political"; the living proof of the compatibility between political commitment and a more personal attention to one's own femininity and beauty in a rather traditional sense (Pérez-Villalba 2007: 296). While this argument may sound unimportant or even trivial today, it was innovative and challenging in the 70s. In fact, while respectful of her female colleagues' aesthetics—she herself was somehow a syncretised in-between, as noted—she offered women fans a different model compared with other political female artists. Furthermore, she also showed men (and women) that progressive political activism, elegance, and the display of a "feminine" femininity could go together. Her commitment to left-wing politics was in fact undeniable, and her widely-known membership of the PCE actually caused her trouble and serious threats from the extreme right (Villena 2002: 58). Ultimately, Ana Belén could perhaps be seen as a pioneer, as a playful, sexy, daring but politically serious and coherent post-modern feminist who achieved prominent visibility at a time when imported, more incipient and

[20] The humorous and playful "Los amores de Ana", a song from the 1979 album *Ana* (CBS), mocks elements typical of Francoist folklore (for example, "tunas") and constitutes a defence of female sexual freedom.
[21] They were married in Gibraltar in 1972 in a civil ceremony (Villena 2002: 67). At the time this was provocative in two ways. Franco's regime was particularly obsessed with the recuperation of Gibraltar for Spain (Otero 2000: 228, 229) and so marrying in territory regarded officially as under foreign occupation would be read by Francoists as disrespectful and antipatriotic. On another level, celebrating a civil ceremony rather than a religious one was also quite daring in the Spain of the Transition, because Catholicism was still deeply rooted in society (Vázquez Azpiri 1974: 73).

restrictive forms of feminism struggled to influence the Transition society (Salas and Comabella 1999: 28, 44).

WORKS CITED

Barbáchano, M. and A. Domínguez. 2006. *Al levantar la vista. 30 años de cantautores aragoneses*. Zaragoza: CMA.
Boyle, C. 1995. "The Politics of Popular Music: On the Dynamics of New Song." In *Spanish Cultural Studies: An Introduction*, ed. H. Graham and J. Labanyi, 291-94. Oxford: Oxford University Press.
Fabuel Cava, V. *Las chicas son guerreras. Antología de la canción popular femenina en España*. Lleida: Editorial Milenio.
Garrett, J. 2001. *Guide to Photography*. London: Dorling Kindersley.
González Lucini, F. 1998. *Crónica cantada de los silencios rotos. Voces y canciones de autor, 1963-1997*. Madrid: Alianza Editorial.
Gracia García, J. and A. M. Ruiz Carnicer. 2001. *La España de Franco (1939-1975). Cultura y Vida Cotidiana*. Madrid: Síntesis.
Kelley, M. 2000. "Cross Gender/Cross Genre". *PAJ: A Journal of Performance and Art* 64 (1): 1-9.
Korsmeyer, C. 2004. *Gender and Aesthetics*. London: Routledge.
Labordeta, J. A. 2001. *Banderas Rotas*. Madrid: La Esfera de los Libros.
Maynard, P. 1997. *The Engine of Visualization. Thinking Through Photography*. London: Cornell University Press.
McClary, S. 1991. *Feminine Endings: Music, Gender, and Sexuality*. Minneapolis: University of Minnesota Press.
Menéndez Flores, J. 2001 *Miénteme mientras me besas. Encuentro con la música*. Barcelona: Plaza y Janés.
Niño, A. 1996. "Las armas de la voz". *El País*, 5 March. http://www.elpais.com/articulo/madrid/SERNA/_ELISA/MADRID__/COMU NIDAD_AUToNOMA/MADRID_COMUNIDAD_AUToNOMA/CUERPO_ NACIONAL_DE_POLICiA/armas/voz/elpepiautmad/19960305elpmad_12/Te s/ (Accessed 15 December 2009).
Otero, L. 1999. *La Sección Femenina*. Madrid: EDAF.
——. 2000. *Flechas y Pelayos*. Madrid: EDAF.
Pérez-Villalba, E. 2007. *How Political Singers Facilitated the Spanish Transition to Democracy, 1960-1982: The Cultural Construction of a New Identity*. Lewiston, NY: The Edwin Mellen Press.
Rodríguez Marchante, O. 1993. *Ana Belén*. Mitografías: Barcelona.
Rogoff, I. 1998. "Studying Visual Culture". In *The Visual Culture Reader*, ed. N. Mirzoeff, 14-26. London: Routledge.
Román, M. 1994. *Canciones de nuestra vida. De Antonio Machín a Julio Iglesias*. Madrid: Alianza Editorial.
Salas, M. and M. Comabella and P. Fernández Quintanilla, eds. 1999. *Españolas en la transición*. Madrid: Biblioteca Nueva.

Sierra i Fabra, J. 2000. "Poetas y Cantautores". In *Poetas y cantautores. Un país de música: (Libro-disco de El País)*. Madrid: El País.
Torrego Egido, L. 1999. *Canción de autor y educación popular (1969-1980)*. Madrid: Ediciones de la Torre.
Turtós, J. and M. Bonet. 1998. *Cantautores en España*. Madrid: Celeste Ediciones.
Vázquez Azpiri, H. 1974. *Víctor Manuel*. Madrid: Júcar.
Villena, M. 2002. *Ana Belén. Biografía de un mito. Retrato de una generación*. Barcelona: Plaza y Janés.

CHAPTER TWO

A WOMAN FOR ALL SEASONS: TERESA OF ÁVILA ON SPANISH SCREENS

CELIA MARTÍN-PÉREZ

Teresa of Ávila (1515-1582) was a prominent Christian Counter-Reformation Carmelite nun, who was both a reformer of the order to which she belonged and a founder of the Discalced Carmelites. She devoted much of her life to setting up new convents based on monastic traditions as she travelled around Spain. Teresa was also a mystic who experienced ecstatic visions and levitations and it was for this that she was eventually persecuted by the Inquisition. She was the only female theologian in print in sixteenth century Spain when her books on mystical theology—*Libro de la vida* (1588), *Meditaciones sobre los cantares* (1611), *Las Moradas del castillo interior* (1588), *Camino de perfección* (1583), and *Libro de las fundaciones* (1610)—were first published. In 1970 she was granted the title of Doctor of the Church by Pope Paul VI, becoming the first woman to obtain this distinction. After her canonisation in 1622, Teresa typically was viewed as an examplar of obedience, and depictions of her frequently showed her fainting or in a state of ecstasy (Bilinkoff 1989: 200). Gian Lorenzo Bernini's marble sculpture of a nun looking as if she has just fainted, with half opened eyes and mouth (see Fig. 2-1), became the classic image of Teresa for hundreds of years (Medwick 2000: 6).

In recent times the typecasting of Teresa of Ávila—epitomised by Bernini's portrayal—has been questioned and she has become the focus of scholarly criticism. Jodi Bilinkoff (1989) and Cathleen Medwick (2000), have re-read Teresa as a dynamic, enterprising, resolute woman. Medwick, for instance, perceives Teresa as a feminist icon, "not only because she came to represent the missing link between female sexuality and spirituality, but also because of her ability to function within a male dominated hierarchy" (2000: xvi).

The dichotomy between the two versions of Teresa, the frenzied mystic on the one hand, and the active, intelligent woman on the other, also comes into view in many of the representations of what we could think of as the saint's cultural afterlives. In this chapter, I will examine

how the two sorts of portrayal emerge in three film versions of Teresa's story and I will also consider the close relationship of these revisions with the socio-political backdrops against which they were shot. The titles I focus on are Juan de Orduña's *Teresa de Jesús* (1961), the television drama series directed by Josefina Molina, *Teresa de Jesús* (1984), and Ray Loriga's *Teresa, el cuerpo de Cristo* (2007). As Marcia Landy observes "Through the spectacle of exemplary figures—monarchs, nobles, religious figures, military heroes, artists, musicians—the spectator is immersed in domestic or public issues that relate to questions of gendered identity, sexuality, and family" (1994: 127) and, as she goes on to say, reconstructions of the lives of exemplary figures from the past can often reflect present conditions (1994: 128). With this in mind, I concentrate on the gender ideology attached to Teresa's story and ask to what extent the films I study challenge orthodoxies both of the sixteenth century and of our own times.

Juan de Orduña's *Teresa de Jesús* was made in 1961, when General Franco, having abandoned his political and economic autarkic policies at the end of the 1950s, turned the management of the economy over to technocrats from Opus Dei, a lay Catholic organisation. This government opened up the country to foreign trade and investment, initiating the so-called economic miracle which laid the ground for a consumer society, characterised by access to more information and greater mobility, and which ushered in new, more relaxed, social values, especially amongst the younger generation. Notably, tourism emerged as one of the most important new sources of wealth in the country and shifted cultural trends as Spaniards came into greater contact with the outside world. Spanish customs were also reshaped by the influx of Spanish workers returning from their labour as expatriates in more industrialised and liberal countries of Western Europe.

Another important influence came from the Vatican, with Pope John XXIII calling the Second Vatican Council in 1962, and designing a new, more liberal, path for the Church. The Vatican's more open outlook began to exert its influence over sectors of the Spanish Church, pushing elements within it to question the religious rigidity of the regime. Women were also affected by this process of modernisation and economic growth. The need for new labour forced the government to pass a law in 1961 called "Ley de derechos políticos profesionales y de trabajo de la mujer." This law gave women the right to work and attempted to give them equal working rights, except in some fields traditionally associated with men, such as the armed services. Married women were still required to obtain their husband's authorisation to work.

Despite this rapid social change, the Spanish film industry continued to reflect the moral ideology of the regime, producing many films that recreated the life of saintly nuns, encouraging the female audience to live in virtue, obedience and purity, thus promoting the patriarchal and dogmatic gender paradigm endorsed by the regime. In 1961, for instance, films based on the lives of religious female figures abounded: José María Elorrieta's *Canción de cuna*, which commented on the life of a group of nuns who adopt an abandoned child; *Santa Rosa de Lima*, also directed by Elorrieta, which narrates the story of the Peruvian saint; and the film studied here, *Teresa de Jesús*, by Juan de Orduña.[1]

In this context of rapid social modernisation, it seems at odds with the atmosphere of the time that a saint such as Teresa of Ávila was chosen as the subject for a film, given that she had been used as a figurehead for the most recalcitrant aspects of the regime's ideology: Teresa had served as a key role model for the reactionary Sección Femenina, an organisation for women propelled by the fascist Falange party. And it was common knowledge that Franco—a great devotee of Teresa—kept the saint´s embalmed arm next to his bed at the Pardo Palace. Indeed, as Helen Graham indicates, during the first period of the dictatorship, Teresa's image was bowdlerised and "pressed into service to exemplify ideal Catholic womanhood [...] editing out certain awkward heterodoxies: in this case, St Teresa's possible Jewish ancestry, independent thought, and [her] active role as a religious reformer" (1998: 185).

In de Orduña's film, however, Teresa is portrayed as a dynamic and enterprising woman, reflecting the country's more open attitudes towards women and social behaviour in general. Thus, from the very beginning of the film, we encounter scenes where the saint appears reading books voraciously, writing her biography—which she will read as a voiceover in the film—or energetically confronting church dignitaries during her struggle to prove she was not a visionary. The second part of the film concentrates on presenting Teresa's role in founding new convents as she travels on a cart over tortuous Castilian roads and deals with men (whom she exceeds in intelligence) from all social backgrounds. De Orduña's film also shows her doing keen manual work in the convent's garden. In

[1] Also in 1961 Luis Buñuel returned briefly to Spain to make *Viridiana*, a film about a nun, and a caustic critique of Catholicism in which the protagonist ends by questioning her own faith. The film clearly identifies the process of modernisation Spain was going through at the time and portrays religious morality as a relic from the past. *Fray Escoba*, directed by Ramón Torrado, was another 1961 production which enjoyed enormous success. It recounts the life and miracles of a religious figure, this time a friar, Saint Martín de Porres.

fact, by the official standards of the time, Teresa is so masculine that she finds it difficult to cry, and we see her in various scenes begging God to grant her what she considers an unattainable gift.

However, the casting of actress Aurora Bautista as Teresa complicates this apparently re-worked vision of a woman and her work. As Aston and Savona note "the identity of a performer may make an important contribution to the process of signification" (1991: 102) and this arguably holds true with respect to de Orduña's film where Bautista's starring role brought additional layers of meaning to the character she played. In 1948, in the film *Locura de amor*, Bautista played the part of Joan I, the Catholic Monarchs' daughter who descends into madness after her beloved husband's death. In 1950, she also played the leading role in *Agustina de Aragón*, a story of the heroine's life and struggle against French troops in the War of Independence. The two films belonged to the historical genre and were produced by Cifesa, a film studio that became the prime exponent of Francoist cinema and ideology. Through such historical narratives Cifesa promoted nationalist interpretations of Spain's past, legitimising prevailing conditions.

These were Bautista's credentials when she played Teresa, undoubtedly bringing to the character an accretion of connotations tied to the most rancid Francoist ideology in which some of her previous work was steeped. Furthermore, it was Bautista's role as Joan "the mad" that catapulted her to stardom and for which she won the best actress award at El II Congreso Cinematográfico Hispanoamericano (1948), and a medal bestowed by El Círculo de Escritores Cinematográficos (1948). In some parts of *Teresa de Jesús* Bautista repeats the overwrought performance she gave in *Locura de amor*, and this poses the question of whether or not the audience would be able sufficiently to differentiate between the two characters.

As José Luis Guarner points out, Bautista's performances in de Orduña s films were characterised by excess and affectation (1970: 35), and while this acting method worked effectively for representing a mad queen shaken by jealousy, in some scenes of *Teresa de Jesús* it disrupts the saint's image and turns her into an insane woman who is led by hysteria rather than modesty and discretion. One of the scenes where Juana and Teresa's identity may overlap occurs when the saint is accused of talking to the devil instead of God, to which she reacts dramatically. Bautista's performance here is so overacted and theatrical, that it mirrors one of the central scenes in *Locura de amor* in which Queen Juana's attempts to prove her sanity at the royal court backfire when her enemies,

who want to dethrone her, meddle with key evidence that would have vindicated her.

The actress uses the same melodramatic wide-eyed horror-filled expression in both scenes, blurring the lines between both characters for the audience (see Fig. 2-2). Additionally, the costumes she wears for both scenes—as Juana she wears a black dress and veil with a white circlet, reminiscent of a nun's habit—facilitates a correlation between the two protagonists. This cross-identification may have bolstered Francoist medical dogma that "presented women as weak and emotional creatures, a miry mess of hormonally inspired conditions" (Graham 1998: 184) but equally it may have disturbed the image of a discreet religious Teresa which served to perpetuate the regime's gender discourses. *Teresa de Jesús* did not achieve significant commercial success. Perhaps, as José Luis Guarner notes, the public had become tired of these cinematic formats, or perhaps they did not appreciate Bautista's performance style, which had run its course within a few years (1970: 35).

The television drama *Teresa de Jesús* hit the smaller screen in a different socio-historical context. When its eight episodes were broadcast between January and February 1984, the Partido Socialista Obrero Español (PSOE) had been in power in Spain for two years. On 28 October 1982, after the difficult transitional years following Franco's death, Spaniards voted massively in favour of the PSOE, which had fought clandestinely against the Franco regime and was historically linked to the conflictive periods of the Spanish Civil War and the Republic. However, at the PSOE's twenty-eighth Congress in May 1979, there had been a key shift in its political direction when the then General Secretary, Felipe González, proposed a move away from the party's Marxist identity. The revolutionary idealism was dissipating in the party as a whole and desire for drastic rupture was being replaced by a mood of peaceful reform. The slogan for the election campaign was "Por el cambio" ("For change"). However, this proposed change was moderate, and, as the journalist José Oneto commented at the time, Felipe González rejected everything that might disquiet the moderate electorate (1984: 15) and the party's politics grew more restrained, especially in terms of reforms related to the Church, the Army, and economic institutions (Martínez 1999: 317).

The practice of temperate and conciliatory policies towards these institutional powers was reflected in the structure for broadcasting adopted by the party when it took complete control of television during the 1980s. At the time, only two television channels existed in Spain, both controlled by the State; the first regional channels (Catalan and Basque) appeared in 1984. Luis Mariñas, a television news journalist, noted that

with socialist José María Calviño as Director General of Televisión Española (1982–1986), television had become an effective ideological vehicle for the party (Díaz 1994: 539). And as cultural critic Stuart Hall has theorised, television, even more so than cinema, transmits cultural values effectively, owing to its immediacy and directness, making everything familiar and natural, "the hope of every ideology" (1988: 8).

According to Katherine M. Vernon, although the choice of subject and genre may have seemed provocative—since it was associated with reactionary Francoist historical cinema—the purpose of the television production was clearly to reclaim and reposition Teresa's image which had for so long been appropriated exclusively by the right (1995: 242-43). I would add that producing a television series based on Teresa's life also reflected the PSOE's conciliatory politics and the party's attempts to achieve warmer relations with the Church. Consequently, the portrayal of members of the Church in the series is, for the most part, benevolent. At times, however, the programme allows us to see certain priests letting Teresa down. For example, Father Gracián, Teresa's confessor in her last years, prevents her from founding a convent in Madrid. Nonetheless, the portrayal of the clergy remains measured and deferential. In fact, the preview of the series was attended by Felipe Fernández García, the Bishop of Ávila at the time, and Antonio Montero, the president of the Episcopal Conference, and both congratulated the producers of the series and praised its "fidelidad a la persona, la doctrina, el espíritu y el mensaje de Santa Teresa" (Unsigned 1984b).[2]

At the same time, the programme also mirrored other PSOE policies which aimed to modernise the situation of Spanish women, for example, the creation of the Instituto de la Mujer (Women's Institute), a government agency charged with promoting gender equality and the full participation of women in political, cultural, social, and economic spheres. In the programme, Teresa is hailed for her work as a convent founder and writer and for her untiring dynamism; despite the length of the series, she is already a nun in the first episode, and she is also planning to found her first convent as early as the third episode. Furthermore, scenes in which the saint appears writing abound in the production; for example, in episode four, one of the nuns comments on how Teresa's face radiates joy when she writes. In contrast with de Orduña's film, Concha Velasco's performance as Teresa in the television series is controlled and avoids excesses (see Fig. 2-3), thus moving away from the image of a "mad woman" conveyed by Bautista at certain points in the 1961 production.

[2] "Fidelity to the person, the doctrine, the spirit and the message of Saint Teresa."

As Vernon suggests, the television production takes an interest in Teresa's mysticism, but avoids characterising the protagonist as a "loca divina" ("religious nutcase") (1995: 246). Instead, the show brings to the fore an active, enterprising Teresa.

Significantly, the production was directed by a woman, Josefina Molina, whose films can be perceived as an oppositional voice within the context of male-dominant cinema and culture (Vernon 1995: 227). Additionally, the dialogues were written by Carmen Martín Gaite, an author famed for championing women's issues and who creates markedly feminist dialogues for Teresa. For example, in the second episode, the saint says:

> La vida de la mujer casada solo es sometimiento al varón, al ambiente, a la costumbre. Los embarazos se suceden hasta morir de parto o agotamiento. Ese fue el destino de mi madre, y será el destino de mi hermana María, el de Juanita, y el de tantas…Dios me hizo la merced de escogerme para sí y me libró de estar sujeta a un hombre que me hubiera acabado la vida y quizá también el alma. (Transcribed from television series) [3]

In episode four, during a scene in which a group of nuns is complaining about how hard their work is, Teresa tells them: "Que no quisiera yo que mis hermanas no pareciesen otra cosa que varones fuertes."[4] Towards the end of the series, in episode seven, she complains about how she is losing control of the order on account of having left men in charge of it. In fact, the centre-right paper *ABC* reviewed *Teresa de Jesús* and found the degree to which the series presented its story from a feminist perspective worthy of comment: "*Teresa de Jesús* está impregnada de detalles, palabras y pensamientos de un aire ligeramente feminista, hecho que no ha de extrañar si se tiene en cuenta que es una obra practicamente realizada por y sobre mujeres" (Unsigned 1984a).[5]

The casting of Concha Velasco as Teresa was also very opportune. The actress's public image responded perfectly to the socialists'

[3] "The life of a married woman consists of being subjugated to men and routine. Pregnancies come one after another, until these women die in labour or from exhaustion. That was my mother's destiny, and it will be my sister María's, and so many others […] God granted me the favour of choosing me, saving me from being tied down to a man, who would have finished with my life and perhaps my soul."

[4] "I would not like my sisters to be weaker than men."

[5] "*Teresa de Jesús* is impregnated with details, words and thoughts which are vaguely feminist, a fact which should come as no surprise given that it is a production made for and about women."

reconciliatory intentions. Velasco had risen to stardom as a pop singer in the 1960s, when she also began to act in innocuous and depoliticised films. It was not until the 1970s, when she met the communist actor Juan Diego, that she became involved in protest movements against the regime (Arconada 2001: 147). Although never a radical, she belonged to the Comisión de los once, a committee representing the interests of Spanish actors during the famous strike in 1975 which, like most strikes at the time, was politically charged (Prego 1996: 207). Thus, Velasco's image brought to Teresa's character a de-radicalised, progressive quality which echoed the ideal picture the socialists aimed to promote.[6] In religious terms, the fact that Velasco herself had consistently affirmed her Catholic credentials worked well with socialist attempts to seek out a conciliatory relationship with the Church. In an interview with Eva Reuss in 2007, Velasco explained: "Soy muy católica, muy conservadora y de izquierdas."[7] Velasco's public persona was so easy to digest for all parties involved that the members of the ecclesiastical hierarchy who attended the preview screening for the series congratulated the actress on her performance as the saint. The series was a great success when it was broadcast, and in retrospect is considered one of the most celebrated dramas in the history of Spanish public television (Unsigned 2003), a success that certainly contributed to the socialists' efforts in the 1980s to reinforce their image as the party of emancipated and active women.

Loriga's film, however, shows a very different Teresa. Since *Teresa, El cuerpo de Cristo* (2007) was an independent production, it did not respond so directly to any single dominant political or institutionalised ideology. In any case, Spain had suffered great socio-political transformations during the twenty-three years that elapsed between the television production and Loriga's film. In relation to women's issues, for instance, Spain has recently witnessed considerable advances in gender

[6] TVE produced another historical series in 1984, *Proceso a Mariana Pineda*. This gave an account of the life of the nineteenth century liberal heroine who was executed for ordering the embroidery of a constitutional flag. In my article on the series I look at how the programme legitimised the PSOE political and gender discourses explained above, though the casting of Marisol/Pepa Flores as Mariana, unlike Velasco as Teresa, disrupted the party's narratives. Flores was an active member of the more radical communist party, and she had expressed publicly on numerous occasions her opposition to moderate politics. In fact, the series received much criticism from intellectuals and the press who described the actress's performance as hysterical, vulgar, and, what is still more revealing, as pro-soviet (Martín Pérez 2003).

[7] "I am very Catholic, very conservative, and of the left."

politics with socialist leader and prime minister, José Luis Rodríguez Zapatero, famously declaring himself a *feminista* and appointing nine women as members of his cabinet, including Carme Chacón as minister of defence (previously a position that had been the exclusive preserve of men). Nevertheless, as the feminist writer Atenea Acevedo notes:

> Hay, sin duda, temas no resueltos en lo que respecta a la participación de las mujeres en la vida pública. No obstante, el quid de la cuestión femenina se encuentra en el espacio privado, concretamente en el cuerpo. Si bien se ha ganado un vasto terreno en cuanto a los derechos sexuales y reproductivos gracias al motor de la lucha feminista, el cuerpo de las mujeres sigue en manos del Estado, del templo, de la iniciativa privada, de su pareja sentimental. (2009)[8]

Thus, one of the most ardent debates within the Spanish political arena is the abortion law, while domestic violence is also a pressing problem. And despite the gains pointed to by Acevedo, publicity still exploits women's bodies portraying them as passive sexual objects as evidenced by the fact that the Observatorio de la Publicidad, a body that regulates advertising in Spain, received a high number of complaints about sexism in 2007 (Albeira Rodríguez 2007).

If only for these reasons, Loriga's approach to the saint is rather startling. In the "Making of" documentary included on the DVD release of the film, the director explains that the intention of the film was to illustrate the struggle of a woman to be herself and to defend her ideas. However, from the very beginning his film associates Teresa with the body, returning to the most stereotypically traditional and patriarchal representations of womanhood. The title of the film emphasises Teresa's carnality, while the promotional poster uses a photo of a young naked Teresa being caressed by Christ's wounded hand. Loriga also emphasises the saint's mysticism rather than her labour and the fact that the film closes just when the first convent is established skips over the rest of Teresa's untiring work as an organiser. This contrasts with the 1980s television production in which Teresa's efforts to extend the work of the order she founded formed a stronger focus within the narrative. Loriga's approach palpably favours the sexualisation of Teresa in the film, and the

[8] "There are, without a doubt, many unresolved issues in relation to women's participation in public life. However, the nub of the question is private space, specifically the body. Although much ground has been won in terms of sexual and reproductive rights thanks to the feminist struggle, women's bodies continue to be in the hands of the State, of the temple, and of their lovers."

transverberation scene, for instance, shows Teresa's convulsions in what appears to be a simulacrum of the sexual act.

Furthermore, at the beginning of the film, Loriga suggests that the saint experiences pleasure through corporal punishment. In one of the first sequences, we see Teresa being pricked on her back with the thorn of a flower, while she is embraced by a man just before becoming a nun. A close up of her face shows a gesture of pleasure, which suggests her enjoyment of this physical discomfort. After this putatively explanatory scene, the director elaborates at various moments in the film wherein the saint is shown inflicting pain on herself with a whip. In another sequence he takes great delight in showing the bleeding caused by the cilice that Teresa is wearing around her waist. Although both de Orduña's film and the television mini-series also depict Teresa inflicting pain on herself, such scenes are far more limited in the earlier productions. In the television drama, when Teresa is an elderly woman, she is shown as having rejected such mortification practices.

Loriga justifies this sensual approach to Teresa by arguing that his intention was to show the saint's lyrical side and to reveal how she used the senses to reach God, claiming: "Hay muchas cosas de Santa Teresa que no se han contado y que son un misterio sin resolver: su sexualidad o su relación tan cercana a Dios, casi piel con piel" (Hermoso 2007).[9] This might explain why he chose Andalusian actress, Paz Vega, to play Teresa. Vega is one of a number of Spanish actresses who have openly revealed their naked bodies on screen since the start of their careers. She shot to fame with the erotic *Lucía y el sexo* (2001), directed by Julio Medem, and continued her success with films such as *Carmen* (dir. Vicente Aranda 2003), where she plays the passionate and sexual female lead, and most recently *Los Borgia* (dir. Antonio Hernández 2006), in which her role as the historical character Caterina Sforza is highly sexually charged. Subsequently, yet more intensely than in any of the other films, in *Teresa, el cuerpo de Cristo*, the image of the actress adds very tangible connotations to Teresa's character, corporealising her identity and crystallising her as an object of desire. In this sense, and perhaps to avoid blemishing such an image, Loriga's film—unlike the television production and de Orduña's film—avoids showing effects of the aging process on the protagonist, and the film ends when Teresa is still young and beautiful, just as she is at the beginning of the story.

[9] "There are many things about Saint Teresa which remain untold and which are an unsolved mystery: her sexuality or her very close relationship with God, almost flesh to flesh."

Teresa's sensual quality is further augmented by an extremely stylised mise-en-scène, with José Luis Alcaine's photography recalling sixteenth century paintings, reminding us in some parts of Bill Viola's stylised video installation *The Passions.* An exquisite wardrobe designed by Eiko Ishioka sees Teresa dressed in satin habits and elegant nightdresses. Although at that time Spanish nuns were allowed to dress as they pleased, this is about more than historical accuracy—Loriga opts for delicacy and exquisiteness in dressing Teresa, and it is not until the closing stages of the film that she appears wearing a common habit. This depiction contrasts vividly both with de Orduña's production and with Molina's where, for the most part, the saint dresses in the same traditional and austere habit. The aesthetics of *Teresa, el cuerpo de Cristo* may have been intended to satisfy the contemporary audience's visual tastes. Whatever the reason, Loriga ends up associating Teresa once again with the corporeal world of the senses.

It is true that in certain parts of the film Loriga places Teresa in positions where she daringly confronts high-ranking clergymen. However, in one of these scenes, where the men accuse her of being possessed by the devil, the director predictably sexualises her response when she answers, shouting: "Endemoniada no, sino toda engolfada de Dios que de tanto quererlo le he hecho ya mi prisionero."[10] Perhaps Loriga's version of Teresa speaks to the director's desire to maintain his image as the *enfant terrible* of the Spanish literary establishment. During the 1990s, works such as *Héroes* (1993) and *Días extraños* (1994) characteristically explored the image of the rebel without a cause who fought against convention. In 1996, Loriga wrote and directed his first film, *La pistola de mi hermano*, an adaptation of his novel *Caídos del cielo*, which dealt again with the figure of the rebel misfit. In keeping with his reputation as irreverent artist, *Teresa, el cuerpo de Cristo* can be read as an attempt to provoke the Church and as a bid to ignite controversy. Indeed, the film managed to cause a stir when La Comisión Episcopal de Medios de Comunicación Social declared that the film's content verged on being unacceptable. However it should be noted that Loriga's provocative approach to Teresa was hardly a novel enterprise. If *Teresa, el cuerpo de Cristo* was meant to provoke or shock the spectator by recycling Teresa mainly as a sexual being, Nigel Wingrove's nineteen minute film, *Visions of Ecstasy* (1989), had beaten him to it. In the British film Teresa appears caressing and kissing Christ: it includes shots of her being erotically

[10] "I am not possessed, but I am so in lust with God and so in love that I have made him my prisoner."

touched by a female character representing her psyche and was the only film to be banned in Britain on the grounds of blasphemy.

In short, although the image that Loriga creates of Teresa supposedly belongs to post-feminist discourse, in fact it only serves to reinforce the kind of neo-macho attitudes which usually appear camouflaged and which many feminists, such as Paulina Irene Salinas Meruane, maintain must be resisted. On this note, it is important to add that *Juana la loca* (2001), Vicente Aranda's recent remake of *Locura de amor*, coincides with Loriga's sexualised approach to Teresa. In *Juana la loca* the character of the Castilian queen is also over-sexualised and portrayed as an insatiable woman who lives and breathes for sex, thus undermining her credibility as a public and political figure (Martín Pérez 2004). When the film was being promoted, Aranda made clear his intention to represent Joan in a way that would vindicate her as a woman (Fernández Santos 2000), thus offering a similar explanation for the aesthetic of this film as Loriga advanced for the style in which he portrayed Teresa. I would argue that both directors fail in this vindication and that they predominantly reduce Joan and Teresa to spectacles for a modern audience which seeks titillation.

Teresa Teresa (2003) by Rafael Gordon, another recent film based around the saint's life, is perhaps an example of a representation where Teresa's image does in fact undergo a more interesting renovation. The film explores Teresa's life through the format of a twenty-first century television talk show in which the saint appears as a guest in the form of an ectoplasmic image (Fig. 2-4). It deals with two apparently polarised instantiations of femininity: the natural, humble and intelligent Teresa and the self-satisfied, materialistic television presenter who interviews her. Gordon's film at least initiates a debate about women's roles in the post-feminist era and is worthy of discrete and more extensive consideration which space does not permit me to go into here.

There have been many representations of Teresa of Ávila over the years, and there will no doubt be more. In this chapter I have sought to look at just three iterations of the saint's life and would not claim to have found the authentic Teresa. My approach rejects essentialising notions of identity, studying Teresa as the accretion of multiple layers of diverse readings, coloured by various historical contexts. Thus, the Teresa that emerges in this chapter is a constellation of identities, which vary from hysterical religious mystic, through feminist icon, to sex symbol. These representations of Teresa, then, reflect different models of womanhood, marking shifts in gender attitudes across five decades of Spanish cultural history.

30 Chapter Two

WORKS CITED

Acevedo, A. 2009. "La conquista del cuerpo." *Mujer y palabra...pisadas sin huarache* [blog site]. 9 March. http://my.opera.com/mujerypalabra/blog/8-de-marzo-la-conquista-del-cuerpo (Accessed 19 July 2010).
Albeíra Rodríguez, T. "Si la publicidad fuese persona tendría cuerpo femenino, mirada masculina y echaría de menos la dignidad." *Partido comunista de España*: *Quiosco de prensa*, 23 November. http://nodo50.org/pce/q_pl.php?id=1994 (Accessed 12 December 2008).
Arconada, A. 2001. *Concha Velasco: diario de una actriz*. Madrid: TB.
Aston, E. and G. Savona. 1991. *Theatre as Sign-System: A Semiotics of Text and Performance*. London: Routledge.
Bilinkoff, J. 1989. *The Avila of Saint Teresa: Religious Reform in a Sixteenth Century City*. Ithaca, NY: Cornell University Press.
Díaz, L. 1994. *La televisión en España 1949-1985*. Madrid: Alianza.
Fernández-Santos, E. 2000. "Vicente Aranda recrea los engaños y los celos que enloquecieron a Juana de Castilla." *El País*. 22 November. http://www.elpais.com/articulo/cultura/ARANDA/_VICENTE/LOPEZ_DE_A YALA/_PILAR_/ACTRIZ/Vicente/Aranda/recrea/enganos/celos/enloqueciero n/Juana/Castilla/elpepicul/20001122elpepicul_5/Tes (Accessed 22 July 2002).
Graham, H. 1998. "Gender and the State: Women in the 1940s." In *Spanish Cultural Studies: An Introduction*, eds. H. Graham and J. Labanyi, 182-195. Oxford: Oxford University Press.
Guarner, J. L. 1970. *Enciclopedia ilustrada del cine*. Barcelona: Labor.
Hall, S. 1988. *The Hard Road to Renewal: Thatcherism and the Crisis of the Left*. London: Verso.
Hermoso, B. 2007. "Nuevas levitaciones teresianas." *El Mundo*. 9 March http://www.elmundo.es/elmundo/hemeroteca/2007/03/09/n/cineclu.html (Accessed 8 April 2009)
Landy, M. 1994. *Film, Politics, and Gramsci*. Minneapolis: University of Minnesota Press.
Martínez, J. A. 1999. *Historia de España siglo XX 1939-1996*. Madrid: Cátedra.
Martín Pérez. C. 2003. "Defying Common Sense: Casting Pepa Flores/Marisol as Mariana Pineda." *Tesserae: Journal of Iberian and Latin American Studies* 26 (2): 149-162.
——. 2004. "Madness, Queenship, and Womanhood in Orduña's *Locura de amor* (1984) and Aranda's *Juana la loca* (2001)." In *Gender and Spanish Cinema*, eds. S. Marsh and P. Nair, 71-85. Oxford: Berg.
Medwick, C. 2000. *Teresa of Ávila: The Progress of a Soul*. New York: Alfred A. Knopf.
Oneto, J. 1984. "¿A dónde va Felipe?." *Diario 16*. 16 January. 15
Prego, V.1996. *Así se hizo la transición*. Barcelona: Plaza & Janes.
Reuss, E. 2007. "Concha: actriz." *Época*. 1 August. http://goliath.ecnext.com/coms2/gi_0199-6885962/Concha-Velasco-actriz-Soy-muy.html (Accessed 2 January 2009).

Salinas Meruane, P. I. 2007. "Los discursos masculinos como dispositivos de control y tensión en la configuración del liderazgo y empoderamiento femenino." *Revista Estudos Feministas* 15 (3): 541-562.

Unsigned. 1984a. "Presentación en Ávila de la serie *Santa Teresa de Jesús*." *ABC* 4 March. http://hemeroteca.abc.es/nav/Navigate.exe/hemeroteca/madrid /abc/1984/03/04/117.html (Accessed 1 March 2009).

Unsigned. 1984b. "Estreno de la producción de 'Teresa de Jesús', una de las series más caras de TVE." *El País*. 12 March http://www.elpais.com/articulo/Pantallas/Estreno/produccion/vida/Teresa/Jesus /series/caras/TVE/elpepirtv/19840312elpepirtv_2/Tes (Accessed 3 April 2009).

Unsigned. 2003. "Televisión española estrena esta noche la versión corta de 'Santa Teresa de Jesús.'" *El Día*. 23 April. http://www.eldia.es/2003-04-17/comunicacion/comunicacion2.htm (Accessed 30 January 2008).

Vernon, K. M. 1995. "Cine de mujeres, contra-cine: La obra fílmica de Josefina Molina." In *Discurso femenino actual: ensayos críticos sobre la teoría del feminismo*, ed. A. López Martínez, 225-252. San Juan: Editorial de la Universidad de Puerto Rico.

CHAPTER THREE

SUBJUGATION, REBELLION, AND POWER: THE METONYMY OF THE SLIPPERS IN BUÑUEL'S *TRISTANA*

M. GRAZIELLA KIRTLAND GRECH

Tristana is one of the last films produced by the Spanish director Luis Buñuel. Shot in Spain in 1970, the film is an adaptation of the novel of the same name by the Spanish author Benito Pérez Galdós published in 1892. It tells the story of its eponymous orphan heroine, Tristana, and how her character changes as she transitions from being first the ward of Don Lope Garrido—a proud but impoverished aristocrat, who shows one face to the world and another to those under his control—and then the lover of Horacio, a younger man and Don Lope's nemesis.

According to Joan Mellen, in *Tristana*, as in *Belle de Jour* and *Viridiana*, Buñuel condemns the persecution of women by the French and Spanish bourgeoisie, revealing the hypocrisy embedded in the values of bourgeois culture in general "which have conspired to keep [women] in a condition of subservience and servitude" (Mellen 1978: 14). But this does not mean that the characters have to remain in a state of submissiveness and servitude throughout their lives. It is possible for the female character to rebel and to succeed in living a life in pursuit of accomplishing her own goals or desires. *Tristana* is, in fact, one example of how a female character can change in such a way during the course of a Buñuelian narrative. It is curious that Buñuel would explore this theme in several of his works given that his personal views about the role of women in society seem to have been quite traditional. In the course of an interview for the BBC documentary *The Life and Times of Don Luis Buñuel* (1984) Catherine Deneuve suggested that the director was a conservative person who respected women but also believed that their place was in the home, where they should concentrate on being wives and mothers.

The transformation of Tristana's character throughout the film has been the subject of numerous studies. In "From Mistress to Murderess: The Metamorphosis of Buñuel's Tristana" Beth Miller discusses how Tristana's character "develops through the film's tripartite structure", from a submissive and obedient "daughter" to a young woman "searching for

sex, experience and freedom", and thence to a domineering wife who finally murders her husband (1983: 341-343). She also points out how Tristana's handling of Don Lope's slippers changes as her character evolves (1983: 342-343). Jo Labanyi, on the other hand, analyses *Tristana* through a series of feminist readings of Freud's theory of fetishism and proposes that Buñuel "posits the castrated woman as a castrator of men" as Freud did (1999: 78). She describes how the film reveals Tristana's "progressive empowerment through 'castration' and fetishization" (1999: 78-79). Labanyi's interpretation of the slippers associates them with "political demands for the 'castration' of the patriarchal order", represented by Don Lope and against which Tristana rebels when she throws the slippers in the dustbin (1999: 81).

Zoila Clark also interprets *Tristana* as a male centred vision of the nightmare of castration, but adds that "It is based on the terror of the modern woman of the twentieth century" (1999: 33). Clark describes how Tristana, who sees Don Lope as a father figure at the beginning of the film, soon starts to mimic him and becomes progressively more domineering and powerful (more masculine), while Don Lope becomes more submissive (more feminine) until there is virtually an "exchange of roles" at the end (1999: 31-33). This role reversal is also highlighted by Gwénaëlle Le Gras in "Soft and Hard: Catherine Deneuve in 1970", who attributes it to Buñuel's own perversity, choosing to present "a female character who reverses the normal sadistic relationship and takes on male prerogatives, so that the male can, unscrupulously, be denied in his turn, even killed" (2005: 32). Le Gras interprets the amputation of Tristana's leg as a punishment to ensure that the law of the phallus is not threatened by the castration she represents.

There are several components in Buñuel's film which underscore the process by which the relationship between Don Lope and Tristana shifts. In his study *Galaxia textual: cine y literatura, Tristana (Galdós y Buñuel)*, Aitor Bikandi-Mejias points out Buñuel's liberal use of metonymy, mostly associated with the use of feet, shoes, and legs (1997: 160). Bikandi-Mejias also describes how walking sticks and hats are symbols of authority and form part of the metonymical play in the film (1997: 161).[1] However, although Bikandi-Mejias identifies these metonymies in

[1] The *Routledge Dictionary of Literary Terms* defines a symbol as "something that represents something else by association, resemblance, or convention, especially a material object used to represent something invisible." Bikandi-Mejias explains that the signs that can be found in cinema and literature are not of the same kind, since in literature we have a collection of written signs, whereas in film, one finds verbal and graphic signs (1997: 18).

Tristana, he does not analyse in detail how they are used to underline and symbolise the transformation of the character from a docile, obedient young lady to a rebellious woman who takes control of her future. Departing from Bikandi-Mejias's analysis, this chapter introduces a new metonymy focused on Don Lope's slippers and explains how they are used to reflect Tristana's transformation and her changing relationship with her guardian.

In this study, I first analyse three sequences from Buñuel's adaptation of *Tristana* to examine the way in which a particular metonymy, which I call the metonymy of the slippers, is constructed using a variety of cinematic techniques, for example, shot composition, facial expressions, body language, speech, and costumes. Following this, I investigate the use of certain symbols that form part of the same metonymic play. Through these two analyses, changes in the character of *Tristana* during the course of the film are identified, from an innocent and defenceless young lady to a rebellious and ultimately powerful woman who takes control of her life.

In *The Imaginary Signifier: Psychoanalysis and the Cinema*, Christian Metz identifies two types of metonymies in cinematographic narrative: the metonymy presented paradigmatically, which occurs when two elements are associated through "real" or diegetic contiguity, only one of which is present in the sequence while simultaneously evoking the other; and the metonymy presented syntagmatically, which occurs when two elements, both of which are present in a sequence, are associated through real or diegetic contiguity (1982: 190). The two elements can be, for example, two images, two motifs in the same image, two entire sequences, or an image and a sound (Metz 1982: 189). Metz also explains that the semiotic mechanism of the symbolic operation can change several times during the course of a filmic episode, whereas the symbolic element itself does not change (1982: 190-191). For example, a metonymy presented syntagmatically can later be presented paradigmatically.

Barry Jordan and Mark Allinson explain in *Spanish Cinema: A Student's Guide* how actors communicate with spectators verbally and through facial expressions, body language, and movements, while costumes help establish social class and certain character traits. Costumes can further indicate changes in circumstances or attitude (2005: 37). Jordan and Allison also explain how the position and the movement of the camera permit a whole range of expressions (2005: 43). But, as the present study of *Tristana* demonstrates, the cinematic techniques they describe can also help construct symbolic relationships and thereby metonymies.

In one of the film's early sequences, we meet Don Lope, who has just returned home feeling tired. A medium shot shows Don Lope sitting in an

armchair with Tristana standing near him. Don Lope tells Tristana that he has walked a lot and that his feet are "deshechos" ("exhausted"). Smiling, and in a gentle tone of voice, she asks him whether he would like her to bring him his slippers, to which he responds affirmatively. Before turning around to leave the room, Tristana lightly taps on the back of the armchair, an obviously playful gesture which demonstrates her filial affection for him. While Tristana is leaving the room, the camera focuses on Don Lope as he takes off his shoes. When Tristana returns with the slippers, she kneels down by Don Lope. Tristana and Don Lope share the frame in a composition that reveals the harmonious relationship between the two characters. She gently puts the slippers on Don Lope's feet which he lifts to make her task easier. Afterwards, Tristana takes his shoes and stands up, holding them close to her body. Don Lope, smiling, takes her hands and tells her affectionately: "Eres mi hijita adorada y sólo te pido que me quieras como un padre", and she answers: "Es usted muy bueno" and gives him a kiss on his forehead.[2] Tristana then leaves the frame whilst glancing tenderly back at Don Lope. The facial expression and the body language of both characters during this sequence indicate that they are both happy and that they love each other like father and daughter—a conclusion supported by their dialogue.

This sequence serves, first of all, to establish a relationship between Don Lope and his slippers. They are a metonymy of Don Lope through contiguity with the element they refer to: in other words, a metonymy presented syntagmatically, since Don Lope and his slippers both appear in the same scene. Tristana holds the slippers in her hands, close to her body, an action that reflects the affection she feels towards Don Lope. This scene is important since, as shown later on, through the representations of this metonymy during the course of the film, the spectator can observe a change not only in the character of Tristana, but also in the relationship she has with Don Lope.

The second time this metonymy is presented, Tristana is no longer the innocent and happy young lady she had been earlier. Neither is the relationship between Tristana and Don Lope as it was. Once more we see Don Lope returning home. We are shown a medium shot of Tristana, Don Lope, and the maid, Saturna, in the entrance hall. Their facial expressions are very serious. It is now Don Lope who kisses Tristana on her forehead, while she lowers her eyes and bends her head downwards, as if in an act of submission. There is virtually no dialogue, the only exception occurring

[2] Don Lope says "You are my beloved little daughter and I only ask you to love me as a father." Tristana replies "You are very kind". Spanish dialogue is transcribed here, as throughout the chapter, from the film.

when Don Lope asks Saturna to serve dinner. Afterwards, he turns and exits the left side of the frame, followed by Saturna. In a mid-shot, the camera focuses on Tristana, who is about to follow Don Lope and Saturna, but her facial expression indicates she has suddenly remembered something. In fact, she turns and exits the frame from the right hand side. A medium long shot is then superimposed, in which we see Don Lope sitting on a chair. He puts on his glasses and starts reading the newspaper aloud. Tristana enters the frame from the left with the slippers in her hands, walks in front of Don Lope and without uttering a single word she kneels down next to him and tries to put the slippers on his feet. The task is made more difficult given that Don Lope barely lifts his feet to assist her in this duty. This time the camera does not reveal Tristana and Don Lope together in the same frame. Instead we only see the lower part of Don Lope (his legs) and the newspaper he is reading, and Tristana kneeling down beside him trying to put the slippers on his feet. Don Lope continues reading the newspaper aloud, without paying any attention to what she is doing. Tristana then stands up with the shoes in her hands and the camera tracks her briefly before she walks out of the frame. This time she does not even glance at Don Lope.

This sequence contrasts strongly with the previous iteration of this scene. Through the facial expressions of both Tristana and Don Lope, we realise that the relationship has changed since the beginning of the film. There is now a coolness between them, with none of the affectionate dialogue of the first sequence. In fact there is basically no dialogue at all between the characters. The manner in which Tristana brings Don Lope's slippers to him and puts them on his feet indicates that these actions form part of the daily routine, performed without affection or free will, but rather through obligation and a sense of being under Don Lope's control. Now she is more servant than daughter. There is also a contrast between the shots used in this sequence and the first one described earlier. In the second sequence Tristana and Don Lope do not appear in the same frame and thus this image now reinforces the idea that the affection they shared at the beginning of the film no longer exists and highlights Tristana's subjugation. Both characters bear serious expressions (mixed with an element of sadness, in the case of Tristana), that reveal the greater formality in their relationship. As in the case of the first sequence, here we have a metonymy presented syntagmatically. The relationship has already been established between Don Lope and his slippers, and the spectator understands the slippers can metonymically be a substitute for Don Lope. In this sequence, therefore, we can conclude that the rough manner with which Tristana puts the slippers on Don Lope's feet is a reflection of the

resentment she feels towards him. This is not really surprising since by this point in the film he has already attempted to confine her to the house and has begun sexually abusing her.

Later on in the film, the slippers appear again, but in this case we have a metonymy presented paradigmatically. The sequence starts with a mid-shot of Don Lope preparing to leave his house. He tells Tristana that he has left his slippers in the bathroom and asks her to go and put them in his bedroom, after which he leaves and shuts the door behind him. In a mid-shot, we see the closed door onto which is superimposed another mid-shot of Tristana entering the kitchen, where Saturna is doing the washing up. From her posture, Tristana appears to be sure of herself and is holding Don Lope's threadbare slippers with her fingertips, away from her body, as if she finds them objectionable and does not want them near her. Tristana looks at them in disgust and says "¡Qué porquería!" ("How filthy!"), before throwing them in the dustbin. Here we also have a medium shot, this time of Tristana's feet and the dustbin. Afterwards we see Saturna lifting the slippers from the dustbin, throwing leftover food in their place and finally replacing the slippers on top of the leftovers, asking Tristana what she should tell Don Lope if he asks them. Tristana replies coldly: "Dile que se compre otras o que se vaya descalzo: me da igual."[3] Tristana's facial expression, body language, and speech during this sequence show the changes in her character that have taken place over the course of the film. She is no longer docile, no longer pliant and subservient. The sweetness and innocence evident in the first sequence analysed above have now disappeared. Instead, she is now a determined and rebellious young woman, ready to fight for her own dignity. The modified reiteration of sequences around the metonymy of the slippers succinctly conveys the situational metamorphosis. We no longer see Tristana kneeling down next to Don Lope, in an act of submission. She is now standing up and the slippers, which represent Don Lope, have been disposed of.

We have already examined how, through metonymy presented syntagmatically, the slippers substitute Don Lope in scenes where he is absent. In this sequence we see how Tristana picks up the slippers by their tips and holds them as far away from her body as possible, as if they might contaminate her. These actions sharply contrast with the way she has held them close to her body in the first sequence. Through metonymical play, the director demonstrates the emotional distance that separates Tristana and Don Lope and the fact that Tristana wants to avoid all contact with

[3] "Tell him to buy another pair or to go barefoot: I don't care."

him, including sexual contact; which is not surprising since by this time she has established a romantic relationship with a young painter, Horacio. Through the same metonymical play, Tristana's comments regarding the slippers apply to Don Lope. The word "porquería" (filth) is evidence of the repugnance she feels towards him. Bikandi-Mejias says that the slippers are a symbol of the power that Don Lope exerts over Tristana (1997: 161). By throwing the slippers into the dustbin, Tristana symbolically frees herself of Don Lope and the power he has over her. This moment coincides with the inflection point in Tristana's rebellion against her guardian. As Bikandi-Mejias explains, after Tristana's leg is amputated, later in the film, we neither see her picking up Don Lope's slippers nor putting them on his feet (1997: 161). In other words, there are no further actions that can be associated with Tristana's subjugation under masculine power.

But the slippers are not the only object that forms part of the metonymical play. Bikandi-Mejias explains that "bastones y sombreros también son goznes de este engranaje metonímico" as examined below (1997: 161).[4] The first time Don Lope appears in the film, we have a mid-shot of the character walking down the street. In voice-over we hear a character (who turns out to be the teacher of Saturno, the maid's son) saying: "Gran caballero Don Lope, ya quedan pocos como él."[5] Don Lope is wearing a dark suit, gloves, and hat. A white handkerchief is in the breast pocket of his jacket and he carries a walking stick (Fig. 3-1). Underscored by the teacher's spoken assessment of Don Lope as a "gran caballero", this costume presents Don Lope to the world and the viewer as the image of the ideal Spanish gentleman, complete with the traditional symbols of male authority and power, namely the hat and the walking stick. These are also metonymies of Don Lope through contiguity with the referent, presented syntagmatically, since Don Lope, the hat, and the walking stick, all appear in the same scene. During the course of the film, every time these two objects are present, they bring to mind Don Lope, and masculine authority. According to the changing contexts in which they appear throughout the film, we can deduce how relationships between the characters, and even the characters themselves, have changed.

For example, before Tristana throws the slippers in the dustbin, the film includes an important episode which highlights the metonymy of the hat.[6] Tristana has just returned home after a visit to her lover Horacio. She

[4] "Walking sticks and hats are also hinges of this metonymic machinery."

[5] "Don Lope is a great gentleman, there are very few like him these days."

[6] In *Freud, Psychoanalysis, and Symbolism* Agnes Petocz describes how Freud connects "the symbolic equation hat = head = penis" with the horror of being

is almost out of breath, but has a smile on her face, possibly reflecting the pleasure of the sexual encounter she may have had with Horacio. Don Lope is waiting for her in the hall. He has just woken up from his afternoon nap. He is holding a towel in his hand and has not yet had time to dress and sort himself out. His hair is in a mess and with the exception of his trousers he is wearing nothing over his underwear. He has virtually no energy and appears to be embarrassed to be seen like this by Tristana. He tells her it is late and asks her where she has been all alone. She shows no fear and replies that it is not late and that she has not been alone. During this scene we have a mid-shot framing both Don Lope and Tristana. They are both standing up, looking each other in the eye. Subjugation has been replaced by confrontation, in stark contrast, for example, with the shots where we saw Tristana kneeling before Don Lope. Rather than disciplining her for this insubordination, Don Lope attempts to defuse the situation by telling her that she looks very pretty, but she does not reply. Afterwards, he asks her to clean the ribbon of his hat. She takes the hat from Don Lope's hands, looks at it, and then looks at Don Lope and back again at the hat; her expression changes, revealing her repugnance. Then she lifts her head defiantly and leaves Don Lope. The shot changes. Through what André Gaudreault and François Jost call "internal ocularisation" we see how Don Lope watches Tristana walking down the corridor while playing with his hat, throwing it up in the air and catching it in her hands.[7]

In this sequence, we first have a mctonymy presented syntagmatically since Don Lope and the hat appear in the same scene. Afterwards, when the camera focuses on Tristana playing with the hat, we have a metonymy presented paradigmatically, since we only see the hat substituting Don Lope. In playing with it, Tristana demonstrates that not only has she ceased to be respectful or afraid of her guardian, but that neither does she treat him seriously any more. It is also obvious that she does not care about the masculine authority the hat represents. The association between the hat, Don Lope and masculine authority, is reinforced through what Tristana says while she is cleaning the ribbon of the hat. She implies that when Don Lope is not wearing his suit and his hat and carrying his walking stick, or in other words the attire of the traditional gentleman, he

beheaded, an eventuality treated as synonymous with castration (1999: 108). The fact that Tristana plays with the hat can thus be interpreted as signifying a threat to Don Lope. Even though she does not literally decapitate him or castrate him, she does refuse to have sex with him and accelerates his death at the end.

[7] According to Gaudreault and Jost "'ocularisation' caractérise la relation entre ce que le caméra *montre* et ce que le personnage est censé *voir*" (2005: 130).

behaves like a chicken without feathers and "no canta" ("does not sing")—
that is, he loses his sense of superiority and power and he lacks even the
confidence necessary to discipline Tristana. In the interview conducted for
the BBC documentary cited above, Catherine Deneuve echoes Tristana's
observations when she comments that in Buñuel's unsparing view of men
they resemble cockerels, prideful and immature, "try[ing] always to look
more than what they are." [8]

By way of contrast, a little later, we have a mid-shot of Don Lope, now
fully dressed and ready to go out. He picks up his walking stick and his
coat and calls Tristana. She brings him his hat. With the hat, the walking
stick, and Don Lope all included in the frame, we have a metonymy
presented syntagmatically. The camera shows a medium shot of Tristana
and Don Lope. Armoured now with the complete costume of a gentleman,
Don Lope has the courage to reprimand Tristana for arriving late and tells
her that when he returns they are going to sort things out. It is evident in
this sequence, where the dialogue reinforces the hat and the walking stick
as symbols of authority and masculine power, that in the film's symbolic
matrix costume influences a character's self-assurance and the projection
of power.

The next stage of Tristana's transformation from subjugation to power
is revealed when she appears for the first time after her leg has been
amputated. While Tristana is living with Horacio, she becomes seriously
ill. Believing her condition to be hopeless, she asks Horacio to take her
back to Don Lope's house. As her condition worsens, the doctor tells Don
Lope that the only chance for her survival is to have her leg amputated.
Don Lope agrees to the surgery and Tristana survives, though with her leg
amputated at the knee. A medium shot shows Tristana playing the piano
with Horacio standing to her right. On the piano, at the centre of the frame,
lies a walking stick. It is obvious that it belongs to Tristana as she now
needs it for mobility. In fact, later in the film, after the relationship with
Horacio has ended, there are various scenes in which we see Tristana with
her walking stick where she uses it not only for getting around, but also for
giving orders and instructions to the two remaining male characters in her
life, Don Lope and Saturno (Fig. 3-2), as noted by Gwynne Edwards (2005:
77). As Bikandi-Mejias notes, Tristana "se muestra más dominante y lleva
la voz de mando" (1997: 162).[9] Just as the walking stick metonymically

[8] Deneuve expresses Buñuel's views about men and women as follows: "When
you see women talking together you can feel they're women having real problems,
they're really in trouble. But men, they're like…I don't know how you say, *des
petits coqs, comment dit le* hen? […] little chickens."

[9] Tristana "appears more domineering and is the one who gives orders."

represents Don Lope and his position in the world, so the fact that Tristana has obtained a walking stick of her own implies that a domestic balance of power has been reached. Tristana is no longer a timid young lady, kneeling submissively while putting slippers on Don Lope's feet. Nor is her rebellion against masculine power limited to playing with Don Lope's hat and throwing his slippers in the dustbin. With her walking stick, Tristana wields perhaps the most potent symbol of that power, and by extension is on the cusp of having Don Lope under her control. The images of Tristana wielding her walking stick resemble those of Bernarda, the matriarch in Federico García Lorca's play, *La casa de Bernarda Alba*. As in Bernarda's case, the walking stick is a symbol of power and authority, but unlike Bernarda, who uses it to perpetuate the patriarchal law she represents and to keep her daughters under strict control, Tristana starts to use a walking stick when she actually rebels against patriarchy and has Don Lope under her control. Tristana's crippling illness has unexpectedly granted her strength, and it only takes Don Lope's own sickness, which confines him to his bed in the closing scenes of the film, for the reversal of fortune, and Tristana's revenge, to be complete.

The metonymy of the slippers in conjunction with two other symbols of masculine power (the hat and the walking stick) which form part of a complex metonymical braid in the film, underline Tristana's transformation. They enable us to delineate the stages through which she passes in her journey from subjugation, to rebellion, and finally to power, when she takes control of her life and of Don Lope's household.

This theme of female transformation, unrestrained by women's traditionally circumscribed role in society, has been the subject of a number of Buñuel's films, including *Belle de Jour* and *Viridiana*. In order to transcend their assigned roles, Buñuel's protagonists transform into a variety of feminised "monsters", whether sexually voracious, megalomanic, or simply deviously homicidal: in other words, Buñuel's females inevitably, and perhaps necessarily, render themselves dangerous outsiders to "civilised" patriarchal society. As distinctly Buñuelian femmes fatales they use their feminine characteristics, most notably their sexual allure and deceptive vulnerability, to overcome their male antagonists and assert their right for freedom and autonomy in society; yet, in contrast to their typical Hollywood counterparts, Buñuel's femmes fatales not only survive to the closing credits but do so with their hard-won positions enhanced or assured. The subversion of assigned social roles and the unpredictable transformations that ensue are entirely characteristic of Buñuel and his critical assessment of the staid, not to say ossified, societies which, whether obliquely or not, he saw himself confronting.

WORKS CITED

Bikandi-Mejias, A. 1997. *Galaxia textual: cine y literatura, Tristana (Galdós y Buñuel)*. Madrid: Pliegos.

Childs, P. and R. Fowler. 2006. *The Routledge Dictionary of Literary Terms*. London: Routledge.

Clark, Z. 2007. "Buñuel's Version of *Tristana* and the Inversion of Power Relations." *Making Waves* 5: 31-34.

Cohan, S. and L. Shires. 1988. *Telling Stories: A Theoretical Analysis of Narrative Fiction*. Florence, KY: Routledge.

Edwards, G. 2005. *A Companion to Luis Buñuel*. Woodbridge: Tamesis.

Gaudreault, A. and F. Jost. 2005. *El Récit cinématographique*. Lassay-les-Chateaux: Armand Colin.

García Lorca, F. 2006. *La casa de Bernarda Alba*. Barcelona: Espasa Calpe.

Jordan, B. and M. Allison. 2005. *Spanish Cinema: A Student's Guide*. London: Hodder.

Labanyi, J. 1999. "Fetishism and the Problem of Sexual Difference in Buñuel's *Tristana*." In *Spanish Cinema the Auterist Tradition*, ed. P. Evans, 79-92 Oxford: Oxford University Press.

Le Gras, G. 2005. "Soft and Hard: Catherine Deneuve in 1970." *Studies in French Cinema* 5 (1): 27-35. DOI: 10.1386/sfci.5.1.27/1

Metz, C. 1982. *The Imaginary Signifier: Psychoanalysis and the Cinema*. Trans. C. Britton. Bloomington: Indiana University Press.

Mellen, J., ed. 1978. *The World of Luis Buñuel: Essays in Criticism*. New York: Oxford University Press.

Miller, B. 1983. "From Mistress to Murderess: The Metamorphosis of Buñuel's *Tristana*". In *Women in Hispanic Literature: Icons and Fallen Idols*, ed. B. Miller, 341-359. Berkeley: University of California Press.

Petocz, A. 1999. *Freud, Psychoanalysis, and Symbolism*. Port Chester, NY: Cambridge University Press.

CHAPTER FOUR

EN CONSTRUCCIÓN AND EL CIELO GIRA: THE REPRESENTATION OF SPACE IN CONTEMPORARY SPANISH CINEMA

ANTONIO SÁNCHEZ

Throughout the last decades of the twentieth century there was a cultural as well as a theoretical shift away from the engagement with early concepts of time and progress that dominated the project of modernity, and a growing commitment towards space and this is often associated with so-called postmodern culture. As David Harvey has argued in *The Condition of Postmodernity*:

> This trend to privilege the spatialization of time (Being) over the annihilation of space by time (Becoming) is consistent with much of what postmodernism now articulates; with Lyotard's 'local determinisms', Fish's 'interpretive communities', Frampton's 'regional resistances', and Foucault's 'heterotopias.' (1990: 273)

This cultural transformation has also become evident in cinema and film studies. While space has had a key role in the development of cinema from the earliest years, I argue in this chapter that its representation in contemporary Spanish cinema has become more dynamic and complex. By looking at some recent examples of Spanish cinema, such as *En construcción* (2001), directed by José Luis Guerín, we will see that the representation of space provides a thorough critique of the consequences of the urban redevelopment of Barcelona in general, and that of the old neighbourhood of El Raval in particular. Additionally, throughout the film's representation of an old Barcelona neighbourhood, there emerges a complex and multi-layered historical, ethnic, and cultural reality that stands in opposition to the homogenous official image of Barcelona disseminated by the local authorities.[1] Furthermore, *En construction* conveys a representation of space as essentially social and historical; it

[1] Recently, there has been a vast number of studies focussed on the social and cultural consequences of the current urban and architectonic redevelopment of Barcelona (Rowe 2006; Marhsall 2004; McNeill 1999; Epps 2001).

envisions the city as a structure constantly in the process of change, as a work in progress—unfinished and fragmented—where there is always digging and constructing going on in the ruins of the past. Through this critical perspective, urban space becomes a rich cultural tapestry or palimpsest.

Contrasting with *En construcción*'s engagement with urban space, *El cielo gira* (2004), by Mercedes Álvarez, constructs a representation of rural space, focusing on the village of Aldealseñor and the surrounding countryside in the province of Soria. This film discovers a space that is literally fading into oblivion, becoming extinct like the dinosaurs that once used to live there. Yet, as in *En construcción*, death and renewal, the past and the present, emerge as part of an ongoing process that inscribes these cycles into the space that they constitute and which will continue changing even after the current community has disappeared.

Throughout the analyses of these films, this chapter proposes a perception of space that is dynamic and complex; that is, a space that is constantly changing, and which thus challenges any attempt to define it with a homogenous and stable meaning. In conversation with Karen Lury, Doreen Massey makes a case for this new perception of space when she defines it as "precisely the sphere of the possibility of coming across difference" (Lury 1999: 232).

Finally, this chapter will claim that these filmic representations of space are rooted in the tradition of cinematographic neo-realism which celebrates and pursues a concept of space as a dimension open to unpredictable and unexpected encounters between subjects and realities.

EN CONSTRUCCIÓN

José Luis Guerín's documentary exemplifies a new approach within Spanish cinema to engaging and representing urban space. Among other awards, the film won the Premio Nacional de Cinematografía and a Goya for best documentary; it was well received by critics and also at the box office. The film's cinematic release in Spain took €680 000 from an audience of 150 000 spectators. This return is particularly unusual for a documentary, and even more so for one like *En construcción* with such a tight focus on a single neighbourhood. The film follows the demolition of a derelict block of flats (and the construction in its place of a more exclusive building) in the neighbourhood of El Raval, a place with a long history of social marginalisation and urban decay but also with a strong sense of local identity. El Raval is located at the very centre of Barcelona and previously formed part of what was known as El Chino, a red-light

district where social marginalisation, criminality and the lower working classes co-existed.

As in his previous work, Guerín turns the focus of this film—the old, deprived area of El Raval and its inhabitants—into an opportunity to explore time and its consequences. The opening scene already establishes this concern. Vintage black and white documentary footage of the area provides a glimpse into a lively, popular culture in which images of factories are juxtaposed with those of children playing, prostitutes and clients in the streets, and inebriated sailors drifting towards the red light district. These old images of the area are followed by up to date ones in colour which capture a moment where the redevelopment imposed by the local authorities is about to transform the urban landscape. As the captions to the inset black and white film indicate, El Chino was born as a neighbourhood with the twentieth century and died with it. So, what the film invites the spectator to witness is in some fashion a post-mortem of a neighbourhood, the representation of a marginal community and its space in a process of extinction.[2] By looking at the urban and social decay of El Raval as a body which is in the process of dying (something also central to *El cielo gira*, as we shall see later), Guerín transcends the specific local nature of the neighbourhood and transforms it into a more symbolic space that spectators from other parts of Barcelona, Catalonia, Spain, and indeed across the world, can relate to. Treating a space as if it were a cemetery has clear narrative potential, as we can see from Michel Foucault's reference to the graveyard's inclusivity in "Of Other Spaces":

> The cemetery is certainly a place unlike ordinary cultural spaces. It is a space that is however connected with all the sites of the city-state or society or village, etc., since each individual, each family has relatives in the cemetery. (1986: 25)

Right from the outset there emerges in *En construcción* a subtle criticism of the popular and official vision of Barcelona as an aesthetically beautiful city, a perfectly planned and developed urban environment capable of fulfilling not only the needs of the prosperous middle classes, but also those of the increasing number of tourists who are encouraged into the city's historic centre, transformed from ruin to attractive habitat by the same expensive local authority investment which prices the working classes out of the area. There are plenty of examples throughout the film of a critical denunciation of the process of gentrification and of the ensuing

[2] Cristina Martínez-Carazo (2001) provides an excellent critical analysis of the film and the consequences of urban redevelopment for the inhabitants of El Raval.

marginalisation of the traditional inhabitants of El Raval. As Manuel
Vázquez Montalbán, one of the best chroniclers of Barcelona, forecast in
his book *Barcelonas*:

> The apparent 'remodelling' of old Barcelona will simply be a means of
> gentrifying the inner city, flattening districts which time and poverty
> have already partially demolished. The present economically
> impoverished community will soon be replaced by a new middle class,
> keen to conquer the centre and south of the city, following the
> installation of central heating and security guards, without which it is
> difficult to feel comfortably hegemonic. (1992: 7)

Interestingly, there is a surprising lack of resistance to this process
throughout *En construcción*. Arguably, this is due to the social and
political marginalization of a considerable part of the local population and
the fact that we are witnessing the implementation of a spectacle which
was decided on and organised a long time ago. Yet, despite the official
promotion of the project and, particularly, its emphasis on the spectacular
aspect of the redevelopment of the city, the fact is that many of the local
protagonists will have to move to other parts of the city as a consequence
of the speculation and gentrification triggered by the model of Barcelona
promoted by the local authorities. The tragedy of this transformation lies,
however, in the fact that, as the film shows, the social lives of many of the
protagonists are rooted in the area and now they will be marginalised even
further by a combination of economic and political forces that are beyond
their control. Despite the Marxist beliefs and values embodied in the figure
of the older Moroccan labourer working on the building site, there are
apparently no functional alternatives to, or forms of resisting, the urban
redevelopment and its socio-economic consequences. In fact, the instances
of solidarity that emerge throughout the film do not coalesce around the
idea of a Marxist social revolution led by the working classes, but instead
are based on a sense of belonging to a particular space and community.
The final scene of the film, in which a young couple playfully carry each
other on the back as they abandon the area of El Raval, becomes a
powerful symbol of the removal from the local environment of a whole
social stratum.

The apparently inevitable process of gentrification triggered by the
redevelopment of El Raval also begs questions about the vision of the city
as a socially unified space promoted by the local authorities and planners.
Let us not forget that the so-called urban renaissance experienced by
Barcelona has been taken forwards on the basis of a massive urban and
architectural redevelopment which has integrated as essential to its success

the promotion of the idea of citizenship. In this sense, the existence of the marginal characters foregrounded by *En construcción*, as well as its emphasis on the intimate relationship that they have with their local space, questions the official drive towards improving the social and urban quality of the area by homogenising and sanitising the social and urban landscape of the area. In other words, while most of the marginal characters emerging throughout the film seem to lack any substantial socio-political voice, their very existence challenges the concept of the city as a socially unified space that lies at the core of the official discourse of urban redevelopment.

The centrality given throughout the film to a large number of characters creates a sense of community enhanced by the experience of those protagonists who live and work in an urban space which is in the process of being demolished, rebuilt, and sold in the form of a new block of flats to those who can afford the price. In essence, the new Catalan bourgeoisie is now considering moving into a neighbourhood which it had previously considered a no-go area. Throughout this urban transformation emerges the existence of individuals who are increasingly being pushed out of the new spaces by the forces of gentrification and cultural exclusion, namely, elderly people, people with learning disabilities, sex workers, the unwanted, and marginalised citizens of the new Barcelona living in decrepit houses and streets. The amusing aspect of their dialogues and behaviour should not divert our attention from their hard existence which entails scavenging from rubbish containers, loneliness, alcoholism, mental illness, and prostitution. Contact with marginalisation is often highlighted in the film by focusing on the graffiti written on the walls of El Raval, denouncing urban speculation. As the charismatic older Moroccan worker in the film points out to his compatriot when discussing the compensation measures offered by the local authorities to those who have been forcefully removed from the flats that are being demolished: "Les dan 800 000 pesetas y ellos venden los pisos por 20 millones." [3]

One of the most fascinating aspects to *En construcción*'s representation of El Raval is the vision of the space as essentially constituted by people, a heterogeneous group of characters co-existing in the same neighbourhood; these subjects, with their conversations, activities, and varied forms of self-presentation, are precisely the source of the neighbourhood's cultural identity. Guerín referred to this during an interview with Inmaculada Barrio Marina when he stated that:

[3] "They have received 800 000 pesetas in compensation while the new flats are being sold for about 20 million."

La manera más justa y precisa de mostrar un barrio no era hacerlo
filmando calles, plazas y avenidas sino delegándolo en los rostros humanos
que, a nuestro juicio, lo representaban. Un barrio es esencialmente la gente
que lo habita más que las casas y monumentos. (2002: 107)[4]

Furthermore, the vision of El Raval constructed by the film suggests a
perception of the urban space as a palimpsest, constantly highlighting the
variety of signs, messages, and graffiti inscribed on the walls of the urban
landscape; the idea of the neighbourhood's history as a layered texture of
buildings is also underscored by the discovery of Roman ruins. The
spectral emergence of the Roman site brings the building work to a halt
and, more importantly, opens a space and time for contemplation, creating
a temporary space in which passers-by (the *flaneurs* of the modern city)
and the same local characters who head the film's cast, meet and exchange
their views on anything and everything from the building site itself to
death and the meaning of life, all within a diverse range of religious,
cultural, and social perspectives. These reactions to the discovery of the
Roman burial site beneath the redevelopment work create an opening for
meditation on the city's multiple identities, and on the co-existence of so
many social and historical layers within the same space. Space ceases to
be exclusively the battlefield for a debate over the consequences of
gentrification and urban speculation and gives way to a concern for the
transient nature of the human condition, emphasised by the constant
supply of news about the war in Kuwait that coincided with the period
when the film was shot. Critically, the film's title establishes a concept of
the city as an unfinished process, a structure that is always in a process of
construction, not only in the sense of the inevitable maintenance and
regeneration required by an ageing infrastructure but also in the sense of
the vitality of all those thousands of anonymous characters whose
everyday actions and activities—often unpredictable—provide the space
with meaning, no matter how briefly they inhabit it, leaving traces of the
undeniable presence of a community that is about to disappear.

The black and white images of the city with which the film opens
highlight an image of a community and a way of life that no longer exists,
a space dominated by memories and the ruins of the past. This emphasis
on the transient nature of the urban environment enhances the vision of the
modern city as a space in a process of constant change and transformation

[4] "The most fitting and accurate way of showing a neighbourhood wasn't to film
streets, squares, and avenues but instead to show the place at one remove through
the human faces which, in our judgement, represented it. A neighbourhood is in
essence the people who inhabit it more than its houses and monuments."

in which death and renewal, destruction and construction, are different aspects of the same dynamic. As one of the protagonists in the film points out as she contemplates the Roman necropolis: "Vives encima de los muertos y no te enteras."[5]

It is precisely through the emphasis on the decay of the area, the ruins of the past, and the process of urban renewal that the film creates a contemplative mood and reflects on the effects and meaning of the passage of time. The constant use in *En construcción* of a fixed camera and the employment of extremely long takes contribute to a cinematographic experience in which the spectator is invited to share alongside the protagonists a meditation on space and to experience with them the passage of time.

The scenes of the Roman ruins also reveal the vision of the city as a space of encounter and unexpected interactions, echoing Víctor Erice's intimate representation of Madrid in *La luz de membrillo* (1992). As in Erice's film, *En construcción* shows the renewed influence of neo-realist cinema with its concentration on open public spaces such as streets, squares, and terraces, as ideal places for unexpected encounters and, therefore, spaces of an unpredictable social nature. As Michael Cowan suggests in a recent article, "for neorealist directors and theorists, the street formed one of the quintessential spaces for opening up closed film to the effects of chance" (2008: 119). Interestingly, the reflection provided by the constant contemplation of the inhabitants of El Raval, as well as the space itself, leads to some brilliant and spontaneous exchanges between the neighbourhood's inhabitants on the fragility of human existence and the fleeting nature of life.

Henri Lefebvre is one of the key intellectual figures in terms of the shift which has occurred in our attitudes towards the importance of space. Throughout his landmark work *The Production of Space* (1991), Lefebvre argues that while culture is not entirely reducible to the circulation of capital and commodities, it cannot be separated from it. Nevertheless, this materialistic emphasis on the production of space may neglect the fact that the seemingly limitless energy and intensity of the city is generated not only from people inhabiting and working in the highly organised structure of the city, but also in people's ability to resist, and even to sabotage, the city's dehumanising forces, constantly creating new social and spatial alternatives through their daily activities, constituting what Michel de Certeau describes in "Walking in the City" as:

[5] "Here we are, living atop the dead, and we don't even realise it."

The thicks and thins of an urban 'text' they write without being able to read it. These practitioners make use of spaces that cannot be seen; their knowledge of them is as blind as that of lovers in each other's arms. The paths that correspond in this intertwining, unrecognized poems in which each body is an element signed by many others, elude legibility. It is as though the practices organizing a bustling city were characterized by their blindness. (2007: 153)

Unlike the strategies designed, promoted, and implemented by urban planners and local authorities, the often unpredictable and spontaneous actions of individual subjects who inhabit and constitute city space have the potential to undermine and even transform the officially sanctified vision with their unregulated, anarchic, and creative activities. Thus, space is conceived here as at once produced by economic and political forces and productive of specific, but unpredictable, social and subjective effects.

EL CIELO GIRA

Mercedes Álvarez, the director of *El cielo gira*, also worked as the editor on *En construcción*, which may partially explain the continuity between the two projects and their shared concern with space, community, and the passage of time. It could even be argued that *El cielo gira* constitutes a kind of rural companion to *En construcción*'s representation of urban space, one in which the neighbourhood of El Raval is replaced by the last fourteen inhabitants of Aldealseñor, a little village in the province of Soria. There are some substantial similarities, as well as differences, in these two films' depiction of space; while in *En construction* space is constantly described as a process that is never completed, in *El cielo gira* the village is initially perceived as a static place where nothing much has changed since the narrator left when she was three years old. As the title suggests, nature and time keep changing the appearance of the village, but only superficially; deep down, it has remained unchanged, or so we are led to believe, since, as the narrator points out, she cannot remember anything about the village: she was only a toddler when she left with her family. In any case, the initial image depicted by the film is that of a typical, rural, village where life is constituted by the daily activities of a community gradually fading away into oblivion. Aldealseñor and its inhabitants are in terminal decay, although signs of renewal do eventually emerge. In any case, Aldealseñor (like El Raval) is ultimately seen as a process/space inseparable from its protagonists, the inhabitants who inscribe the place with the meaning of their daily existence. Similarly, the debris of the past is never far from the surface and neither is the threat of the fatal consequences of current political decisions. If in *En construcción* this is

illustrated by the soundtrack's inclusion of news about the war in Kuwait, in *El cielo gira* it is the war in Iraq that reverberates in radio bulletins and the noisy fighter planes crossing the skies above Aldealseñor. On the one hand, the film provides an account of the village and its inhabitants as being in a final process of decline, marching towards oblivion, yet, on the other hand, it suggests the incursion of current affairs and politics in Aldealseñor's day to day life, even if the potential negative consequences of such geopolitical adventures are highly unlikely to affect the village. The reaction of the villagers to the brief visit by politicians canvassing for votes is also highly illustrative of their feelings of being aware of, yet excluded from, the process of history in the making. Thus, while one young political activist does not even try to locate Aldealseñor's residents, they themselves cannot be bothered to leave the church where some are praying and others are enjoying their afternoon nap.

El cielo gira does not open with an image of Aldealseñor but instead starts with a shot of a painting by Pello Azketa. This narrative strategy is repeated towards the end of the film when we witness Azketa completing the painting of a landscape based on his experience in Aldealseñor and that, according to the narrator, could be one of the artist's last works due to the deterioration of his sight. The framing structure thus established highlights the importance given by the film to the representation of space. To a great extent, these paintings constitute an introduction to the film's dominant concern with the nature of representation. This is emphasised early on when the narrator describes the painting we see in the film's opening sequence. On the canvas, two children are looking down at the water with frozen excitement, staring at something beyond the frame; something that we cannot see but which, according to the narrator, is either about to vanish or to emerge, or perhaps both, just in front of our eyes. Similarly, the film's aesthetic responds to the very contemporary artistic concern with preservation. It aims to capture the images and voices of Aldealseñor at the very moment when Spain's modernisation has left such communities in an advanced state of decay.

As the film keeps reminding us, this is nothing new since the entire province of Soria is littered with the traces left by the early settlements of Celtiberians, Romans, and Arabs, among other cultural groups who had lived in those lands before. Yet the film gradually reveals that the decline of one culture often leads to the cyclical rise of another in a process that mirrors the seasonal change which provides *El cielo gira* with its structure. As we shall see, this perception of time has an intimate connection with the vision of space constructed by the film and it is best illustrated in the final scenes in which the landscape painted by Azketa dissolves into the

countryside framed by the film, and where the figures of Antonino and Silvino, wandering through the hills, gradually merge into the space. The village of Aldealseñor, at least in its current state, is destined to disappear, as is its shrinking population, contributing to a certain sense of inevitability in the film. Similarly, the transient quality of life is constantly illustrated, creating the impression that everything is part of a cycle. The aestheticisation of decay and change in the film and in Azketa's paintings creates the illusion of a redemptive way out of this process of decline. In this respect, the final painting executed by Azketa mirrors the film's ability to illuminate the redemptive nature of history, as described by Eduardo Cadava in *Words of Light* in reference to Benjamin's theses on photography and history:

> The possibility of history is bound to the survival of the traces of what is past and to our ability to read these traces as traces. That these traces are marked historically does not mean that they belong to a specific time—as Benjamin explains in his early essay on the *Trauerspiel* and tragedy, '*the time of history is infinite in every direction and unfulfilled in every instant.*' (1997: 64)

El cielo gira focuses alternately on the landscape of Aldealseñor, on the effects of the passage of time, and on the intimate relationship between the inhabitants and the spaces of the village and the surrounding countryside that they populate with their daily activities and with conversations increasingly dominated by their own sense of decay. That gloomy view is, somehow, tempered throughout the film by a lively engagement with their daily existence, by their sense of community, and by their sceptical detachment from history and politics.

The emphasis on specific, often marginal, local communities can lead to a dangerous disregard for the forces of history and the socio-economical agents that shape space, as previously discussed with reference to *En construcción*. Indeed, in *El cielo gira* the constant emphasis is on nature, the seasons of the year, the inevitability of death, and the view of history as a inevitable cycle of wars and invasions: the concatenation of Sagunto, the Romans, the Arabs, the Spanish Civil War, and now the war in Iraq, can lead to a vision of history as a cycle, constantly repeating itself. This is illustrated by one of the inhabitants of Aldealseñor when he points out that: "Hace dos mil años esto se despobló y ahora va a pasar lo mismo; aquellos

se fueron y otros vinieron después."[6] The demotic view expressed in observations like these seems to reverberate with the philosophical concept (elaborated by Nietzsche, Bergson, and Eliade, for example) of the eternal return, and somehow promotes a tendency to conform with and to accept the impossibility of change since, ultimately, change is bound to be perceived as irrelevant when compared with the natural drive towards death and oblivion imposed by the passage of time.

If there is a shift in *El cielo gira* away from concerns with history and socio-economical factors in favour of a focus on transcendental meaning or myth, this could suggest a reading of the narrator's journey to Aldealseñor as a return of sorts to her origins. As Mercedes Álvarez indicates, she was the last person to be born in Aldealseñor. So, her return to the village has a tremendous personal and symbolic significance, even more so given that we know that the village and its community are in an inevitable process of decline. To some extent, *El cielo gira* echoes the photographic work of Cristina García Rodero, particularly *España oculta* (1989) and the texts of Julio Llamazares but, perhaps more importantly, it reflects Susan Sontag's exposition of the relationship between photography, death, and decay:

> Cameras began duplicating the world at that moment when the human landscape started to undergo a vertiginous rate of change: while an untold number of forms of biological and social life are being destroyed in a brief span of time, a device is available to record what is disappearing [...] Like the dead relatives and friends preserved in the family album, whose presence in photographs exorcises some of the anxiety and remorse prompted by their disappearance, so the photographs of neighbourhoods now torn down, rural places disfigured and made barren, supply our pocket relation to the past. (2002: 15-16)

Equally, *El cielo gira* can be criticised too for fulfilling this modern function of replacing reality with representation to displace any feeling of guilt or criticism directed towards the modern forces that have provoked these changes. Nevertheless, Álvarez's film avoids the temptation of pretending to rescue and preserve the other of modern Spain; neither does it descend into an idealisation of a way of life that is in the process of fading away. Significantly, the film strikes a balance between the nostalgia triggered by close contact with some of the protagonists and the village, and the acknowledgment of a number of current changes that are

[6] "Two thousand years ago the population that was here disappeared and now the same is going to happen again; one group of people went away and others came in after them."

transforming Aldealseñor and its landscape such as the arrival of wind turbines, the redevelopment of the abandoned palace into a luxurious hotel or, perhaps even more surprisingly, the presence of two Moroccan characters who are now part of the landscape, illustrating a potential reversal of the growing depopulation of rural Spain and a reminder of a fundamental aspect of Spanish cultural heritage that is often repressed or neglected. As the Moroccans point out during their conversation, the palace (whose origins are unknown by the natives of Aldealseñor) is recognised by them as a medieval Arab post, highlighting the earlier and long-term presence of their ancestors in Spain.

While the countryside spaces of Soria and its rural culture are celebrated in this film, and its light and colours are embraced by Azketa in his final painting, the concept of space created by the painter and the director is radically different to the obsessive attempts by the painters and writers of the so-called Generation of 1898 to present the space of rural Castile as natural evidence of the transcendental essence of Spain and its national identity. Rather than proposing space as a mythical entity or romanticising what is about to disappear, the representation of space proposed by the two films explored in this chapter offers a vision of space in constant flux, never completed and always carrying with it the debris of the past. History, however, is not the only force in the transformation of space; as discussed above, in *En construcción* the forces of capitalism share a great deal of responsibility for the constant processes of destruction and construction of space. Indeed, both the forces of capital and those of history must be taken into account to explain the growing process of depopulation experienced in many parts of rural Spain.

The dominant concept of space as something tangible, solid, and objective is challenged throughout *El cielo gira* and, particularly, in Azketa's paintings. Aldealseñor and its community are fading away despite the undeniable evidence of a physical persistence. Gradually, throughout the film, a different vision emerges; one in which space is perceived as malleable and constantly changing. A poetic example of this plasticity emerges in the final scene when Antonino and Silvino, (probably the most charismatic of the film's subjects) are wandering throughout the barren hills, and fade into space as they continue with their daily chattering about life and death. As the closing credits appear their conversation continues on until the lights of the cinema bring their

existence, that of the countryside, and even that of the film itself, to a close.[7]

As previously mentioned, the painter's advancing blindness adds a poetic poignancy and sense of urgency to his attempt to represent the space of the countryside around the village. His final creation is a race against time, as is the narrative which is limited by the natural cycle of the seasons that articulates the film and by the inescapable fact that the village, its inhabitants, and their way of life are disappearing from contemporary culture. As the final scene suggests, the closure of the film echoes the inevitable death of the village and its protagonists and their final integration into the space that they have constituted. With their day to day conversation, their mere presence and activities, Antonino and Silvino, as well as the remaining inhabitants of the village, have become an intrinsic part of Aldealseñor and the surrounding countryside. Space is shaped by them and inscribed by their traces as well as those of their ancestors.

Focusing on the constant natural cycle of death and renewal as a quintessential aspect of the life of the village, Álvarez adds a further quality to her representation of space. Like *En construcción*, *El cielo gira* discovers physical as well as symbolic remains of the past in a re-written landscape. The countryside of Aldealseñor is infused with traces left behind by the biological and historical cycles of death and renewal. This is best illustrated in the scenes of Silvino and Antonino digging in the local cemetery and having a hilarious conversation on the nature of life and death; more poignantly, the scene marking the absence of Eliseo's plastic chair outside the house points to another death; fossilised tracks left by dinosaurs, and the human skulls found at the base of the dead elm tree, signal more literally cultural traces of a past that has disappeared but which, somehow, is still inscribed on the landscape.

CONCLUSION

While the two films I have discussed contain different levels of criticism of the socio-economic forces that increase social marginalisation, either through speculative gentrification of urban space, or through the collapse of rural cultures, they also provide, alongside their critique, an alternative form of engagement with the spaces they describe: El Raval and

[7] The final scene of *El cielo gira* provides an intertextual tribute to the Iranian director Abbas Kiarostami by echoing similar closing images in his film *Through the Olive Trees* (1994). In Kiarostami's film, the final scenes show the male protagonist running after his beloved through the olive trees, gradually merging into the countryside and the screen until they become indistinguishable.

Aldealseñor are viewed in terms of a positive appreciation of the spaces they describe as multiple, open, and inclusive. Both films also question the notion that a local culture is fixed and homogenous and suggest instead that it can be as diverse and flexible as the concepts of time and space which shape it. In *Space, Place and Gender* Doreen Massey proposes that:

> The identities of places are inevitably unfixed. They are unfixed in part precisely because the social relations out of which they are constructed are themselves by their very nature dynamic and changing [...] Moreover, that lack of fixity has always been so. The past was no more static than is the present. Places cannot really be characterized by the recourse to some essential, internalized moment. (1994: 169)

Beyond being constituted by the activities of people, space emerges also through these representations as essentially shaped by time rather than opposed to it. Space is not only malleable and vulnerable to the socio-economic forces of capitalism that constantly build it up only to pull it down again; as *En construcción* illustrates so well, space is in a state of permanent construction and continuous decline and is defined by the practices of the living as much as by the traces of the dead. As the films of Guerín and Álvarez reveal, space is littered with historical, archaeological, and even biological vestiges. The tracks of dinosaurs in Aldealseñor are as intrinsic a part of its landscape as the vestiges of the Celtiberians, Romans, and Arabs. Similarly, alongside traces of the past the films also discover for us elements of what may constitute the future. The presence in Soria of the Moroccan shepherd and the marathon runner, and the variety of ethnic groups populating El Raval, constitute a present reality that is already shaping the future space of urban and rural Spain. Space, as represented in the two films examined here, is no longer held in opposition to time or as a stage for history but, instead, emerges as an integral part of the different times converging in a place. As Linda Ehrlich suggests in her analysis of *El cielo gira*, the film mixes "a cyclical sense of time [...] with historical/biographical time and with mythic time" (2008).

In "Urban Space in European Cinema" Pierre Sorlin criticised the tendency of European films to dismiss the potential of the city in contrast with the tradition of other national cinemas where the city plays a more crucial role, but one in which the urban space is employed in opposition to the characters:

> In most European films, cities do not exist by themselves, they are merely a setting and a stock of potential stories. It is the characters' gaze, their search or their mental agility which selects some of these many possible narratives and cause [sic] them to develop on the screen. Towns gain life

from the expansion of human exchanges; they are nothing but the relationships that exist between their inhabitants. (2005: 35)

While this view coincides broadly with the concept sustained throughout this chapter that space, whether urban or rural, is anything but a reality constituted by the activities of its inhabitants, my approach diverges from the rather reductive perception of space in European cinema as being a mere "setting and a stock of potential stories".

My aim throughout this chapter has been to highlight the radical transformation in the representation of space in current European films, one in which space plays a more dynamic and fundamental role alongside its inhabitants. Space is constituted by its inhabitants, but the mental and social life of its protagonists is shaped dramatically by the spatial conditions under which they live as *En construcción* and *El cielo gira* so successfully illustrate. This is precisely the concept of space given by Foucault:

> The space in which we live, which draws us out of ourselves, in which the erosion of our lives, our time, and our history occurs, the space that claws and gnaws at us, is also, in itself, a heterogeneous space. In other words, we do not live in a kind of void, inside of which we could place individuals and things. We do not live inside a void that could be coloured with diverse shades of light, we live inside a set of relations that delineates sites which are irreducible to one another and absolutely not superimposable on one another. (1986: 23)

Unlike early modern visions of the city as a totality, and of traditional rural culture as the marginal space of the other, the representations of the spaces depicted by *En construcción* and *El cielo gira* succeed in conveying a concept of space that is both constituted by those who inhabit it and open to the changes imposed by socio-economic forces, and also able to register the presence and past of those communities at the margins of contemporary culture. Space, despite its deceptive image of solidity and permanence, is understood in the new approaches to be found in *En construcción* and *El cielo gira* as inevitably provisional and precarious, part of a process rather than a fixed reality, open to change as well as to the forces of resistance.

WORKS CITED

Barrio Marina, I. 2002. "Paisaje humano, paisaje urbano Entrevista a José Luis Guerín." In *Imágenes de la ciudad: II curso de cine y literatura: Burgos 1 al 22 de marzo de 2002*, eds. A. A. de Armiño, I. Barrio Marina, E. Nabal Aragón, and C. Lozano García, 105-12. Burgos: Universidad de Burgos.

Cadava, E. 1997. *Words of Light: Theses on the Photography of History*. Princeton, NJ: Princeton University Press.

Cowan, M. 2008. "Between the Street and the Apartment: Disturbing the Space of Fortress Europe in Michael Haneke." *Studies in European Cinema* 5 (2): 117-29.

De Certeau, M. 2007. "Walking in the City". In *The Cultural Studies Reader*, ed. S. During, 151-160. London: Routledge, 2007.

Ehrlich, L: 2008. "Three Contemporary Spanish Films: Landscape, Recollection, Voice." *Senses of Cinema* 46. www.sensesofcinema.com/contents/08/46/contemporary-spanish-films.html (Accessed 4 June 2008).

Epps, B. S. 2001. "Modern Space: Building Barcelona." In *Iberian Cities*, ed. J. R. Resina, 148-197. London: Routledge.

Foucault, M. 1986. "Of Other Spaces." *Diacritics* 16 (Spring): 22-27.

García Rodero, C. 1989. *España oculta*. Madrid: Lunwerg.

Harvey, D. 1990. *The Condition of Postmodernity: An Enquiry into the Origins of Cultural Change*. Oxford: Blackwell.

Lefebvre, H. 1991. *The Production of Space*. Trans. D Nicholson-Smith. Oxford: Blackwell.

Llamazares, J. 1988. *La lluvia amarilla*. Barcelona: Seix Barral

Lury, K. and D. Massey. 1999. "Making Connections." *Screen* 40 (3): 229-238.

Marshall, T. 2004. *Transforming Barcelona*. London: Routledge.

Martínez-Carazo, C. 2001. "Deconstrucción/Reconstrucción: *En Construcción* de José Luis Guerín." *Letras Hispanas* 4 (2): 2-15.

Massey, D. 1994. *Space, Place and Gender*. Cambridge: Polity Press.

McNeill, D. 1999. *Urban Change and the European Left: Tales from the New Barcelona*. London: Routledge.

Rowe, P. G. 2006. *Building Barcelona: A Second Renaissance*. Barcelona: Actar

Sontag. S. 2002. *On Photography*. London: Penguin.

Sorlin, Pierre. 2005. "Urban Space in European Cinema." In *Revisiting Space: Space and Place in European Cinema*, eds. W. Everett and A. Goodbody, 25-36. Oxford: Peter Lang.

Vázquez Montalbán, M. 1992. *Barcelonas*. Trans. A. Robinson. London: Verso.

CHAPTER FIVE

VISUAL NATION: CONSTRUCTING A NATIONAL IDENTITY ON CATALAN TELEVISION

SILVIA GRASSI

Benedict Anderson defines a nation as an "imagined political community. It is *imagined* because the members of even the smallest nation will never know most of their fellow-members, meet them, or even hear of them, yet in the minds of each lives the image of their communion" (1991: 5). This communion is created through what Homi K. Bhabha calls a "narrative construction of nation" (2005: 188): a national identity is not something *natural*, intrinsic in ourselves but it is a representation made of shared experiences and narrated histories, thus it is constructed through discourses. This ability to generate identity references was once the preserve of written culture, especially literature; this is particularly the case for Catalan culture since during Franco's dictatorship the use of Catalan was forbidden and print media in languages other than Spanish were suppressed. However, nowadays visual media comprise the main platforms for portraying and transmitting symbolic references, due to thier ability to penetrate society on a massive and unprecedented scale.

Perceptions about our national identity are acquired through the process of socialisation and one of the most powerful socialising institutions is undoubtedly television. This medium could be defined as an *aedo* of our time: in Ancient Greece, the *aedo* was the narrator of the past, keeping alive through his voice the memory of his people. I would argue that nowadays it is television that mainly performs this role: it functions as a mediator between collective and individual experience, creating an *imago mundi*, an imagined space that gives cohesion to the society that recognises itself on the small screen. As Stuart Hall states, television is implicated in "the provision and the selective construction of social knowledge, of social imagery, through which we perceive the 'worlds', the 'lived realities' of others, and imaginarily reconstruct their lives and ours into some intelligible 'world-of-the-whole'" (1977: 341).

It is evident, therefore, that political entities which wish to be perceived as nations are often desirous of projecting a kind of identity through fictions which are seen to be their own. As Enric Castelló

observes, "a nation needs its own fiction" (2007: 49). However, feelings are not homogeneous in a country, and people perceive their individual and collective identities in different ways. Following Gramsci's notion of hegemony, Terricabras states in "Identitat i identificació" that "Els grups dirigents sovint estan més interessats a afavorir la idea d'homogeneïtat, la idea d'una identitat nacional que sigui essencial, forta, inesborrable i participada per tots. La idea és útil perquè es posa al servei de la cohesió i en contra de la possible disgregació del grup" (2001: 180).[1] In a similar vein, Bourdieu considers television to be "un formidable instrument de maintien de l'ordre symbolique" (1996: 14).[2] Moreover, as Chris Barker argues:

> The globalization of the institutions of television raises crucial questions about culture and cultural identities. Thus, the globalization of television has provided a proliferating resource for both the deconstruction and reconstruction of cultural identities. That is, television has become a leading resource for the construction of identity projects. By identity project is meant the idea that identity is not fixed but created and built on, always in process, a moving towards rather than an arrival. (1999: 3).

This role is particularly important for those countries which do not have fully-recognised political borders and which lack full political sovereignty over their territory, the so-called nations without a state. National culture is itself a space of conflict, and being socially and politically constructed it undergoes continuous evolution. These political entities generally perceive that it is important to use television to create a space that includes all different cultural expressions, but which is also able to function as an instrument marking criteria of social integration and cohesion. Thus, after the transition to democracy, one of the most significant actions of the Generalitat de Catalunya was the creation of public radio and television services: the first broadcast of Televisió de Catalunya was on 11 September 1983,[3] but regular broadcasts began on 16

[1] "Powerful groups are often more interested in favouring an idea of homogeneity, the idea of a national identity that is essential, strong, indelible and shared by everyone. This idea is useful because it serves for cohesion and goes against a possible disaggregation of the group."
[2] "An extraordinary instrument for maintaining the symbolic order."
[3] September 11 marks the *Diada*, Catalonia's National Day. Choosing this date for the inaugural broadcast exemplifies clearly Televisió de Catalunya's intended status as national instrument. The dates I refer to here are for TV3. A second channel, Canal 33, was launched in 1989 and a news channel, 3/24, began broadcasting on 11 September 2003, when it relayed the entire *Diada* ceremony.

January 1984. Until then, the television monopoly in Spain was controlled by the other public service television channel, Televisión Española, which corresponds to the Spanish state. Private channels would be launched a few years later when in 1990 Antena 3, Tele 5, and Canal+ all began service. Therefore, Catalan public television presented itself as a primary point of reference for Catalan society in the Catalan government's project of recuperating a national identity.

Seen from this perspective, the provision of public service television in Catalonia was motivated by ambitious aims and contrasted completely with notions held about it by the Director General of RadioTelevisión Española, according to whom autonomous television should be of an anthropological nature and "complementaria" (complementary) to the two Spanish public channels, La Primera and La2 (Gifreu i Casasús, 2003: 6). On the contrary, the idea of a folkloric television was rejected in favour of what Jaume Ferrús has defined as "televisió total" (total television) (1991: 200-201), which aimed at creating a virtual space of identity where Catalan people could recognise themselves, thus functioning as an element of cohesion in Catalan society and as an instrument contributing towards the re-construction of a national identity. This is explicitly stated by Law 20/2000, which created the Institut Català de les Indústries Culturals (Catalan Institute of Cultural Industries) and says: "Les indústries culturals d'un país són percebudes avui no només com un factor de progrés econòmic, sinó també com la via de garantir la presència de productes culturals propis, és a dir, de presentar la creativitat i el punt de vista propis en el mercat cultural universal."[4] The Corporació Catalana de Ràdio i Televisió (Catalan Radio and Television Corporation) has always insisted on defining Catalan public radio and television as national media. According to Lluís de Carreras, "Las televisiones que realizan la función de representar a una comunidad que puede identificarse políticamente como una nación y que han nacido o se justifican para ser vehículo de una lengua o preservar una cultura propia y diferenciada tienen vocación de ser 'televisiones nacionales'" (1995: 153).[5]

[4] "Nowadays the cultural industries of a country are perceived not only as a factor of economic progress, but also as a way of guaranteeing the presence of that country's own cultural products, that is to say, of presenting its own creativity and point of view in the universal cultural market."

[5] "Television services that perform the function of representing a community which can politically identify itself as a nation and which were either born to be or have as their raison d'être being the vehicle of a language or preserving a singular and differentiated culture have as a vocation the role of 'national television.'"

In this sense, national television is a medium that takes on the responsibility for becoming an important institution and platform of nation-building for a community for which it is a primary reference point and around which it shapes its programming in terms of proximity (Castelló 2005:128): "El concepto de proximidad aplicado a la televisión tiene que ver con la idea de que entre la emisora y sus receptores existe un escenario de experiencias compartidas, cosa que, en definitiva, se verá reflejada en los contenidos de la programación" (de Moragas Spà and Garitaonandía and López 1999: 19).[6] Thus, Catalan television was born to be television made by Catalan people for Catalan people about Catalan people as reflected in its slogan: *la teva* (yours). Nowadays, television is still considered essential for the future of the Catalan language and culture because it continues to perform a significant role in defining identity and differentiation with respect to the rest of Spain.

Due to the visceral importance that language has in Catalan nationalism, Catalan television was created with an overtly expressed sociolinguistic purpose, that of establishing a space for the Catalan language with as wide an audience as possible in mind, so that at least on the small screen, people would have constant contact with the language. Not only did it aim to improve people's command of Catalan but also "[to] show them the broad usefulness of a language that had been artificially confined to domestic or high cultural domains" (Crameri 2008: 113). The importance acquired by linguistic norms in the process of constructing a national identity is evident in the great attention paid by Televisió de Catalunya to ensuring orthodoxy and standards in the Catalan used in its programmes: it created the Comissió de Normalització Lingüística (Commission of Linguistic Normalisation) and has a linguistic advisor for each area of its programming (Crameri 2008: 12). In 1995 *El català a TV3: Llibre d'estil* was published with the purpose of serving as a detailed manual of the language as it should be used by professionals working for Catalan television.

Central Catalan (the variety of Catalan spoken in the greater urban area of Barcelona) was chosen as the standard variety. It was thought that the choice of one variety as a standard would ensure consistency, albeit to the detriment of representing the plurality of accents and varieties of which the Catalan language is made up. The more "neutral" of the alternatives was chosen: central Catalan is the variety of the language spoken by the

[6] "The concept of proximity applied to television has to do with the idea that between the broadcaster and its viewers there is a scenario of shared experiences, something that, ultimately, will be reflected in the contents of the programming."

largest number of people, and since most Catalan drama series are set in Barcelona seemed the right choice.[7]

As well as variety, other factors—such as style and register—were also at work in the process of fixing upon a form of Catalan to be used on the new television channels. As has been argued already, Televisió de Catalunya was created to be a tool of linguistic normalisation and was meant to improve viewers' command of Catalan. As a consequence, great attention was dedicated to correctness, resulting in little variation in the kind of language used in different genres, such as soap operas or news. Enric Castelló has suggested that in the opinion of some writers and directors working for television in Catalonia, this attention to linguistic orthodoxy and standardisation reduced the credibility and realism of characters in soap operas and drama series, and blurred the social and cultural differences among them (2007: 61).

However, more recently, Televisió de Catalunya has been broadening the varieties of Catalan used in its programming, including not only different accents within Catalonia but also varieties from other Catalan-speaking territories. Moreover, there is now much more latitude with regard to linguistic usage in Catalan television series than was the case 25 years ago: drama scripts now include colloquialisms, vulgarisms, and even "castellanismes" (words and expressions imported to Catalan from Spanish). As Kathryn Crameri argues "The initial insistence on standardization and correctness was appropriate for the overall linguistic situation of Catalan at that time, whereas with more of the population now formally educated in Catalan and able to manipulate the language in a variety of communicative situations, greater flexibility is both possible and desirable" (2008: 133).

I would also argue that Televisió de Catalunya not only played a role in the process of linguistic normalisation but also in linguistic naturalisation: As Oriol Izquerido notes: "Es deia que havíem d'aspirar a fer-ho tot en català, des de l'alta cultura fins a la pornografia, com qualsevol altra societat, com totes les societats 'normals'." (2002: 100).[8] One of the strategies used to achieve this naturalisation was dubbing: everything for the Catalan channels' schedules was dubbed into Catalan,

[7] As we will see later, in the last ten years there has been an effort to improve the presence of other accents and varieties on television and to move the location of drama series outside Barcelona. This is the case with *Ventdelplà*, a series shown for the first time in February 2005, and set in a small town in Empurdà, a *comarca* (geographical region) in the north of Catalunya.

[8] "We were told that we had to aspire to do everything in Catalan, from high culture to pornography, as in any other society, as in all 'normal' societies."

including North-American series such as *Dallas* and *Magnum*. The importance attached to foreign programming with Catalan dubbing is evident in the case of *Dallas*: Lluís Prenafeta, who was in charge of the Departament de la Presidència (Presidency Department) from 1980 to 1990 and who was therefore Catalan President Jordi Pujol's right-hand man, went personally to New York to secure the rights for the series (Antich 1994: 98). The effort paid off: the version of *Dallas* dubbed into Catalan immediately achieved a large audience and had a great social impact. For the first time, native speakers of Catalan had the chance to hear television characters—including wealthy American oilmen— speaking their own language, conveying in this way the idea that Catalan was appropriate in any communicative situation.[9] Television's role in linguistic normalisation was arguably particularly important for children, who have a much closer relation and a very direct response to the images they see on the screen. This explains the great attention Televisió de Catalunya has paid to children's entertainment since the very beginning of its transmissions. This led in 1991 to the creation of *Club Super3*, a "frame" structure for children's programming: the Club's characters linked together discrete series and cartoons and the continuity thus became part of the programming designed specifically for children. In October 2009 this programme became a channel entirely dedicated to children's programming.

As well as imported dramas, films were also dubbed. A significant example is *Some Like It Hot*. In Spain this film had always been known by the title *Con faldas y a lo loco* ("In Skirts and Gone Wild"). Televisió de Catalunya used a noteworthy strategy in finding a new title in Catalan for the film. It asked viewers to choose the title for the Catalan version, demonstrating in this way the effort made to convey a feeling of shared responsibility in the construction of a national identity that had been suffocated by 40 years of dictatorship. The winning title was *Ningú es perfecte* ("Nobody is perfect"), the last line of the film, uttered by the millionaire Osgood when he finds out the "woman" he is in love with is in fact a man. In the new title, the ambiguous message of the film and the blurring of identity boundaries that it suggests are made explicit.

The aim of creating a "mass Catalan imaginary" is shared by all kinds of programming on publically funded Catalan television: "News, current affairs, sport, fiction, gossip and debate could all be framed within a Catalan context and contribute to the generation of a sense of identity and

[9] Dubbing series and films in Catalan on television had a great impact on society in the early 80s but nowadays it is something taken for granted, meaning that in this field the normalisation effort has been a success.

social cohesion" (Crameri 2008: 110). The concept of television of proximity is clearly evidenced in news reports where Catalonia is treated as the primary point of reference. Moreover, apart from the national news, there is also *Telenotícies comarques* (created in 1988), news that deals with what happens in the *comarques*, the geographical regions into which Catalonia is divided. Catalan people who had been used previously to watching news with Spain as a national frame could now watch news that focused instead on Catalonia as a nation. A similar shift occurred in terms of meteorological maps: the weather in Catalonia is shown, followed by the weather in all the *Països Catalans*, Catalan-speaking countries (the autonomous Valencian community, the Balearic Islands, Franja de Ponent, Andorra, Northern Catalonia, and Alghero) and, finally a list of temperatures in the most important European capitals in which Madrid enjoys no privileged status compared with London, Paris, or Berlin.[10]

The responsibility of projecting a national identity is also undertaken by fictional shows. As I have argued above, identity is constructed through discourses, and television series, through their content, transmit social values and build a collective image about a country and a culture. As Enric Castelló argues "National culture is conformed [sic] as a site of contestation where diverse political versions of the nation are constantly debated [...] and this contest is also played out in drama series. Television dramas are ideological and cultural products that project a point of view about our society and our nation through their narrative ideology" (2007: 51). Similarly, Hugh O'Donnell states that "Spain's 'culebrones autonómicos' not only operate as long-running melodramas but also serve to narrate 'national identities' in an on-going process of negotiation with their viewers within dense and dynamic relationships of political, economic and cultural forces. Alongside their endlessly recurring plot twists and cliff-hangers, they tell a more complex tale of Spanish society of the late twentieth and early twentieth-first century" (quoted in Castelló 2005: 140).

To explore O'Donnell's contention, we will look more closely at *El cor de la ciutat*, the longest running drama series (2000 to 2009) on Televisió de Catalunya. This soap opera is set in Barcelona, in the working-class district of Sant Andreu de Palomar: the set is inspired by real locations, and sometimes real places are used, such as a traditional bar

[10] Televisió de Catalunya can be received not only in Catalonia but also in all the Països Catalans. One of its aspirations was to recover the sense of a common identity based on language among all the Catalan-speaking territories. In 2007, the autonomous Valencian community's government (led by the Partido Popular) closed Televisió de Catalunya's transmitters on its territory.

in Carrer Gran de Sant Andreu. Location shooting and recreation or evocation of real spaces in the studio corresponds to what has been defined as television of proximity, establishing a sense of geographical space that makes it easy for the audience to identify with the stories. Another strategy which works to this end is the use of a large and varied core cast of regular characaters representing a great range of ages, professions, origins, and levels of education. This is intended to attract as broad an audience as possible and creates a fictional microcosm based on a very concrete point of reference, constructing an archetypal model of society, very diverse but unequivocally Catalan. To use O'Donnell's terminology, the macronarrative—the kind of society depicted in the series—is constructed through two other levels: the micronarrative, that is to say personal relationships among characters, and metanarrative, narrative lines that develop around themes such as racial and social conflict, topical subjects, and taboos (quoted in Castelló 2005: 139).

Using *Eastenders* as a model, the original creators of *El cor de la ciutat* wanted to give the programme what scriptwriter Lluís Arcarazo calls "caràcter social" ("social character") (Castelló, 2005: 428): it was to be an incisive series, able to tackle difficult themes without hypocrisy and one which would also be capable of expressing social criticism.[11] In spite of the fact that *El cor de la ciutat* has also been influenced by what Bourdieu calls the dramatisation of television (1996: 18), the series tried to reflect topical problems, issues, and debates within Catalan society: for example, prostitution, drug addiction, abortion, euthanasia, immigration, and unemployment have all figured in the story line at some point. One of the final plotlines in the series (first aired 2007-08) focused on squatting and the phenomenon of the *okupas*: at a time when in big cities across Spain—and in particular in Barcelona—young people were occupying unused houses to protest against speculation and the steep rise of house prices, a large number of characters in the show were also caught up in a story about squatting.

El cor de la ciutat has also dedicated a lot of attention to gender-related violence, and this is of a piece with Televisió de Catalunya's general output. A great effort has gone into using the drama series to denounce domestic violence, dismissing sensationalist plotlines in favour of bringing to light family tragedies. Apart from bringing to the fore violence against women, *El cor de la ciutat* has also been lauded for dedicating sensitive plotlines to intimate personal and family dramas. A story that resonated in

[11] *Eastenders* aired on Catalan television from 1987 for several years with the title *Gent del Barri*.

society described one of the women character's treatment for breast cancer. However, the story did not end with the operation, as is common with this kind of plotline, but followed through on the narrative and portrayed the woman's struggles to adapt to the body which had undergone such a dramatic change, and to regain physical intimacy with her husband.

The series has also gained recognition for its portrayal of gay people, having included in one season alone four gay men and two lesbians, an on screen presence for this constituency which is significant when compared to the general panorama of Spanish television broadcasting. Within the scope of Televisió de Catalunya's programming, *El cor de la ciutat*'s portrayal of the LGBT community was far from being a one off. Televisió de Catalunya was the first broadcaster in Spain to include a gay character in a domestically produced drama serial when a storyline about Xavier (a thirty something gay man) was introduced to *Poble nou* in 1994. Another drama series, *Ventdelplà*, was given an award in 2008 by H20 (a Taragona-based LGBT organisation) for its portrayal of the LGBT community and "per haver contribuït de manera efectiva a la normalització i visibilització dels homosexuals, incloent a la sèrie televisiva aspectes de la realitat de les persones del col·lectiu."[12] Therefore, it is fair to say that the representation of the gay community on Televisió de Catalunya is quite diverse and complex, being generally appreciated by the community itself. One of *El cor de la ciutat*'s writers describes how he tried to avoid the didactic approach that was typical of representations of homosexuality during the early years of Televisió de Catalunya. This kind of perspective was necessary for a society that had lived under a dictatorship which strongly condemned homosexuality—as a crime, a sin and an illness—and the gay character consequently had a normalising purpose, but he believes that nowadays Catalan society is sufficiently evolved to be able to understand that a television character cannot represent an entire community, thus freeing the series from the burden of the "politically correct" and allowing it to present a more nuanced portrayal of gay people (*A cor obert* Podcast 6).

In order to facilitate social commentary, Catalan soap opera in general has opted for what scriptwriter Maria Jaén defined as a naturalistic spirit: a preference for concentrating on small things that happen in everyday life, and which gives to these small things a bigger political meaning. The series focuses on friendship, camaraderie, love, and family, notions which seem at home within a conservative lexicon, but puts them under a

[12] "For having contributed in an effective way to the normalistion and visibility of homosexuals, including in the television series aspects of the reality of people in the LGBT community."

progressive light. The interpretation of family, for instance, is open enough to include subjets like divorce, civil unions, second marriages, gay marriage, and adoption; friendship is treated as a route for social inclusion and is portrayed as transversal, crossing different ethnicities, origins, religious beliefs, and age groups.

In this sense we do well to remember Lluís Badia and Jordi Berrio's words: to wit, television creates a "projecte nacional de societat" ("national social project") (1997: 235), and thus presents a correct and aspirational image of the nation, becoming the projection of a possible society rather than the mirror of a real one. This is evident in the emphasis Catalan soap operas attach to respect for disadvantaged and marginalised people (one of *El cor de la ciutat*'s characters, Narcís, is disabled), and in its portrayal of a strong community spirit where building a society through negotiation of its differences is privileged over the neoliberal ideology of individual success. Such values are treated as intrinsic aspects of Catalonia's national character, derived from its history (a tradition of democracy, republicanism, and opposition to the Franco dictatorship) and its culture: here the notion of social project (representing a society as it should be, or how some would like it to be, instead of as it really is) becomes particularly evident.

This same consideration could be applied to one of the most important aspects of the series: its projection of Catalan as linguistically and socially normative. *El cor de la ciutat* is shot almost entirely in Catalan, in its standard variety. In the programme language serves as an instrument of identification: it uses a model of language which is realistic with some colloquialisms, popular expressions, mistakes, even *castellanismos*. Most importantly, Catalan is presented as the normal language of the country with Spanish representing otherness. In the world depicted by Televisió de Catalunya's drama series (especially in the early days of its output) Spanish is only spoken by new immigrants and proficiency in Catalan is used as the litmus test of their integration: to begin with they do not speak Catalan, but thanks to the dedication of people who keep talking to them in Catalan (without switching to Spanish), they quickly acquire an active competence in the language. The representation of Catalan as the language of everyday use is achieved not only through the way characters are portrayed, but is also reflected in every aspect of the series: when they appear in Catalan soap operas, the mass media, such as television and radio, books, signs, songs, are all seen and heard to be in Catalan.[13] Even

[13] Here again the representation is far from realistic: many media are in Spanish, and in the case of music, in particular, Catalan-language songs and popular musicians are more marginalised in real life than they are in soap opera.

products are used with the same purpose: the characters seem to consume only Catalan brands, completely dismissing Spanish brands which in real life are much more commonly used. With regard to the soundtrack, it is noteworthy that the final episode of *El cor de la ciutat* ends with one of the characters singing a famous Catalan song: "Que tinguem sort" ("May we have luck"), a love song about hope and the future. The lyrics were written by Lluís Llach, a songwriter who began to sing with Els setze jutges (The Sixteen Judges), a group of antifascist intellectuals who wanted to defend Catalan culture and identity during the dictatorship. Over the years Llach acquired the status of a national icon and the significance of one of his songs marking this milestone in Catalan broadcasting would not have been lost on the audience.

The use of Catalan is one of the most controversial aspects of *El cor de la ciutat* and of Televisió de Catalunya's output in general. A significant number of people in Catalonia are not native Catalan speakers and the insistence on representing Spanish as a signifier of the alien can make them feel uneasy and excluded from this fictional representation of their nation. However, one could argue that, especially in the past, this exclusion was a necessary step in order to represent Catalan society as distinctive and unique, and to represent Catalan, so long subjected to prohibition, as the normal language of the country. Significant efforts have been made more recently to include other expressions of Catalan society and culture as well. This is an evident trend in all Televisió de Catalunya's drama series. As far as *El cor de la ciutat* is concerned, towards the end of its run its storyline included a significant number of immigrants from different parts of the world: Nélson, for example, was from Cuba, whereas Hiresh and Dhara were from New Delhi, and they were portrayed as predominantly Spanish-speaking. The character who most represented the change of sensibility in the representation of Catalan identity was Juan Benjumea Carmona, an elderly man originally from Andalusia who has lived in Catalonia for many years and still speaks Spanish.[14]

El cor de la ciutat, and Televisió de Catalunya in general, makes active use of the internet, with on-line forums, summaries of episodes, games, quizzes, and spaces for people to propose ideas for scripts. This element of interaction which the internet has allowed brings into focus David

[14] There is also a tendency to represent a more flexible situation within families: Juan speaks Spanish but his grandchildren speak Catalan. In *Ventdelplà* a Catalan man is married to a Latin American woman, and their conversations are almost always bilingual. Moreover, in the same series, a Spanish couple who own a bar always speak Catalan with the clients but they speak in Spanish between themselves.

Buckingham's emphasis on ludic aspects of audience engagement with soap opera: "Perhaps the most appropriate metaphor for soap-opera is to regard it as a form of collective game, in which viewers themselves are the major participants. The programme itself provides a basis for the game, but viewers are constantly extending and redefining it. Far from being simply manipulated, they know they are playing a game, and derive considerable pleasure from crossing the boundaries between fiction and reality" (1987: 204).

In addition to the official web portal offered by Televisió de Catalunya, some viewers are using unofficial channels, such as Youtube to create new spaces which are open to greater interaction, charging them with significant political meaning. "Politics" derives from the Greek word "polis", which means community, thus "political" means something that concerns the community. In this sense, the LGBT community makes a very interesting use of Youtube's video-sharing platform. As Manuel Castells has observed: "Como Internet se está convirtiendo en un medio esencial de comunicación y organización en todos los ámbitos de la actividad, es obvio que los movimientos sociales y los agentes políticos lo utilizan y lo utilizarán cada vez más, transformándolo en una herramienta privilegiada para actuar, informar, reclutar, organizar, dominar y contradominar" (2001: 179).[15]

Manipulating scenes culled from *El cor de la ciutat*, a spin-off series has been created completely centred around Max, a secondary character who first appeared on the show when he was about 13 years old and later revealed his homosexuality. In this new series we are able to follow Max's storyline in concentrated form (his family, his studies, his love stories, his personal and emotional development) without it being dispersed across the original long-running series and among its large cast of characters. Thus, a shift from periphery to centre occurs, of the sort that Stuart Hall considers an intrinsic characteristic of post-modernity (1998: 44). Moreover, the people who upload these remixed videos subtitle them in English (and other languages, including Chinese) allowing them to circulate among an audience that does not understand Catalan (see Fig. 5-1). A lot of people around the world can watch and comment on these stories through Youtube and are able to see a plotline that might reflect their lives (something that their national television broadcasts may not provide them

[15] "Since the internet is becoming an essential medium of communication and organisation in every area of activity, it is obvious that social movements and political agents will use it more and more, turning it into an privileged tool for taking steps, informing, recruiting, organising, controlling, and acting against that control."

with) and to connect with members of the community to which they feel they belong (something that can be difficult in their own countries). In this configuration cyberspace really does become an "ágora electrónica global", a virtual space through which "procesamos nuestra creación de significado"[16] (Castells 2001: 180, 259). Thus, a series that was created in part for nation-building uses and as an instrument to construct an identity defined by language and territory, is re-ordered to be used for community-building and as a vehicle for representing another identity which includes and crosses national borders: a political manipulation, indeed.

It could be argued that this Youtube manipulation recovers (for at least a part of the audience) a political engagement that has been diluted over the years of its run as *El cor de la ciutat*'s role as social critic has lost ground to sensationalist plotlines. Several factors may account for this shift of emphasis. First of all, long-running series often risk a loss of quality with the years. Secondly, we have to remember that in their process of constructing a collective and cohesive identity television series must answer to the demands of a mass audience whose tastes are mutable. If a programme wants to reach a vast audience it has to satisfy the largest possible number of political and cultural sensibilities. Therefore, in the contemporary context, where the television market is becoming increasingly competitive, spectacular and sensational elements sell, at the expense of socially engaged storylines. This state of affaris led Imma Tubella to observe that although Televisió de Catalunya "has estat i és una eina de normalització lingüística, eina de normalització cultural i eina de cohesió nacional" (1999: 278), it had been far more successful on the first front than on the other two: while its extraordinary role in linguistic normalisation is clear, according to Tubella now Televisió de Catalunya must show "que també és una important eina de normalització nacional" (1999: 287). [17]

Notwithstanding criticisms that have already been made of its output, and those which will come in the future, the fundamental role that Televisió de Catalunya has performed in the process of linguistic and cultural normalisation is undeniable. As Enric Canals remarked in 1987, only three years after the launch of Televisió de Catalunya it was already by then "difícil d'imaginar aquest país o quina hauria estat la seva evolució cultural, política i social sense l'existència d'aquest mitjà, la

[16] "A global electronic agora" through which "we process our creation of meaning."
[17] "Has been and is a tool for linguistic normalisation, a tool of cultural normalisation and a tool of national cohesion [...] Needs to demonstrate that it is also an important tool of national normalisation."

creació del qual—i em crec portaveu d'una opinió bastant generalizada— és l'obra de govern més important que ha dut a terme la Generalitat" (1987: 192). [18]

WORKS CITED

A cor obert [podcast], 2007. www.tv3.cat/elcordelaciutat/podcast/acorobert.xml Uploaded 28 November. (Accessed 4 Jan 2010).

Anderson, B. (1991). *Imagined Communities: Reflections on the Origin and Spread of Nationalism.* London: Verso.

Antich, J. 1994. *El Virrey: ¿Es Jordi Pujol un fiel aliado de la Corona o un caballo de Troya dentro de la Zarzuela?* Barcelona: Planeta

Badia, L. and J. Berrio. 1997. "Les teories de la comunicació a Catalunya: tendències d'investigació." In *Un segle de recerca sobre comunicació a Catalunya,* ed J. Berrio, 151-288. Bellaterra: Universitat Autonoma de Barcelona.

Barker, C. 1999. *Television, Globalization and Cultural Identities.* Philadelphia: Open University Press.

Bhabha, H. K. 1990 'DissemiNation: Time, Narrative and the Margins of the Modern Nation.' In *Nation and Narration,* ed. H. K. Bhabha, 291-322. London: Routledge.

——. 1994. *The Location of Culture.* London: Routledge.

Bourdieu, P. 1996. *Sur la télévision.* Paris: Liber éditions.

Buckingham, D. 1987. *Public Secrets. Eastenders and its Audience.* London: British Film Institute.

Canals, E. 1987. "Televisió i cultura de masses". In *Segones reflexions crítiques sobre la cultura catalana: una perspectiva de futur,* ed. J. Gifreu et al., 191-204. Barcelona: Departament de Cultura de la Generalitat de Catalunya.

Castelló, E. 2005. *Sèries de ficció i construcció nacional: La producció pròpia de Televisió de Catalunya (1994-2003).* Doctoral thesis. Departament de Periodisme i Ciències de la Comunicació. Facultat de Ciències de la Comunicació. Univesitat Autònoma de Barcelona.

——. (2007). "The Production of Television Fiction and Nation Building: The Catalan Case." *European Journal of Communication* 22 (1) : 49-70. doi: 10.1177/0267323107073747.

Castells, M. 2003. *La galaxia internet. Reflexiones sobre internet, empresa y sociedad.* Barcelona: Debolsillo.

[18] It is "Difficult to imagine this country or how it would have evolved culturally, politically, and socially, without the existence of this medium, whose creation— and I think I speak for a rather generalised opinion here—is the most important government work the Generalitat has carried out."

Commissió de Normalització Lingüística, 1995. *El català a TV3: Llibre d'estil.* Barcelona: Edicions 62.

Crameri, K. 2008. *Catalonia: National Identity and Cultural Policy, 1980-2003.* Cardiff: University of Wales Press.

de Carreras, Lluís. 1987. *La ràdio i la televisió a Catalunya, avui.* Barcelona: Edicions 62.

de Moragas Spà and M. C. Garitaonandía and B. López. 1999. "Televisión de proximidad en la era digital: razones para el optimismo". In *Televisión de proximidad en Europa. Experiencias de descentralización en la era digital*, 15-42. Barcelona: UAB

Ferrús, J. 1991. "Televisión de Cataluña." In *II Jornadas sobre televisión autonómica.* Zaragoza: Diputación General de Aragón

Gifreu, J. and J. M. Casasús. 2003. "TV3 y Catalunya Ràdio, líderes con deudas." *El País*, 8 October (Cataluña edition), p.6.

Hall, S. 1977. "Culture, the Media and the 'Ideological' effect." In *Mass Communication and Society*, eds. J. Curran and M. Gurevitch and J. Woollacott, 315-348. London: Edward Arnold.

——. 1998, "Minimal Selves." In *Identity: The Real Me; Post-modernism and the Question of Identity* [*ICA Documents* 6], ed. Lisa Appignanesi, 44-46. London: ICA.

Izquierdo, O. 2002. "Identitat simulada, identificació dissimulada". *Trípodos* 12: 95-109.

O'Donnell, H. 2002. "Recounting the Nation: The Domestic Catalan Telenovela." In *¡Cultura Popular!: Studies in Spanish and Latin American Popular Culture*, eds. S. Godsland and A. White, 243-268. London: Peter Lang.

Terribas, M. 1997. "Televisió, identitat nacional i esfera pública: un estudi etnogràfic aplicat a la investigació de dos programes de debat televisiu a Escòcia i Catalunya. *Formats* 1 (no pagination) http://84.88.10.30/index.php/Formats/article/view/57150/67090 (Accessed 11 June 2009).

Terricabras i Nogueras, J. M. 2001. "Identitat i identificació." In *Catalunya i Espanya. Fets i actituds diferencials*, 179-191. Barcelona: Proa.

Unsigned. 2008. "H20 lliura a Reus el premi Ploma Daurada a la sèrie Ventdelplà." *Tinet* website, 27 June. http://www.tinet.cat/portal/sheetshowold.do?sheet=21896 (Accessed 19 October 2010).

Tubella, I. 1999. Televisió i identitat: el cas de Televisió de Catalunya. Doctoral thesis. Perpinyà: Universitat de Perpinyà.

Chapter Six

Classical Confusion: Myths, Paintings, and Other Windows into Don Quixote's Erotic Life

Keith Budner

Carroll Johnson states in his essay "Cervantes and the Unconscious" that to examine a literary text under the framework of psychoanalysis is "to make the unspoken speak" (1993: 84). In his earlier work, *Madness and Lust* (1983), Johnson posits that the reader is not alone privy to an unconscious. Through a careful—if at times conjectural—analysis of interpersonal character dynamic in *Don Quixote*, Johnson presents a reading of Cervantes's work centred on the notion that the very modernity of this modern novel is to be found in its inhabitation by characters who are driven by unconscious motives and desires. To seek out the unspoken in a text is thus to provide voice to elements that either character or author, or both, prefer to keep silent. And yet, as Françoise Meltzer reminds us in her discussion of the unconscious in literary interpretation, what is unconscious and unspoken rarely, if ever, remains entirely so:

> Unconscious thoughts will always manifest themselves obliquely in consciousness through dreams, slips of the tongue, puns, and so on. These are events that the Subject does not consciously 'intend,' and that he will assure any listener are coincidences or mere accidents. (1995: 151)

Dreams, slips, and puns can thus serve as textual indicators of deeper psychological activity. In this essay I will focus specifically on slips of the tongue, the unspoken that is pronounced through the misspoken. I will explore three specific moments in *Don Quixote* in which our protagonist errs when referring to the name of a god or hero from Classical mythology. Due to the esoteric nature of Classical allusions, it is more than reasonable to read these erred references as the product of confusion on Cervantes's part or even as misinformation from a literary climate less steeped in the Classics than was its Italian counterpart, which often served as a conduit through which knowledge of Greco-Roman culture passed to Spain. However, we would do well to follow Meltzer's warning that to see such

slips as "coincidences or mere accidents" (1995: 151) is to succumb to the very wishes of a subject whose unconscious has got the better of him. Furthermore, as I shall argue, these slips are in fact part of an intricate textual narrative that integrates plot with myth, text with image, fantasy with memory, the spoken with the unspoken and, as a result, not only hints at inner, unconscious, and repressed psychic activity but also suggests an image of human psychology that, while faint in its articulation, bridges notions of the mind from antiquity to Freud.

The three slips I will focus on all occur within a span of ten chapters, a relatively short chunk of the novel. Aside from sharing the common attribute of pointing in each case to Classical mythology the allusions appear unrelated. The three myths these allusions point to share no direct association in the corpus of Classical literature; nor, within the novel, are the allusions presented in a way that would underscore a unifying textual connection. Even a reader attuned to the minutiae of Classical mythology and who thus recognises the error within each allusion is offered little as a means of moving beyond the sense of having detected three separate instances of misappropriation. By exploring the specific content of each erred allusion in relation to the overarching narrative, we can begin to see that far more than error and hastiness are implicated. And it is with the content of the myths themselves that we should begin: in the first allusion Quixote confuses Silenus for Bacchus; in the second he evokes a helmet built for Mars by Vulcan that exists nowhere in Classical literature; and in the final slip he confuses the myth of Theseus for that of Perseus. The meaning and importance of these erred allusions become all the more complex when we realise that they all occur only a few chapters before or after the Maritornes episode, acting approximately as bookends to one of the few overtly sexual moments for Don Quixote in the text, an episode in which Don Quixote invites a tavern maid into his bed. Lost in fantasy, he imagines her to be the daughter of a lord of the castle. As such, the nature of these slips is very much in keeping with Freud's conception that erotic desires and erotic acts (and the subsequent guilt they often produce) are the prime mover at work when thoughts repressed at an unconscious level are inadvertently brought to the surface.

Of course, the use of psychoanalysis to analyse early modern texts is itself contentious. In his 1995 essay, "Cervantes Foreshadows Freud", James Parr attempts simultaneously to refute Johnson's claim that literary characters are able to harbour unconscious motivations while still allowing for a certain level of psychoanalytic depth to the novel by examining Quixote's behaviour as a precursor to Freud's theories regarding society and sexuality. Oddly enough, one of the moments Parr focuses on to

support his claim is, I believe, ripe with material that points further toward Johnson's notion of unconscious activity, namely, the episode in which Rocinante pursues a group of mares. Parr writes:

> Repressed sexuality finds its symbolic expression in the antics of Rocinante, when he feels the urge to dally with the Yangüesan mares. [...] In some of his earlier writings, Freud compared the relation of the ego to the id to that of a rider to his horse, a metaphor that harks back to Plato's *Phaedrus*. (1995: 19)

Parr, however, misses the opportunity to connect this symbol of unconscious sexual desire to Quixote's own sexual actions with Maritornes only several chapters later.

After a thorough beating by the mares' owners, Rocinante is left in such an injured state that Don Quixote is unable to ride him and so must ride Sancho's donkey. However, this requires Don Quixote to search for some precedent that would justify a knight errant riding a donkey, which brings us to his evocation of Silenus and the first Freudian slip:

> No tendré a deshonra la tal caballería, porque me acuerdo haber leído que aquel buen viejo Sileno, ayo y pedagogo del alegre dios de la risa [Bacchus], cuando entró en la ciudad de las cien puertas [Thebes] iba muy a su placer caballero sobre un muy hermoso asno. (Cervantes 2004: I, 15, 180) [1]

It was not Silenus but rather Bacchus who entered Thebes upon an ass, and the distinction proves meaningful.[2]

As Frederick de Armas discusses in *Cervantes, Rafael and the Classics* (1998) and *Quixotic Frescoes* (2006), Cervantes's treatment of the classical world was very much influenced by the manner in which myths were depicted in the paintings of Renaissance masters. This is most certainly the case here as well, for at the beginning of the sixteenth century, Alfonso d'Este, Duke of Ferrara, and a renowned patron of the arts, commissioned a series of paintings for a gallery which came to be known

[1] "I shall not consider such a mount a dishonour, because I remember reading that when Silenus, the good old tutor and teacher of the merry god of laughter, entered the city of one hundred gates, he rode very happily mounted on a beautiful jackass" (Cervantes 2005a: 108).
[2] Though James Iffland (1998) likens this erred allusion to a Freudian slip, he draws far different conclusions from it by discussing Don Quixote in relation to the comic function of the Silenus figure in Classical and Renaissance literature; furthermore he does not relate this erred allusion to those that follow.

as the *Camerino d'alabastro*. These paintings depict myths relevant to our investigation and similarly important is the art-historical milieu of the Camerino as a space in which the notion that painting and poetry were interconnected forms of art assumed physical form.

The centrality of works by Titian (who painted three of the five paintings in the gallery) is also crucial in understanding the merging of the visual and textual in the Camerino. Rona Goffen argues in *Titian's Women* that Titian's self-conception as a painter can be seen as a reaction to a certain Renaissance understanding of painting as being akin to a science, an approach spearheaded by artists such as Leonardo da Vinci who emphasised the use of perspective and optics in painting. Titian, on the other hand, employed poetic terminology such as *poesie* and *favola* to characterise his works and identified himself, as Goffen writes, "as both a poet and painter" (1997: 107). Furthermore, Goffen argues that Titian's works go beyond mere visual "quotations" of paintings and function as the artist's own "critical editions of the ancient texts," a notion of exploring the possibilities of mythological subject matter that could likewise be applied to Cervantes's own use of myth (1997: 107).

As Cervantes spent part of his youth in Italy (from 1569 to 1575), it is possible that he saw the Camerino first hand. Another possibility is that Cervantes's understanding of the room came from his reading of the Italian painter and art historian Giorgio Vasari's *The Lives of the Artists,* an encyclopaedic catalogue of Renaissance artists which included a description of the gallery. Were this the case it would deepen the symbiosis of visual and textual media: Cervantes would have been relying on textual description of paintings which were themselves inspired by textual descriptions of other imaginary paintings. We should now move to the works themselves.

In Giovanni Bellini's *Feast of the Gods* (1514, see Fig. 6-1), we have a depiction of the Silenus on whom the unhorsed Quixote would model himself, a noble and dignified Silenus who (important to note) is riding a donkey. However, immediately alongside this painting we have another image, that of a Silenus who is drunk to the point of having passed out. In fact, if we see the two paintings side by side (as they supposedly were in the Duke of Ferrara's gallery) the arm of the dignified Silenus of Bellini leads us to the depiction of the inebriated Silenus in Titian's *Bacchanal of the Andrians* (1518, see Fig. 6-2). This painting of orgiastic celebration depicts not only the drunken Silenus but, in the centre and foreground of the work, also the wild and lustful Bacchus. If corrected, Quixote's allusion would more accurately point to this latter figure of Bacchus, and

one Don Quixote more closely resembles when he lures Maritornes into his bed.

Depictions of Silenus and Bacchus as wild and lustful were perhaps more in keeping with the concept of the two figures which prevailed in seventeenth century Spain. In his encyclopaedic compilation of Classical myth, the sixteenth century Spanish scholar Juan Pérez de Moya writes of Silenus:

> Por la mayor parte carga la cabeza y hace andar titubeando y lleva más presto a la vejez; por esto dicen ser Sileno viejo y ventrudo y andarse cayendo con un bordón. Y porque los que se dan al vino sin medida son lujoriosos, por esto dicen que SIleno y los sátiros, que donatan la lujuria, acompañan a Bacho [...] por esto dicen que andaba en un asno, animal espacioso, y que parecía siempre dormir. (1995: 317) [3]

In this quote Pérez de Moya, associates Silenus (and Bacchus as well) with drunkenness and lustful activity. Indeed, the very riding of a jackass is likened to the lethargy of this drunken and lust-filled way of life. Cervantes, it seems, is thus presenting us with a rather complex series of intertwined allusions and images that all speak to a division in Don Quixote's own self-perception. On the one hand, he sees himself as a dignified knight (the Silenus of Bellini he refers to) who is able to control his sexual desires; on the other hand, he certainly harbours, and eventually succumbs to, the wanton and lustful desires represented by the Silenus and Bacchus of Titian and Pérez de Moya. The erred allusion thus portrays a psyche in conflict with itself and which is torn between forces dictating what one feels one must be and others which urge the expression of one's more truthful repressed desires. Through interplay of image and text, Cervantes has anticipated both the Freudian superego (the need to live up to a certain image) and the Freudian unconscious (home to one's repressed sexual desires).

Before continuing to the next erred allusion, I would like briefly to engage with an essay that, like Parr's, cautions against the reading, or over-reading, of Early Modern texts within the framework of psychoanalysis. The essay is Stephen Greenblatt's immensely insightful

[3] "Most of the time Silenus droops his head and walks stumbling, giving more attention to his old age; for this reason they say the old Silenus was potbellied and that he walked with a cane. And because those who give themselves to wine are without a doubt lustful, out of this they say that Silenus and the satyrs, who denote lust, accompanied Bacchus [...] for this reason they say that he rode a donkey, a directionless animal that always seemed to be sleeping."

"Psychoanalysis and Renaissance Culture", which examines the role of Freud's theories in interpreting Renaissance literature and drama through a discussion of the historical trial of the imposter Arnaud de Tith, who attempted to steal the identity of Martin Guerre.

In Greenblatt's analysis, Tith's trial spoke to a universal concern throughout the Renaissance that one's identity was not necessarily one's own, that it could in fact be stolen. By contrast, Freud recognised an "irreducible identity" that was wholly linked to one's physical person. Greenblatt writes:

> Arnaud de Tith can manipulate appearances [...] he can improvise the mannerisms and insinuate himself into the complex social network of Martin Guerre, but he cannot seize the other man's inner life. [The roots of Martin's identity] reach down, as psychoanalysis assures us [...] to the psychic experience of his infancy—the infancy that only he can possess and that even the most skilful imposter cannot appropriate—and beneath to his biological individuality. (1986: 214)

To provide a philosophical underpinning for the Renaissance notion of identity as an object that can be appropriated by others, Greenblatt turns to Hobbes. Hobbes posits a conception of the self that recognises the linguistic origin of the word *person* in the Latin *persona* which connotes (as it does in English) a fictive identity or disguise. As Hobbes writes: "A *person* is the same that an *actor* is, both on stage and in common conversation" (1994: 101). Or, as Greenblatt paraphrases: "The 'natural person' originates in the 'artificial person' [...] Identity is only possible as a mask, something constructed and assumed" (1986: 222-23). This discussion of the person as persona echoes an underlying notion from another of Greenblatt's works, his oft-cited *Renaissance Self-Fashioning*. Renaissance culture, Greenblatt writes, saw "poetry as a performing art, literature as a storehouse of models. It offered men the power to shape their worlds [...] it implied that human character could be similarly fashioned, with an eye to audience and effect" (1980: 162).

As there is perhaps no figure throughout Renaissance and Early Modern literature for whom identity is more a product of fictive construct than Don Quixote, it is somewhat curious (and somewhat remiss) that despite its immense influence over the study of Early Modern English scholarship, Greenblatt's notion of fictive self-fashioning has yet to be applied in an extensive way to the study of *Don Quixote*. Cervantes's work is nothing if not a two-tome meditation on the possibilities of self-fashioning according to literary models. Yet I would argue that Don Quixote represents not only the utmost iteration of this notion of crafted

identity and fictive self-fashioning but also the inherent frailty of this approach to living. The enormous gap between the idealised "Don Quixote knight errant" and whatever real man exists beneath the mask registers throughout the novel. On the many occasions when Don Quixote cannot live up to his professed knightly greatness he comes across as a caricature figure in Cervantes's satire of misplaced idealism. Yet there are also moments when Don Quixote cannot help but recognise his own inadequacies and becomes a more tragic and sympathetic figure who embodies not the comic foolishness of idealism, but rather the failure and shame of not being able to live up to one's expected image of oneself. Analysing this disjuncture of self within Don Quixote through Greenblatt's notion of Renaissance culture thus invites, rather than constricts, a psychoanalytic reading, whilst also recognising both the fictive, fashioned self, and the underlying "irreducible" self. If, as Greenblatt suggests, "psychoanalysis is, in more than one sense the end of the Renaissance" (1986: 210), then I would add that *Don Quixote* is for similar reasons the beginning of this end as it marks an initiation point in the process of carving away at the authority of the person-as-persona model of selfhood prevalent in the Renaissance.

Furthermore, though we may have no clear and full picture of the irreducible or actual self behind the "Don Quixote" mask—perhaps an intimation that all true selves are unknown—this actual self becomes most apparent through lapses that lend themselves to a distinctively Freudian schema. The disjuncture within Quixote's self becomes even more evident as we draw closer to the Maritornes episode. We must look at the moment when Don Quixote arrives at the inn, which he imagines to be a castle, and sees the daughter of the inn-keeper, whom he imagines to be, or, perhaps more accurately, *fantasises* as a beautiful young noble maiden:

> Se imaginó haber llegado a un famoso castillo [...] y que la hija del ventero lo era del señor del castillo, la cual, vencida de su gentileza, se había enamorado dél y prometido que aquella noche, a furto de sus padres, vendría a yacer con él una buena pieza; y teniendo toda esta quimera que él se había fabricado por firme y valedera, se comenzó a acuitar y a pensar en el peligroso trance en que su honestidad se había de ver, y propuso en su corazón de no cometer alevosía a su señora Dulcinea del Toboso. (Cervantes 2004: I, 16, 187-188)[4]

[4] "He thought he had come to a famous castle [...] and that the innkeeper's daughter was the daughter of the lord of the castle, and that she, conquered by his gentle bearing, had fallen in love with him and had promised to steal away from her parents that night and come and lie with him for a time; and since he considered this entire fantasy, which he had invented, as solid and true, he became

As those familiar with the text will know, his resolve fails him and Don Quixote not only ends up pursuing these fantasies but does so with Maritornes who is described as being far less attractive than the innkeeper's daughter. By providing us with this glimpse into Don Quixote's inner life, Cervantes allows us to confirm that the outward utterance of the confused Silenus/Bacchus allusion was an early foreshadowing of these inner libidinal desires. Like his declared intention of remaining true to Dulcinea, Don Quixote's mention of Silenus reveals a strong urge to fight his sexual desires, to remain knightly and noble. However, the error he makes in the allusion reveals the coming to the surface of the repressed desires which will then be acted out.

Yet, in another sense, these internal musings also suggest that this fashioned identity is itself of a disjointed and contradictory nature and that its relationship to the irreducible Freudian self of drives and desire lacks stability. In imagining himself to be a knight who wins the love of the lord of the castle's daughter, Quixote is channelling his desires through his fictive knightly-self, the very identity that previously acted to constrain his sexual desires. By creating a situation reminiscent of courtly love, Quixote has provided (or at least attempted to provide) an acceptable space for his erotic urges within his constructed self. Within the world of this sexual role-play, he is not an older man aroused by an innkeeper's daughter, but instead a chivalric knight who attracts the attention of a noble maiden.

To understand further how our protagonist's urges are channelled through the "Quixote" persona, we should again turn to Greenblatt, but this time to a different piece that discusses the connection between reading and one's internal erotic life. In his review of *Solitary Sex*, Greenblatt calls attention to Thomas Laqueur's claim that the societal mindset which saw solitary sexual lives and masturbation as both taboo and vice took hold concurrently with the rise of the novel (Greenblatt 2004: 32-36). Greenblatt begins his discussion by presenting the contrasting image of the Puritan condemnation of the theatre during Shakespeare's time. Referring to John Dunton's *The Night-walker, or Evening Rambles in Search After Lewd Women* (1696), Greenblatt relays an encounter in which a prostitute tells of the commercial boon she would experience after a play had ended. Her customers would pretend "that they were Antony and she would pretend that she was Cleopatra" (2004: 36). Novels on the other hand, created what Greenblatt identifies as "a certain kind of absorption, a deep

distressed as he began to think of the dangerous predicament in which his virtue would find itself, and he resolved in his heart not to betray his lay Dulcinea of Toboso" (Cervantes 2005a: 112-113).

engagement of the imagination [that could lead] with terrifying ease toward the dangerous excesses of self-pleasure" (2004: 36). In summation, Greenblatt writes:

> For it was reading—and not just any reading, but reading the flood of books churned out by the literary marketplace—that seemed from the eighteenth century onward at once to reflect and to inspire the secret vice (2004: 35-36).

Notwithstanding Carrol Johnson's strongly held view that one of the merits of *Don Quixote* lies in a profundity that allows readers to interpret aspects of the characters' psychology that Cervantes does not explicitly describe, I will nevertheless not go so far as to propose that Don Quixote succumbs to these "dangerous excesses of self-pleasure" when he reads. However, we do not need to extend our reading of Cervantes too far to see that Don Quixote does embody Laqueur's and Greenblatt's notion of the absorbed, solitary reader engendered by the literary marketplace; indeed, he is arguably one of the first literary representations of this modern phenomenon.[5] Emphasising both the solitariness of reading and Quixote's consumerist approach to works of fiction as goods of private material consumption,[6] Cervantes writes:

> Este sobredicho hidalgo, los ratos que estaba ocioso—que eran los más del año—se daba a leer libros de caballerías, con tanta afición y gusto, que olvidó casi de todo punto el ejercicio de la caza y aun la administración de su hacienda; y llegó a tanto su curiosidad y

[5] Discussions of private reading go back to Augustine's *Confessions* in which Augustine recounts his own reading as conversion experience and where the Bishop Ambrose's reading habits are also described. Although Santa Teresa was a near contemporary of Cervantes (her *Libro de la Vida* predating the *Quixote* by some twenty years), her descriptions of her own private devotional reading and of owning books are still very much heir to the medieval tradition of these practices as elements of life in religious institutions. In Cervantes's work, by contrast, such activities become attached to the private, lay individual.

[6] Laqueur and Greenblatt characterise the novel as a creation of the eighteenth century, thus placing Cervantes and the *Quixote* at least a century ahead of their time frame. However, I believe that this stems from their focus on the English novel and need not be taken as a restrictive chronology. As the quote from Cervantes illustrates (see below), both solitary reading and the mass consumption of literature were already well established in sixteenth century Spain.

desatino en esto, que vendió muchas hanegas de tierra de sembradura
para comprar libros de caballerías. (Cervantes 2004: I, 1, 39)[7]

It is worth paying close attention to Cervantes's description of the genesis
of the fictive "Don Quixote" persona and the burgeoning of this new
identity: "Y así, con estos tan agradables pensamientos, llevado del estraño
gusto que en ellos sentía, se dio priesa a poner en efeto lo que deseaba"
(Cervantes 2004: I, 1, 44).[8] Although hours spent reading books of
chivalry are the most obvious inspiration behind our protagonist's
becoming "Don Quixote", Cervantes's emphasis on his protagonist's "tan
agradables pensamientos" ("exceedingly agreeable thoughts"), "estraño
gusto" ("strange pleasure"), and "lo que deseaba" ("what he desired")
suggests that other forces—perhaps even libidinous forces—are at play.
For Don Quixote, reading and desire go hand in hand, and as the
ruminations during the Maritornes episode illustrate, the "Don Quixote"
persona is, at least partly, a sexual persona.

Returning to the allusive lapses, we can see how Don Quixote's next
slip of the tongue continues to map this inner conflict. Don Quixote has by
now left the inn and "discovers" the famed helmet of Mambrino, which he
compares to a helmet of Mars built by Vulcan: "La que hizo y forjó el dios
de las herrerías para el dios de las batallas" (Cervantes 2004: I, 21, 247).[9]
While Don Quixote may have departed from the inn and the narration
itself may be signalling a move towards other episodes, by examining the
nature of this comparison we will see that Don Quixote's mind has not
been able to move on. Despite his efforts to leave behind the events at the
inn, his guilt follows him. We begin by examining the nature of what is
mentioned. Vulcan, the "god of smithies" as Don Quixote deems him, was

[7] "This aforementioned gentleman spent his times of leisure—which meant most of
the year—reading books of chivalry with so much devotion and enthusiasm that he
forgot almost completely about the hunt and even about the administration of his
estate; and in his rash curiosity and folly he went so far as to sell acres of arable
land in order to buy books of chivalry" (Cervantes 2005a: 20).
[8] "And so it was that with these exceedingly agreeable thoughts, and carried away
by the [strange] pleasure he took in them, he hasted to put into effect what he so
fervently desired" (Cervantes 2005a: 22). Although Grossman translates the
Spanish "estraño gusto" as "exceeding pleasure", I have chosen to amend her
translation here with the more literal "strange" for "estraño." This not only allows
us to remain closer to the text, but also connotes a sense of unfamiliarity, or even
anxiety, about Quixote's pleasures that likens them to the discovery of sexual
impulses.
[9] "The one made and forged by the god of smithies for the god of war" (Cervantes
2005a: 155).

the blacksmith god; Mars was the god of war. Despite the seeming logic to Don Quixote's belief that Vulcan forged a helmet for Mars, nowhere in Classical literature is such a helmet mentioned.

It would be easy to look past this error as nothing more than forgivable ignorance were it not for the quite special relationship that existed between Vulcan and Mars and that is retold in a variety of Classical works, Homer's *Odyssey* and Ovid's *Metamorphoses* chief among them. Both works tell a story of amorous infidelity, the same issue that, unsurprisingly, earlier filled Quixote's anxious mind, and which, as the allusion shows, still does. Though the Classical tradition depicts Vulcan as ugly and crippled he was in fact the husband of Venus, goddess of beauty and love. Venus was not entirely happy with this marriage and was prone to having affairs, most notably with Mars. Homer and Ovid relate that during one of their liaisons, Vulcan was notified of what was happening and decided to build a net of subtle chains to ensnare the two adulterers in order to display their affair and shame them in front of the rest of the gods. It was not, then, a helmet that Vulcan built for Mars, but rather a net that represents the shamefulness of adulterous liaisons and the anger they provoke. By identifying the helmet of Mambrino as one of Vulcan's construction, Quixote errs once again and externalises the guilt he feels over betraying Dulcinea; and as Dulcinea is not an actual, physical woman, the very notion of staying true to her should be understood as a guise enabling Quixote to refrain from any erotic activity whatsoever.

Perhaps even more interestingly, though, only a little further on in this chapter (and the proximity should be taken as meaningful), Don Quixote describes a scenario that is strikingly similar to his role-play fantasy of courtly love during the Maritornes episode:

> El caballero [...] hallará [la señora reina] con la infanta, su hija, que ha de ser una de las más fermosas y acabadas doncellas que en gran parte de lo descubierto de la tierra a duras penas se pueda hallar. Sucederá tras esto, luego en continente, que ella ponga los ojos en el caballero, y él en los della, y cada uno parezca a otro cosa más divina que humana, y sin saber cómo ni cómo no, han de quedar presos y enlazados en la intricable red amorosa. (Cervantes 2004: I, 21, 251)[10]

[10] "The knight will find her [the queen] with the princess, their daughter, who is, beyond any doubt, one of the most beauteous and perfect damsels that one could fine anywhere in the known regions of the earth. After this she will very chastely turn eyes to the knight, and he will turn his eyes to hers, and each will seem to the other more divine than human, and without knowing how or why, they will be captured and caught in the intricate nets of love" (Cervantes 2005a: 158).

Firstly the repetition of this theme further confirms the notion that Don Quixote uses the idea of knighthood as an outlet for his libidinal urges. Secondly, and perhaps more importantly, by characterising their love as "intricate nets", Cervantes evokes the notion of lovers tied together in a web, the very image with which the Vulcan/Mars/Venus myth concludes.[11] Thus, despite earlier attempts to situate these urges within the world of chivalric romance, Quixote cannot help but feel a continued guilt over his betrayal of Dulcinea and of having succumbed to his libidinal drives.

Beyond the psychological element, this slip also connects to the previous erred allusion in terms of its visual, art historic qualities. Many great artists of the Italian Renaissance chose to represent elements of the Vulcan/ Mars/ Venus myth (Botticelli in 1485, Tintoretto in 1550, and Veronese in 1575), and it is also noteworthy here that the myth had a dominant role in the visual arrangement of Aflonso d'Este's Camerino. Though these paintings by the lesser known artist Dosso Dossi did not survive, they are mentioned by Vasari:

> Duke Alfonso de Ferrara was having a small changer decorated and had commissioned Dosso, a painter from Ferrara, to execute in several small compartments scenes of Aeneas, of Mars and Venus, and of Vulcan in a cave with two blacksmiths at the forge. (1991: 493)

The series of images thus depicts both Mars with Venus as well as Vulcan at the forge and in doing so provides for the onlooker a complete visual narrative of the myth. Though we cannot determine what visual impression onlookers would have had, if we return to Pérez de Moya, we see that, like Silenus and Bacchus, Mars was often known for his lustful ways:

> El decir que era enamorado y el adulterio de Venus significa la ejecución de la lujuria, la cual se allega mucho a los hombres de esta manera de vivir, más que a los de otros ejercicios. (1995: 291)[12]

[11] It is worth noting that in his short story "El celoso estremeño" ("The Jealous Man from Extremadura"), Cervantes also describes the completion of an act of adultery by evoking the net of Vulcan. He writes: "Llegóse en esto el día, y cogió a los nuevos adúlteros enlazados en la red de sus brazos" (Cervantes 2005b: 363) ("The sun arrived and caught the adulterers entwined in the net of their own arms").
[12] "It is said that because Mars was in love and committed adultery with Venus that performing lustful behaviour very much characterises men of this [warrior] way of life, and more than those of other professions."

By creating a parallel between himself and Mars, Don Quixote takes on not only Mars's warlike nature but also his lustful ways—aspects that, as we see in Pérez de Moya, were often seen as going hand in hand.

In the third and last of the confused allusions studied in this chapter, Don Quixote speaks of the difficulty of finding one's way in the Sierra Morena and uses a mythological reference to provide what he believes to be a fitting comparison for the location. He likens the landscape of the Sierra Morena to the "hilo del laberinto de Perseo" (Cervantes 2004: I, 25, 316) ("thread of Perseus in the labyrinth", Cervantes 2005: 204). The problem with this comparison is that the labyrinth comes not from the myth of Perseus but rather that of Theseus, the hero who had to kill the Minotaur in the labyrinth and who saved Ariadne. Interestingly enough, later in the *Quixote* Cervantes refers once again to this myth and this time accurately cites the myth's hero; in chapter forty-eight he mentions "la soga de Teseo" (Cervantes 2004: I, 48, 610) ("the cord of Theseus", Cervantes 2005: 420). Although we could attribute this inconsistency and error to simple hastiness, if we look deeper we see that this erred allusion also connects to the previous two examples and completes the narrative of Don Quixote's anxiety over his sexual desires, and furthermore, that it also corresponds to yet another painting in the Duke of Ferrara's gallery.

It is important to note that this allusion occurs several chapters after the Maritornes episode, in chapter twenty-five, in the episode that recounts Don Quixote's penitence and his attempt at purification. He undresses his armour in order to reach a state of infantile bareness and, through the penitence, undergoes a kind of rebirth, in his mind at least. This act of rebirth is reflected in the confused allusion itself, for while the previous two allusions created a parallel between Quixote and a lust-filled figure (either Silenus or Mars), with this final allusion Don Quixote distances himself from the unfaithful hero, Theseus, and positions himself closer to the more loyal Perseus, who, it should be noted, was in many regards the chivalric lover's Classical counterpart due to his rescue of princess Andromeda from Poseidon's sea monster (a noticeable parallel to medieval tales of knights saving damsels from dragons).

By contrast, Theseus was perhaps the unfaithful lover-hero *par excellence*, leaving a trail of disappointed female lovers that permeates Classical literature and which includes not only Ariadne, but also Phaedra, Antiope, and even Helen of Troy, all of whom Plutarch mentions in his *Lives*, going so far as to make clear that these affairs "were done out of wantonness and lust" (2001: 51-52). The seduction and abandonment of Ariadne is itself recounted by Pérez de Moya in rather noteworthy way:

Al tercero año cayó la suerte a Theseo, hijo del rey Egeo (según Plutarcho), mancebo muy esforzado y valiente; y como ya estuviese en Creta, donde la habían de echar al Minotauro, viole Ariadna, hija del rey Minos; y viendo su gentileza y sabiendo ser hijo de rey, enamoróse dél. (1995: 483-84)[13]

Most interesting to note are the similarities between Pérez de Moya's description of Theseus and Don Quixote's daydream fantasy during the Maritornes affair. Like Theseus, Quixote sees himself as a valiant foreigner who no sooner than he arrives compels the king's daughter to love him. Clearly, were Don Quixote to want to erase from his mind lust-filled desires, a figure like Theseus would not make for an ideal comparison; this error is thus less an articulation of repressed thoughts and more about wish fulfilment. And though the Duke of Ferrara's gallery contained no image of Theseus himself, it did display prominently an image of Ariadne abandoned on the island of Naxos, where Theseus left her, waving out to his departing ship, offering us in a sense the very image of Theseus's transgressions as a lover.

The final allusion to Theseus, and the penance with it, acts thus as a bookend to Don Quixote's erotic anxieties that first began to reveal themselves with the Silenus allusion, realised themselves in full with the Maritornes episode, and which continued to express themselves as senses of guilt with the parallel to Mars and Vulcan's net. As interconnected moments of the text, these slips portray a Don Quixote caught up in a dilemma over who he truly is: a noble knight able to stave off libidinal drives and remain true to his idealised lady Dulcinea, or simply a typical male who succumbs to his baser passions. Though Don Quixote desperately wants to be the former, we see that he at least recognises elements in himself that bear more similarity to the latter.

I would like to conclude by focusing on the importance of the visual interconnectedness of these allusions. That these three myths were in one way or another visually represented by a series of paintings in a single room suggests Renaissance ideas about the mind that may have served as a source of inspiration for Cervantes, and as an idea to which he gave a new twist. As Thomas Puttfarken describes in his study of Titian, Alfonso d'Este's Camerino was rather unique in that the selection of the paintings was in no way arbitrary; on the contrary the paintings were selected so as

[13] "In the third year the luck of Theseus, King Aegeus's son and a very lively and valiant youth, diminished (according to Plutarch); and as he had already been in Crete, where he expelled the Minotaur, he forced himself upon Ariadne, daughter of King Minos. Seeing his gentility and knowing that he was the son of a king, she fell in love with him."

to encourage the viewer to make connections between them: "The individual pictures would be subsumed as parts of an overall decoration and in which they were seen to reflect, or even to define in one way or another, the function and purpose of that room" (2005: 130). Drawn to the possibilities of what this interconnectedness could mean, Cervantes could very well have been intrigued by the images (and/or by Vasari's description of them) and sought to create his own textual rendering of the room. All of this points to something more: a connection between architectural space and the human mind, a concept that was not without precedent during the Renaissance.

I will refer once again to Frederick de Armas (2005), who establishes a connection between Cervantes's conception of memory in several works and notions of memory discussed by the Italian thinker Giambattista Della Porta in his work *Arte de ricordare* (*The Art of Memory*). Among Della Porta's topics of discussion is an idea that draws in part from Classical authors (namely Cicero), which states that the remembering of images aids one in memorising complex matters; Della Porta even went so far as to add a stroke of Renaissance specificity to his theories by claiming that paintings by renowned painters of the time, Titian among them, had particular impact on one's memory. But while Della Porta confined his theories to memorising and artificial mnemonic devices, we see that Cervantes may have taken the notion much further, depicting the mind itself as something akin to a gallery filled with paintings that represent not those topics we attempt to memorise, but, more importantly, those memories which we would rather forget, but which, as Freud well knew, have their way of rising to the surface. The Greek poet Simonides characterised paintings as "silent poems". In *Don Quixote* however, it is the paintings that speak and give voice to these unspoken and repressed elements of the psyche.

WORKS CITED

Augustine. 1991. *Confessions*. Trans. H. Chadwick. Oxford: Oxford University Press.

Cervantes, M. de. 2004. *Don Quijote de La Mancha*, ed. Instituto Cervantes, dir. F. Rico. Barcelona: Galaxia Gutenberg.

——. 2005a. *Don Quixote*. Trans. E. Grossman. London: Vintage.

——. 2005b. *Novelas Ejemplares*, ed. J. García López. Barcelona: Galaxia Gutenberg.

De Armas, F. 1998. *Cervantes, Raphael and the Classics*. Cambridge: Cambridge University Press.

——. 2005. "Cervantes and Della Porta: The Art of Memory in *La Numancia, El retablo de las maravillas, El Licenciado Vidriera*, and *Don Quijote*." *Bulletin of Hispanic Studies* 82 (5): 83-97.

——. 2006. *Quixotic Frescoes: Cervantes and Italian Renaissance Art*. Toronto: University of Toronto Press.

Goffen, R. 1997. *Titian's Women*. New Haven: Yale University Press.

Greenblatt, S. 1980. *Renaissance Self-Fashioning From More to Shakespeare*. Chicago: University of Chicago Press.

——. 1986. "Psychoanalysis and Renaissance Culture." In *Renaissance Texts/Literary Theory*, ed. P. Parker and D. Quint, 210-224. Baltimore: Johns Hopkins University Press.

——. 2004. "Me, Myself and I." *The New York Review of Books*. 51 (6): 32-36.

Hobbes, T. 1994. *Leviathan: with selected variants from the Latin edition of 1668*, ed. E. Curley. Indianapolis: Hackett Publishing Company.

Iffland, J. 1998. "Don Quijote como Sileno: ¿Una pista para descifrar las intenciones de Cervantes?" *Anales Cervantines* 34: 135-144.

Johnson, C. 1983. *Madness and Lust: A Psychoanalytic Approach to* Don Quijote. Berkeley: University of California Press.

——. 1993. "Cervantes and the Unconscious." In *Quixotic Desire: Psychoanalytic Perspectives on Cervantes*, ed. R. A. El Saffar and D. de Armas Wilson, 81-90. Ithaca: Cornell University Press.

Meltzer, F. 1995. "Unconscious." In *Critical Terms for Literary Study*, ed. F. Lentricchia and T. McLaughlin, 147-162. Chicago: University of Chicago Press.

Parr, J. 1995. "Cervantes Foreshadows Freud: On Don Quixote's Flight from the Feminine and the Physical." *Cervantes: Bulletin of the Cervantes Society of America* 15 (2): 16-25.

Pérez de Moya, J. 1995. *Philosofía Secreta*, ed. C. Clavería. Madrid: Cátedra.

Plutarch. 2001. *Lives: Volume 1*. Trans. J. Dryden, ed. with preface by A. H. Clough. New York: The Modern Library.

Puttfarken, T. 2005. *Titian and Tragic Painting: Aristotle's 'Poetics' and the Rise of the Modern Artist*. New Haven: Yale University Press.

Redondo, A. 1997. "Las dos caras del erotismo en la Primera Parte del Quixote." In *Otra manera de leer el* Quixote, 147-169. Madrid: Castalia.

Teresa de Jesús. 1986. *Libro de la vida*, ed. Otger Steggink. Madrid: Clásicos
 Castalia.
Vasari, G. 1991. *The Lives of the Artists*. Trans. J. Conaway Bondanella and P.
 Bondanella. Oxford: Oxford University Press.
Yates, F. 1966. *The Art of Memory*. Chicago: University of Chicago Press.

CHAPTER SEVEN

RIVER, RAIN, POOL:
ENVISIONING ADOPTIVE IDENTITY IN
THREE WOMEN'S NARRATIVES FROM
CONTEMPORARY SPAIN

RYAN PROUT

There are good reasons for studying transnational adoption in Spain. In terms of numbers, Spain has become Europe's most significant receiving country for adopted children who cross an international frontier to be with their new parents and is second only to the US when considering transnational adoption in per capita terms (Selman 2007). Close to five and a half thousand children born outside Spain were adopted by Spanish parents in 2005 (de la fuente 2006: 34). The figure was just above 900 in 1997 (del Castillo 2006; Unsigned 2006; Unsigned 2007). These figures are matched by a correspondingly well developed set of institutions, of the formal and self-help variety, geared towards facilitating transnational adoption and to supporting the families of transnational adoptees. Alongside the latest books on Isabel Preysler and home improvement, high street bookstores in Spain carry titles like *Quiero adoptar*, the analogue of which one is unlikely to come across in WH Smith or Borders. Adoption across borders is a global phenomenon, then, but one which has a locally Spanish significance. And whilst the upsurge in numbers may have occurred only recently, the idea of adoption from overseas has been part of Spanish cultural discourse for much longer. As evidence of this, I would point, for example, to Eloy de la Iglesia's 1976 film *La otra alcoba*. Unable to conceive naturally, the parents in de la Iglesia's film initially decide to adopt a child from Vietnam. They attend a handing over ceremony where the person in charge of the adoption process stands alongside several rows of seated Vietnamese children. Flanked by vertical and horizontal banners in the colours of the Spanish flag, she addresses the assembled adoptive parents-to-be with a general introduction that sites their future relationship with their children within a project that builds Spanishness on the basis of flight from another country diminished by war and strife:

Estos niños conocen todo el horror y toda la miseria; miles de kilómetros
had debido de recorrer hasta llegar a nuestra patria, huyendo de su país
desolado por la guerra y por la barbarie. Pero al fin han sido afortunados.
Ellos al menos se ha librado de la tragedia en estas lejanas tierras. Aquí
encontrarán una familia cristiana que sepa educarles y convertirles en
auténticos caballeros, en hombres de bien. Nosotros los recibimos con los
brazos abiertos ofreciéndoles nuestra paz y nuestro amor.[1]

In the next scene, the master of ceremonies meets the film's husband and
wife protagonist in private session to tell them how lucky they are to have
been allocated Lao Mi, a child about five or six years of age. She advises
them that when he is baptised they can give him a name which is "menos
raro" ("less strange") and that on account of their special status she singled
out this child, "una verdadera joya" ("a real treasure") especially for them.
While the husband is keen to proceed with the adoption contract, his wife
makes a rapid exit from the room saying that she needs to think it over.
For Eloy de la Iglesia, then, transnational adoption presents a means of
satirising the educational inculcation of Spanish Catholic culture as well as
a way of exploring the motivations behind a heterosexual couple's urgent
need to reproduce. Made on the cusp of the transition, La otra alcoba, with
de la Iglesia's typical esperpéntico exaggerations, can only seem to figure
transnational adoption as a kind of perverse technology capable of
recruiting the offspring of far flung cultures to the strait jacket of
nacionalcatolicismo. Even before the film was made, however, children
were being adopted to Spain from overseas, and with the assistance of
Catholic institutions, but without the consequences imagined by La otra
alcoba. For evidence of a successful trans-national adoption facilitated by
Catholic institutions we can turn to Asha Miró's autoethnographies La hija
del Ganges (2004) and Las dos caras de la luna (2005).[2]

[1] "These children know all about horror and deprivation; fleeing their own country
left desolate by war and barbarity, they have had to come thousands of kilometres
to reach our homeland. But finally they have been lucky. These children at least
have been liberated from the tragedy in those distant lands. Here they will find a
Christian family capable of educating them and turning them into real gentlemen,
decent through and through. We receive them with open arms and offer them our
peace and our love."
[2] Miró's two volumes of autobiography were originally published in Catalan as La
filla del Ganges (2003), and Les dues cares de la lluna (2004). In both Spanish and
Catalan they have been bestsellers. I have examined the construction of Miró's
adoptive Catalan-Indian identity in more detail elsewhere (see Prout 2009).

RIVER: *LA HIJA DEL GANGES*

In 1974, when she was six, Asha Miró was adopted by parents in Barcelona. The transnational adoption process, facilitated by links between the Catholic church in Spain and its offshoots in India, moved Asha as a child from an orphanage outside Mumbai to a new life in Catalonia with the Miró family. While the adoption process itself may have begun through the ministrations of organisations close to the heart of the Franco regime, its outcome has strayed very far from the strictures of *nacionalcatolicismo*. Asha Miró's adoptive family, for example, reinvented itself as Catalan at the same time as it became the home for two daughters adopted from India. Miró's mother, originally a Spanish speaker from Zamora, decided to bring up her children with Catalan as their mother tongue and Asha Miró now defines herself as Catalan-India, and has written both volumes of her autobiography in the language her adoptive mother adopted with her children. As an adult, Miró sees herself as a spokesperson for multiculturalism within Spain and her election as Catalan Personality of the Year seems to speak to the regional culture's ability to embrace ethnic diversity within linguistic uniformity (Unsigned 2005).

Like many adoptees who pursue a story of origins, Miró is forced to consider the question of the relative contributions of nature and nature in making her who she is. The attempt to find an answer is the impetus behind the two parts of her memoir. Like many transnational adoptees before her, Miró undertakes a roots journey and returns to India where she attempts both to unravel the story of the adoption process which took her to Spain and to discover who she might have been had she stayed in India. In one of the most moving scenes of her account of this trip, Asha is reunited with her sister, also called Asha. The interplay between nature and nurture is played out vividly in this encounter, perhaps more so in Jordi Llompart's's film *Asha: Daughter of the Ganges* (2003)—which was being shot as Miró made the first of her return journeys to India—than in Miró's written text. Genetically alike, the two Ashas' phenotypes are nevertheless dramatically different, confounding any simplistic attribution of features to ethnicity or nationality. When the Asha who has lived all her life in an Indian village meets the other Asha who has grown up in suburban Barcelona, the scene is charged not only with the emotionality of a meeting between long lost family members but also vividly illustrates the sedimentation in the sisters' appearances of two very different sets of life chances.

While the object of adoption may be to seal the child within the receiving culture, Miró's narrative illustrates how transnational adoptees

interrupt and query borders, not only as they first travel across them but as their lives unfold and they continue to traverse the categories which would define them. The first roots journey entails another, and this, another. The zero point of origins is ultimately elusive, not only because of the difficulty of establishing kinship facts through records and databases in India which are sketchy and poorly maintained by Western standards, but also because the exercise Miró undertakes reveals to her that the person she was intended to be is none other than the person she actually is. On her roots journey she finds nothing more definite than the dogged holding on to contingencies: maternity and filiality are revealed as performative acts, not established once and forever, but dependent on the iteration of maternal and filial behaviours over time.

As a child in the Mumbai orphanage, Asha had persistently asked the nuns who cared for her then who her parents were. They told her she was a daughter of the Ganges. She protested the need for parents and in what looks retrospectively like an act of will, found a family across a distance of thousands of miles. While never disowning her adoptive parents' role as her family, or her biological parents' as the source of her genetic inheritance, Miró's recourse as an adult in quest of her origins to the definition first bestowed on her as an orphan, i.e. "Hija del Ganges" ("Daughter of the Ganges"), is striking.

The roots journey definitively decides nothing in terms of a contest between nature and nature. Miró cannot return to a single originary place or to a single originating person, but she does return to an idea, the one that suggests that kinship exists not only between individuals but between an individual and a collective figured as the earth or, as within Hindu mythology, as a life giving source such as the Ganges.

RAIN: "MI ALEGRÍA ES GRANDE COMO EL OCÉANO"

There are adoption memoirs in Spanish, written by adoptees themselves, going back at least as far as the second republic, and, at a stretch one could argue that in fiction the genre extends as far back as *Lazarillo de Tormes* (1554) the story of a child given up for serial adoption. A form of writing about adoption that is peculiarly contemporary, on the other hand, is the memoir written by transnational adoptive parents detailing both the bureaucratic processes and the physical labour involved in adopting a child from overseas. There are already several of these works in Spanish and the one I concentrate on here is Sara Barrena's *Venida de la lluvia: historia de una adopción internacional* (2005). Whereas Asha Miró's autoethnography charts the process of becoming a daughter, Barrena's first person account chronicles the path she followed to motherhood. Her

account is not only a record of the seemingly endless and insurmountable series of obstacles that she and her husband must overcome in order to offer an orphaned child a home and a family, but also an examination of what maternity means.

Working through one of the regional agencies in Spain that facilitates transnational adoption, Barrena and her spouse learn that they must wait until they are thirty years old even to be considered as adoptive parents by the authorities in China, from where they decide to adopt. Their aptitude as Spanish parents is paradoxically determined by Chinese parameters: their Body Mass Index must fall within a certain range; they must not be homosexual; they must not ever have been separated (although a history of divorce is allowed); they must have a certain amount of capital in the bank. And even when these rigorous conditions have been met, the wait to be matched with a child is one measured in years. Barrena says of this wait: "En total, desde que empezamos el proceso, fue una espera equivalente a tres embarazos normales" (2005: 48).[3] She locates the moment at which she became a mother very precisely: while she was driving home to San Sebastián through the rain, the agency called her to tell her that she had been allocated a recently born infant and this was the beginning of her maternity:

> Fui madre por teléfono. Cuando colgué […] tenía una hija de nombre incierto al otro lado del mundo, y me eche a llorar […] Mi coche se había transformado en una sala de partos de corazon (2005:14-15).[4]

On a poor mobile phone line, Barrena misses the name of her daughter, Yu Lai, but later she learns that the Chinese characters used to write the name mean "brought from the rain". Her daughter's Chinese name becomes the name of her adoptive family's story as Barrena casts the obstacles to the adoption process as "un páramo eterno" ("an eternal dust bowl") and "el desierto de Gobi" ("the Gobi desert") in contrast with the fertility of her plans as represented by her daughter's original inscription in Chinese nomenclature. When Yu Lai begins to smile, Barrena says:

[3] "Since we began this process, the wait has been equivalent to three normal pregnancies."

[4] "I became a mother by telephone. When I hung up […] I had a daughter, whose name I didn't quite catch, on the other side of the world, and I burst into tears […] My car had been transformed into a delivery ward for births from the heart."

Aquella risa me reconfortaba el corazón después de tantos años, como una lluvia retrasada y largamente esperada después de tanto tiempo de mirar al cielo buscando las señales. (2005: 115)[5]

From the outset, Barrena conceives her future child as a child born of the imagination, and she figures this as "una gestación en el alma" ("a gestation in the soul") (2005: 22). In the process she discovers that even before being paired with her child, the mere fact of having opened her heart to a mixed race family has set her apart as different for some. She receives the fist of many sidelong glances, impertinent questions, and lectures about the risks of adopting from overseas, which lead her to reflect: "Quizá para muchos padres adoptivos es la primera vez que experimentan esa sensación de no encajar con la mayoría, y hay que acostumbrarse a la diferencia" (2005: 58).[6]

While Barrena thinks of herself at times as a Basque parent, the process of international adoption funnels her, together with adoptive parents from all over Spain, through Madrid: a journey to parenthood which sidesteps any notion of centrality is at the same time one which reinscribes not only a centralised political geography of Spain, but also of China. Whilst exploiting globalised channels of communication, the adoption process re-creates a community of parents as Spaniards who have in common that they have children adopted from China. In Changsha, while she and her husband are waiting to sign yet more documents prior to taking their daughter out of the country, Barrena runs into a parent from the USA who is also caught up in the same bureaucratic process and reflects: "La presencia de un cuerpecito cálido sobre cada uno de nosotros nos unía a través de los océanos. Mi niña hubiera podido ser americana o su niño español" (2005: 76).[7] As *Venida de la lluvia* illustrates, however, the process of becoming a daughter and of becoming a mother is intricately linked with the process of assuming a nationality and Sara Barrena's reflections on the nature of motherhood go hand in hand with her questions about Sara Yu Lai's heritage. "Yo no he dado la vida a mi

[5] "After so many years, that smile lifted up my heart, like a much delayed rain shower, long awaited after so much time looking up at the sky for signs that it was coming."
[6] "For many adoptive parents this may be the first time they have experienced the sense of not fitting in with the majority, and this difference takes some getting used to."
[7] "The presence of a warm little body held against each one of us linked us across the oceans. My daughter could have been American or his child could have been Spanish."

hija, me la dio ella a mí en una bella y misteriosa inversion de papeles", Barrena reflects (2005: 74),[8] and if her relationship with her daughter reworks the normal understanding of kinship it also queries the limits of national identity:

> Yu Lai nos enriquece a todos, su cultura de origen es también parte de todos nosotros. Ella es española, nosotros nos hacemos chinos y finalmente descubrimos que el espíritu está por encima de las nacionalidades, no depende de culturas ni de geografías (2005 : 128)[9]

Bonding becomes less a matter of genetics than of a shared emotional landscape. As another adoptive parent tells Sara Barrena of her future child: "No tendrá tus ojos, pero tendrá tu sonrisa" (2005: 93).[10] Several years later Barrena reflects :

> No tiene mi pelo, ni es de sus padres la forma de sus uñas de los pies, pero sí lo es la forma de responder o de mirar, sus gestos, sus sonrisas y, como yo, se muere por los helados de chocolate. Su carácter, su imaginación son también un poco los míos. Habitamos los mismos mundos de fantasía. (2005: 154)[11]

Her experience leads Barrena to several conclusions about parenthood, maternity, and blood relations.Adoption, she says, "no es una maternidad de segunda categoría, todo lo contrario, es muy de primera, hace falta mucho amor, mucho deseo, ganas incontenibles de ser madre o padre" (2005: 74).[12] Three years in to being Sara Yu Lai's mother, she observes:

[8] "I'm not the one who brought my daughter into the world: she is the one who has brought me into it in a beautiful and mysterious reversal of roles."

[9] "Yu Lai enriches everyone, her birth culture is also part of all of us. She is Spanish, we become Chinese and ultimately we discover that the spirit is something that goes beyond nationalities and does not depend either on culture or geography"

[10] "She won't have your eyes but she will have your smile."

[11] "She doesn't have my hair and the shape of her toe nails doesn't come from her parents, but her reactions and her way of looking, her gestures, her smile, these do come from us. For her, as for me, chocolate ice cream is to die for. Her character and her imagaintion are also a little bit like mine. The fantasy worlds we inhabit are the same."

[12] "[Adoption] is not a second rung form of maternity. On the contrary, it's A-grade parenting which requires a lot of love, much desire, and an uncontainable wish to be a mother or a father."

La maternidad no tiene que ver con los lazos de la sangre. Aunque siempre he pensado así, ahora no he hecho sino confirmarlo. No basta con nacer. A todos nos tienen que adoptar, aprender a querernos con el tiempo. (2005: 86)[13]

For Barrena, then, an umbilical cord is something that can reach between Spain and China, like the red thread which in Chinese mythology is supposed to tie together the destinies of strangers. Her experience as an adoptive mother leads Barrena to imagine that all parents and their children are strangers to begin with and that her bonding with her daughter is no different than a biological mother's with her son or daughter. While discounting biological paternity's pre-eminence on the one hand, Barrena's account nevertheless models adoptive parenthood on the more conventional kind, as if it were a gold standard of kinship. This, despite the fact that biological parenthood has patently failed to provide a family or a home for the thousands of international children who are thus available for adoption in Spain each year.

Barrena's account is not blind to this uncomfortable truth, however, She recognises that "si yo puedo ser la madre de Sara es porque alguien la abandonó" (2005: 117).[14] Large sections of *Venida de la lluvia* are given over to considering the social and political factors that predetermine the gender of Barrena's adoptive child. If adoptive parents in Spain know that their babies will be baby daughters, it is not because of any ultrasound scan but because there are very few abandoned baby boys in Chinese orphanages. While the Chinese authorities are able within a globalised logic of available children to prescribe the criteria for a perfect parent in Spain, at home the consequences of unfortunate local cultural practices are what put them in a position of having a surplus of children. Barrena stops to consider the position her daughter's biological mother may have been in before abandoning her child—a cultural backdrop of a one child policy where daughters are devalued and where a second child who is also female may bring not only legal penalties but financial penury, a backdrop where the lot of women in rural areas is so tough that suicide is one of the biggest killers for female Chinese living away from urban centres. Sara Barrena does not know the identity of her daughter's other mother, but she tries to give her a voice as best she can by incorporating within her book the

[13] "Maternity has nothing to do with blood ties. I always thought this was the case and now this has simply been confirmed for me. Being born isn't enough. We must all be adopted, to become loved in a learning process over time."

[14] "If I can be the one who is Sara's mother it is because someone else abandoned her."

testimony of a Chinese mother who gave up her baby in what may have been similar circumstances. Xin Ran, the author of *The Good Women of China: Hidden Voices* (2002), recalled in 2003 her rescue in 1990 of an abandoned baby found in a pile of clothes at the entrance to a public toilet. She spoke about the discovery on the radio and the birth mother called her show to explain herself:

> I know many people hate me; I hate myself even more. But you don't know how hard life is for a girl in the countryside as the first child of a poor family. When I saw their little bodies bullied by hard work and cruel men, I promised I wouldn't let my girl have such a hopeless life. Her father is a good man, but we can't go against our family and the village. We have to have a boy for the family tree. We can't read or write. But, if you can, please tell my girl in the future to remember that, no matter how her life turns out, my love will live in her blood and my voice in her heart. Please beg her new family to love her as if she were their own. (Xinran 2003: 7)[15]

Barrena's book includes a letter addressed directly to her daughter and she obviously struggles simultaneously to take stock of the faults in Chinese society which brought them together and also to identify for her daughter a birth heritage in which she can take pride. Addressing her daughter in the future, Barrena remembers:

> Con menos de tres años saliste un día del colegio hablando con otro niño. Yo iba detras escuchándoos. Él decía «yo juego muy bien al balón», y tú contestaste con voz firme y alta, «pues yo vivo en China», como diciendo, eso no puedes igualarlo. (2005: 166)[16]

Barrena ultimately rejects biological heritage as a key factor in determining someone's character and personality and also is sceptical of social construction. A kind of abstracted super construction nevertheless creeps back in to her formulation of her daughter's identity in the shape of a distilled Chineseness of positive character traits, such as courage and resilience. In her letter to Sara, Barrena tells her daughter in the future

[15] Barrena includes a quotation from Xinran's article in Spanish. I have included the same quote from the English version of the article originally published in *The Guardian*.

[16] "One day, when you were less than three years old, you were coming out of the nursery with a little boy. I followed behind, listening to you both. He said 'I'm really good at football' and you replied in a high and firm voice 'Well I live in China', as if to say there's no beating that."

"China es en los cinco sentidos y, por encima de eso, China eres tú [...]
llevas en la sangre el misterio de Oriente" (2005: 164). [17] Barrena's
figuration of her daughter's place in the world recalls Claudia Castañeda's
observation that transnational adoption sometimes conceives children
"through the incorporation of global differences [so that they] embody
'harmonious' global relatedness: the child becomes the global" (2005:
106). Indeed, there are episodes in *Venida de la lluvia* which bring to mind
the notion of surplus babies as a commodity produced like other goods on
an industrial basis thanks to China's economies of scale, as when the large
group of international parents waits in the lobby of a Chinese hotel built to
Western tastes for the delivery, one by one, and with production line
efficiency, of their adoptive infants.

But Castañeda's concern that international adoption may evacuate
historical contingency and specificity from an individual's identity seems
unfounded when we read Barrena's memoir. It is true that the book is a
very obvious part of the process whereby a child adopted from overseas is
re-inscribed within a Spanish family but Barrena is also extremely
conscientious about trying to fill in some of the gaps so that her daughter's
body is not a vessel emptied of biological history simply to be refilled with
one constructed in Spain. In her letter to Sara Yu Lai as well as in the book
addressed to the reading public, she is at pains to imagine the
circumstances which lead her daughter's biological mother to abandon her
as well as to understand the misogynistic contingencies which create the
availability of female children in China.

If there is an evacuation and an empty body created in the narrative,
then this applies perhaps more to the mother than to the daughter.
Transnational adoptions structure the world according to a hierarchy of
wealthy receiving countries with putatively unproblematic histories and
poorer troubled nations with correspondingly difficult pasts. When she
enters this hierarchy, Barrena as an adoptive transnational mother arguably
becomes detached from the contingencies and historical specificities of her
country and its past. Studying narratives such as Barrena's illustrates that
international adoption's creation of deracinated bodies and subjectivities is
as much an issue with regard to adoptive parents as it is to adoptive
children. This is not meant to criticise Barrena's book, however, because
she does not set out to address this dilemma, one that can be queried,
though, by bringing a third narrative into the picture.

[17] "China is in your five senses and, more than this, China is you [...] your blood
carries the mystery of the Orient."

POOL: *NADAR* (2008)

Carla Subirana's 2008 documentary film, *Nadar*, is about children, families, and ghosts. And, what is striking when one looks at it alongside *La hija del Ganges* and *Venida de la lluvia*, aside from the obvious use of aqueous metaphors in all three texts, is that it is also a story of adoption, implicitly if not by design. Looked at alongside *Venida de la lluvia, Nadar* fills in some of the Spanish maternal history which is evacuated in the process of transnational adoption to Spain. The emphasis placed both by Miró's text and Barrena's on identity as neither constructed nor essential, but as adopted, can also be usefully transferred to an understanding of the deracinated and disinherited position in which Carla Subirana finds herself in *Nadar*.

Like Asha Miró in *La hija del Ganges*, Carla Subirana undertakes a roots journey, not because her biological parentage is a mystery but because her knowledge of her family background was curtailed by the specific history of Spain immediately following the Civil War and more recently. Her grandmother was left as a single parent when her would-be husband (who was already married, without telling her) was executed as a red and as an armed robber. Her father left her mother to pursue another life with a new family in Puerto Rico. She has just a few documents to use in the search for more knowledge about her grandfather's past as she seeks to become a kind of adoptive mother to her own mother and to restore to her a biological legacy, which was supplemented in her upbringing by an adoptive paternity represented by silence and absence. The passage of time and deliberate historical erasures have been as effective in deleting facts about Subirana's family as geographical and cultural distance are in complicating Miró's detective work. What kind of man was Juan Arroniz, her grandfather? Subirana never finds out. He remains a name written on a commemorative pillar in a park in Barcelona where those fallen in the dictatorship are remembered, just as, for Miró and for Barrena, biological families are traces, names half remembered, and uncertain dates kept haphazardly in records in folders and biscuit tins half way across the world.

As a single mother carrying the perceived disgrace of being, furthermore, the love interest of an executed criminal and political agitator, Subirana's grandmother had to seek a new life away from her own family and her daughter and her granddaughter became urbanised, educated, and Catalan (Arroniz was originally from Murcia, one of the few bits of information that is known about him). Subirana's reunion with her country cousins is almost as jarring as is Asha Miró's with her sister in India.

Simultaneous with her roots journey, very much like one undertaken by a transnational adoptee, Subirana documents first her grandmother's death following a period in which she suffered from Alzheimer's, and then her mother's diagnosis with the same illness and the worsening of its symptoms. As the investigation into her grandfather's past keeps hitting the buffers, Subirana's mother's loss of cognitive capacity is made, if anything, all the more affecting. It is not simply loss of memory, but loss of what had yet to be retrieved: loss of an absence, loss of the unknowable. Subirana's film writes together biological and constructed—or adopted—legacies in much the same way that adoption memoirs try to create suture between the two. The film's editing joins together finger prints from Arroniz's criminal record with the visual representation provided by magnetic scans of Subirana's mother's brain as doctors look for the early signs of Alzheimer's. When she confronts one of the specialists involved with her mother's diagnosis and asks about the probability of developing pre-senile dementia herself, the doctor tells her that with such a small family pool to study—Subirana, her mother, her grandmother, her son—it is difficult to be conclusive. She does not lack a biological family and yet the missing family history becomes biological in much the same way as it might for an adopted child trying to provide a doctor with a family history. As Barrena's book shows, such an eventuality is exactly the sort that adoptive parents and families worry about.

The medium between Subirana's detective work—her stymied roots journey back to a Spain separated by an ocean of time—and her day to day life is the swimming pool. She comes back to it at regular intervals in the film and we see her body plunge smoothly through the water, supported by a cushion of anonymity which on dry land threatens her instead with insecurity, ignorance, and absences. The recurrence of this physically inhabited metaphor suggests an unstated idea that all family history is contingent and that all identity is unreliable, that everyone is, ultimately, swimming alone through a protean soup, birthed by an unknowable world, and mothered and fathered by the elements. *Nadar* begins with images of a perinatal ultrasound over which we hear the beat of an infant heart. And it ends with images of Subirana's son, underwater, swimming into the embrace of open arms. Visually the film replicates in images the consonance in romance languages of words to do with swimming and nativity and the closing gesture of the film can perhaps be read as one which says that whilst Subirana claims the maternity of her son, in light of the story the film has told, she does not do this in a possessive or individualistic way: the presentation of her son in the same aquatic medium that had negotiated her own journey between past and present and

between the identity that her mother and grandmother created for her, ex nihilo, places her child in the care of a larger family and of a maternity that is as much about imagination as it is about biology.

Sara Barrena, not a biological mother, feels maternity in every bone of her body. Carla Subirana, a biological mother, conceives parenthood as a creative and communal project with non-biological contingencies. For both women, the conception of motherhood and daughterhood as a process of adoption leads to a very generous location of maternity as a kind of zero point energy that can be tapped by an effort of the will and the power of the imagination: filiality is within them, but it is also out there. As Sara Barrena writes:

> Deberíamos avergonzarnos de que un solo niño muera de hambre, y, más aún, de que muera solo. Todo niño tiene derecho a ser querido y abrazado. A veces pienso con pesar en todos los niños que están allí, en los orfanatos chinos, y que nunca saldrán. Me gustaría poder besarlos y arroparlos cada noche. Algo me atenaza el alma cuando pienso en ellos. (2005: 108)[18]

The dynamic I want to suggest between these three texts, one in which Asha Miró envisions herself as a daughter of the river Ganges, another in which Sara Barrena views her daughter as a gift brought by the rain, and a third in which Carla Subirana tries to swim through the mysteries created by political and family lacunae, is one which points up the specifically Spanish context in which roots journeys are undertaken. Spanish transnational adoptees who aim tor recover a biological past overseas, and adoptive parents of international children who try to map out a priori an otherwise missing past do so within the Spanish pool of history where in living memory the children of families whose histories were erased have, like some adoptees, undertaken roots journeys in search of their biological parents, and where this discovery process is not only an individual endeavour of choice but a national project of necessity. As a structure for understanding the relationship between generations of Spaniards, perhaps the model created by adult adoptees in their quest to reunite biology and history is one which could be useful: it places the emphasis less on the macabre and on ghosts than on a living future, one where the past is an inheritance and not just a tombstone. In the three narratives looked at in

[18] "We ought to be ashamed that even a single child should die of hunger and all the more so when that child dies alone. Every child has the right to be loved and held. It grieves me to think of all those children who are in orphanages in China and who will never leave them. I would like to be able to kiss them and to tuck them into bed every night. It wrenches my heart to think about them."

this chapter, mothers and daughters are each other's historians for whom imaginative and physical creativity are not only of equal worth but mutually essential.

WORKS CITED

Anonymous. 1949. *La vida de Lazarillo de Tormes y de sus fortunas y adversidades*, ed. J. Cejador y Frauca. Madrid: Espasa Calpe.

Barrena, S. 2005. *Venida de la lluvia: historia de una adopción internacional.* Barcelona: Granica.

Castañeda, C. 2002. *Figurations, Child, Bodies, Worlds.* Durham NC: Duke University Press.

de la Fuente, I. 2006. "Los españoles prohijaron 5.423 menores extranjeros en 2005." *El País.* 19 July, p. 34.

del Castillo, J. 2006. "La mitad de los niños extranjeros adoptados procede de China. Ningún matrimonio homosexual solicitó adopción internacional en 2005." *El Mundo.* 19 July, p. 19.

Fernández-Zúñiga Marcos de León, A. and C. Rodríguez Bustelo Beamonte and M. Rodríguez, and J. E. Morgado de Moura Machado. 2009. *Quiero adoptar. Todo sobre la adopción internacional.* Barcelona: CEAC.

Miró, A. 2004. *La hija del Ganges.* Trans. G. Sardà. Barcelona: DeBolsillo

——. 2005. *Las dos caras de la luna.* Trans. S. Sáenz Bueno. Barcelona: DeBolsillo.

Prout. R. 2009. "Cradling the Nation: Asha Miró's Autoethnographies, Discourses of International Adoption, and the Construction of Spanishness." *Bulletin of Spanish Studies* 86 (4): 493-512.

Selman, P. 2007. "The Diaper Diaspora: Prime Numbers." *Foreign Policy*, 1 January, p. 32.

Unsigned. 2005."*El Periódico* entrega hoy el premio Català de l'Any 2004." *Terra.es*, 25 January. http://personal.telefonica.terra.es/web/joanmanuelserrat/news/gen05/periodico_hoy_catala_any.htm (Accessed 25 June 2007).

——. 2006. "España se mantiene a la cabeza del mundo en adopciones internacionales." *Consumer.es*, 19 July. http://www.consumer.es/web/es/solidaridad/2006/07/19/153974.php?print=true (Accessed 5 June 2007).

——. 2007. "Nueve de cada diez niños adoptados en España son extranjeros." *Trámite* http://www.tramiteparlamentario.com/content/ view/586/2/ (Accessed 5 June 2007).

Xinran. 2003. "'It's different for girls: Do the foreigners who adopt our girls know how to feed and love them in their arms and hearts?'" *The Guardian*, 19 September, p. 7.

PART II
MEXICO AND PERU

CHAPTER EIGHT

BODY BROKEN: FRAGMENTED BODIES IN IMAGES OF MEXICO

NASHELI JIMÉNEZ DEL VAL

An anonymous 1522 German engraving representing human sacrifice in Yucatán depicts some infants being cut into pieces by two priests on an altar before a devilish idol. Another priest flings more children's bodies down the steps of a high staircase. With neither hands nor feet, these broken babes resemble tattered dolls that have rolled down the stairs into a chaotic heap at the foot of a temple. In twenty-first century Mexico, similar illustrations of fragmented bodies have found their way into the media. Following the reckless "declaration of war" against drug cartels by Mexico's *de facto* president Felipe Calderón in December 2006 (Sullivan and Elkus 2008), drug lords responded with a spectacular display of vengeance executions.[1] Scenes of human heads rolling onto the dance floors of discotheques and of maimed bodies wrapped in black plastic bags dumped by the side of the road have become common. The federal government has, in turn, countered these visually gory statements by producing images of dead drug-traffickers captured by the Marines. The Mexican body is now, as it was in the sixteenth century, a spectacle in pieces.

This chapter will explore the theme of the broken body in images of Mexico, from the very first engravings of Mesoamerica produced by Europeans, to recent photographs documenting a particularly violent period in Mexican history. The first part of the chapter will look at the historical antecedents within a Mexican context for the iconography of the body in pieces, while the second part will focus on more recent images as metaphors for a fragmented body politic. Chiefly, this chapter will argue that in Mexico the purposefully *spectacular* presentation of body fragments exercises a propagandistic role that often accompanies acute societal upheaval. Hence, the spectacle of the body in fragments serves a

[1] Calderón's legitimacy as president of Mexico was called into question following the controversial federal elections of 2006 when numerous irregularities led a significant proportion of Mexican citizens to reject his investiture as president.

distinctly political function, with variations which correspond to differing contexts and varied types of struggle for power. For the Spanish conquistador, the spectacle of the pieced body was used as evidence of the savagery of a godless Mesoamerican society that thrived on violence. For the drug cartel boss, the broken body functions as a statement of purpose and as a visible threat to competitors. The presentation by the Mexican government of the drug lord's shattered body is the expression of a weak administration feeding into a puerile exercise of the *ley del Talión*: an eye for an eye. The spectacle of the body in pieces is, in short, one of the most explicit types of message that can be exchanged between groups in conflicts over power or in the ideological representation of others, as in the case of early Europeans' depiction of Mesoamericans.

European depictions of the New World were, very early on, central in establishing the iconography and discursive tradition of the broken Mexican body. While some of the early images of the Americas focused on the representation of the natives as Edenic innocents—for example, Jean de Léry's engravings of indigenous peoples in Brazil in *Histoire d'un voyage faict en la terre de Brésil* (1580, second edition)—in many other cases—the early Grüninger engravings illustrating Vespucci's voyages (1509, Strasbourg edition), as well as most of Theodor de Bry's *Americae* (1592), among other examples—the European image-makers concentrated their abilities on depicting scenes of violence and bodily disintegration. In *Newe zeittung von dem lande, das die Spanier funden haben im 1521. iare genant Jucatan*, the engraver chose a scene of human sacrifice to frame the depiction of the discovery of Yucatán by Spanish explorers. Similar scenes of ritual sacrifice are described in Sahagún's *Historia general*:

> Para [la fiesta llamada *atlacahualo*] buscaban muchos niños de teta, comprándolos a sus madres; [...] A estos niños llevaban a matar a los montes altos, donde ellos tenían hecho voto de ofrecer. A unos de ellos sacaban los corazones en aquellos montes, y otros en ciertos lugares de la laguna de México; [...] Gran cantidad de niños mataban cada año en estos lugares; después de muertos los cocían y comían. (1988: 104)[2]

[2] "For [the festivity of Atlacahualo] they searched for many breast-feeding children, buying them from their mothers. [...] These children were taken to be sacrificed in the high hills, where they had made an offering vow. Some of them had their hearts taken out at these hills, and others in certain places in the lagoon of Mexico. [...] They killed a large number of children each year in these places. Once dead, they cooked them and ate them."

And Bernal Díaz del Castillo described a similar scene in the following terms:

> Cuando sacrificaban a algún triste indio, que le aserraban con unos navajones de pedernal por los pechos, y bullendo le sacaban el corazón y sangre, y lo presentaban a sus idolos, en cuyo nobmre hacía aquel sacrificio; y luego les cortaban los muslos y brazos y la cabeza y aquello comían en fiestas y banquetes; y la cabeza colgaban de unas vigas y el cuerpo del indio sacrificado no llebagan a él para le comer, sino débanlo a aquellos bravos animales. (1984: 327)[3]

In both the *Newe zeittung* engraving and these descriptions, the ritual ceremonies that involved the piecing apart of the human body were the main focus of European interest. For the producers of these images, sacrificial rituals, idolatry and fragmented bodies characterise the strange land. The broken bodies of the sacrificed evoke the Americas as a turbulent, shattered space in the European imaginary, particularly in the context of a highly violent process of exploration and conquest.

In many Spanish descriptions and depictions (Cortés 1963; Díaz del Castillo 1984; Las Casas 1967), the Mesoamerican temple is a house of destruction, a palace of violence. Not only were prisoners sacrificed to the gods, but allegations of ritual cannibalism added a further dimension to images of the Mexican body in pieces. In many of their accounts, Spanish conquistadors express horror at the cannibalism that supposedly accompanied ritual and ceremony. Frequently, there is a fixation on the quartering of prisoners during ceremonies, mainly with regards to the representation of dismembered limbs:

> Después de desollados, los viejos llamados *cuacuacuilti* llevaban los cuerpos al *calpulco*, adonde el dueño del cautivo había hecho su voto o prometimiento. Allí le dividían y enviaban a Motecuzoma un muslo para que comiese, y lo demás lo repartían por los otros principales o parientes. Íbanlo a comer a la casa del que captivó al muerto. Cocían aquella carne con maíz, y daban a cada uno un pedazo de aquella carne en una escudilla

[3] "When they sacrifice a wretched Indian they saw open the chest with stone knives and hasten to tear out the palpitating heart and blood, and offer it to their idols, in whose name the sacrifice is made. Then they cut off the thighs, arms and head and eat the former at feasts and banquets, and the head they hang up on some beams, and the body of the man sacrificed is not eaten but given to these fierce [zoo] animals" (Díaz del Castillo 2005: 295).

o caxete, con su caldo y su maíz cocida, y llamaban aquella comida *tlacatloalli.* (Sahagún 1988: 108)[4]

In Sahagún's view, the body in pieces expresses not only a religious dimension, such as that of the ritual sacrifice, but also a material one that involves the consumption of the human body as a piece of well-cooked meat.

In fact, the European trope of the body part is derived from a medieval iconographical tradition that equated warfare with culinary practices. As Bakhtin has argued, there is a clear relationship between the body part, "a [European] fighting temperament (war, battles), and the kitchen" (1984: 193). In battle, the knight was seen as a systematic "anatomiser" who dismembered and transformed human bodies into "minced meat" (1984: 194). The body of the native was represented accordingly in many European engravings depicting the New World. In Münster's *Cosmographia* of 1554, the body is depicted as being chopped into pieces on a butcher's block. In Pieter van der Aa's *La galerie agréable du monde* (1729), it is represented as a collection of joints of meat pierced through by a roasting skewer. As Linda Nochlin suggests, the impact of these kinds of images resides in a very simple, yet "utterly original formal means: consigning the human elements to the realm of the horizontal" (1994: 20). Pictorially, the chopping and piercing of human flesh in such a spectacular manner reduces the human body to a state of patent objectification and, consequently, of ultimate vulnerability. Thus, the helplessness of the fragmented body becomes highlighted in a very graphic visual manner through the simultaneous presentation of the familiar—European culinary practices—and the horrific—bodily disintegration. In short, the body part as a culinary "ingredient" in the iconography of war and battle adds a further layer of meaning within these images of New World bodily fragmentation.

Moreover, the representation in Western iconography of the body in parts pre-dates the exploration and conquest of the Americas. During the Middle Ages there was a solid European tradition of dividing up the bodies of saints and displaying their body parts, accompanied by the

[4] "After being skinned, the old men called *cuacuacuilti* took the bodies to the *calpulco*, where the master of the captive had made his vow or promise. There it was divided and a thigh was sent to Motecuzoma for him to eat, and the rest was divided amongst the other principles or relatives. They went to eat it at the house of the one who captured the prisoner. They cooked the meat with maize and gave each person a piece of that flesh in a gourd with its broth and boiled maize, and they called that food *tlacatloalli.*"

establishment of an important market for the trade of relics and reliquaries (Walker Bynum and Gerson 1997: 4). According to David Hillman and Carla Mazzio, "the social and symbolic practices of piecing out the body in the early modern period" further included dismemberment as corporal punishment, and the pictorial representation of body parts in religious iconography (1997: xi). As Jonathan Sawday explains, the practice by the nobility of dissecting a single body for burial in more than one place, and the veneration of the body parts of saints were quite common before the sixteenth century and corresponded to a belief system in which the division of corpses was legitimate when carried out for religious ends (1995: 99). Thus, the veneration of saints and of their body parts as holy relics demonstrates the major role the body played "as a signifier, commodity, object of worship and source of magical power" (Grantley and Taunton 2000: 5).

In many cases reliquaries which supposedly contained the actual body part of the saint took the shape of a head or an arm. The tendency to present arms, legs, and heads over other body parts results in heightened focus on the body part that has been separated from the whole (Walker Bynum and Gerson 1997: 5), and responds to the rhetorical trope of synecdoche in which the part is taken as the whole (Hillman and Mazzio 1997: xiii). This particular use of the body fragment in religious iconography further confirms the Pauline view of the Christian body: "As the body is one, and hath many members, and all the members of that one body, being many, are one body: so also is Christ" (cited in Hillman and Mazzio 1997: xiii). The Mexican body fragment, when depicted within this frame of reference, becomes doubly scandalous. It functions on the assumption of familiarity with a well-established European religious iconographical trope yet, in doing so, it further stresses the "Godlessness" of the Mexicans. In contrast to Christian reliquaries, the Mexican body in fragments was closely associated with human sacrifice in what Europeans considered to be pagan rituals of worship to bloody-thirsty gods; in a sense, it was the symmetrical opposite of the Christological body and, as such, reveals a site of symbolic dispute between the two practices of bodily fragmentation.

BEHEADING THE BODY POLITIC

If Mesoamerica was in the European imaginary the land of the broken bodies of human sacrifice, then the peoples practicing these rituals were the target of a form of warfare that was equally violent and produced a large number of bodies in parts. Mirroring their own descriptions of the fragmented real bodies of captured sacrificial victims, the Spanish enacted

both a physical and symbolic disintegration of the Mexican body politic. The physical body part was central in establishing the earliest forms of punishment and governance in the newly emerging colonies in the Americas. As Fray Bartolomé de las Casas denounced in his *Breve relación de la destrucción de las Indias Occidentales* (1957), when a native was found guilty of stealing, the corresponding punishment would be the amputation of his hand. In terms of symbolic fragmentation, when Cortés entered the Templo Mayor in the centre of Tenochtitlán, he ordered that the largest idols be thrown "por las escaleras abajo" (Cortés 1963: 53), in much the same way that sacrificial victims' bodies had been hurled down the exterior of Mesoamerican temples.[5] Subsequently, Cortés had the Mexica cleanse the temples that were "llenas de sangre que sacrificaban, y [puso] en ellas imágenes de Nuestra Señora y de otros santos" (Cortés 1963: 53).[6] In this manner, the institutions that sustained Mexica rule were effectively broken into pieces. Hence, the very foundation of the colonies was based on the physical and symbolic disintegration of what had gone before.

Allegories of the American continent that emerged from 1570 also had recourse to the body part in their representation of the new world. Most of them depict America as a reclining nude woman wearing a feathered cap with a severed human head at her feet. In the early seventeenth century de Passe allegory, for instance, several human heads are displayed before the viewer and a cauldron full of body parts is shown simmering over a fire. This way of portraying America, "in contrast to the social and cultural integrity and totality emphasised in the emblem of Europe", highlights dismemberment and fragmentation through the symbolism of body parts (Schreffler 2005: 305). In Schreffler's words, while the allegory of Europe is "characterized by an ensemble of objects and attributes that constitute the body politic, America is presented instead as an ensemble of anatomical units that constitute the flesh—and blood—body" (2005: 305).

Most noteworthy among body parts is the decapitated head that was represented at America's feet. Following Ripa's *Iconologia* (c. 1603), the iconographical handbook which most baroque artists consulted in order to represent abstract ideas (Honour 1975: 89), America was to be depicted with a human head at her feet that "plainly shows that it is the custom of many of these barbarous people to eat human flesh" (Ripa 1976, *America* plate). For Schreffler, this emblem's "unorthodox juxtaposition of a severed human head with the figure's feet encourages the visually literate

[5] "Flung down the stairs" (Cortés 1962: 90)
[6] "Full of the blood of human victims who had been sacrificed, and [he then] placed in them the image of Our Lady and other saints" (Cortés 1962: 91).

spectator to contrast America's intact body with the decapitated head at
her feet, presented as a kind of macabre punch line to the composition"
(2005: 299). In European iconography, the head in the context of the body
politic was understood as the metaphorical site of sovereign power. If the
king was "the fleshly embodiment of the State", then decapitations became
a metaphor for a "primal scene of political transgression" (Nochlin 1994:
11). Operating through synecdoche, the head at America's feet emphasises
the representation of America "in terms of parts and fragmentation", while
Europe is represented "in terms of totality and wholeness" (Schreffler
2005: 305). Hence, Europe is the model for "social and political integrity,
cohesion and organization", while America is a reality determined by
"social and political chaos" (Schreffler 2005: 305).

A SEMIOTICS OF INTIMIDATION

If the severed head was an attribute of America in seventeenth century
European allegories of the continent, recent images of body parts have
further fed into the image of Mexico as a nation whose quotidian realities
are determined by social and political chaos. In the context of the war
declared by Felipe Calderón against drug cartels, the body in fragments
has taken centre stage in Mexican media since 2006. In September of that
year five decapitated heads were flung onto a dance floor in Michoacán
and subsequently the media circulated widely images of this event
(Martínez 2006); in March of 2009 five heads were found in Styrofoam
coolers on a road in Jalisco (Unsigned 2009a). In fact, in the course of the
so-called "war on drug cartels" led by the Mexican regime, dozens of
headless bodies have appeared throughout the country (Schiller 2006).[7]

Believed to be the result of warring cartels sending each other
intimidatory messages, these body parts function in terms of a body
grotesque in the sense of Bakhtin's theorisation. Based on a principle of
degradation, the body grotesque enacts a "lowering of all that is high,
spiritual, ideal, abstract" by transferring the bodily substance back to a
purely material level (Bakhtin 1984: 19). Hence, the body is denied its
human dimension and its status is, instead, demoted to that of a
defenceless piece of flesh. It is no coincidence that the case of "El
Pozolero" ("The Stew-Maker") should have drawn so much media
attention. According to the official version of events, "El Pozolero" was
hired by the Arellano Félix cartel to dispose of the bodies of narco-victims

[7] Interestingly, in his article for *The San Diego Union-Tribune*, Schiller sees in this
method of intimidation the adoption of the execution techniques of "Middle
Eastern terror groups" (2006).

by dissolving them in vats of acid, thereby acquiring his macabre gastronomic nickname (Méndez 2009). Reverting to the medieval trope of warfare as a culinary exercise, the language used in the case of "The Stew-Maker" reiterates a discourse which equates the body part to nothing more than a piece of meat.

Moreoever, as Carlos Monsiváis has pointed out, this "aesthetics of intimidation" refers back to primitive tactics where the mutilation of bodies was used as a signifier of persecution beyond death (2009: 22). The body presented in this manner is, thus, a very carefully constructed message and recalls Foucault's theorisation of the dismemberment of the prisoner's body whereby the "infinitesimal destruction of the body is linked [...] with spectacle: each piece is placed on display" (1995: 51). The dismemberment of the human body highlights its lack of wholeness, thereby allowing the body part to become symbolically enlarged and isolated from the scene in which it is placed. In this context, the fragmented body is, quite purposefully, an intimidatory spectacle to be beheld by rival cartel members and the public at large in order to assert the *sicario*'s dominance over the body of the enemy.

THE SPECTACLE OF THE BODY BROKEN

Governmental response to these exemplary images has been provocative at best. In the recent Marine operation to take down drug cartel head Arturo Beltrán Leyva ("El jefe de jefes"), photographs of his lifeless body were leaked to the press. Among these photographs, one in particular stood out on account of its graphic portrayal of the dead body. Beltrán Leyva's bullet-ridden corpse is lying on the ground, his body plastered in dollar bills and Mexican pesos artfully arranged, and his head figuratively decapitated by the photographer's cropping of the image so that the body's head has been excluded from the photograph's frame. As Carlos Monsiváis has argued, this purposeful arrangement of the body functions across several layers of meaning (2009: 20-22). Monsiváis relates the money carefully arranged on top of the drug baron's bloody body to the images of written prayers and relics pasted on the sculptures of saints and virgins in Mexican churches. Hence, for Monsiváis the implicit message of the staged photo is: "Que aprendan los delincuentes: eso les espera, un sudario de los papeles del Banco de México que ya no podrán gastar" (2009: 22).[8] Moreover, the head of the cartel leader's head has figuratively been cut off by the cropping of the image. This manner of presenting the

[8] "Know this, you delinquents: this is what awaits you, a shroud of papers from the Bank of Mexico that you won't be able to spend."

fragmented body of Beltrán Leyva is a clear message from the Mexican government to other cartel heads: just as the decapitation of the sovereign is the ultimate act of political transgression, the representational beheading of "The Chief of Chiefs" plays into the same semiotics of intimidation used by the drug gangs themselves.

Officially, these images were leaked to the Mexican media by an unknown source. The emergence of these images stirred up a huge controversy, with the Secretary of the Interior, Fernando Gómez Mont, declaring in a television interview that the photographs "[son] infamantes y perniciosas" (in Barría 2009), and contrary to the communication policy of the federal administration (Unsigned 2009b).[9] The Office of the General Prosecutor (Procuraduría General de la República), the National Forensics Service (Semefo), and the Secretary of Marines have all denied involvement (Monsiváis 2009: 22). However, it is hard to believe that the circulation of these photos in the national media was not officially sanctioned by the federal government: the Marines and the agents involved in the operation, the forensic doctors, and the judicial officers were all present at the scene under official orders. Moreover, given the current situation of increasing complicity between the federal government and many media outlets in Mexico, most branches of the media complex have arguably developed a symbiotic relationship with the federal government. Even if the government did not actively promote the widespread dissemination of the image, it was complacent about doing anything to stop it.

If the federal government did indeed have any direct involvement in leaking these images, then it would have fallen into the very logic of a semiotics of intimidation such as that established by the cartel leaders themselves. By inscribing the body of Beltrán Leyva in such a spectacular fashion, the image functions as "la teatralización bárbara del triunfo sobre el enemigo de la Patria" (Monsiváis 2009: 21).[10] It can be argued that this montage is, as Monsiváis describes it, "[una] obra maestra: convertir un cuerpo en un telón de fondo de la metamorfosis del narcotráfico" (2010).[11] Hence, the "inscriptions" of the State on the body of Beltrán Leyva are a way of maintaining a "theatre of hell" in the context of the spectacularity of the tortured body as theorised in a Foucauldian sense (Miller 1990: 479). Exemplary punishment and spectacular torture are meant to send a clear message to those who are of Beltrán Leyva's kind, and to society at large.

[9] "[Are] infamous and pernicious."

[10] "Barbaric dramatisation of the triumph of the Nation over the enemy."

[11] "A work of art: the transformation of a body into a backdrop for the metamorphosis of drug-dealing."

As Daniel Punday argues, as a site for the inscription of the State's power the body allows for the dramatisation of "the inevitable conflicts between social discourses" (2000: 514), and, moreover, "the inscribed body implies that all political texts are ultimately arguing over a single entity, since they have only one 'table' upon which to write" (2000: 514). If the body functions as a recurrent metaphor for order and harmony (Walters 1978: 13), as well as a metaphor for effective social and political organisation, then the broken body signals a preoccupation with the blatant social disintegration of the body politic. By playing into the rhetoric of gore, the Mexican government makes evident that it is locked in to a power struggle with the drug cartels that seem to be taking over the country. If this is the case, then one must repeat the question posed by James Miller, to wit: "What, if any, role ought cruelty to play in society?" (1990: 472). If a State is to consider itself "modern"—and Calderón has consistently characterised his administration in this way—then it must, "as a matter of humanitarian and egalitarian principle, [...] outlaw harsh forms of punishment and cruel practices generally" (Miller 1990: 478). Images such as Beltrán Leyva's broken body should have no place in a regime with well-functioning institutions, for there is a risk that lies in the reversal of such spectacularity. The highly visible display of the body in parts can easily feed into an "uncertain festival in which violence [is] instantaneously reversible" (Foucault cited in Miller 1990: 480). Faced with a violence of the everyday, as is currently the situation in Mexico, "the cruel pleasure taken in punishing" may, at any moment "[embolden the crowd] to vent its own subversively 'bestial virility' on the sovereign's official representatives" (Miller 1990: 480).

The relationship between the broken body and turbulent, oftentimes violent, power struggles is one that may initially seem self-evident. In any violent process to which it is subjected, the human body will inevitably be broken into pieces. However, as this chapter has explored, the spectacular display of such fragments implies a second level of political struggle beyond that of physicality. The body broken is also society fragmented, the sovereign decapitated, a cautionary tale. However, the display of the body broken can, in many instances, be counterproductive to the original intent. As James Miller has expressed in his reading of Foucault, dependence on the spectacularity of the tortured body as a means of political control is a double-edged sword as its effects can quite easily become reversed. Beltrán Leyva's body would then no longer remain a cautionary tale, but potentially the subject of legend, a modern-day human sacrifice, a Mexican martyr in the eyes of many who feel disenfranchised due to the regime's institutional failings. Importantly, if the Mexican

government has fed into the strategy of semiotic intimidation by presenting tortured bodies as cautionary tales, the war against drug cartels has already been lost; for by playing under the rules established by others, the government reveals a power void born of the illegitimacy of its ascent to power. In the struggle for power on the representational terrain, the display of the broken body is an ambiguous and unstable trope, and it can be as revealing of weakness as it is of strength.

WORKS CITED

Bakhtin, M. 1984. *Rabelais and His World*. Bloomington: Indiana University Press.
Barría, C. 2009. "México: La mafia detrás de Beltrán-Leyva" *BBC Mundo*, 20 December.
http://www.bbc.co.uk/mundo/america_latina/2009/12/091220_1940_mexico_mafia_gm.shtml (Accessed 26 February 2010).
Cortés, H. 1962. *Five Letters, 1519-1526*. New York: Norton & Co.
Cortés, H. 1963. *Cartas de relación*. Mexico: Editorial Porrúa.
Díaz del Castillo, B. 1984. *Historia verdadera de la conquista de la Nueva España*. Tomo A. Madrid: Historia 16.
Díaz del Castillo, B. 2005 [1928]. *The Discovery and Conquest of Mexico 1517-1521*, ed. G. García, trans., with an intr. and notes by A. P. Maudslay. London: Routledge.
Foucault, M. 1995. *Discipline and Punish: The Birth of the Prison*. New York: Vintage Books.
Grantley, D. and N. Taunton. 2000. *The Body in Late Medieval and Early Modern Culture*. Aldershot: Ashgate.
Hillman, D. and C. Mazzio. 1997. "Introduction: Individual Parts." In *The Body in Parts: Fantasies of Corporeality in Early Modern Europe*, eds. D. Hillman and C. Mazzio, xi-xxix. London: Routledge.
Honour, H. 1975. *The New Golden Land: European Images of America from the Discoveries to the Present Time*. New York: Pantheon Books.
Las Casas, B. de. 1957. *Breve relación de la destrucción de las Indias Occidentales*. Mexico: Romerovargas y Blasco Editoriales.
——. 1967. *Apologética. Historia Sumaria, Tomo II*. México: UNAM/IIH.
——. 2004. *A Short Account of the Destruction of the Indies*. London: Penguin Books.
Martínez, E. et al. 2006. "Arrojan 5 cabezas humanas en centro nocturno de Uruapan." *La Jornada en Internet* 7 September.
http://www.jornada.unam.mx/2006/09/07/index.php?section=estados&article=037n1est
(Accessed 26 February 2010).
Méndez, A. 2009. "Presenta la PGR a El Pozolero." *La Jornada en Internet* 26 January. http://www.jornada.unam.mx/2009/01/26/index.php?section=politica&article=012n1pol (Accessed 26 February 2010).

Miller, J. 1990. "Carnivals of Atrocity: Foucault, Nietzsche, Cruelty." *Political Theory*, 18 (3): 470-491.

Monsiváis, C. 2009. "Semiótica bárbara." *Proceso* 1730 (27 December): 20-22.

——. 2010. "Los apadoristas de las fotos de Beltrán Leyva." *El Universal* 3 January. http://www.eluniversal.com.mx/editoriales/46893.html (Accessed 26 February 2010).

Nochlin, L. 1994. *The Body in Pieces: The Fragment as a Metaphor of Modernity*. London: Thames & Hudson.

Punday, D. 2000. "Foucault's Body Tropes." *New Literary History* 31 (3): 509-528.

Ripa, C. 1976. *Iconologia*. New York: Garland Publishing.

Sahagún, Fr. B de. 1988. *Historia general de las cosas de Nueva España, Tomo I*. Madrid: Alianza Universidad.

Sawday, J. 1995. *The Body Emblazoned: Dissection and the Human Body in Renaissance Culture*. London: Routledge.

Schiller, D. 2006. "Mexican drug cartels now using decapitation to scare enemies." *San Diego Union-Tribune Online* 1 October. http://legacy.signonsandiego.com/uniontrib/20061001/news_1n1behead.html (Accessed 26 February 2010).

Schreffler, M. 2005. "Vespucci Rediscovers America: the Pictorial Rhetoric of Cannibalism in Early Modern Culture." *Art History* 28 (3): 295-310.

Sullivan, J.P. and A. Elkus. 2008. "State of Siege: Mexico's Criminal Insurgency." *Small Wars Journal*. http://smallwarsjournal.com/blog/journal/docs-temp/84-sullivan.pdf (Accessed 26 February 2010).

Unsigned. 2009a. "Hallan en Jalisco 5 cabezas con mensajes intimidatorios." *La Jornada en Internet* 11 March. http://www.jornada.unam.mx/2009/03/11/index.php?section=politica&article=007n1pol (Accessed 26 February 2010).

Unsigned. 2009b. "Gobernación se deslinda de las fotos del cadáver de Beltrán Leyva." *La Jornada en Internet* 19 December. http://www.jornada.unam.mx/2009/12/19/index.php?section=politica&article=006n1pol (Accessed 26 February 2010).

Walker Bynum, C. and P. Gerson. 1997. "Body-Part Reliquaries and Body Parts in the Middle Ages." *Gesta* 36 (1): 3-7.

Walters, M. 1978. *The Nude Male: A New Perspective*. Middlesex: Penguin.

CHAPTER NINE

SUBTLE CANVASES OF MEXICO AND ITS REVOLUTION: APPRENTICESHIP, ANDROGYNY, AND NATIONAL IDENTITY IN ABRAHAM ÁNGEL'S ART

ALEJANDRO LATINEZ

In 1983 Mexico's Museo Nacional de Arte exhibited a José Clemente Orozco cartoon—a grotesque description of a group of male homosexuals—which had originally been published in the August-September 1924 issue of *El machete* (McCaughan 2002: 103). The cartoon's six figures are surrounded by the darkness of the night and such illumination as the design allows comes from a weak street light leaving no doubt about the tone of the composition and its attitude towards the homosexual subjects. The disdain is further emphasised by details such as a crown of laurels, a Greek harp, ink feathers, books, and a naked muse with a trumpet who flies above the subjects, their expression depicted as one of sexual hunger and their physiques feminised with well rounded hips and heavy eyelashes. For the Mexico of the first two decades of the Revolution (1911-1930) such iconography was coetaneous with the new fashion for mural images in urban places and modern public buildings made by well known painters. The coincidence is not entirely a surprising one.

The fear of gender indeterminacy in pre-Revolutionary Mexico is well documented; masculinity was valued as a source of stability, as Buffington affirms with reference to the working class from the period—"with recognizable attributes and pretentions of ideological coherence"—and this connection was consolidated during the Porfirio Díaz regime of 1876 to 1911 (2003: 194). The last decade of the Porfiriato saw the industrialisation of the print media and the penetration across the country's urban areas of the press, and of press opinion. New technologies facilitated the circulation of images of people and of events and gave the public the opportunity not only to read about but also to visualise graphic representations of a spectrum of behaviours that were or were not coherent with normative masculinity. As Ben. Sifuentes-Jauregui argues, graphic

representations of scandal in the press set up "a relationship of difference
[...] prompting the community to establish an imperative of discipline.
More precisely, the notion of community becomes manifest and singular at
the breakout of a scandal, and it demands that the scandalous subjects be
normalized" (2002: 16). In this case, the scandalous individuals were
depicted as homosexuals. Indeed, in 1901, with the infamous episode of
los cuarenta y uno—in which forty-one men, half of them dressed as
women, were arrested whilst at a private party in Mexico city—a state of
anxiety which bundled together apprehensions about the future came to a
head. The new century opened, then, with an event that symbolically tied
together the new power of an industrialised print media, fears about the
subversion of gender, hegemonic government policies, a bohemian artistic
movement, and social expectations of modernity (Irvin and McCaughan
and Nasser 2003: 2).

In 1911, after Madero's rebellion which forcibly brought an end to the
Porfiriato, the revolutionary national narrative came into being; despite
political turmoil and savage in-fighting between revolutionary factions, a
new society was taking shape. As Thomas Benjamin points out,
"Contemporaries told stories, drew comparisons, and made arguments
about recent events in particular ways [...] Their talking, singing, drawing,
painting, and writing invented *la Revolución*: a name transformed into
what appeared to be a natural and self-evident part of reality and history"
(2000: 14). Following this trend, from 1922 to 1924, the muralist
movement initiated as a priority the institutionalisation of the
revolutionary process through the construction of a national identity using
iconography and symbolism that concurred with the expectations of the
masses (Folgarait 1998: 13-26). José Vasconcelos, the powerful and
influential Mexican intellectual, espoused ideas which enlisted the support
of painters such as Fernando Leal, Ramón Alva, Diego Rivera, Jean
Charlot, Fermín Revueltas, David Siqueiros, as well as Orozco. Muralist
art combined two monumental facets: a wide architectural frame and
imposing gigantic lines which together resulted in commemorative
nationalistic artefacts.

As Edward McCaughan argues, murals not only represented the
popular classes, but were also "key to representing Mexico as a mestizo
nation, proud of its indigenous past and disgusted with the slavish
imitation of all things French that had characterized the Porfirio Díaz era"
(2002: 101). Moreover, the iconography of a new Mexican society also
incorporated a culture of modern industrialism through images of
technological apparatuses and used techniques appropriated from popular
and traditional art. Muralists created a pedagogical view of revolutionary

Mexico as both a mestizo nation and a modern space for the new human being belonging to the masses. Their work also conveyed more subtle information such as the privileging of a gendered hierarchy, with a central male dominance and a subordinated female sphere; no other gender paradigm held any sway in the period concerned. Murals are fundamental to working out the puzzle of the identity of the Mexican revolution, and the structures defining nationhood, citizenship, and gender dominance which flowed from it. Murals revisited and reviewed Mexican history and the collective national memory to trace a cohesive social future. But there were other forms of artistic expression in the period which also deserve our attention.

While Leonard Folgarait recognises the inevitable presence of muralists in scholarship surrounding Mexican art, he nevertheless queries it:

> Some explanation is necessary of the narrow choice of murals and painters. What has happened to the under- and unrepresented dozen or so other protagonists of this history worthy of critical attention, especially as including them would serve as a corrective [...] to the elitelore and canonization that forever hovers around "the big three" [the muralists Rivera, Orozco, Siqueiros]? (1998: 8)

It is my contention that in this particular period, the androgynous images in the art of Abraham Ángel (1905-1924)—another of the artists whose work is under-represented in the way Folgarait describes—have social relevance as well as cultural value. Additionally, Ángel's biography as an artist adds to our understanding of the period. The construction of Abraham Ángel as a protagonist in the artistic environment of early twentieth century Mexico reveals contentious areas in the narrative of the Revolution, a revision of the social "normality" as well as the role of the values assigned to different artistic trends in negotiating the meanings of a national art. In this sense, I argue that Ángel's performance—as a totality of his biographical self and his oeuvre—is a bridge toward the consolidation of modernity; his androgynous images relate to a state of human kind described not only during this historical epoch, but also later on by Latin American writers such as José Lezama Lima and Clarice Lispector, among others (Latinez 2008).

As *los cuarenta y uno* demonstrated, modernity in Mexico had given rise to a kind of voyeuristic curiosity with respect to gender deviance. Indeed, during the last three decades of Porfirio Díaz's government an interest in homosexuality as psychological deviation combined with the isolation of the practice as criminal, and the theme was covered by the

newly industrialised media through the increasing number of newspapers and magazines vying for the attention of the growing consumer base. Among them were the widely popular magazines *El Imparcial* (1896-1914), *El Mundo*, and *El Mundo Ilustrado*.

Soon, the urban population was exposed to modern ideals which prescribed not only revolutionary industrial progress but also moral and behavioural norms that echoed clearly the recent pre-revolutionary era. As McCaughan states with reference to representations of homosexuality and Orozco's cartoon "such imagery [...] combined with the efforts of filmmakers, writers, criminologists, political leaders, and others in the first half of the century to associate Mexican culture, and thus power, with the construct of heterosexist, phallocentric machismo" (2002: 103). In fact, when we take into consideration that it was published ten years after the Revolution, an exhaustive look at the genealogy of Orozco's cartoon reveals a more complicated picture. The image virulently attacks not only individual subjects but also gender indeterminacy when linked to artists; in the very conservative context of the Porfiriato this would not be a surprise. But the publication of Orozco's cartoon in the leftist magazine *El machete*—the voice of SOTPE, the Sindicato de obreros técnicos, pintores, y escultores—where revolutionary ideas of change and freedom were at stake, highlights the confrontation between gender deviance and a national ideology of social justice, and complicates our understanding of the historical moment. The antagonism between progressive ideas about some aspects of human experience and more conservative ideas about gender can also be seen in the work of Latin American intellectuals such as the Uruguayan José Enrique Rodó, the Nicaraguan Rubén Darío, as well as Mexicans Justo Sierra, José Vasconcelos, and Antonio Caso among others.

The idea of the androgynous being as a symbol of a turning point in the construction of a new society was not unknown in those revolutionary days. Adolfo Best-Maugard, the most important figure within the pedagogy of Mexican art in the 1920s and 1930s, refers in *The Simplified Human Figure* to a subject who "has aroused the sleeping woman in himself and has become thereby a polarised human being. From this interaction new perceptions, new faculties, new powers arise" (1936: 196). By the 1940s the conservative environment which had been established by then squeezed out this new man to whom Best-Maugard looked for progressive potential in human affairs and in the legacy of the Revolution. And by the 1950s, polarised genders as opposed to ambiguity and androgyny were once again the order of the day. For example, in his famous essay of 1950, *El laberinto de la soledad*, Octavio Paz exploits binary gender to explain Mexican identity in terms of power, possession,

hegemony, and subjugation. He regards the national subject as a psychological construction in which *mexicanidad* is built on violent male possession, the oppression of the female, and the opposition between a patriarchal active sexual role and a weak and feminine passive role that connects with images of the "rajado" and of the homosexual (Paz 2001: 174-75). For Paz as for the muralists, there is no place for androgyny. Both Best-Maugard and Paz were influential intellectual figures connected with the political apparatus of the Revolution, and, from Best-Maugard's holistic view of gender to Paz's dualism, their opinions reflect the struggle over gender and sexuality in defining Mexican identity.

Classical understandings of androgyny were rediscovered by the modernists and Karen Kaivola describes androgynous agency as a "fluctuation of gender" (1999: 235) which occurs during periods of struggle when the construction of a new society (political or symbolic) is contested. For Kaivola, androgynous characters assume a central space in the debate over culture and social teleology where they are not static but rather dynamic figures who represent gender dichotomy or fusion within a specific historical and anthropological context. If, as she mentions, society expresses concerns about the nature of androgyny which provokes both dreams and fears (1999: 238), this concept helps us to identify a crucial aspect of the negotiation of the identity of a new man that oscillates between a gendered fusion and a patriarchal heterosexuality. Kaivola specifies the complex and contentious net androgyny casts due to the fact that it invites us "to look for its structural connections and disconnections with other intermediate forms that seem to undermine epistemological distinctions, whether those distinctions arise from racial, sexual, or national difference" (1999: 239).

Sifuentes-Jauregui notes that the event of *los cuarenta y uno* in 1901 is the materialisation of "posing," which "is an affect of gender that may destabilise the security of stereotypical masculinity; whereas transvestism is an effective debunking of gender codes" (2002: 21). It is significant that *los cuarenta y uno* is a visual concretisation almost identical to Orozco's 1924 cartoon in *El machete* where individuals are portrayed as criminalised outsiders in a world that rejects them. In direct antagonism, both Kaivola's androgyny and Sifuentes-Jauregui's transvestism translate into subjects' performances that reject a national teleology built on an articulation of heterosexuality and masculine power, and challenge its quest for revolutionary identity. To understand particularly the role of androgyny in the construction of national identity and gender negotiation, it is helpful to consider the current global economy and the study of management. As Larin McLaughlin states, recent decades have seen the

construction of a type of management class able to cross not only geographical but also cultural and national boundaries without antagonism. This boundary includes gender since "good managers learn to transgress the boundaries of their own gendered identity in order to maximize profits and productivity" (1999: 189). McLaughlin identifies three types of approach to androgyny or non-normative gender behaviour: firstly, *co-presence*, which situates the subject's behaviour according to circumstances; secondly, *fusion*, in which the blended subject innovates but is difficult to identify; and thirdly, *transcendence*, where "Androgyny indicates not a blend of masculine and feminine characteristics, but an absence of them, and where androgynies are perceived to rely on neither masculine nor feminine behaviours and where [quoting Lorenzo- Coldi] 'Their assumed original ways of thinking suggest the likelihood of the foundation of a new society'" (McLaughlin 1999: 193). It is this third category that is useful in approaching androgyny in the Mexico of the 20s and 30s. McLaughlin's description of transcendence sheds light on how gender deviance was accommodated within an obstructive and contentious social environment such as the one supposed by the Mexican revolution. Using this perspective on androgyny in a cultural reading of Abraham Ángel's work, *transcendence* reveals mechanisms for negotiation with gender homogeneity and hegemony and opens up a pathway for alternative expressions of gender.

Although critics agree that Abraham Ángel is one of the most significant artists of his time, there is no organic reading of his art. The substantial works about him are Luis M. Schneider's, Olivier Debroise's, and a catalogue which includes articles prepared by the Dirección de Patrimonio Cultural del Estado. Schneider's innovative study highlights the growing importance of Ángel's art, which, he suggests, "colabora a configurar desde dentro la relevancia de una creación de frescura primitiva, juvenil, pero que, sin embargo, revoluciona" (1995: 51). [1] Moreover, Ángel's œuvre and the story of his life and work represent a marginal but significant Mexican history and resemble a sort of unfinished and fragmentary Bildungsroman.

One can see the artist's biography as a kind of novel of adolescence whose narrator can be figured as the national collective. It allegorises the development of a nation's identity where the adolescent, as a general category, embodies the future citizen, one who will embrace the hopes and the ideals of a people. Ángel's story reveals a very young artist of great

[1] "Adds to the configuration from within of the relevance of a creation marked by primitiveness freshness, juvenile, yet also revolutionary."

promise whose life and creations defied the patriarchal environment that surrounded him and which included his family and their attitudes toward him, towards his gender presentation, and his professional interests alike. Moreover, the peak of his artistic production corresponded with the time when he shared his life with the prominent Mexican artist, Manuel Rodríguez Lozano. It was precisely during this interval between 1923 and 1924 that Ángel painted approximately twenty-five works, comprising almost his entire oeuvre as can be seen from Luis Schneider's attempt thoroughly to catalogue the artist's output (1995: 51). The works concerned are mostly portraits and rural landscapes with canvases that range in size between 30 by 22.5 cm for *Concepción* (1923) and 221 by 122 cm for *La indita*. When Ángel died in 1924, apparently as a result of suicide, Manuel Rodríguez Lozano published a leaflet in which a number of intellectuals and artists commemorated his life and work. Thanks to this leaflet we also know of the existence of a number of works which remain uncatalogued and whose whereabouts are unknown.

Ángel's painting depicting androgynous figures in the midst of rural Mexican landscapes suggests a particular political narrative in a context in which mural painting takes centre stage within the official scenario. Although not well known in Mexican culture, he was celebrated among his contemporaries—particularly those belonging to Best-Maugard's school of painting—as a unique and mature visionary of Mexican reality, one who redefined academic perspectives. Of particular importance is the fact that the narratives remembering him also create a hybrid subject. The different testimonials which describe him define an identity that goes even beyond mestizo; he is said to be Argentinian, half mulato and half Indian, descended from Scots, a feminine subject (even a mother), happily in love, depressed, a victim, a genius, an adolescent, and a person sometimes with and sometimes without a patronymic surname, which was in fact Card and which he was afraid to use (Schneider 1995: 36). These micro-narratives recover him from oblivion but ironically, at the same time, they place him in the margin of a hegemonic narrative about the Revolution's *mexicanidad* where there is no place for him as an agent.

Ángel's work originated from the precepts of his first maestro, Best-Maugard, who has been accurately described by Anita Brenner as:

> The first pedagogical-artistic experimenter, [who] went digging in archaeological collections and bargaining at fairs, and burdened his elegant self with many pots. [He] explained that a few very simple lines and curves composed the apparent intricate native decoration, moreover according to certain principles the result of long development, good eyesight, love of surfaces and forms, and earthy craftsmanship. (1929: 237)

Although far removed from the conceptual frame of the mural project, Best-Maugard's technique and his philosophy of Mexican identity complemented Vasconcelos's plan for a nationalistic Revolutionary art. As Olivier Debroise explains, when José Vasconcelos assumed the role of Secretary of Education in 1921, with his quest to apply his ideas about the Revolution to the arts, he embarked Mexico on a "visual adventure" committed to finding and portraying the spirit of the Mexican people, the like of which the country had never seen before in terms of its massive scale and levels of organisation (Debroise 1994: 20-23). At the same time, Best-Maugard's mystical approach functioned as the cornerstone of Ángel's work. In conjunction with Best-Maugard's ideas about national artisanship within revolutionary Mexico, Ángel's paintings offered an androgynous solution to the political uncertainty toward gender seen in the construction of a new society as depicted by mural painting.

During Ángel's life, few commentaries on his work were published. However, by the time that David Alfaro Siqueiros was finishing *Los elementos* (1922), and Diego Rivera was completing *La creación* (1923)— powerful murals which were appreciated in the Escuela Nacional Preparatoria—Abraham Ángel was already well known among the artistic Mexican community. This recognition was due to very distinctive attributes, namely his precocious talent, his delicate and naive lines, his animated figures drawn from popular iconography and his use of vivid colours. Despite his recognition, Ángel's work did not enjoy any official status. The causes for this could vary from the fact that, like Best-Maugard and Rodríguez Lozano, he was detached from political power and relationships, to the notion that his artistic vision was far from the official imaginary. Nonetheless, there was a consensus in Ángel's own time that national art, like his own, proclaimed values of spontaneity and seeming artlessness. Nowadays, he is all but forgotten and overlooked. Some of his works are missing, few theoretical approaches to his oeuvre have been published, and the place accorded him within the history of Mexico's revolutionary art is a minor one, even though he was certainly a political presence by the time Rivera wrote his protest against the academy in 1923, along with figures such as Antonio Caso and Pedro Henriquez Ureña. Ángel's signature is there among those of others who wanted to underline the national character of the new art in terms which asserted that painting was an expression of Mexican nationality.

Ángel's paintings mirror the artist's personal biography; in some ways they are clear, easy to contemplate, and are luminous, yet they are also enigmatic. His minor works such as *La bañadora* (1921), *Concepción*

(1921), *Y la serpiente, furiosa* (1922), and *Sigue adelante* (*autorretrato*) (1924) reflect his particular cosmology and share Best-Maugard's precept of oscillatory movements bringing to the design tones similar to those of popular ceramics and carved wood from central Mexico. Central figures vary, but people dominate these canvases. *La bañadora* looks very simple and its somehow incomplete figure shares with *Sigue adelante* the forms of naked male and female bodies. *Concepción* and *Y la serpiente* follow the same concepts in terms of lines but the world that surrounds the bodies they depict relates to folk tales rather than to nature. All of these works carry sexual connotations that connect with a world of dreams; Schneider says aptly of *Y la serpiente* that "es una acuarela de ritmo lujurioso" (1995: 37).[2] Although simple and primitive, these works convey a re-reading of the popular imaginary through a modernist approach; pagan figures including animals and flowers create a hybrid conceptualisation of a dream world that collides with a mundane urban spectacle. This strong sense of hybridism and primitivism can also be found in the literary work of the Nicaraguan poet Rubén Darío. These reminiscences on mythology in urban landscape and the strong presence of androgynous figures contrasting with nationalistic popular images actually call for a new order within the political period.

Another level of Ángel's artistic capability is visible in the format of works such as *Autorretrato* (1923), *La india* (1923), *El cadete* (1923), and *La chica* (1924). Traditional large format portraits, these works share with those discussed above a main subject positioned in the centre of the image, this time looking obliquely at the spectator with a sort of smile. Male and female figures look very similar and, with the exception of *El cadete*, they are surrounded by daylight. There is strong evidence that Ángel was very meticulous and committed to creating organically and the level of his productivity during these two years clearly demonstrates this. As a representation of the artist *Autorretrato* can be positioned as the axis of the works in this group and unifies in its corporeal characteristics and background several attributes common to these four paintings. We can speculate that *Autorretrato* is a blend of subjectivities that results in an androgynous subject.

Abraham Ángel's lines and attributes are far from the goals of mural art and the political strategy of the state. In the 1921 issue of *Vida Americana* Siqueiros asks all "indoamericanos" to embrace traditions and monumentality in the arts.[3] He states that "now we draw silhouettes with

[2] "It is a watercolour with a sexual rhythm."

[3] "Indoamericano" was the preferred word for Latin American intellectuals mainly during the 20s: the term Indoamérica was widely popularised by Peruvian leader

pretty colours; when we model we are infested in skin-deep arabesque, and we forget to conceive the great primal masses—cubes, cones, spheres, cylinders, pyramids, which should be the girders of all plastic architecture" (quoted in Brenner 2002: 241). As Virginia Steward suggests, Rodríguez Lozano would clearly oppose muralist goals as "The rise of a concept of art that required gigantic size and social meaning" (1951: 45). However, in the middle of this discussion, Abraham Ángel's achievement cannot be neglected among the artistic idioms of that moment in time. Best-Maugard, for example, defines his work as "a perfect expression of the popular spirit of Mexico"; Mérida thinks that Ángel's style belongs to an "Indo-American art"; Rivera adds that he was the painter of Mexico (all quoted by Brenner 2002: 239). Rodríguez Lozano strikes the right balance in terms of national recognition, commenting that it was "too bad [Ángel] didn't get to do any walls" (quoted in Brenner 2002: 239). Overall, his art needs to be articulated within the frame of the Revolution, art with a national definition, and the ideals of a cosmic race.

I argue that Ángel's art is conceptually a political answer to mainstream images and the dissemination of gender differences during the first decades of the Revolution and later. Nonetheless, the spirit of scandal that made other subjects suffer prosecution did not touch his work and life; this is symptomatic of a state of negotiation that would locate places for different gender performances in and out of a national revolutionary stage depending on political importance, as in the case of Manuel Rodríguez Lozano, for example. At the same time, ironically, within the Mexican national narrative Ángel's position (still somehow a marginal one) may confirm the notion that standardised pictures of non-heterosexuals as others "have served to define and confirm the heterosexuality of the center" (Bertens 2008: 181). Ángel's art and life themselves are revealing, as is the secondary literature about him. Together they uncover unexpected views towards gender formation, androgyny, apprenticeship, national narratives and the role of art in constructing them, and conceptions of the Revolution's new human being.

Raúl Haya de La Torre (1895-1979), close ally of the Mexican Revolution and Diego Rivera.

WORKS CITED

Azuela, A. 1993. "El Machete and Frente a Frente. Art Committed to Social Justice in Mexico." *Art Journal* 5 (1): 82-87.

Benjamin, T. 2000. *La Revolución: Mexico's Great Revolution as Memory, Myth and History*. Austin: University of Texas Press.

Bertens, J. 2008. *Literary Theory: The Basics*. Routledge: London.

Best-Maugard, A. 1926. *A Method for Creative Design*. New York: Alfred A. Knopf.

Brenner, A. 2002. *Idols Behind Altars*. New York: Dover .

Buffington, R. 2003. "Homophobia and the Mexican Working Class, 1900-1910." In *The Famous 41. Sexuality and Social Control in México, 1901*, eds. R. Irwin, E. J. McCaughan, and M. Nasser, 193- 226. New York: Palgrave.

Debroise, O. 1994. *Figuras en el trópico, plástica mexicana, 1920-1940*. Barcelona: Océano.

Folgarait, L. 1998. *Mural Painting and Social Revolution in Mexico, 1920-1940*. Cambridge: Cambridge University Press.

Irwin, R. and E. J. McCaughan and M. Nasser. 2003. "Introduction. Sexuality and Social Control in Mexico, 1901." In *The Famous 41. Sexuality and Social Control in México, 1901*, eds. R. M. Irwin, E. J. McCaughan, and M. Nasser, 1-19. New York: Palgrave.

Kaivola, K. 1999. "Revisiting Woolf's Representations of Androgyny: Gender, Race, Sexuality, and Nation." *Tulsa Studies in Women's Literature* 18 (2): 235-261.

McCaughan, E. 2002. "Gender, Sexuality, and Nation in the Art of Mexican Social Movements." *Nepantla: Views from South* 3 (1): 99-143.

McLaughlin, L. 1999. "Androgyny and Transcendence in Contemporary Corporate and Popular Culture." *Cultural Critique* 42: 187-215.

Paz, O. 2001. *El laberinto de la soledad*. Madrid: Cátedra.

Rivera, D. and A. Ángel, et al. 1923. "Protesta." *El Universal Ilustrado*: 19-24.

Schneider, L. 1995. *Abraham Ángel*. México: Universidad Autónoma de México.

Sifuentes-Jauregui, B. 2002."Nation and the Scandal of Effeminacy: Re-reading Los '41'." In *Transvestism, Masculinity, and Latin America Literature: Genders Share Flesh*, 15-51. New York: Palgrave.

Steward, V. 1951. *45 Contemporary Mexican Artists. A Twentieth-Century Renaissance*. Stanford: Stanford University Press.

CHAPTER TEN

FROM POP TO POPULISM: JESÚS RUIZ DURAND'S AGRARIAN REFORM POSTERS

TALÍA DAJES

The image in Fig. 10-3 represents a finger that projects outwards from the middle of the frame, pointing at us, the viewers. From here, our gaze is then drawn downwards and to the left where we then find the strong arm and the hand of the body to which the finger belongs. The bright yellow background is bordered by contrasting red irregular oval shapes while, at the centre of the frame, behind the hand, there is a white splash resembling the caricaturesque representation of an explosion. The use of saturated, primary colours and defined black strokes—the drawing style reminiscent of comic books—as well as the offset printing technique employed to reproduce the image in poster format were typical characteristics of 1960s American Pop Art and indeed, at first sight, applying this definition to Fig. 10-3 seems entirely apt. However, this image is also something else entirely distinct from American Pop Art and if we look more closely at the text printed on the rectangle above the graphic, we begin to see why:

> Grandes cosas están pasando. No se te vayan a pasar. El proceso peruano necesita tu participación revolucionaria para alcanzar sus metas. Cada paso que tú no das es una demora para la revolución. Acuérdate que la reacción no descansa ni de día ni de noche Petróleo, Reforma Agraria[...] Ley de Expropiación Forzosa de Terrenos [...] Nacionalización de las Telecomunicaciones [y del] Comercio Exterior del Cobre[...] la Revolución se ha puesto en marcha y mucho depende ahora de tu actuación. [...] Compréndela y ayuda en el esfuerzo al nivel de tu propio trabajo: el colegio, la fábrica, la hacienda, la oficina, la universidad, donde más puedes ayudar es en el sitio en que estés porque está en todas partes la Revolución y la Revolución está llegando a todas partes. Únete a las Brigadas de apoyo de la Reforma Agraria, o forma un Comité de Apoyo a la Revolución en tu centro de estudio o de trabajo.[1]

[1] "Big things are happening. Don't let them pass you by. The Peruvian process needs your revolutionary participation to reach its goals. Every missed step is a setback for the revolution. Remember that reactionary forces never stop working. Oil, Agrarian Reform [...] Forced Land Expropriation Law [...] Nationalisation of

Repeated references to "the revolution" signal the process set forth by the Gobierno Revolucionario de las Fuerzas Armadas (Revolutionary Government of the Armed Forces) which was established in 1968 following the coup d'état which overthrew Fernando Belaúnde, the incumbent president of Peru. In the wake of the Cuban Revolution, this similarly military-led revolution, headed by General Juan Velasco Alvarado, sought dramatically to alter the institutional and cultural structures of Peruvian society.[2] The Armed Forces' project strove to breathe new life into the political, economic, and cultural sectors of Peruvian society that had been continuously marginalised since the Wars of Independence (1820-1826) and even before this. The emergence of a post-Independence republican project in the nineteenth century failed to erase the discrimination against and marginalisation of indigenous peoples, something that had been a marked feature for the entirety of the three centuries of Spanish colonial rule. Despite declaring equality for all Peruvians, in practice this new national ideal actually left the majority— the Quechua speaking indigenous population—on the periphery of the newly formed national community.[3]

The nineteenth century republican project—conceived by a mainly white, Creole, Spanish speaking, urban, Catholic and educated elite— claimed as its conceptual foundation the tenets of positivism and of an economic liberalism modelled after the nationalist ideologies which were then current in Europe. The civilised elite took for granted that the values of republicanism and democracy were shared by its own kind but saw the indigenous population as a barbaric and ignorant mass which might threaten its project without appropriate education. Thus, the image of the Andean indigenous peasant was utilised symbolically by hegemonic discourse not to represent a national subject, but instead to call into being a potentially violent adversary to the original national-republican project.

Telecommunication [and] Copper Foreign Trade [...] the Revolution is set in motion and much depends on your actions. The revolution moves forward and has its own internal workings. Understand it and aid in its efforts in terms of your own work: at school, at the factory, at the hacienda, in the office, at the university, your help is most valuable wherever you are, because the Revolution is everywhere and the Revolution is reaching every place. Join the Brigades in support of Agrarian Reform or organise a Committee in Support of the Revolution at work or at school."

[2] The GRFA was not a project devised by a *caudillo* style strongman, but jointly by the three corps of the Peruvian Armed Forces with the Army as the predominant branch. In this sense, it can be described as an institutional revolution.

[3] For a study of early republican configuration in Peru and the separation of the "two republics" see Mark Thurner's *From Two Republics to One Divided* (1997).

The GRFA presented itself as a force which would put right the wrongs done to the peoples of Peru both prior to independence and subsequently. In typical populist fashion, therefore, it exercised power against the interests of the established elite. As an oppositional movement, however, the GRFA adhered closely to the conceptual and practical limits offered by the original nineteenth century model. That said, the manner in which the GRFA deployed images of the indigenous peasant was in marked contrast to the use made of such representation by earlier republican movements. The GRFA actively incorporated the indigenous population as a primary resource for state propaganda, via specific discursive practices and strategies. By doing this it questioned the historical concept of national identity, provided a degree of official visibility for subjectivities that had been kept on the margins for centuries, and it opened up new possibilities for social criticism and activity.

The GRFA's approach to culture and the political tenor of its discourse are reflected in its mass communication campaigns. For instance, the poster reproduced in Fig 10-3—one of a larger series—was designed by artist Jesús Ruiz Durand in 1969 while he was working for the Peruvian government's Dirección de difusión de la Reforma Agraria (Agrarian Reform Media Office). The aim of this governmental agency was to publicise the scope and objectives of the recent Ley de Reforma Agraria (Agrarian Reform Law), which was intended to bring about a major reorganisation of the agrarian system. Among other things, the law was intended to effect an egalitarian redistribution of land. This reform—as well as those foreseen in the fields of education, workers' rights, and the economy—was central to the populist reformist program designed by General Juan Velasco's military government and thus its message needed to be appropriately disseminated.

As well as communicating specific information about the Agrarian Reform Law, Ruiz Durand's poster ties into another image from the same series (see Fig. 10-1). In this image the subject's clothing and the use of the Quechua word *jatariy* (meaning "get up" or "stand up") refer the viewer to an Andean context and connect with Velasco's official *indigenista* policies and the GRFA's populist, nationalist, and anti-imperialist ideals.[4] Seen alongside each other, these two posters indicate some of the complex tensions present during the rule of the GRFA. The posters' clear debt to the style and form of Pop Art, for example, leads one

[4] The complete caption reads "Tu estas con la revolucion!! [sic] La Reforma Agraria te está devolviendo la tierra que te quitaron los gamonales ¡Jatariy!!!" ("You are with the revolution. The Agrarian Reform is giving you back the land that the landowners took from you. *Jatariy!*")

to question how it was that a revolutionary government which defined itself as anti-imperialist would then use a distinctly American aesthetic in order visually and culturally to represent its cause. In the same way that Roy Lichtenstein appropriated comic book images in general, and DC Comics heroes and heroines in particular, Ruiz Durand takes popular cultural forms from the United States—specifically DC's justice seeking superheroes—and translates them into an expression of Latin American Pop Art in which the wrongdoer is United States imperialism. Indeed, the composition of both posters bears a striking resemblance to a well-known American image: Uncle Sam. The red, white, and blue clad figure of Uncle Sam not only represents the homeland but actually embodies the patriotic emotion that the image strives to arouse in the citizens so that they feel compelled to fight—sacrificing their own lives if necessary—for their country. This allusion to a personification of the United States which urges its citizens to enlist in the army during wartime is certainly an extraordinary choice for a government that was trying to nationalise as many branches of industry as possible in order to reduce the control that the United States exerted over the Peruvian economy and thus to re-configure the paradigm of Peruvian national identity.

Reflecting on Durand's posters, then, allows us to address the link between politics and aesthetics and to re-think the definitions of those terms in reference to Peru. Moreover, the posters' underscoring of the term *Revolución*—which appears repeatedly in the captions—gives us pause for thought about how the idea was conceived in real terms within the project. Additionally, these posters deal with the concepts of nation and the national in a way that sees the semantic field of these terms in flux and rendered open to renegotiation. In the GRFA's official discourse we encounter a rigid nationalism and a reform-oriented populism that sought to fulfil the goals of a program dedicated to the transformation of the country's social structures. Jesús Ruiz Durand's artwork, however, constructs a space in which the assumptions that underpin the scope of the national, and of what is conceived as authentically Peruvian, are not only questioned but also effectively destabilised.

CRISIS AND UNREST

According to sociologist Julio Cotler, the Peruvian political crisis of the 1950s and 60s was generated by the social contradictions that emerged from the process of capitalist penetration initiated at the end of the nineteenth century (1993: 4-13). Popular protest against an oligarchy that had perpetuated its hold over power since the dawn of republicanism not only became more keenly felt but also became more socially inclusive.

Lower and middle class sections of the population which historically had a very limited or even non-existent political voice were now starting to become strongly engaged in social movements. Government control of this growing faction through traditional disciplinary methods was becoming impossible; to maintain order it became imperative to take the momentum being generated by popular participation and accommodate it within an institutionalised state practice.

Simultaneously, popular demand for more effective redistribution policies led to the government adopting measures designed on the one hand to end Peru's foreign dependence and, on the other, to nationalise the economy. This reformist paradigm imposed from above was what drove Peruvian politics in the 60s. Its fundamental nature was captured—along with the renewed nationalist and anti-oligarchic sentiments—by the political program of Fernando Belaúnde who was elected president in 1963. However, the Belaundista initiatives ended up being crushed as a result of political tensions inside the government and among opposition parties. Not only was the government itself seen to be failing but coalitions among its political opponents were also coming apart. In addition to the frustration generated amid those social groups directly affected by these failures, another consequence of the governmental collapse was that for some sectors of the population radicalisation suddenly became a completely viable option (Cotler 1993: 16-17). Movements associated with the revolutionary left were able to take advantage of the new political circumstances and started their organising efforts, especially among students and intellectuals, two constituencies that had up until then been co-opted by APRA. The new members of these radicalised leftist groups were the ones who would in 1963 and 1965 make up the core of the organisations that embarked on two different guerrilla experiments.

REVOLUTION FROM BELOW / REVOLUTION FROM ABOVE

The first of these experiments, led by Hugo Blanco, involved the takeover of land by peasants in La Convención Valley in Cusco. The second one, carried out by the Movimiento de Izquierda Revolucionaria (Revolutionary Left Movement)—a spin-off of APRA Rebelde, a faction composed of disgruntled members of the original APRA—and in the same area of the Andes was openly characterised and self-identified as radical and, as such, developed a *foquista* guerrilla strategy inspired by the Cuban experience of 1959.[5] According to Julio Cotler, when faced with this

[5] Here I am referring to the revolutionary practice associated with Che Guevara, and later theorised by Regis Debray according to which an insurrectional *foco* (a

situation, and in order to "prevent a popular uprising", the army responded with a military offensive that ended up quashing the guerrilla insurrection (1993: 17). As Cotler goes on to remark: "The neglect of these problems by the 'political class' convinced the military intelligence that a democratic government could not resolve the critical national security issues" (1993: 17). It was against this background—with an army that supported the idea of a reformist government as the only solution to the country's problems—that the military was to articulate an institutional response that would profoundly affect the political landscape and leave a legacy that continues to be felt to the present day.

Belaúnde's political base—the middle class, primarily, but also workers and peasants—was weakened by his government's inability to fulfil the myriad promises of reform and change that had brought him to power in the first place. Along with political turmoil, there was also an economic crisis brewing. This was "evident in the stagnation of traditional exports and the simultaneous increase of both industrial and food imports" and resulted in monetary devaluation and, more importantly, in further impoverishment of the less well-off sectors of the population (Cotler 1993: 17).

Politically, the economic crisis brought about a reorganisation of the working class and the left, two sectors which had moved away from APRA since its deal with the politically conservative block which also supported economic free trade. On the other hand, Belaúnde's legitimacy began to be questioned because his government was still unable to contain—or respond to—the growing social unrest. The organised population seemed—at least to the government and the military—ready and more willing than ever to rise in order to carry out an overthrow of the hegemonic order. It was precisely this possibility of a popular uprising which drew the attention of commanding officers in the army and which led them to decide to take over the institutions of government. With this move, the army managed not only to depose a government perceived as illegitimate and to establish in its stead the GFRA, but also managed to silence the emerging popular protest through the institutionalisation of a renewed revolutionary sentiment at grass roots level.

This moment signals the beginning of what would eventually be known as the first phase of the GRFA (1968-1975), led by Velasco.[6] An

small guerrilla vanguard operating in the countryside) can actually create the conditions for a revolution, instead of having to wait—as traditional Marxism posits—for those conditions to be produced by a structural socio-economic logic.

[6] The second phase of this government (1976-1978) involved Velasco's removal from office and his replacement by General Francisco Morales Bermúdez. This

initial series of reforms took place very early in the military government, with the explicit intention of promoting "superiores niveles de vida, compatibles con la dignidad de la persona humana [para] los sectores menos favorecidos de la población, realizando la transformación de las estructuras económicas, sociales y culturales del país" and of making the revolution an irreversible process (Schydlowsky and Wicht 1993: 99).[7] It is the putatively revolutionary character of the military regime installed in 1968 which needs to be examined more closely.

INTERPELLATING NATIONAL IDENTITY

General Velasco's speeches together with official statements of government goals, as set out in decrees published in the Estatuto del Gobierno Revolucionario de la Fuerza Armada, form a completely cohesive and seamless discursive whole.[8] However, if we turn our focus to the GRFA's production of visual culture—and this means largely Jesús Ruiz Durand's Agrarian Reform posters—we gain a subtler, more nuanced approach to the populist revolutionary politics of the time.

The idea of instituting an agrarian reform did not originate with the GRFA. In fact, agrarian reform had been one of the previous government's proposals and had also been debated as a key source of contention by the popular movement's factions. Nevertheless, the GRFA administration was the first to develop a project for agrarian reform into concrete policies that would bring about a shift in land ownership and thus in the dynamics of power. The GRFA took over the land-owning elite's big estates and essentially transferred the properties and their control to the peasants who actually worked the land.

The central message of the Ley de Reforma Agraria was summed up by two government slogans that were very widespread during Velasco's tenure as head of the GRFA: "Campesino, el patrón ya no comerá más de tu pobreza" and "La tierra para quien la trabaja."[9] In a way, Ruiz Durand's agrarian reform posters also convey these ideas as well, but they also seem

change in power meant the dismantling of several of the populist reforms enacted by Velasco as well as a move towards a properly neoliberal model.

[7] "Superior living standards, compatible with human personal dignity, [for] the least favoured sectors of the population, changing the economic, social and cultural structures of the country (Decreto Ley número 17063—previously Decreto Ley 1—of the Estatuto del Gobierno Revolucionario de la Fuerza Armada, October 3, 1968).

[8] Velasco's speeches are collected in *Velasco, la voz de la revolución* (1972).

[9] "Peasant, the landowner will not feed off your poverty anymore" and "The land is for those who work it."

to suggest a dualistic and contradictory position towards the meaning of this particular putatively revolutionary project: on the one hand the posters evoke the reforms as something emanating from a liberatory or even subversive impulse and, on the other, they reference the process of change as a disciplinary force that is exercised strictly from power. Both the revolution and the agrarian reform were organised by the government but they were conceived as mechanisms the population could use to gain greater political control and to channel the spirit of rebellion that had been unleashed by successive administrative failures. The posters construct a complex narrative through their images that transcends the unambiguous pamphleteering often associated with the medium.

Direct and simple, posters have traditionally been used for political propaganda purposes as was the case in China during Mao's Cultural Revolution and also in Cuba following the 1959 revolution. These events called for clear-cut messages spelled out in block letters, bright colours, sharp images, and bold lines. Certainly, these elements are all present in Ruiz Durand's work but there is also a further dimension to his agrarian reform posters, namely the inclusion in their content of the Andean peasant, one of the most marginalised subjects of Peruvian society. In Ruiz Durand's posters, the Andean peasant is not only included, but also takes centre stage. Historically, the hegemonic discourse of the lettered Criollo class represented the non-Spanish speaking indigenous population of Peru as outsiders, and cast them as the essential other. Constructed by hegemony as lazy and submissive, the Andean peasant was thus denied the possibility of any claim to an independent political subjectivity. By contrast, the peasant in Ruiz Durand's poster is looking directly at his interlocutor, pointing at him, and calling him to action. The subject Ruiz Durand calls into being here, then, is clearly characterised as one who possesses a degree of autonomous agency.

However, state hegemony and control are not completely absent from the image and their presence is felt through what we could identify as the Althusserian concept of interpellation. Althusser stated in "Ideology and Ideological State Apparatuses" that interpellation is the operation through which ideology "'acts' or 'functions' in such a way that it [...] 'transforms' [...] individuals into subjects" (1971: 174). State institutions—mainly the school, the Church, and the Army—work to "ensure *subjection to the ruling ideology* or the mastery of its 'practice'" (1971: 133) to make sure that everyone performs his or her particular task and that every subject remains in his or her assigned place. Subjects—and subjectivity—then are the products of the dominant ideology in which individuals live and not just an assertion of the self through the conscious

and subconscious mind. Althusser illustrates the idea of interpellation with the following seemingly mundane example:

> That [...] operation which I have called interpellation or hailing [...] can be imagined along the lines of the most commonplace everyday police [sic] (or other) hailing: 'Hey, you there!' Assuming that the theoretical scene I have imagined takes place in the street, the hailed individual will turn round. By this mere one-hundred-and-eighty-degree physical conversion, he becomes a subject. Why? Because he has recognized that the hail was 'really' addressed to him, and that 'it was really him who was hailed' (and not someone else). (1971: 174)

In much the same way that Althusser's policeman hails or summons his subject, the pointing finger in both posters—more efficiently in the first one—interpellates the viewer. The policeman's "Hey, you there!" is now a visual cue that signals the individual to recognise himself a priori as a subject of state ideology. The first poster's text also emphasises this idea through the use of the Spanish personal pronoun "te" (the singular "you" in English) which gives the impression of directly addressing each viewer individually, stressing the personal obligation each interlocutor should have with the revolution.

Along this same line, the posters appear to make evident an authoritarian notion of social change, urging the population not to stage their own uprising but instead to support and follow a revolution that is already underway. This "revolution from above" originated by and from state power seeks to replace one hegemonic structure with another— giving political power to those who were powerless—i.e. the lower classes and indigenous peasants depicted and referenced in the posters—instead of dismantling the set of social, cultural, and economic structures that make such vertical power relations possible. Yet, paradoxically, in this particular moment the official stance of the state was one of opposition to most of the social constructions and discursive practices that had been perpetuated in Peruvian cultural tradition since the founding of the republic, especially those that tended to exclude the lower classes and indigenous peoples. This objective becomes clear when we review Velasco's many proposed and enacted reforms designed to take down the structures which supported the hegemonic Criollo discourse: viz. making Quechua an official language; assigning stock shares to industry workers; restructuring the provision of education so that access to schools would not be the exclusive right of any one social class. However, even if the GRFA was serious in its endeavour to dismantle the structural conditions that made exclusion, racism, marginalisation, and poverty possible in the country, at the same

time it failed to question the constructed nature of national identity and nationhood. Attachment to the national ideal became one of the obstacles that prevented the GRFA's populist reformism from developing into a more radical revolution, since it conceived nationhood as a monolithic entity that purportedly produced a seamless national identity. Thus, the progressive military government employed a political formula that, in keeping with this paradigm, only shifted the common terms of the exclusion/inclusion binary construction rather than questioning its origins and the interests behind it. Through their visual representations, the posters of Velasco's Agrarian Reform equated "authentic Peruvianness" with the image of Quechua-speaking indigenous peasants and working-class people instead of identifying it with the traditional Criollo elite.

POLITICS, AESTHETICS, AND VISUALITY

In order to understand how the process described above negotiates seemingly contradictory terms of authoritarianism and revolution to redefine national identity it will be useful at this stage to introduce two notions that French philosopher Jacques Rancière has developed in depth, namely, *politics* and *police* (Rancière 1999 and 2004). For Rancière these two ideas are almost opposites, and his notion of *police* (or the "police order") is related to what we commonly understand by politics when this is conceived—following Michel Foucault—as a "mode of government":

> The petty police is just a particular form of a more general order that arranges that tangible reality in which bodies are distributed in community. It is the weakness and not the strength of this order in certain states that inflates the petty police to the point of putting it in charge of the whole set of police functions [...] The policeman is destined to play the role of consultant and organizer as much as agent of public law and order [...] The police is, essentially, the law, generally implicit [...] [It] is an order of bodies that defines the allocation of ways of doing, ways of being, and ways of saying, and sees that those bodies are assigned by name to a particular place and task. (Rancière 1999: 28-29)

Thus, *police* includes ideas of a sovereign authority and of the public administration of an order where places and hierarchies are assigned. This order not only arranges positions but also prescribes ways of being and doing and defines "parts and roles in a community as well as its exclusions" (Rancière 2004: 89).

In turn, Rancière defines *politics* as the practice of disagreement, as a challenge to the *police* order:

Whatever breaks with the tangible configuration whereby parties and parts or lack of them are defined by a presupposition that, by definition, has no place in that configuration—that of the part of those who have no part. This break is manifest in a series of actions that reconfigure the space where parties, parts, or lack of parts have been defined. Political activity [...] shifts a body from the place assigned to it or changes a place's destination. (1999: 29-30)

While *police* is the force that tries to "keep things, activities, and people in their proper places" and to "define the configuration of the visible, the thinkable, and the possible through a systematic production of the given" (Rancière 2007: 256), *politics* attempts to disturb the grid-like organisation of *police* to make visible what was not supposed to be visible before. Ruiz Durand's posters seem to express the tension between *police* and *politics*—a tension that is also prevalent in the GRFA project itself—in the sense that his images disrupt traditional ideas, social hierarchies, and class power dynamics whilst at the same time maintaining—perhaps even reproducing—the very same paradigms whose legitimacy is at stake.

Taking into consideration the concept of aesthetics with which Rancière works and applying this to Ruiz Durand's posters emphasises the role played by their visual qualities in negotiating between *police* and *politics*. While the *police* order is the organising principle behind what Rancière terms the "distribution of the sensible", what he calls "the aesthetic" is conceived as a force that can disturb this distribution (2004: 26-28). The distribution of the sensible determines our common modes of perception so as to impose a certain order and to administer forms of participation in particular historical contexts, thus specifying "modalities of what is visible and audible as well as what can be said, thought, made or done" (Rancière 2004: 85). It is in the broader framework of these "image regimes" that the aesthetic calls into question the "conceptual coordinates and modes of visibility operative in the political domain" (Rancière 2004: 82) producing a new articulation between forms of action, perception, and thought. In other words, aesthetics makes visible "the part of those who have no part" in the established order (Rancière 1999: 29-30), something that will, in turn, interrupt the coordinates of perception and conceptualisation established by the *police* order through the distribution of the sensible.

This set of interrelated theories can be useful when we turn to a third poster from the series designed by Jesús Ruiz Durand (see Fig. 10-2). In this case, the central representation is a double image: we see both a frontal and a profile likeness of the face of José Gabriel Condorcanqui, better known as Túpac Amaru II and leader of one of the most important

anti-colonial uprisings against the Spanish Empire. Even if Túpac Amaru's 1780 rebellion echoed both indigenous and Criollo interests, the fact is that Criollo elites withdrew their support after witnessing the growing violence that characterised the movement. The prospect of the indigenous population—a majority continuously oppressed since the arrival of the colonialist enterprise—actually attempting to take power in order to effect change by their own means, unsettled the elites because it faced them with the very real possibility of a popular insurrection that would strip them of the privileged position they had always held.

The image of Túpac Amaru—a mestizo who always identified with the indigenous population—was not featured in any official narratives until the Velasco government chose it to represent a symbolic ideal of the Peruvian revolution.[10] This process of making Túpac Amaru visible again, after his image had been kept out of sight for almost two centuries, was a bid to alter the ruling paradigm precisely by pushing at the limits of the dominant distribution of the sensible. By producing an aesthetic shift in what can be seen—that is, in the field of the visual—changes were also being generated in parallel modes of thinking, doing, and being.

Moreover, in the poster there is a third image that converges with and, at the same time, emphasises the other two. The circle above Túpac Amaru's double facial representation is in fact a depiction of the sun. Once again, a dual relation is established, this time with Peru's historical past: firstly, the sun was the principal deity in the Inca Empire's religious configuration and, secondly, José Gabriel Condorcanqui claimed the name of Túpac Amaru II in reference to the last ruler of that empire, Túpac Amaru, to whom he was also related. This play of doubles and, especially, the seemingly disjointed references, point towards Ruiz Durand's use of one of Pop Art's most ubiquitous aesthetic strategies: recycling. I have already discussed the stylistic markers that connect the posters to the American Pop Art movement in general—vivid colours, geometric lines, formats, and reproduction techniques—and to the work of artist Roy Lichtenstein in particular through the comic book influence as well as the use of thought bubbles and Ben-day dots. However, the method of recycling images from different contexts is what truly cements Ruiz Durand's work within its Pop roots.

[10] It is worth noting that the next time that Túpac Amaru is prominently featured is in the name and iconography of the Movimiento Revolucionario Túpac Amaru (Túpac Amaru Revolutionary Movement), a communist and anti-imperialist guerrilla movement, active between the 1980s and 1990s, which participated in the 20 year internal conflict which also involved Sendero Luminoso (Shining Path) guerrillas and the Peruvian state.

Pop Art was conceived as an artistic movement that would reflect mass consumption in aesthetic terms so as to transmit an ironic critique of consumerism. This irony is achieved essentially by reproducing the logic of the market, by taking its own strategies and means of production to generate pieces that reused iconic images of capitalist consumption in order to evidence the relations between the market and the work of art. In the case of the agrarian reform posters, the critique seems to be directed towards national identity and to the structures that model what is defined as essentially Peruvian. The subjects featured by Ruiz Durand in his posters as icons of the revolution and the new nation represent those who had been conceptualised in hegemonic discourses, at least since the beginning of the republican era, as excess, as the barbaric outside of the normative national space, as submissive, pre-political beings incapable of understanding the republican order, much less of inhabiting it as stake holders. With regard to the Ruiz Durand posters I have examined here, recycling means appropriating the set of images, stereotypes, and symbols of "the popular"—with all their positive and negative connotations—and redefining the limits of what is considered to be authentically Peruvian in terms that include the indigenous, the rural, and, more generally, everything that had been marginalised by the dominant Criollo urban culture.

RE-IMAGINING POLITICAL CONSCIOUSNESS

These images—aside from their official objectives and notwithstanding any control the government might have had over the final version of Ruiz Durand's designs—reproduce as well as reflect the contradictions that plagued the GRFA during its tenure in power. Velasco's government attempted to control the emerging popular movement in order to steer its interests towards those of his government. Thus, by channelling this new social force through government approved processes and agencies, the GRFA was able to maintain the *police* order—to employ Rancière's terminology—while at the same time creating the illusion of a revolutionary change being enacted by and for the people. However, in the process of this populist reform, an autonomous political impulse that transformed the existing ways of seeing, doing, and thinking, was inevitably unleashed

Although the agrarian reform posters fulfil their role as official propaganda vehicles through clear and direct verbal messages, the more purely visual elements of the designs also seem to create an aperture for another way of thinking. The images of the Andean indigenous peasant had only been utilised previously, by distinct hegemonic discourses, to

symbolise the essential other who preceded the national subject and who served as a constitutive outsider. The indigenous inhabitants of the Andes were not considered a part of the original national project. Therefore, every attempt to integrate them into national life through predetermined programs and policies was destined to fail. Jesús Ruiz Durand's posters, however, tell a different story: he re-conceptualises this continuously marginalised image not only to help attain the goals of the new government's political agenda, but also to problematise the notion of nationality by redefining its limits and, more importantly, by making visible those subjectivities which had until then only comprised in the Peruvian national context "the part of those who have no part."

WORKS CITED

Althusser, L. 1971. "Ideology and Ideological State Apparatuses. Notes Towards an Investigation." In *Lenin and Philosophy and Other Essays*, trans. B. Brewster, 127-193. New York: Monthly Review Press.
Carnevale, F. and J. Kelsey. 2007. "Art of the Possible: An Interview with Jacques Rancière." *Artforum*. March: 256-267.
Cotler, J. 1993. "Democracy and National Integration in Peru." In *The Peruvian Experiment Reconsidered*, eds. C. McClintock and A. F. Lowenthal, 3-38. Princeton: Princeton University Press.
Craven, D. 2002. *Art and Revolution in Latin America, 1910-1990*. New Haven: Yale University Press.
Davidson, R. and D. Craven. 2006. *Latin American Posters: Public Aesthetics and Mass Politics*. Santa Fe: Museum of New Mexico Press.
Gobierno Revolucionario de la Fuerza Armada. 1968. *Decreto Ley N°1 de 3 de octubre de 1968 (Estatuto del Gobierno Revolucionario)*. Lima: Diario Oficial El Peruano.
Rancière, J. 1999. *Disagreement: Politics and Philosophy*, trans. J. Rose. Minneapolis: University of Minnesota Press.
——. 2004. *The Politics of Aesthetics*, trans. G. Rockhill. London: Continuum.
Ruiz Durand, J. c. 1969-71 Untitled (Agrarian Reform Posters). Offset on paper, 100 x 71 cm. Centro Cultural San Marcos Collection. Lima: Agrarian Reform Office.
Schydlowsky, D. M. and J. J. Wicht. 1993. "The Anatomy of an Economic Failure." In *The Peruvian Experiment Reconsidered*, eds. C. McClintock and A. F. Lowenthal, 94-143. Princeton: Princeton University Press.
Thurner, M. 1997. *From Two Republics to One Divided: Contradictions of Postcolonial Nationmaking in Andean Peru*. North Carolina: Duke University Press.
Velasco Alvarado, J. 1972. *Velasco, la voz de la revolución*. Lima: Peisa.

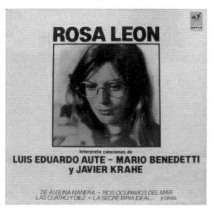

Fig. 1-1. Front cover of Rosa León's
1973 album *De alguna manera.*

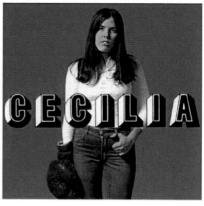

Fig. 1-2. Front cover of Cecilia's
1972 album *Cecilia.*

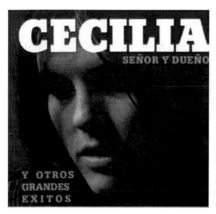

Fig. 1-3. Front cover of Cecilia's 1991
album *Señor y dueño.*

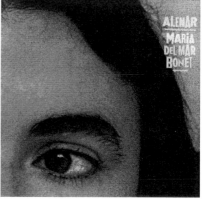

Fig. 1-4. Front cover of María del
Mar Bonet's 1977 album *Alenar.*

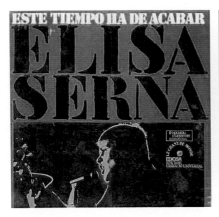

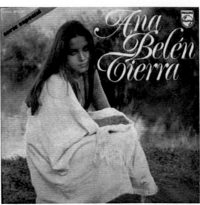

Fig. 1-5. Front cover of Elisa Serna's 1974 album *Este tiempo ha de acabar*.

Fig. 1-6. Front cover of Ana Belén's 1973 album *Tierra*.

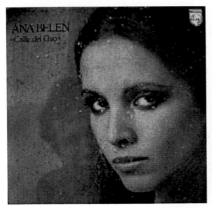

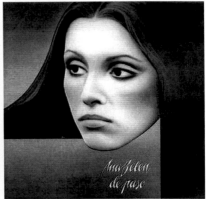

Fig. 1-7. Front cover of Ana Belén's 1975 album *Calle del Oso*.

Fig. 1-8. Front cover of Ana Belén's 1976 album *De paso*.

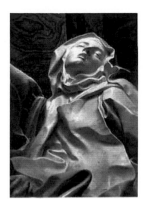

Fig. 2-1.

Gian Lorenzo Bernini
Ecstasy of Saint Teresa
(1647–1652).

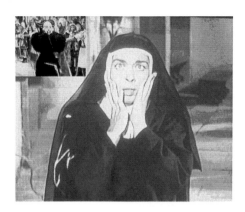

Fig. 2-2.

Aurora Batista as Teresa in de Orduña's
Teresa de Jesús (1961) and, inset, as
Dona Juana in *Locura de amor* (1948).

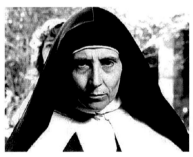

Fig. 2-3.

Concha Velasco as Teresa
in TVE's 1984 mini-series.

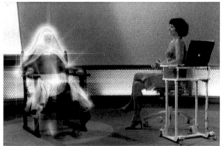

Fig. 2-4.

Saint Teresa does the chat show circuit:
Rafael Gordon's *Teresa Teresa* (2003).

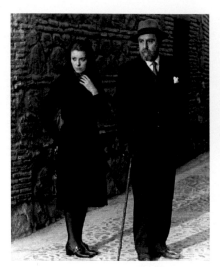 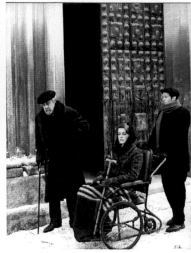

Fig. 3-1 (above left). Don Lope dressed as a
Spanish gentleman and Tristana the submissive ward.

Fig. 3-2 (above right).Tristana uses the stick not only as
a walking aid, but also to impart orders to the two men.

Fig. 5-1 (below). Screen grab from Youtube upload
of *El cor de la ciutat* with Chinese subtitles.

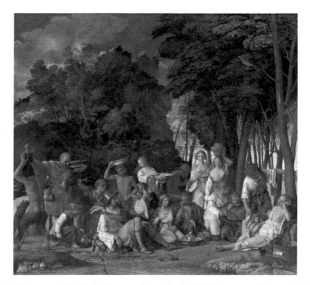

Fig. 6-1. Giovanni Bellini, *Feast of the Gods* (1514), one of the paintings on mythological subjects produced for Alfonso d'Este's *camerino d'alabastro*. National Gallery of Art, Washington DC.

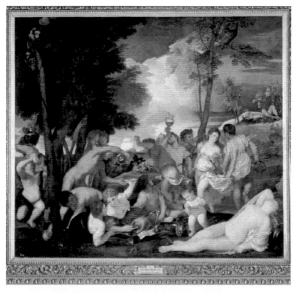

Fig. 6-2. Titian (Tiziano Vecellio), *Bacchanal*, 1518. Museo del Prado, Madrid.

Fig. 10-1 (above left). The use of Quechua and the image of the Andean peasant were key elements of the GRFA's national imaginary.

Fig. 10-2 (above right). The hat, the sun, and the letter A all converge in one image that references resistance hero Túpac Amaru.

Fig. 10-3 (below). Roy Lichtenstein and his comic book aesthetic are referenced in this poster by Jesús Ruiz Durand.

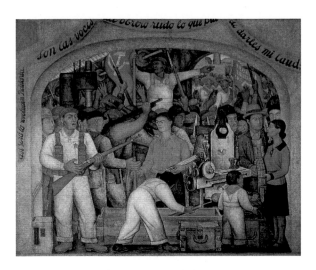

Fig. 11-1. Diego Rivera
En el arsenal
(mural panel at SEP).

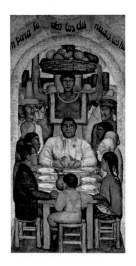

Fig. 11-2. Diego Rivera
El pan nuestro
(mural panel at SEP).

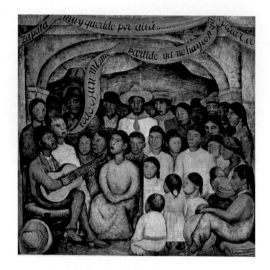

Fig.11-3. Diego Rivera
Cantando el corrido
(mural panel at SEP).

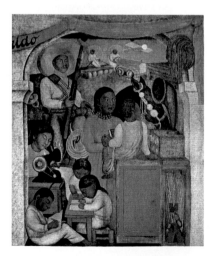

Fig. 11-4. Diego Rivera
Fin del corrido
(mural panel at SEP).

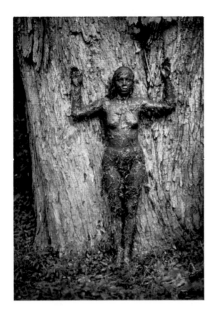

Fig. 13-1. Ana Mendieta
Tree of Life (Iowa, 1977).

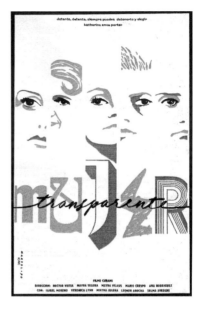

Fig. 14-1. Poster for
Mujer transparente.

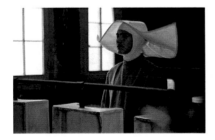

Fig. 15-1. Javier dresses as a nun in a
scene from *Madrigal*.

Fig. 15-2. *Viva Cuba*: The striking
resemblance between Jorgito and Malú.

Fig. 16-1. Books produced by Eloísa Cartonera.

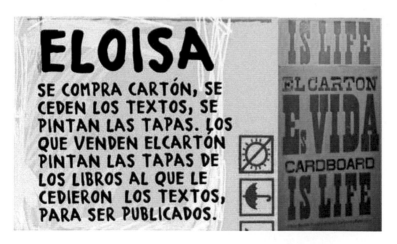

Fig. 16-2. Eloísa Cartonera posters.

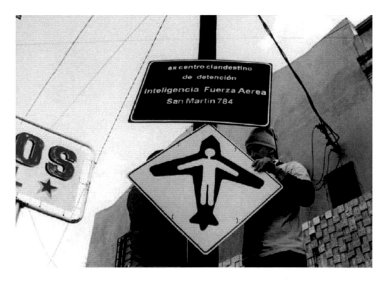

Fig. 17-1. Street signage being re-purposed by Grupo de arte callejero.

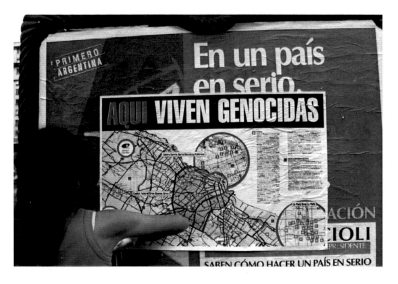

Fig. 17-2. "Aquí viven genocidas". A Grupo de arte callejero action.

Fig. 18-1. *El Gringuito*: Jorge is startled by the sight of a policeman.

Fig. 18-2. *El Gringuito*: anguished rapprochement of an exile and one who stayed.

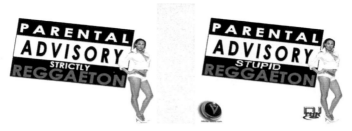

Fig. 21-1. Remaking pro-reggaeton images as anti-fan signage.

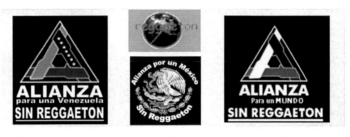

Fig. 21-2. Instances of global and national anti-reggaeton alliance imagery.

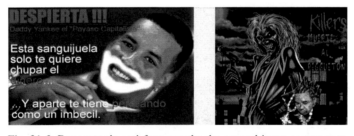

Fig. 21-3. Reggaeton's anti-fans remake the genres' icons as monsters.

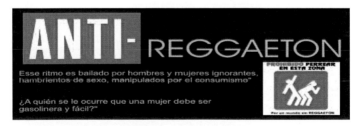

Fig. 21-4. Policing the sexualisation of reggaeton dance.

Fig. 22-1 (left). A young Morfudd Rhys Clark in the garden at Managua, Nicaragua, reading *Cymru'r Plant.*

Fig. 22-2 (below). T. Ifor Rees (far right) and two unidentified men, waiting for a train in the mountains at Antímano, Venezuela.

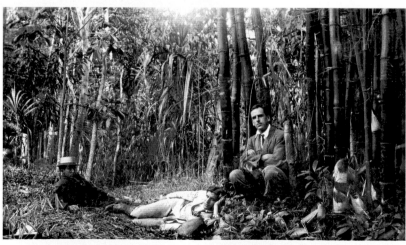

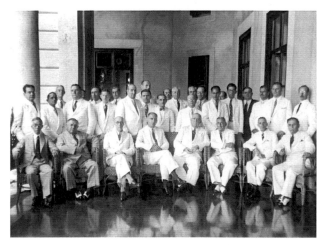

Fig. 22-3.

A party of diplomats, Havana.

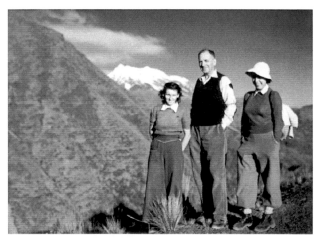

Fig. 22-4.
Rees with his daughter Morfudd (far left) and a friend
in the mountains above La Paz.

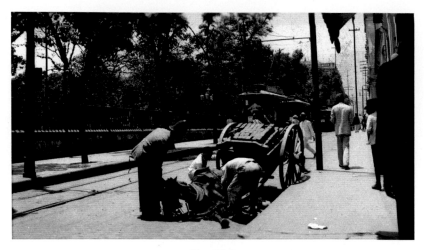

Fig. 22-5.
A street scene in Caracas. Rees carried at least one camera with him at all times in order to capture such candid scenes.

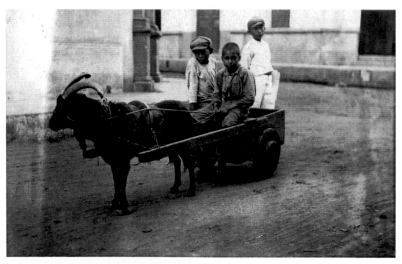

Fig. 22-6.
"Goat Taxi"
Undated and no location indicated in album.

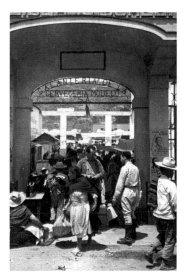

Fig. 22-7.
A street scene in Mexico.

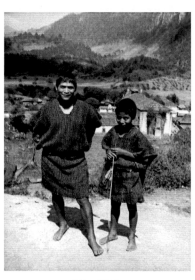

Fig. 22-8.
Tzendal man with his son.

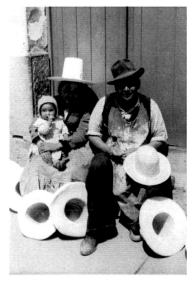

Fig. 22-9.
Family Portrait, Bolivia.

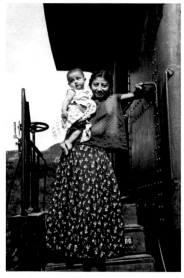

Fig. 22-10.
Mother and child, Mexico.

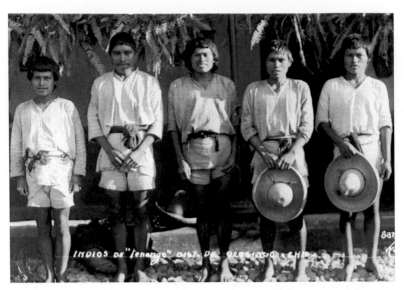

Fig. 22-11.
A commercially-produced postcard inscribed "Indios de 'Tenango'".

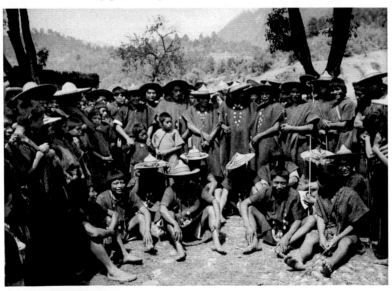

Fig. 22-12.
Photograph by T. Ifor Rees of a group of Tzendal men.

CHAPTER ELEVEN

LOCAL AND GLOBAL DREAMWORLDS IN DIEGO RIVERA'S MURALS AT THE SECRETARÍA DE EDUCACIÓN PÚBLICA

MAURICIO CASTILLO

The muralist movement has commonly been understood as the cultural platform for the post-revolutionary Mexican state's modernisation project. The dominant state ideology which frames this can be traced back to the Obregón administration and the construction of a nationalist discourse that appropriated the Mexican Revolution's basic ideal of land reform. In turn, this ideal derived from the Zapatistas' desire for the return of peasants to the ancient form of agrarian communalism.

Recent studies such as Leonard Folgarait's *Mural Painting and Social Revolution in Mexico, 1920-1940* have shed light on the state-building aspect of muralism (particularly in Diego Rivera's work) and on the ways in which patrons and those who commissioned murals influenced the movement's ideology and thus ultimately shaped the murals' value as public art. Folgarait's perspective, which echoes those of Octavio Paz and Carlos Monsiváis, focuses on the nationalist and populist character of the Obregón administration and is fully anchored in the present-day perception of the murals as an institutionalised artistic movement. The early post-revolutionary government envisioned the revival of muralism as beneficial on account of the format's pedagogical qualities and the simplicity of the visual message it projected to the newly emerging masses. It was during the *Porfiriato*'s positivist government at the turn of the century that muralism was incorporated for the first time within a modernisation project (Ramírez-García 1989: 36). In order for the state's new ideology to project a national identity based on the principles of modernisation and social inclusion, the murals had to articulate the discourse of an actual post-revolutionary moment in Mexican history. It is from this viewpoint that studies such as Folgarait's have focused their analyses on muralism's path to institutionalisation in modern Mexico.

My study analyses the movement's early years in order to recast the muralist project as a more complex set of ideological negotiations where artists, patrons and the local and global political context of Mexico came

into play. I study Diego Rivera's murals at the Secretaría de Educación Pública (Secretariat of Public Education) as paradigmatic of how muralism emerges from two disparate ideas of revolution in this early period. While Álvaro Obregón's government anointed this movement as the official art of the new Mexican state, the three most salient figures of muralism— Diego Rivera, David Alfaro Siqueiros, and to a lesser degree José Clemente Orozco (who sympathised with the Mexican Communist Party but never became a member of it)—considered muralism as a political as well as an aesthetic avant-garde movement that functioned as a critique of modernity.[1] The collective nature of muralism that was held by the artists to be inherent in its mode of production, as well as its dissemination in designated public spaces, signalled a rupture with bourgeois individualist art, but also offered through images the illusion of an alternative to capitalism. For this reason, muralism's fundamental *raison d'être,* when it emerged in the early 1920s, was the articulation of revolution in the artistic realm.

The dual capacity of murals as both institutional and avant-garde art was also reflected in the cultural inheritance they took from indigenous and contemporary European traditions. Past, present, and future converged in the murals in terms of artistic techniques (fresco in Rivera and the use of spray gun in Siqueiros for example), but muralism was also a *technik* in itself.[2] In other words, the Mexican murals of the 1920s and 1930s embodied the social and political relations joining the muralists and their means of production at the time, rather than just being a showcase of the techniques used to bring into action the material technology used in the process of painting. As Francisco Reyes Palma writes, the mural

> Fue el ámbito privilegiado para la emisión de consignas políticas, púlpito y tribuna de la campaña social en turno, y vía diferida del archivo contenedor de las visiones del pasado inmediato. Pudiera ser que ningún

[1] At the same time Rivera was working on the SEP murals, David Alfaro Siqueiros and José Clemente Orozco also engaged the theme of revolution in their murals at the Escuela Nacional Preparatoria (National Preparatory School). These panels were initially abstract and still incipient in terms of their revolutionary ideological content (Craven 2002: 46).

[2] *Technik* is a Benjaminian concept. As Esther Leslie explains: "In signifying simultaneously technology and technique, *Technik* alludes to the material hardware, the means of production and the technical relations of production. To accent technical relations of production is to acknowledge that there exist social and political relationships between producers and means of production" (2000: xii).

otro sitio acogiera de modo tan obsesivo la experiencia de la Revolución
en su calidad de gesta heróica. (2002: 37)[3]

Aesthetically and politically, the murals of Mexico's post-
revolutionary period functioned as a visual archive that revived an art form
from indigenous and ecclesiastical traditions. Moreover, the murals also
embraced novelty, from symbolic representations of power and authority
to visual machineries that constructed revolutionary dreamworlds designed
to appeal to the masses. I use the term "dreamworld" in the sense in which
Susan Buck-Morss has used it. Buck-Morss in turn borrows the term from
Walter Benjamin and his conception of the dreamworlds of mass-culture:

> [Dreamworld] acknowledges the inherent transience of modern life, the
> constantly changing conditions of which imperil traditional culture in a
> positive sense, because constant change allows hope that the future can be
> better. Whereas myths in premodern culture enforced tradition by
> justifying the necessity of social constraints, the dreamworlds of
> modernity—political, cultural, and economic—are expressions of a utopian
> desire for social arrangements that transcend existing forms (Buck-Morss
> 2000: xi-xii).

In the murals, such utopian ideas of revolution were articulated in two
contradictory ways: on the one hand they projected the view of the state
and its apparatus as the natural outcome of the Mexican Revolution, while
on the other hand they reflected the view of a global socialist revolution
that would radically transform life.[4]

It is important to clarify that I am not arguing that the representation of
socialist revolution in the murals entails a space of resistance led by the
artist through individual agency. Rivera has been criticised as an
opportunist throughout his career, but I would rather concentrate on
contextualising his work and the ways in which he had to deal with many
political factors in order to complete the murals. The potential for a
socialist revolution that he projected in the murals was the most radical
alternative to capitalism, but it was also one that already had a rigid

[3] The mural "was the privileged space for the broadcast of political slogans, in turn
pulpit and tribune of the social campaign, and a distinctive route for the archive
containing visions of the immediate past. It could well be that no other site
embraced so obsessively the experience of the Revolution as a heroic gesture."
[4] I use *socialism* to refer to most branches of communism that were prevalent after
the Russian Revolution of 1917, specifically Bolshevism, Leninism, and Stalinism.
I also use *socialist* and *proletarian* revolutions interchangeably (as envisioned by
the Comintern).

political chain of command that started with the Partido Comunista
Mexicano (PCM) and reached all the way to the Comintern.[5] It is difficult
to imagine what might have happened if the PCM had succeeded in taking
over the government during the period of political unrest that followed
Obregon's assassination in 1928, but considering the sectarian nature of
the party, the Comintern would have played a very influential role in
determining the PCM's directives. The consensus based on new studies of
the PCM's political situation during the 1920s and 1930s is that Mexico's
industrial base was still incipient and that the country therefore had a
workforce which was in the main comprised of peasants (Vázquez
Ramírez, 2007: 591-599).

Ironically, then, in order to gather adherents for their socialist
revolution, the PCM had to rely on the political support of the peasantry.
This tendency was more evident after 1929, when the PCM split from the
national peasant movements, which led these groups to form the
Confederación General de Trabajo (CGT). Rivera had to deal with this
political reality, and while his creative input in the final object of art was
certainly decisive, the end result was also influenced by the state's own
political interests in its role as the patron of the muralists. In the end, rather
than focusing on the artist's intention as the exclusive means of
interpreting his/her work, I propose to conceive of the murals as the
repository of these ideological tensions; as cultural objects they
constructed a visual language that attempted to articulate contradictions
within a seemingly coherent discourse.

TWO REVOLUTIONARY NARRATIVES

I focus in this chapter on four murals in the Patio de las Fiestas, images
which articulate the merger of the two clear and distinct conceptions of
revolution I outlined above; the Obregón government's official
revolutionary discourse, on the one hand, and, on the other, socialist
revolution as a movement led by the proletariat.

State patronage allowed the masses permanent and unrestricted access
to the murals, making this a more effective means of communication at the
time than literature or even film. Although Mexico's film industry has
generally been a strong one in Latin American terms, very few movies
were produced during the early 20s due to the flooding of the Mexican
market by Hollywood products, the Secretariat's limited budget to support
a domestic industry, and Vasconcelos's personal preference for literacy

[5] The PCM had been founded by foreigners and initially had very close ties with
the Comintern.

campaigns (Doremus 2001: 18-28). The state constructed a populist project of modernisation that was assumed to be the sole inheritor of the ideals of the 1910 Revolution. With time, this perception was finally ingrained into the Mexican imaginary, but I contend that in the Patio de las Fiestas murals this idea of post-revolution merged with the perception that a global socialist revolution was spreading. Before the end of Obregón's term in office in 1924, it became clear that the revolutionary ideals projected by the state were not being realised. As Héctor Aguilar Camín and Lorenzo Meyer point out:

> Power and money had softened the egalitarian and antioligarchic spirit of the 1913 rebellions to open the way to the consolidation of a new oligarchy, which acquired wealth through illegal businesses, commercial speculation, taking over the *haciendas* of the old Porfirian landowning class, personal enterprises that were subsidized and fattened up with public funds, and the development of a new entrepreneurial class of ex-revolutionaries. (1993: 76)

This new political and social order was reflected in the Obregón administration's conservative stance with regard to the Revolution's fundamental issue of land reform. Very few land transfers were granted to peasants during his administration, a trend that was not altered during Calles's presidency. [6] While the new state sought to terminate the monopolistic exploitation of local oil reserves by foreign capital, land distribution was clearly not a priority. [7] Ultimately, what these newly emerging groups in power wanted was to eradicate unproductive *latifundios*. The *ejido* was considered only a marginal and transitory form of property. In other words: "The best agricultural producer was the medium producer: the rancher, from whose ranks so many of the revolutionary leaders had emerged" (Aguilar Camín and Meyer 1993: 99-100).

Against this socio-political backdrop, Rivera's murals articulated a visual language where the post-revolutionary state project and socialist

[6] Despite Obregón's and Calles's discourses during their respective presidencies calling for the revival of the *ejido* over the *latifundio*, the reality was different: "The rural Mexico that Cárdenas found in his electoral tour was still a society dominated by large private properties. According to 1930 statistics, of the 324 805 000 acres registered by the census, 93 percent corresponded to private property and 7 percent to *ejidos*" (Aguilar Camín and Meyer 1993: 120).
[7] Land distribution significantly increased during Cárdenas' presidency (1936-1940), when a series of agrarian reforms began to be implemented with the assistance of the National Agrarian Commission (Hart 1987: 341).

dreamworlds converged. The state's revolutionary ideology was in reality a shift from the positivist oligarchy of the Porfiriato to a capitalist, and thus seemingly more democratic and inclusive, form of governance directed toward control of the masses. The search for a national identity so prevalent in Latin America during the 1920s and 1930s was reconfigured into a populist discourse in Mexico to disguise the fact that the new corporatist state privileged foreign capital investment that benefitted exclusively the middle and upper class.

Rivera's response to this situation was to introduce the possibility of a socialist revolution in Mexico as a strategy to compensate for what had become an unsustainable correspondence between the state's ideology and the political and social events that were unfolding in Mexico. In order to mitigate this reality, the murals constructed a visual narrative of the coming of a proletarian revolution that was to complement the state's post-revolutionary discourse already in place. By pairing both the state's project and the socialist one within a utopian vision of a new social order, the murals sustained the idea of a modern Mexico, which was the government's ultimate goal in order to subdue all the new social actors who were demanding political representation after the 1910 Revolution.

In my view, understanding the co-existence of these two visions of revolution is fundamental to articulating the ontology of muralism as both monumental art and as an avant-garde. The concept of the Mexican post-revolutionary state and the concept of socialism shared similar characteristics: a break with tradition, the search for novelty, and an unfailing faith in the future. Rather than attempting to define the term *revolution*, the event of revolution was contextualised in the murals as cultural artefacts of the time. In other words, I view these two ideas of revolution in Rivera's murals at the SEP building as *revolutionary narratives*.[8]

In terms of how we interpret revolutionary events or actions, a narrative is a collection of events that unfolds in a strict order through time, giving it a powerful logical coherence that does not easily allow for alternative interpretations. Noel Parker defines revolutionary narrative as a concept that "considers revolutions across different places and historical

[8] Noel Parker divides the study of revolutions into two clearly distinct, albeit complementary, areas of inquiry: one is the historical and sociological analysis of why revolutions occurred, and the other is the way in which people's perceptions of these events take shape. He describes these two halves as "the analytical/nomothetic" and "the interpretive/hermeneutic" respectively (1999: 111). My approach concentrates mainly on the mode, which favours the articulation of the revolutionary narrative.

moments. The revolutionary narrative is the form within which the events and actions that constitute one revolution or another are interpreted and acted upon" (1999: 112).

These narratives are not merely consequences of actual revolutions, and neither a revolution nor its narrative is generated by accident nor chance. It is the context established by modernisation that first creates an interpretative need which is then filled by revolutionary narratives.[9] The function of these narratives is to identify and organise the agents of change, the agents targeted by that change, their project and how it will develop across time and space. In the case of the murals at the SEP building, the visual language reveals two revolutionary narratives at play. One concerns the nascent Obregón administration and responds to a project of modernisation that is being developed coetaneously with the production of the art work. This is the post-revolutionary state acting as the agent of change, a paternalistic image embraced by the new emerging masses. The promise of modernising the country is not only based on the idea of providing fair land distribution to the peasants, but also on improving both agrarian and urban sectors of society through technology and education.

The other revolutionary narrative is based on the idea of a world revolution with real potential. This is the global socialist revolution that seemed to emerge first in Europe and then in many other regions. Created in 1919, the Comintern had as its goal the worldwide export of a model of revolt based on the Russian Bolshevik experience. The socialist revolutionary narrative, then, was based on armed struggle with the ultimate aim of taking over the instruments and institutions of government. With the founding of the PCM, one of the first communist parties in Latin America, Mexico was among the very first countries where the ripple effect of the socialist revolution was felt.

The socialist revolutionary narrative articulated in the SEP murals was modelled after the Bolshevik modernisation project begun after the 1917 Revolution in Russia. This socialist project envisioned a new social order based on the union of urban workers and peasants, the creation of a new socialist state, and the overthrow of the bourgeoisie (Wade 2005: 270-271). Many of these ideas were similar to those espoused by the Obregón administration, except for the Bolsheviks' explicit desire to create an egalitarian society. On the other hand, the Obregón and Calles

[9] Parker explains this dependent relationship by describing modernisation as "a source of pressures which challenged, or threatened, societies with transition [...] But, regardless of whether a revolution actually occurs, the revolutionary narrative speaks to the condition of societies experiencing pressures from worldwide modernization" (1999: 115).

administrations only favoured moderate socialist ideals in order to give the impression that their governments were promoting progressive and democratic reforms (in the modern sense of equal access to power for every group through voting rights.) The goal of the new post-revolutionary Mexican government was merely a reconfiguration of the social order signalling the emergence of a new middle class, rather than a communist utopia arising from the proletarian takeover of the state's institutions.

Since Rivera's murals were in tune with then contemporary events, the subversive quality of his visual narrative of a socialist uprising was dependent on the actual advance of the PCM in Mexican politics. However, once the party lost its political influence, socialism was integrated into the state's ideology as part of its own modernisation project. In a similar process of ideological co-optation, the state rewrote the chaotic events of the 1910 Revolution into a narrative of heroism by appropriating the Zapatista agenda.

In the aftermath of the Mexican Revolution there was no clear political programme nor did the event immediately identify an agent of change. The post-revolutionary government had emerged as events unfolded. Obregón had come to power largely because he had been able to survive the infighting among the other *caudillos*. Once the government had been established and the 1917 Constitution had finally been implemented, the state's revolutionary narrative was put into place. Developed by Vasconcelos in his cultural and educational projects, it was structured as a means of appeasing the political demands of the lower classes.

Despite being state-sponsored monumental art, Rivera's murals did not become a mere propaganda tool for the Obregón administration. Rather, the murals functioned as a cultural mediator, a *dispositif*, between the state and the body politic. In order to achieve this, however, the challenge for Rivera's visual narrative of revolution was to reconcile a local post-revolutionary moment embodied by the state on the one hand, with the coming of a world revolution, on the other. Also, for both of these conceptions of revolution to merge, two different times and spaces had to be harmonised. Rivera's representation of time in the murals, then, had to display a logic based on the overlapping of the present and the future. Two revolutions and two different processes were being articulated into one single visual narrative: the Mexican Revolution, whose second phase was being carried out by the state, and the coming of a world socialist revolution to be realised in the near future.

But while revolutions may be perceived as a rupture in time that will lead to a radical change in everyday life, the revolutionary narrative remains part of the discourse of modernity. The narrative of revolution,

due to its nature as a language based on ideas of novelty, progress, and radical change, is resistant to being anchored in the present. For instance, as Susan Buck-Morss observes, in Stalin's First Five Year Plan for rapid industrialisation, "any proposal for 'slowing the tempo' [...] of economic production became tantamount to counterrevolution. *The present was an obstacle to be overcome*, a continual sacrifice for the sake of the communist future" (2000: 37, emphasis added). In the murals the ontology of revolution as a narrative was inscribed in terms of a constant conflict that echoed the Marxist dialectic of class struggle. The articulation of "revolution" qua event, then, needed not only to symbolise the perpetuation of that performance, but also permanently to anchor struggle as a watershed moment in time.

In the SEP murals the state's discourse was one of a revolution where the armed struggle in Mexico was complete, and a new phase of fulfilling revolutionary ideals was being accomplished. As the political context shifted and it was clear that initial promises (land distribution to the masses, and equal access to power for all) were not being met either by Obregón or Calles, Rivera incorporated the coming of a global revolution into the visual narrative of his murals. For Rivera, the *fantasy* of an unrealised socialist revolution eventually became a more powerful and useful discourse than its actual realisation in Mexico. The result of articulating both conceptions of revolution was to prevent the state's ideology from becoming stale and empty of meaning in the face of an increasingly conflictive Mexican social reality. In order to restore the credibility of post-revolutionary ideals, both state and proletarian narratives of revolution were reconciled in a visual dreamworld that alluded to the coming of a harmonious and prosperous new social order in Mexico.

The most powerful visual paradigm of this dreamworld is in the alignment of urban workers alongside peasants in the *Balada de la Revolución (Ballad of the Revolution)* murals. This allegory not only alluded to the reconciliation of these two modes of production in modern Mexico, but was also part of Rivera's narrative of a seemingly harmonious and progressive society.

THE MURALS

There are a total of twenty-six panels in the *Balada de la Revolución*. I have chosen for further analysis the panels which are most representative in terms of illustrating Rivera's particular revolutionary narrative. The first panel is titled *En el Arsenal (In the Arsenal)* (Fig. 11-1) and depicts the scene of a call to arms by both urban workers and peasants. Through the

agitated movement of the figures preparing for battle the action conveys to
the viewer a permanent sense of urgency. Unlike the earlier panels at the
SEP, where women were portrayed either as Mother-Earth figures, or
performing separate work, as in the Patio del trabajo (Courtyard of
Labour), here they are depicted along with children as active participants
in the struggle, distributing weapons.

Some of the characters portrayed are easily recognisable since they
were part of the Mexican socio-political context of the time. Frida Kahlo,
who became Rivera's wife in 1929, is in the centre and is shown handing
out a rifle. On the right, the Italian Tina Modotti, a member of the PCM
who had become a photographer during her stay in Mexico, is seen giving
an ammunition belt to Julio Mella, founder of the Cuban Communist Party.
On the left side of the panel, and behind an urban worker/fighter, is
Rivera's colleague Siqueiros, armed and sporting a hat with a red star.
Rivera's purpose in using real and contemporary characters was to
invigorate the revolutionary narrative of the panels with a sense of
immediacy.

A very important aspect of the composition of *En el Arsenal*, an aspect
that is repeated in the other scenes, concerns the *trompe-l'œil* effect in
which the spectator views the scene as if looking from inside the mural's
interior, marked as an industrial space by the prevalence of machinery in
the foreground and the background. The combination of this effect and of
the machine aesthetic (so prevalent in avant-garde discourses of the time)
allowed Rivera to use space to construct a perspective that incorporated
the viewer as a protagonist in the action. This strategy not only fulfilled
the mural's pedagogical task of communicating with the masses, but also
allowed for symbolism suggesting that the struggle could only emanate
from factories. This is no small detail considering that right at the centre,
above Kahlo's image, the viewer could recognise the real leader of this
uprising: the anonymous proletarian worker, standing well above all the
other famous characters, pointing his finger and guiding the armed
workers while holding a red flag adorned with communist insignia. In
common with the other panels in this series, the enemy is not visible. On
the other hand, we do see groups of peasants who await alliance with their
worker comrades.

In terms of colour, the use of red is very prominent both in the clothing
and in the bunting painted with *corrido* lyrics throughout the series of
panels. Rivera also used red in the banner carried by the workers and
peasants, in which the hammer and sickle are mixed with slogans referring
to land distribution, achieving a blend of references from local and global
revolution. Blue is another prominent colour, used primarily in the

industrial workers' overalls; here a curious detail emerges (one that will recur in later panels) in the inclusion of an apparently Nordic or Slavic worker receiving a rifle from Frida Kahlo. Initially, not only does the interpolation of this worker, presumably of Soviet origin, seem to be out of place in the scene, but it also seems to contradict Rivera's revolutionary narrative. The foreign worker may point to the impossibility of carrying out a socialist revolution in a country that was still mainly agrarian, but his presence may also have alluded to the PCM's dependence on the Comintern for the ignition of any major uprising.

In fact, both of these hypotheses about the foreign urban worker's presence in the panel are in accordance with Mexico's agitated political context between 1928 and 1929. After Obregón's assassination in 1928, both the PCM and the government experienced a transitional period in which the former endured political repression while the latter finally achieved political consolidation. The PCM, still influenced by Lenin's Second Congress (1920) thesis of organising a united front between the proletariat, peasantry, and local bourgeoisie, was now also eager to follow the third-period policy of class struggle, as declared by the Sixth Congress of the Comintern (September 1928).

For this reason the party founded the Confederación Sindical Unitaria de México (Mexican Unitary Trades Union Confederation) on 26 January 1929. This organisation was modelled on Julio Antonio Mella's ideal of the possible unification of both peasant and urban workers in Mexico.[10] On 3 March in the same year, when the *escobarista* rebellion (led by several army generals) erupted against the government of interim president Portes Gil, the armed peasant guerrillas who were affiliated with the PCM immediately sided with the government army, led now by Calles. Once the government had suffocated the insurrection, Calles did not hesitate in vigorously persecuting the members of the PCM as they were considered to be the next big threat to the post-revolutionary government.[11]

As a result, all communist publications, such as *El Machete*, were censored and the most important members of the party were assassinated,

[10] In his position as one of the most influential members of the PCM, Mella wrote two articles that proved pivotal in establishing this alliance: "La internacional amarilla contra la unidad obrera en la América Latina" (published in *El Machete*, 23 June 1928), which gave a more continental scope to the theme (see Mella 1968; Guerrero et al. 1987).

[11] More recent studies based on newly opened archives on the Comintern in Moscow, seem to prove that there was indeed a conspiracy to overthrow the *callistas* from power and establish a proletarian dictatorship (Spenser 2009: 267-280).

incarcerated, or exiled, in a wave of repression that lasted until 1935 when Cárdenas became president. For the post-revolutionary government this victory meant the consolidation of a corporatist form of governance embodied in the foundation in 1929 of the Partido Nacional Revolucionario (National Revolutionary Party), which would eventually be renamed as the Partido Revolucionario Institucional (PRI) (Institutional Revolutionary Party). In the end, both the ideals of the 1910 Revolution, and the PRI as acting agent of that project, finally became institutionalised.

Rivera's stance during these events was ambivalent. At first he became a member of the united front between peasants and industrial workers and participated in PCM candidate Pedro Rodríguez Triana's presidential campaign for the 1929 elections (Tibol 2007: 109-110). Nevertheless, he opposed the party's plan of splitting the unions and did not support its stance on the *escobarista* rebellion.[12] In the end, Rivera was expelled from the PCM for having accepted a government-appointed position as Director of the School of Plastic Arts, and for his stubborn refusal to go on strike in support of his communist comrades.[13]Ultimately, as the last two decades of his life proved, Rivera's turbulent relationship with the PCM was mainly about his opposition to the increasing Stalinisation of its political agenda. The events which took place in 1929 and 1930 showed not only that the SEP murals were in tune with the political and social developments of the time, but also that the proletarian revolution in Mexico was becoming a phantasmagoria as quickly as Rivera produced these mural images.

El pan nuestro (*Our Daily Bread*) (Fig. 11-2) appropriates Christian iconography through allusions to the Lord's Prayer and the last supper. Rivera replaces Christ as the central figure with a depiction of Felipe Carrillo Puerto, the socialist Governor of Yucatán, who is dressed in the blue shirt (adorned with a red star) typically worn by urban workers. (Briuolo 2002: 152). Carrillo Puerto is seated at the head of the table and is shown dividing a loaf of bread for a diverse group comprising elderly

[12] With regard to Rivera's stance on the PCM's armed uprising, Bertram Wolfe writes: "The Communist Party was absurdly unprepared for such an attempt, but given to the fantastic and romantic and encouraged by certain dogmas of the new 'line' of the Comintern, it proceeded to act as if it 'meant business' [...] However Diego was given to fantasy, this was too much; he had opposed it by voice and vote" (1963: 235).

[13] Bernando Claraval (1944: 115-16), Valentín Campa (1978: 87-88) and José Revueltas (1984: I, 24-25, 96-98) suggest that Rivera opposed the united front and the possible uprising because it would have interfered with the completion of his work.

men, women, and children, the most vulnerable members of society. It is impossible to look at this panel without picking up the religious and political charge that Rivera managed to create with the composition of a seemingly everyday event.

Rivera pares down the Christian idea of receiving and sharing the body of Christ to a general concept of communalism. Instead of a spiritual transubstantiation, Rivera presents viewers with a product that circulates only as shared capital. If transformation of any kind does occur, it does so in the sense that the bread is made absent as commodity and embodies instead the ultimate communist ideal of a product of labour that is distributed (by the state) equally among the proletariat. However, negating the exchange value of the loaf of bread as a market commodity does not prevent the dreamworld of communalism from fetishising this product, since its use value as nourishment remains. Anticipating this trap, Rivera locates the essence of communalism in the ancient idea of the spiritual and material value of Mother Earth, as depicted in the woman standing behind Carrillo Puerto. With her raised arms forming the shape of a cross, the woman is holding a basket of fruit on her head, a feminine symbol common in Rivera's previous murals and one that refers to the fertility of the earth as a natural cornucopia.[14]Therefore, the loaf of bread retains value as nourishment, but it is a use value that is only legitimised by its relation to Mother Earth. Ultimately, the utopia of communalism comes full circle, since it harks back to the pre-Hispanic past in order to realise a new social order in Mexico.

In light of Carrillo Puerto's role in the history of socialism in Mexico, his portrayal as a martyr of the Revolution is not as simple as it may initially seem to be. Rivera chose Carrillo Puerto's figure for this panel because of his progressive policies as Governor of Yucatán in favour of indigenous groups, and his reputation as the first successful socialist politician in Mexico. Despite his credentials, Carrillo Puerto was not an exception in the political game of alliances and betrayals that characterised Mexico during this time. His support for Calles as President Obregón's handpicked successor reflected the strategy pursued by all leftist groups in order to maintain their legality and political influence in the early 1920s. When the De la Huerta rebels executed him for his refusal to back away from Calles, he became a symbol of resistance, but this event also signalled the impossibility for the PCM of negotiating on equal terms with

[14] Among these depictions of female fertility are the *Mujeres Tehuanas* (*Tehuana Women*) panels on the first level of the Patio del Trabajo.

the government. Once the rebels were defeated, Calles took power. He outlawed the PCM and persecuted its leaders.

In *Cantando el corrido* (*Singing the Ballad*) (Fig. 11-3) Concha Michel, a well-known performer and musician, is depicted singing to an audience of women, children, peasants, and urban workers. The scene is typical of the time and depicts a casual moment when people gathered around to sing *corridos* about the Revolution (Briuolo 2002: 140). Rivera features Zapata —assassinated in 1919— playing the guitar next to Michel (who was still alive at the time). Completing the rest of the scene, there is on the left a crowd whose clearly attentive faces are visible. This detail contrasts with earlier murals in which the faces of the masses were not shown and the emphasis was instead on how their bodies and their movements resembled the tools and machines they were themselves operating.[15]

Rivera identified crowds as protagonists of the murals in order to reinforce the notion that muralism told an alternative story of Mexico. In *Cantando el corrido*, although the faces in the crowd are visible, they are still anonymous since it is by strength of number that they find their communal identity, a trope Horacio Legrás calls "enumeration" (2005: 16). It is indeed the expressive and attentive faces of the crowd that give life to the composition, as the singer belts out lyrics which seem to float above the crowd's heads, reminiscent of the speech bubbles common in cartoons. As mentioned earlier, the lyrics allude to a moment of harmony that has been achieved in post-revolutionary Mexico. The contradictory temporal and spatial intersections that Rivera constructs in this scene point to a threshold in the revolutionary narrative where fighting has reached a point of culmination and a second phase is about to take shape. At this point in the mural series, the time/space overlap between socialist and state utopias blends into the image of a new modern Mexico.

Rivera achieved this step in his visual narrative of revolution through the figure of Zapata who is invoked as a powerful revolutionary referent for the masses and as the link between the Mexican Revolution and the state's project of modernisation. Zapata's image had the ability both to appease the masses' political claims while also functioning as an ideological precursor of socialism. It is no coincidence that Michel sings the lyrics "todo es un mismo Partido / ya no hay con quién pelear."[16] These lines reinforced Rivera's scheme wherein the Zapatistas' concerns (now mirrored by state propaganda) such as the plight of indigenous

[15] I have in mind panels like *El trapiche* (*The Sugar Mill*), *Entrada a la mina* (*Entering the Mine*) and *La fundición—Vaciando el crisol* (*The Foundry—Pouring the Crucible*) (Lozano 2008: 37, 42, 48).

[16] "All are now one Party / there is no one to fight against any more."

groups, the need for land reform, and for modernisation were in accord with the goals of socialism. With this rhetorical device Rivera did not negate socialism, but rather diffused its revolutionary potential in Mexico by incorporating it as part of the state's post-revolutionary logic. From that moment on, the appropriation of Zapata's image has become fundamental to advancing any claims to reconfigure Mexico's political imaginary. The latest group to lay claim to Zapata's legacy has been the Ejército Zapatista de Liberación (EZLN).

Whilst *El hogar tan querido–Fin del corrido* (*Beloved Home–End of the Ballad*) (Fig. 11-4) may be the last moment in this visual narrative, it points up the beginning of the next revolutionary phase beyond armed struggle. Every aspect of vulnerability has been shorn from the protagonists of the revolution, who are now shown performing their daily tasks: at the centre there is a rural teacher with her pupils; a woman is sewing; and in the background a pair of peasants are ploughing the land. There are no urban workers leading the peasants here. Their presence is now embodied in the technologies (tractor, books, sewing machine) depicted as part and parcel of every day life. This new blending of the masses with modern technology symbolises the total integration of agricultural life into modernity. In terms of the local scope of the panel's utopian image, the blissful synthesis of human beings and machines can be interpreted as marking the emergence of Mexico from a primarily agricultural society to an industrialised one.

Although the machine aesthetic in this scene could also be interpreted in terms of the Marxist conquest of class conflict, the idea of technology's transformative and modernising potential was not exclusive to the dreamworld of socialism. The machine aesthetic as element of progress and modernity could also be found in the discourses of other radical utopias like fascism and National Socialism. The difference, as Rivera makes evident in the panel, is in the presence of the armed Zapatista fighter guarding everyone, and in the sight of the weapons, which have not been entirely put away. With the inclusion of the Zapatista fighters, Rivera concludes the visual narrative by reconciling the Zapatista ideology of the Mexican Revolution with a modern Mexican society. Ultimately, both the fighter and the weapons are symbols of the ongoing need to carry out the never-ending struggle of revolution and always to be vigilant of the capitalist enemy's incursion.

CONCLUSION

In the 1920s, the Mexican Revolution had been widely considered a peasant uprising that led to profound land reform, a perception that in

Rivera's murals at the SEP was recast and run in parallel with the coming of a world proletarian revolution. Given Muralism's dual nature as state-sponsored and avant-garde art, it could not envision a world proletarian revolution unless the official post-revolutionary state was acknowledged as part of that new and profound transformation. However, in the unfolding of the scenes, it becomes clear that socialism's potential for revolution was to remain a mirage. While the SEP murals' visual narrative showcased a radical plan to modernise Mexico, the dreamworld of socialism functioned to conceal disillusionment occasioned by the unfulfilled promises of the post-revolutionary Mexican state. This tension between radical ideologies and political propaganda, between aesthetics and politics, and between local and global revolution was ultimately a reflection of the avant-garde character of the muralist movement.

The years 1928 and 1929, when the SEP murals were being finalised, were fundamental in Mexico's path to modernisation. While socialism was beginning to lose the political and ideological battle in Latin America, the Mexican state's discourse was consolidated with the founding of the Partido Revolucionario Institucional (PRI) and its corporatist style of government. Eventually, all the criticism of Rivera's opportunism and of Siqueiros's Stalinism would fade, once the official history canonised them, along with Orozco, as the big three of Mexican Muralism. In the two decades which followed, the socialist visual language of the SEP murals was co-opted by the state for its post-revolutionary discourse, consecrating muralism as official art. All the political and ideological battles that had shaped Mexican politics and culture after the 1910 Revolution were also incorporated as events of the cultural history of the post-revolutionary period. By the 1930s, it was clear that the PCM had failed to establish socialism as a political alternative to the state's corporatist project. In reality, since its inception in 1919, socialism in Mexico had been dependent on the government's willingness to allow it to operate in the country, if only as part of its carefully constructed reputation as a progressive and modern state. It was indeed the state's dreamworld, and not that of socialism, which became engrained into Mexico's imaginary.

In his discussion of the novel of the Mexican Revolution, Carlos Monsiváis offers an explanation of this process of canonisation: the significance of the Mexican Revolution, he suggests, shifts into a kind of otherness, as if it happened in a different time, to a different generation (Monsiváis 2000: 1008). The emergence of the movie industry in the 1930s would change the perception of the revolution for good by presenting it from a more humorous and light-hearted perspective (Monsiváis 2000:1008). This shift in attitudes towards the revolution

conveniently played into the state's ideological project because it removed any sense of immediacy from the experience of the Mexican Revolution. When the state began to subsidise the film industry in the 1930s, the genres that proliferated were comedies and epic melodramas that dealt exclusively with the Revolution. The melodramas "emphasized social stability and the status quo, dissuading [their] audience from seeking radical social and economic change" (Doremus 2001: 5). By defusing the gravity of the bitter political battles during the 1920s, film became for the state one of the most effective tools for consecrating its official vision of the Revolution. Federico Dávalos Orozco observes that "paradoxically, the vigor of revolutionary nationalism with all of its populist and authoritarian contradictions generated a reactionary response with characteristics of Catholicism and anti-United States thoughts" (1999: 32).

Nowadays, the state's ideology has lost its political currency, a fact that was signalled with the elections of 2000. The Mexican government has shifted from a discourse of extreme nationalism to one that seeks the country's insertion within the global economy. Once again, the distance from the event called "revolution" has created a new otherness in terms of how the visual culture of the past is currently viewed. It is now possible to study the socialist phantasmagoria in muralism from the perspective of a kind of cultural archaeology: it remains to be seen, however, what values the murals' iconography will assume in light of the recent changes.

The SEP murals were not the only ones in which Rivera explored the idea of a socialist dreamworld. He had also been working on murals at the Universidad Autónoma Chapingo (Autonomous University of Chapingo) at roughly the same time as he was fulfilling the SEP commission (1923-1927). Moreover, his later work in the United States also projected socialist ideals but in different and more subtle ways. For instance, in murals in San Francisco like *Allegory of California* (1931), and *Making the Fresco, Showing the Building of a City* (1931), the visual narrative is more allegorical and explores the relations between industry and labour and the function of technology as a means of progress. In a similar way, his work in Detroit addresses the themes of science and technology while it experiments with the aesthetic of socialist realism that was in vogue at the time in Russia.

The same is true of his later work in Mexico. Never again would Rivera attempt to create the convergence of local and global dreamworlds as in *Balada de la Revolución*. This is not to say that he entirely discarded socialist utopia in his work. His next commission was for the principle stairwell at the National Palace where he painted a condensed history of Mexico. In these murals Rivera depicted the major events that marked the

history of the country from pre-Columbian times to his own. In the last section, entitled *México: Mundo de hoy y mañana* (*Mexico: The World of Today and Tomorrow*), painted between 1934 and 1935, at the very top of the mural, right at the helm of events about to come, is the figure of Marx. His presence in this mural, or rather the presence of Marxism, had now assumed the place of socialism as the embodiment of the political avant-garde. Therefore Marxism rather than the political legacy of the PCM or of any of the other Latin American Communist parties is perhaps the last vestige of socialism in the region. [17] Marx was shown pointing to a dreamworld where a modern society is founded on industry, science, and agriculture. This radical transformation of life, according to Marx's own words shown in the panel, will only be realised once class struggle is overcome.

In the end, and coming back full circle to what may have been muralism's ultimate project, González Mello rightly points out that "lo que estaba en juego en el arte mexicano del siglo XX (y en la política); lo que se negociaba, reconstruía e imaginaba sin cesar era la constitución del individuo y el ciudadano" (2008: 306).[18] However, this constant search for individual subjectivities was only possible as long as it was projected into a modern collective identity, such as the one offered by the dreamworld of socialism. The revolutionary language in the SEP murals always vacillated in time and space, and has now become part of the ruins of modernity.

[17] With regard to Marxism in Mexico, Paco Ignacio Taibo writes that "Marx fue publicado al fin del III Congreso (1925). Sin embargo su nombre no ascendió en el santoral, y el objeto número 1 de lectura, admiración y culto de los bolcheviques mexicanos, siguió siendo Lenin" (1986: 298). ("Marx was published at the end of the third Congress (1925). However, his name wasn't sanctified and the number 1 object for Mexican Bolsheviks, in terms of reading, admiration, and cult status, continued to be Lenin.")

[18] "What was at stake in twentieth century Mexican art (and politics), what was being negotiated, reconstructed and endlessly re-imagined, was the constitution of the individual and of the citizen."

WORKS CITED

Aguilar Camín, H. and L. Meyer. 1993. *In the Shadow of the Mexican Revolution: Contemporary Mexican History, 1910-1989*, transl. L. A. Fierro. Austin: Texas University Press.

Briuolo, D. 2002. "El corrido de la revolución, reorientación artística y personal." In *Diego Rivera y los murales de la Secretaría de Educación Pública*, ed. G. Castillo, 134-155. México D.F.

Buck-Morss, S. 2000. *Dreamworld and Catastrophe: The Passing of Mass Utopia in East and West*. Cambridge, MA: MIT Press.

Campa, V. S. 1978. *Mi testimonio: experiencia de un comunista mexicano*. México D.F.: Ediciones de Cultura Popular.

Claraval, B. 1944. *Cuando fui Comunista*. México D.F.: Polis.

Craven, D. 2002. *Art and Revolution in Latin America, 1910-1990*. New Haven: Yale University Press.

Dávalos Orozco, F. 1999. "The Birth of the Film Industry and the Emergence of Sound." In *Mexico's Cinema: A Century of Film and Filmmakers*, ed. J. Hershfield and D. R. Maciel, 17-32. Wilmington, DE: Scholarly Resources.

Doremus, A. T. 2001. *Culture, Politics and National Identity in Mexican Literature and Film, 1929-1952*. New York: Peter Lang.

Folgarait, L. 1998. *Mural Painting and Social Revolution in Mexico, 1920-1940*. Cambridge: Cambridge University Press.

Gall, O. 2007. "El papel del PCM y de Lombardo en la guerra del Kremlin, la Comintern y la GPU contra Trotsky. México 1936-1940." In *El comunismo: otras miradas desde América Latina*, ed. E. Concheiro Bórquez, M. Modonessi and H. Crespo, 615-651. México D.F.: UNAM.

González Mello, R. 2008. "The murals in the SEP." In *Diego Rivera: The Complete Murals*, ed. L.-M. Lozano and J. Coronel Rivera, 28-32. Köln: Taschen.

Guerrero, X. and D. A. Siqueiros and D. Rivera, eds. 1924-37. *El Machete: Periódico obrero y campesino*. Microfilm reproduction. New York: New York Public Library.

Halliday, F. 1999. *Revolution and World Politics: The Rise and Fall of the Sixth Great Power*. Durham, NC: Duke University Press.

Hart, J. 1987. *Revolutionary Mexico: The Coming and Process of the Mexican Revolution*. Berkeley: California University Press.

Legrás, H. 2005. "The Revolution and Its Specters: Staging the Popular in the Mexican Revolution." *Journal of Latin American Cultural Studies* 14 (1): 3-24.

Leslie, E. 2000. *Walter Benjamin: Overpowering Conformism*. London: Pluto Press.

Lozano, L.-M. 2008. "Revolutions and Allegories. A Mexican Muralist in the United States." In *Diego Rivera: The Complete Murals*, ed. L.-M. Lozano and J. Coronel Rivera, 266-271. Köln: Taschen.

Mella, J. A. 1968. *Julio Antonio Mella en El Machete. Antología parcial de un luchador y su momento histórico*, ed. R. Tibol. México D.F.: Fondo de Cultura Popular.

Monsiváis, C. 2000. *"1921, Vasconcelos y el nacionalismo cultural."* In *Historia General de México*: *versión 2000*, ed. I. Bernal et al., 1008México, D.F.: El Colegio de México.

Parker, N. 1999. *Revolutions and History: An Essay in Interpretation.* Cambridge: Polity Press.

Ramírez-García, M. C. 1989. "The Ideology and Politics of The Mexican Mural Movement: 1920-1925." PhD diss. University of Chicago.

Revueltas, J. 1984. *Escritos politicos (El fracaso histórico del partido comunista en México).* 2 vols., ed. A. Revueltas and P. Cheron. México D.F.: Ediciones Era.

Reyes Palma, F. 2002. "Otras modernidades. Otros modernismos." *Hacia otra historia del arte en México.* Vol. 3: *La fabricación del arte nacional a debate (1920 – 1950),* ed. E. Acevedo, 17-38. México D.F.: Conaculta.

Spenser, D. 2009. *Los primeros tropiezos de la Internacional Comunista en México.* México D.F.: CIEAS.

Taibo, P. I., II. 1986. *Bolshevikis: historia narrativa de los orígenes del comunismo en México, 1919-1925.* México D.F.: J. Mortiz.

Tibol, R. 2007. *Diego Rivera, luces y sombras: narración documental.* México D.F.: Lumen.

Vázquez Ramírez, E. M. 2007. "Acciones comunistas: 1929-1935." In *El Comunismo: otras miradas desde América Latina,* eds. E. Concheiro Bórquez, M. Modonessi, and H. Crespo, 587-614. México D.F.: UNAM.

Wade, R. A. 2005. *The Russian Revolution, 1917.* Cambridge: Cambridge University Press.

Wolfe, B. 1963. *The Fabulous Life of Diego Rivera.* New York: Stein and Day.

CHAPTER TWELVE

POLITICAL PARTICIPATION THROUGH ART: THE FILMS OF CARLOS SAURA, AND THE 2006 OAXACA CONFLICT

JAIME PORRAS FERREYRA

In recent times, image analysis in political science has focused principally on political campaigns and the use of the media as vehicles of communication for governmental plans and programs, by means of the field known as political communication. Often overlooked by our discipline is the use of artistic expression as a visual space capable of communicating messages of a political nature. Two examples of the visual ability of artistic expression in becoming an effective channel of political discussion and reflection are the role of film during Spain's transition to democracy in the 1970s and the use of stencil work, graffiti and other techniques by youth collectives during the political crisis which took place in Oaxaca (Mexico) in 2006.

On the one hand, a number of Spanish filmmakers found in the cinematic image a means by which publicly to critique, through metaphor and other hidden messages, the authoritarian values of the Franco regime. On the other, the rebellion on the part of certain sectors of Oaxacan society against governmental repression also found an echo in significant artistic output. Of this, the work produced by youth collectives in the streets was to become the most original and visible artistic element of the social movement, signifying both an innovative way of communicating political messages and a new face of Oaxacan plastic art itself. The fundamental goal of this text is to highlight the richness inherent in the study of artistic images as political vehicles in specific political climates, and thus point to the need of undertaking multidisciplinary studies which will allow us to understand in greater depth an entire range of social events in which the visual aspect acquires pre-eminent importance as a space of expression. In this chapter I consider the political role of film in the Spanish democratic transition, concentrating on the use of metaphor. I then examine the political role played by the young Oaxacan plastic artists in the social conflict of 2006. Finally, I present a series of reflections regarding the importance of the artistic image as a vehicle for the political.

ART AS POLITICAL OBJECT

The study of the relationship between art and politics has for decades interested authors from a number of different disciplines. Analyses of the use of art as a space for political expression have come from fields as diverse as sociology, film studies, comparative literature, cultural studies, anthropology and art history. For its part, political science has had little to say. A review of the relevant literature provides us with two visions in constant conflict. On one side, a number of authors defend a strictly aesthetic vision of art, one which eliminates the possibility of any discursive significance linked to political issues. In this view, art has a meaning and a purpose all its own (Touchard 2002: 47-49). Other researchers, however, defend a conception that directly links artistic expression with social phenomena. The artist, here, acquires a responsibility that is inseparable from the social life around him, and his work is a necessary consequence of a global process that brings all of the spheres in which human beings live and develop into contact (Touchard 2002: 49-50; Fischer 1997).

Despite the fact that the exploitation of art for political purposes may appear for many to be evident at first glance, it is important at this point to make a distinction between its different political uses, to separate what is known as "committed art" from political propaganda. Art and propaganda can fit closely together and act as a vehicle for a specific political ideology—consider the examples of social realism, the Mexican muralists or the films of Leni Riefenstahl during the Nazi regime—whereas other types of artistic expression can become linked to politics by means of a specific issue, as is the case of the protests against the Vietnam War in literature or popular theatre during the period in which African societies were in the process of emancipation.

As regards the artistic sphere, a number of writers in recent years have argued that art continues to be an active space for political action, whereas others speak increasingly of a progressive distancing of artistic creation from the political sphere. In the approach developed here, I consider art to be a space which is capable of being linked to the social sphere, becoming then a space of criticism and reflection regarding the political events of a society. In this way, art takes on the ability to provide a reading of a society and to provoke changes in individual consciences. Art, therefore, can represent a space of insertion into the political sphere, allowing for the communication of a whole series of messages and becoming in the process an innovative form of political participation.

Political scientists interested in political participation through art must confront two serious epistemological problems if they wish to bring their

research in the area to a successful conclusion. The first of these is the need to escape from traditional forms of analysis and turn instead to a multidisciplinary approach. Lacking a theoretical and methodological framework provided by political science, said researches must make use of a number of different tools from other disciplines in order effectively to study non-conventional forms of political action. Disciplines such as literary studies, anthropology, and film studies can provide tools for the political analysis of art. The second problem is the very view of art as a political object. Political scientists, accustomed as they are to the political and social role of art being analysed and interpreted by other fields, continue to overlook the space of art as a political object. Analysts of political participation within our discipline continue to prioritise conventional forms of political action—electoral participation, violence and the dissemination of civic values—by means of traditional political actors. In this sense, art—and specifically, the use of art as a space for political message-making—constitutes a double challenge for the political scientist: a new platform for political reflection along with the presence of a new actor capable of participating in public issues through an innovative discourse. Lucille Beaudry even goes so far as to state that the taking of art into account as a political space means revolutionising our way of understanding and applying traditional analytical categories to political science (1995: 6).

For decades, political science has been the target of criticism for maintaining a close-minded attitude towards a number of different areas where politics are present. Political anthropologist Georges Balandier criticised the radical distancing of politics from other social spheres with which it is in daily contact (1967: 2). In the 80s, Jean-François Bayart denounced the use of a too-canonical definition of politics which failed to take account of people's daily lives and individual forms of expression into account (1981: 53-64). Of all of the discussion regarding the need to take non-conventional forms of political participation into account in our discipline, the most important recent contribution has been French political scientist Denis-Constant Martin's concept of the Unidentified Political Object (UPO), developed in the course of his research at the International Study and Research Centre (CERI) in Paris. Following a number of years of study of social participation in communities, mainly in Africa and the Caribbean, Martin became aware of the need to develop a concept that would help explain the ways in which different societies talk about power indirectly, by means of cultural expression, artistic production and common everyday activities. In effect, Martin discovered that hidden behind certain actions seemingly unrelated to politics, such as sports, the

carnival, film, plays-on-words and painting, ways of communicating a particular political discourse could be found (Martin 2002b: 11-45).

The fact of the artistic image being used as a tool for political expression has been borne out by political events throughout the decades. My interest here is focused specifically on the relationship between art and politics at times of political transformation and focuses on the Spanish transition and the 2006 movement in Oaxaca, Mexico. Both examples are useful for coming to grips with the ability of the artistic image to communicate criticism of authoritarianism, to add new elements to the political debate and, fundamentally, to take into account other societal actors, those traditionally located well outside the political spectrum.

SPANISH CINEMA OF THE TRANSITION

In Spain, the relationship between film and the political sphere is a tradition that goes back decades. Initially wielded as a means of communication by both sides of the Civil War and later as a propaganda machine by Franco, it was transformed over time into a tool of democratic struggle during the transition and, later, as a space for debate regarding the new problems facing Spanish society. In the case of cinema of the transition, despite the fact that not all Spanish filmmakers were sympathetic to a pluralistic ideal, a majority did choose to support the democratic reforms (Hernández Ruiz and Pérez Rubio 2004: 129). As for cinematic production of the time, it is possible to observe that those directors sympathetic to democratic reform made use of certain specific strategies in order, on the one hand, to criticise the authoritarian legacy of Franco and, on the other, to communicate values closely associated with democratic life. Such was the case with so called "historical reinterpretation cinema," "political documentary," "metaphorical cinema," "progressive comedy" and the "cinema of the 'autonomies'" (see Trenzado Romero 1999 and Porras Ferreyra 2008a). In this chapter, my focus is on "metaphorical cinema," which sought, by means of hidden messages and layered meanings, to criticise the values which had been rooted in Spanish society for decades.

In undertaking a detailed historiographical revision of Spanish cinema of the transition, the first thing that becomes clear is that "metaphorical cinema" was very popular in its time. The direct heir to a subversive cinematographic tradition—the founding fathers of which were Luis Buñuel, Luis García Berlanga and Juan Antonio Bardem—the genre was employed in a number of films to make a mordant critique of behaviours and attitudes which were the fruit of so many years of authoritarianism in Spanish society. It is important to note that Francoism, over and above its

nature as a political regime, represented at the same time an entire way of life disseminated into society (López Pina and López-Aranguren 1976: 213-14). For this reason, it was necessary for Spaniards to confront a series of changes in the social value system in order to be able to transition fully from an authoritarian regime to pluralistic democracy.

During the years of transition, the metaphor on screen became a way of avoiding the still-existent censorship of the time and being able, thus, to project certain political ideas to a cinema audience. The use of a certain kind of cinematic language during a period of total transformation evidently eludes traditional forms of structuring and presenting political language during transitions. In this case, we find ourselves witnesses to an innovation in discourse occurring outside of the political arena of elite politicians. "Metaphorical cinema" becomes, then, an interesting example of popular political expression under the guise of mere artistic activity. The seventh art, in its role as an Unidentified Political Object (UPO), and in this particular case "metaphorical cinema", seeks to mask a concrete political discourse through *double entendres* and the possibility of multiple interpretations (Martin 2002b: 11-12). In this way, it came to embody an implicit struggle by certain directors to put specific political ideas on public display. In this regard, James C. Scott underscores the importance of subversive language in resisting abuses of power (2000: 20-21). It is, in fact, thanks to the development of "camouflaged" discourse that dissidents are able to make public a whole set of opinions, with the goal of criticising the powers-that-be and presenting other alternatives.

During the years of transition, a number of directors made incursions into "metaphorical cinema." It is important to state, however, that from a political perspective, two individuals captured most of the critical spotlight: Elías Querejeta and Carlos Saura, who together formed a cinematographic tandem that was fundamental for Spanish cinema. Producer of most of the metaphorical films, Elías Querejeta arguably had the greatest impact in the development of a committed and intelligent cinema, one which was a far cry from the stereotypes imposed by Francoist cinema. Meanwhile, the films of Carlos Saura from the period of transition have become the classic examples of the importance of a metaphorical language with political ends. In this text, I look at three of the Aragonese filmmaker's key works: *Ana y los lobos* (1973), *La prima Angélica* (1974), and *Cría cuervos* (1976).

Saura did not hide the moral obligation he felt to attempt to contribute, through his film work, to the social and political changes taking place in his country (Kinder 1979: 16). For him, there were three specific targets to be hit with metaphor, three basic pillars of the ideological apparatus of Francoism: religious authority, sex, and politics, the three topics prohibited

by the Franco high command both in the public sphere and in many Spanish homes (Castro 2003: 60). In *Ana y los lobos*, Saura makes a ferocious critique of Francoism through the story of a young British governess who has to put up with the perversity of a despotic mother and her three children, each of whom represents one of the three elements mentioned above. The film's plot pointed to the regime's moral contradictions as well as denouncing the ethical-religious forces at work in an environment characterised by violence. As for the metaphorical language utilised by Saura in the film, it was this very "discursive mask" that allowed the projection of the film to be authorised (Higginbotham 1988: 77). The story goes that Franco himself saw the movie at a private showing without being unduly startled by the imagery (Hopewell 1986: 76).

In *La prima Angélica*, Saura tells the story of an editor who, on a trip from Barcelona to Segovia to bury his mother's remains, relives in his mind scenes from his childhood during the Civil War years. Through images that mix memory and the present, Saura seeks publicly to demonstrate the impact of the past on Spaniards from that time, as well as to try to understand how the forces that shape identity actually work (Hopewell 1986: 86-87). One of the most significant themes in Saura's political discourse, in fact, is precisely how the present determines our past, in the same way that memory moulds our present behaviour. Along the same lines, the film also allowed Saura to make a sharp critique, on one hand, of the asphyxiating nature of tradition and the weight of dominant ideology in many Spanish homes and, on the other hand, to underscore the importance of identity and the past on the society of that time (Hidalgo 1984: 30; Lara 1976: 160-61). It is worth noting that the imagery of *La prima Angélica* did provoke a number of incidents in Spanish cinemas among certain groups who felt themselves to be directly alluded to by the film's plot. There was an incendiary bomb attack in the Balmes cinema in Barcelona and sections of the film were stolen by a group of young people from a Madrid auditorium (see Galán 1974).

Both in *La prima Angélica* and *Cría cuervos* the director avails himself of childhood in order to tell a story. As Marsha Kinder points out, this can be explained in two ways. First of all Saura grew up and was educated under the shadow of Francoism. Secondly, the presence of children on screen is in itself a metaphor of the "infantalisation" of the citizenry by the regime, in the lack of individual self-determination and the public imposition of Franco as the father of the nation (Kinder 1983: 58). This latter aspect is in line with the opinions of those political scientists who point out how important it was for Francoism to depoliticise the public, to

create passive and obedient individuals rather than active and participative citizens (Morán 2001: 468-469).

In *Cría cuervos* Saura avails himself precisely of the gaze of a nine-year-old girl in order to analyse a country seeking to recover its conscience, obsessed by death and openly struggling to shake off its authoritarian past. The story, which takes place in a Madrid neighbourhood, relates how little Ana is a witness to her father's infidelities and death, to her mother's sufferings from cancer, and to the secrets of the other members of her family. In the opinion of some critics, what Saura sought to do in the film was to denounce the mental imprisonment suffered by many Spaniards at the hands of the social and political establishment of Francoism, as well as to highlight the search for an emotional emancipation which would allow one to regain free use of reason after so many years of repression (Besas 1985: 128; D'Lugo 1991: 131). In this, Saura's political labour evokes Guy Hermet's observations on the responsibility of artists to work for the moral rehabilitation of a society during a time of political transition (1993: 214).

Through the use of a wide variety of images and narrative techniques, Saura was in large part responsible for consolidating a cinematographic genre that had come into being through the political and aesthetic evolution of a generation of filmmakers who, having grown up and been educated during the darkest years of Francoism, sought to demonstrate both their rejection of the regime's intolerance and their support for other political alternatives (Besas 1985: ix-x). Through metaphor and the stories projected on screen, an attempt was made to denounce the values inculcated by the regime—violence, the lack of participation, the imposition of force over law and intolerance, to name just a few—with the goal of putting on display all the parts that made up the *homo franquista* (Larraz 1986: 226). Since Spanish metaphorical films were shown at major film festivals the world over, they succeeded in presenting an alternative view of Spain, demonstrating the existence of quality filmmaking that both opposed the regime and made a clear break with the characteristic stereotypes of Francoist cinema.

ARTISTIC EXPRESSION AND THE 2006 OAXACA CONFLICT

Midway through 2006, the State of Oaxaca (Mexico) experienced a political and social crisis with disastrous consequences. After years of protest, the unionised teachers were repressed by the government. As a result, the Popular Assembly of the Peoples of Oaxaca (APPO), made up of associations, collectives and other organisations, came into being with a common goal: the removal of Governor Ulises Ruiz and the redefinition of

public participation in state politics. On the heels of the conflict, a number
of academics and journalists took on the task of explaining its causes,
development and final days.[1] Of all of the particular features of the
popular movement, we find that artistic production played an important
role in ensuring that an entire range of ideas and political opinions came to
light. During the most acute months of the Oaxacan movement, poetry,
music, video, photography, and especially the plastic arts served as
instruments for reflection and for communicating different political
postures.

In spite of the significant amount of art produced in Oaxaca, the ties
between artistic creation and political life have not always been so close.
As Robert Valerio points out, separation between aesthetic production and
political messages was the rule in Oaxaca for many decades (1999: 169-
70). It is important that this point be made, seeing that the Oaxacan
conflict of 2006 was to prove so groundbreaking in the use of artistic
expression as a political vehicle, thus breaking with this tradition of rarely
including overtly political ideas in artistic work. Following a series of
interviews with a number of artists, it became possible to pinpoint the
various degrees of their political participation in the movement. On the
one hand, there were those artists who supported the government's actions.
Also, a small group decided to remain on the sidelines of the situation. On
the other hand, it was clearly demonstrable that a majority of artists
supported the demands made by the Asamblea Popular de los Pueblos de
Oaxaca (Popular Assembly of the Peoples of Oaxaca, APPO), although
few decided formally to join the Assembly. Despite the agreement
between a large number of artists resident in Oaxaca and the APPO—
although they remained independent in terms of decision-making—when
the main leaders of the APPO directly proposed to a number of artists that
they form an official cultural wing of the Assembly, the proposal was not
accepted.

Accounting for each and every work of art with political content
produced during the movement would prove overly complex. It is,
nevertheless, important to mention the disciplines which were intensely
active during the most extreme months of the conflict. In the musical
sphere, artists from the most diverse genres—from hip-hop to *son jarocho*,
cumbia and *trova*—expressed their political opinions in both public and
private settings. In photography, artists of the stature of Marcela Taboada,

[1] Essential titles among the literature dedicated to the conflict are Víctor Raúl
Martínez Vásquez's *Autoritarismo, movimiento popular y crisis política: Oaxaca
2006* (2007) and Nancy Davies's *The People Decide: Oaxaca's Popular Assembly*
(2007).

Antonio Turok and Alberto Ibáñez actively brought their lenses into the fray.[2] Some photographers worked directly for news agencies and the local, national, or international media; others operated independently, on personal initiative. Both groups, however, shared the desire to document and publicise the situation confronted by Oaxacan society in those months. In the world of letters, a number of Oaxacan writers described the climate of the conflict, giving expression to their criticisms and solidarity through stories, poems, and principally, essays and articles. These texts were published mainly in the local and national press, in independent magazines, and in personal blogs on the internet. A significant amount of video work was also produced through well organised collectives such as the emblematic "Mal de Ojo," or by artists with more personal motives who, with an eye more focused on aesthetic exploration, sought to break though the information barrier of those months and document the situation.

The Oaxacan cultural sphere has principally been occupied by artists associated with the plastic arts. The work of painters, engravers, and sculptors constitutes the most well-known aspect of Oaxacan art. As with artists from other domains, many plastic artists supported the demands of the movement in 2006; a smaller portion supported the government, while others stayed on the sidelines of the situation or even moved away. Following the attempt to evict the teachers from the city centre, a number of well-known plastic artists decided publicly to support the teachers' union and to denounce the actions of the Ulises Ruiz administration. Participating directly in marches, designing banners and flyers, a good many plastic artists made their presence known in the movement (Porras Ferreyra 2008b; Porras Ferreyra 2008c).

Of all those tied to the plastic arts who participated in the political and social crisis that shook Oaxaca in 2006, it is necessary to distinguish several generations of artists. Mention should be made, first of all, of the painters, engravers, and sculptors with an established career and many years in the public eye, who, in choosing to become politically involved, made use of precisely this name recognition to call attention to the problems of the moment. I refer here to artists such as Francisco Toledo, Rubén Leyva, Nicéforo Urbieta, and Raúl Herrera. Within this group, the name of Francisco Toledo is fundamental. An internationally-renowned artist, Toledo has become an extremely important actor in Oaxacan society due to his involvement in a number of social causes and his work as a disseminator of culture through a series of institutions that he himself has

[2] In December 2008 a book which compiled the photographic work dedicated to the movement along with a number of related articles was presented in Oaxaca City. See Rubén Leyva's *Memorial de agravios. Oaxaca, México, 2006* (2008).

created. In a second category are those plastic artists who, although younger, have already established a solid career. Despite the lack of a totally unified ideological posture—or degree of participation—these artists played an important role in movement-centred cultural expression. Within this group, mention can be made of Demián Flores and Guillermo Olguín.

A third generation gave life to the expressive movement of greatest interest in the conflict. I am thinking here of the youth collectives, the majority of whose members were graduates of the city's art schools and workshops and who, by means of stencilling and printing posters and flyers, succeeded in creating an entire, high-impact artistic phenomenon. Three of these collectives have distinguished themselves for the quality of their work and their omnipresence in the city. ASARO (The Oaxacan Revolutionary Artists Assembly) is a collective founded in October of 2006 to create a space for artists, who, in a manner reminiscent of the Mexican muralists, defend the use of the artistic sphere as a space for political action (Porras Ferreyra 2008d). Founded in 2004, the Jaguar Collective was an active participant throughout the movement, although it insisted on maintaining its independence from the decisions and postures of the APPO (Porras Ferreyra 2008e). In the same fashion, Guillermo Pacheco and the members of the Zape Collective, founded in 2005, articulated through their work issues of importance for Oaxacan society (Porras Ferreyra 2008f).

As Christine Frérot has pointed out, the work of these collectives constituted a rupture with the established aesthetic canons of Oaxacan painting, which had for over twenty years been commercialised, devoid of political content, and dominated in its subject matter by the folkloric (2009: 43-44). On the walls of the city appeared a new form of political expression which made use of a number of different techniques and styles. The young artists drew on elements of popular culture, such as faces from Mexican cinema and comic characters, and on Latin American revolutionary iconography—the mythical silhouettes of Che Guevara and Emiliano Zapata—as well as making caricatures of members of the government and including appearances by those groups traditionally forgotten by political message-making—children, the elderly, and indigenous women. And beyond even all of this, members of the collectives also altered governmental and commercial advertisements, modifying the messages' meaning in so doing. In the same way, they succeeded in integrating into their work images from Mexican religious iconography, such as a series of images of the Virgin, portraits of Christ and the Sacred Heart (Lache Bolaños 2009: 201, 212).

Topics such as police brutality, the inability of the citizenry to participate in the political process, corruption, Oaxaca's multicultural identity, the plight of women, the harsh conditions of life for many members of society and outright support for the rebellion itself appeared on walls, banners, posters, flyers and T-shirts. The use of spray paint, originally considered simply to be artistic, played in Oaxaca a specific political role, as Louis Nevaer and Elaine Sendyk decribe:

> Unlike other cities, such as Amsterdam, Belfast or Los Angeles, where graffiti is recognized by many as a form of 'public art', in Oaxaca, graffiti became political protest speech and a way of achieving social justice through community organization. Graffiti created an ongoing dialogue of rage, informing the public about meetings, and defying government officials. (2008: 59)

By narrating day-to-day problems and the climate of civic rebellion, each member of the collectives became a sort of "modern scribe" (Nevaer and Sendyk 2008: 23). These artists helped to communicate an entire range of popular images—different from those present in official discourse—which expressed both the opinions and feelings of thousands of individuals generally not taken into account in the Oaxacan political and social scene. In this way, the work of these young artists fulfilled, to the letter, a fundamental tenet of UPOs as described by Denis-Constant Martin: expressing the set of representations that citizens construct regarding their daily lives, and especially, the political sphere: how they situate themselves in it and how they are able to act (Martin 2002a: 73-104).

CONCLUSION

The metaphorical cinema of the Spanish democratic transition and the work produced by youth art collectives during the popular rebellion in Oaxaca, Mexico, in 2006 constitute two good examples of how the artistic image can become an effective vehicle for reflection and political participation in determined social climates. In these two cases, the situation was that of a political reform process and a possible rupture with traditional institutions. Carlos Saura's cinema employed codified language to permit criticism of an entire set of values inherited from Francoism, thus contributing to the transformation of Spanish society. Violence, authoritarianism, repression and the lack of civic participation came to be criticised on the big screen thanks to Saura's virtuosity. In the case of Oaxaca, young artists broke through the separation of politics and art, and by means of a variety of techniques, produced works loaded with criticism and insubordination vis-à-vis governmental authorities, plastering the city

streets with images describing the real situation facing the people of Oaxaca.

The two examples considered here confirm the presence, in daily life, of an entire set of actions carried out by citizens who are ostensibly isolated from the political sphere, actions containing discourse that must be taken into account if one wishes to come to grips with the views of these other political actors. In this way, the concept of the Unidentified Political Object (UPO) becomes an extremely important tool for the modern political scientist wishing to study all of the domains where politics are present. The analysis of the artistic image as a space of reflection and political communication doubtless presents a challenge, both on the theoretical and the methodological planes. That is why, in light of the lack of consistent interest by political science, it is necessary to turn to other areas of knowledge and make use of a multidisciplinary perspective to come to understand in depth how, behind an image produced by an artist's inspiration, messages and reflections regarding our life in society can be hidden.

WORKS CITED

Balandier, G. 1967. *Anthropologie politique*. Paris: Presses Universitaires de France.
Bayart, J-F. 1981. "Le politique par le bas en Afrique noire." *Politique africaine* 1 (1) 53-64.
Beaudry, L. 1995. *Le recours à l'art comme lieu d'inscription du politique*. Note de recherche 54. Université du Québec à Montréal.
Besas, P. 1985. *Behind the Spanish Lens: Spanish Cinema Under Fascism and Democracy*. Denver: Arden Press
Castro, A. 2003. "Interview with Carlos Saura" In *Carlos Saura: Interviews*, ed. L. M. Willem, 52-64. Jackson: University Press of Mississippi.
D'Lugo, M. 1991 *The Films of Carlos Saura: The Practice of Seeing*. Princeton, N.J.: Princeton University Press.
Davies, N. 2007. *The People Decide: Oaxaca's Popular Assembly*. Natick: Narco News Books.
Fischer, H. 1977. *Théorie de l'art sociologique*. Tournai: Casterman.
Frérot, C. 2009. *Resistencia visual. Oaxaca 2006*. Paris: Talmart.
Galán, D. 1974. *Venturas y desventuras de la prima Angélica*. Valencia: Fernando Torres.
Hermet, G. 1993. *Culture et Démocratie*. Paris: Albin Michel, UNESCO.
Hernández Ruiz, J. and P. Pérez Rubio. 2004. *Voces en la niebla. El cine durante la transición española (1973-1982)*. Barcelona: Paidós.

Hidalgo, M. 1984. "El escándalo de La Prima Angélica." In *Historia de la transición: Diario 16. Primera parte, 10 años que cambiaron España 1973-1983*, ed. J. T. De Salas, 30. Madrid: Información y prensa.

Higginbotham, V. 1988. *Spanish Film under Franco*. Austin: University of Texas Press.

Hopewell, J. 1986. *Out of the Past: Spanish Cinema After Franco*. London: BFI.

Kinder, M. 1979. "Carlos Saura: The Political Development of Individual Consciousness." *Film Quarterly* 32 (2): 14-25.

——. 1983. "The Children of Franco in the New Spanish Cinema." *Quarterly Review of Film Studies* 8 (2): 57-76.

Lache Bolaños, N. P. 2009. "La calle es nuestra: intervenciones plásticas en el entorno de la Asamblea Popular de los Pueblos de Oaxaca." In *La APPO: ¿rebelión o movimiento social? (nuevas formas de expresión ante la crisis)*, ed. V. R. Martínez Vásquez, 199-217. Oaxaca: IISUABJO.

Lara, F. 1976. "Estructura y estilo en la prima Angélica." In *La prima Angélica*, eds. C. Saura and R. Azcona, 142-167. Madrid: Elías Querejeta Ediciones.

Larraz, E. 1986. *Le cinéma espagnol des origines à nos jours*. Paris: Les Éditions du Cerf.

Leyva, R. 2006. *Memorial de agravios*. Oaxaca: Marabú Ediciones, 2008.

López Pina A. and E. López-Aranguren. 1976. *La cultura política de la España de Franco*. Madrid: Taurus.

Martin, D-C. 2002a. "À la quête des OPNI (objets politiques non identifiés.)" In *Sur la piste des OPNI (Objets politiques non identifiés)*, ed. D-C. Martin, 73-104. Paris: Karthala.

——.2002b. "Les OPNI, l'essence du pouvoir et le pouvoir des sens." In *Sur la piste des OPNI (Objets politiques non identifiés)*, ed. D-C Martin, 11-45. Paris: Karthala.

Martínez Vásquez, V. R. 2007. *Autoritarismo, movimiento popular y crisis política: Oaxaca 2006*. Oaxaca: CDPE/CAMPO/EDUCA/IISUABJO.

Morán, M. L. 2001. "Deux récits sur la culture politique. Transition démocratique en Espagne et perspective nationaliste au pays Basque". In *Cultures politiques*, ed. D. Cefaï, 463-483. Paris: Presses Universitaires de France.

Neaver, L. E. V. and E. Sendyk. 2008. *Protest Graffiti Mexico: Oaxaca*. New York: Mark Batty.

Osorno, D. E. 2007. *Oaxaca sitiada. La primera insurrección del siglo XXI*. México: Grijalbo Mondadori.

Porras Ferreyra, J. 2008a. "El cine y las transiciones a la democracia: algunas reflexiones en base al caso español," *Cine-Historia* 17 (2). http://www.pcb.ub.es/filmhistoria/ensayo_cine_transicion_1.html.

——.2008b. Interview with plastic artist Francisco Verástegui. 22 April.

——.2008c. Interview with plastic artist Raúl Herrera. 30 April.

——.2008d. Interview with "Mario", founding member of ASARO. 14 May.

——.2008e. Interview with "Vain", member of the Jaguar Collective. 26 May.

——.2008f. Interview with plastic artist Guillermo Pacheco. 27 May.

Scott, J. C. 2000. *Los dominados y el arte de la resistencia*. Mexico: Ediciones Era.

Touchard, J. 2002. "En guise d'ouverture: Littérature et politique. Faire de la politique sans le savoir." In *Sur la piste des OPNI (Objets politiques non identifiés)*, ed. D-C. Martin, 47-71. Paris: Karthala.

Trenzado Romero, M. 1999. *Cultura de masas y cambio político: el cine español de la transición.* Madrid: Centro de Investigaciones Sociológicas.

Valerio, R. 1999. *Atardecer en la maquiladora de utopías.* Oaxaca: Ediciones Intempestivas.

PART III
CUBA

CHAPTER THIRTEEN

PERFORMING THE NATION AND THE BODY IN ANA MENDIETA AND NANCY MOREJÓN

DOLORES ALCAIDE RAMÍREZ

In Nancy Morejón's poem "Ana Mendieta," the poetic voice appropriates the artistic work and body of Mendieta, turning them into symbols of Cuban nationalism. Simultaneously, Morejón widens the limits of the Cuban nation in order to incorporate those who live in the diasporic communities in the United States. In this way, Morejón subverts both the official rhetoric of the Cuban Revolution and the idea of a nation as homogeneous and fixed. The delicate lyricism of Morejón's poetry transforms Mendieta into a member of the Cuban nation, despite the fact that she lived most of her life in the US, thus bringing into question her presumed identity as Cuban-American, while Mendieta's work itself suggests an unstable national identity, always in constant movement, circulating among nations. Ultimately, Morejón uses Mendieta's tragic death to criticise the fragmentation of the identity of fourteen thousand children and teenagers who were relocated from Cuba to the United States through the ministrations of Operation Peter Pan (1960-1962).[1] Through Ana Mendieta, Morejón establishes a criticism of United States imperialism and capitalism, but at the same time she recovers as members of the Cuban nation those Cubans who live in the diaspora within the United States. Fidel Castro's government either refuses to talk about those who left the island, or, when it does, it qualifies them as *gusanos* (worms), thus framing expatriate Cubans within a politics of betrayal and forgetting.[2] Morejón subtly subverts this politics of reading physical removal as rejection.

[1] Ana Mendieta died tragically at the age of thirty-six when she fell from the balcony of the apartment in Manhattan where she lived with her husband, the minimalist artist Carl André. After suspicion fell on her husband, Mendieta's death was finally ruled to have been either accidental or a suicide.

[2] Fidel Castro qualified those who were against the Revolution as *gusanos* (worms) in a 1961 speech. The term quickly came to be used to denote those who left Cuba for the USA, and more specifically still to refer to the Miami Cubans (see Castro Ruz 1961).

Before analysing Morejón's poem in depth, it is important to talk about the concept of nation that can be seen in Ana Mendieta's performance art. Ana and Raquel Mendieta arrived in the United States under the auspices of Operation Peter Pan, an airlift undertaken by charitable organisations, supported by the Catholic Church and other Christian groups, after the Revolution of 1959. The goal of the Peter Pan project was to take Cuban refugee children away from Cuba and place them with families in the United States in order to protect them from Communism.[3] When Ana left the island she was only twelve years old and her sister Raquel was fifteen. However, unlike some other Cuban children who had relatives in the United States, Ana and Raquel did not have family there so they were sent to Dubuque, Iowa, and spent several years being bounced from one orphanage to another (some of which were more like correctional facilities) until their mother and their younger brother were able to join them two years later.[4]

It was indeed a traumatic experience for the Mendieta sisters to leave Havana, with its tropical climate, its palm trees, and the sound of the ocean, and suddenly to find themselves in Iowa, with its overwhelmingly white population, its intense cold, and its constant silence. Mendieta and her sister took a long time to become acclimatised to a country where their skin colour and their cultural background made their otherness very visible. Despite the fact that both sisters came from a quasi-aristocratic family in Cuba—where they had probably been considered as white—in Iowa their physical appearance conspicuously contrasted with that of the predominantly northern European population. During the 1960s the Mendieta sisters suffered from constant racial discrimination, exacerbated by the climate of racial violence and by antagonism to the civil rights movement. Raquel Mendieta recounts that while they were in high school, Ana used to receive anonymous phone calls from people who would call her a "nigger" and tell her "go back to Cuba, you whore!" (Blocker 1999: 53). It was while living in Iowa that the sisters realised that perceptions of skin colour change as one travels from one place to another, and where they learned, harshly, that race and colour are cultural constructions. According to Blocker, such experiences led Ana Mendieta to become

[3] After the Castro government took control, the rumour circulated that parents would lose *patria potestad* over their children, who would instead become wards of the State. Many upper class and aristocratic Cubans decided to send their children to the United States on the basis that the Revolution would not last more than a few months and that the separation would be only a temporary one.

[4] They were not reunited with their father until many years later when he was released from prison in Cuba (Cabañas 1999: 12).

disassociated from whiteness and "to identify herself as a woman of colour or as non-white" (1999: 53). [5] In this way, Mendieta consciously assumed a mestizo/mulatta identity in order to be able to talk from the point of view of the colonised subject, and as a woman from the Third World (though living in the First World). As a woman in Cuba she experienced the otherness rooted in biological gender, and her experience of exile in the United States was one where she felt another equally violent kind of otherness rooted in the body, this time connected to ethnicity and to her skin colour.

In *Where is Ana Mendieta?* Jane Blocker maintains that Mendieta uses her exile as a liminal, interstitial space from which to perform her identities and, simultaneously, as a place from which to subvert the concept of nation:

> To identify herself with the 'earth' and not with either Cuba or the United States means that Mendieta can sustain rather than assuage exile. She can make exile home. By searching for her roots in the earth and not in country, she can claim an identity anywhere. Her imagined community crosses all territories, escapes all border guards, can be found anywhere on the planet, is tied neither to language nor race. (1999: 78)

For Blocker, Mendieta uncovers the instability of categories such as gender, race, and nation, and attaches herself to multiple identities, eschewing singularity. By living among nations, constructing exile as her home, and living between colours, appropriating cultural experiences from the Taino people as well as from Afro-Hispanics, Mendieta confounds and subverts the notion of a fixed and homogeneous identity.

Mendieta has been criticised for the essentialism that seems to permeate her work, especially her *Siluetas* series, in which she inscribes her own body (or rather its absence) on the earth. Mendieta's use of her

[5] In an essay written for the catalogue accompanying one of her exhibitions, Mendieta herself affirms that "during the mid to late sixties as women in the United States politicised themselves and came together in the Feminist Movement [to] end the domination and exploitation by the white male culture, they failed to remember us. American Feminism as it stands is basically a white middle class movement [...] This exhibition points not necessarily to the injustice and incapacity of a society that has not been willing to include us, but more towards a personal will to continue [...] being 'other'" (Blocker 1999: 62). Mendieta not only disassociated herself form the US feminist movement but also aligned herself with the margins and with difference, a position from which she sought to resist the imposition of a homogenising identity and to fight for the voices of white America's others (among whom she included herself) to be heard.

body as a tool for inscribing her (non-)self on the elements can be interpreted as a wish to feminise the earth, to situate the female body in communion with nature. Due to the long tradition of associating women with nature, some have seen the recurrent use of the earth in Mendieta's work as being in sympathy with the stance of American feminists of the 60s and 70s who proclaimed a return to the cult of the Goddess as a source of energy and power for women (Blocker 1999: 61). Nowadays many feminists reject this idea because, according to Mikwon Kwon, "the 'feminine' and 'woman' are presented as ahistorical categories with characteristics that belong [...] naturally and universally to one gender" (1996: 166). There was not room in this concept of gendered identity for different types of women from different classes or races. Mendieta herself, through her scarce writings, contributed to this essentialist view of her work: "Through my earth/body sculptures I become [...] an extension of nature and nature becomes an extension of my body" (quoted in Kwon 1996: 167).

Mendieta also clearly disassociated herself from those 70s feminists she considered as middle class white women (Mendieta 1980: 1). Her identification with the wretched, with victims of violence and colonisation, should foreground Mendieta's Cuban cultural heritage as we interpret her work. In spite of the influence of American art from the 60s and 70s which is to be found in her work, we need also to consider Mendieta's acts of deconstructing concepts of national, racial, and sexual identity. When she inscribes one of her silhouettes on the surface of the earth, we know that it is indeed a temporary act and that its impression will disappear with time. Additionally, as Irit Rogoff points out, Mendieta presents works of art without borders or national limits. In the sihouettes, we do not know where the creative artifice leaves off and the work of nature begins, so that these works blur boundaries within physical space: "They cannot be framed or bound within conventional artistic or geographical territorialities" (Rogoff 1997: 169). Likewise, her works cannot be defined by concepts of nation which resort to the parameters established either by a political map or an official history. The lack of borders locates Mendieta's work in an in-between space where it is possible to question putatively static notions, not only of nation (whose boundaries are in constant flux for this artist) but also of gender and of race.[6]

[6] Anne Raine makes an interesting psychoanalytical analysis of the uncanny in Mendieta's silhouettes. She observes that gender in these works is diffuse, seemingly a given due to the similarity with the figures of mythic goddesses, yet also precarious: when we look at Mendieta's anthropomorphic figures after some time has passed by, when the lines marking gender have almost completely

The identities Mendieta sought to establish through her work never remain in the same place long: they constantly travel, confusing and erasing borders. Mendieta herself observed that "having been torn from my homeland [...] during adolescence I am overwhelmed by the feeling of having been cast out of the womb (Nature)" (Blocker 1999: 92), and her silhouettes have been interpreted as a form by which she sought to root herself, to take possession of the earth, to repair the childhood loss of her home and of her nation. However, Mendieta inscribes her body within the geographical spaces of different nations: she staged her performance art (and the fleeting performance of identity) not only in the United States (in Florida as well as in Iowa) but also in Cuba and Mexico. If to inscribe the body on the earth is to take possession of it, to reclaim roots denied to her by her exile, then this way of constructing home is transitory and ephemeral because it does not last: it disappears. The act of fixture undoes itself when repeated in such different historical and national contexts, and thus Mendieta performs the loss of identity in the same act which ostensibly retrieves it.

Bearing in mind Mendieta's subversion of the concepts of nation, race, and gender, we will go on to look at Nancy Morejón's poem "Ana Mendieta". Firstly, however, we must consider Morejón's negotiation of issues of race within the context of post-revolutionary Cuba. Nancy Morejón (born Havana, 1944) is an internationally recognised Afro-Cuban poet. Her role in inscribing the body of the Afro-Cuban woman as creative and revolutionary agent has been widely studied and, according to Flora González, Morejón establishes herself as mediator between her African heritage and the Revolution's project of national unity (1995: 991). Poems such as "Amo a mi amo" ("I Love my Master") and "Mujer negra" ("Black Woman") discuss the slavery suffered by Afro-Cubans and emphasise the role of the African diaspora's women not only as victims of colonial violence, but as agents of history. There has been some debate about the role of the individual in Morejón's poetry. For example, Claudette Rosegreen-Williams suggests that in "Mujer negra" Morejón's attachment to the Cuban Revolution's communist ideology produces individual (racial and gender) identity which, by being subsumed under a collective identity, will lead to racial equality. The poem ends with the triumph of the Revolution and switches from a first person singular subject in the first stanza to the first person plural in the last: now everything belongs to everybody and there is neither discrimination nor racial strife

disappeared from the landscape, their gender becomes ambiguous (Raine 1996: 240).

(2003c: 202). For Rosegreen-Williams, the poem reverberates with the dialectic of transgression and orthodoxy:

> In 'Mujer negra' one is left with the impression that while nationalist sentiments are considered politically legitimate, certain racial sentiments are not. In this regard the title of the poem may even be seen as ironic, since the racial specificity which it anticipates is undercut by the raceless nationalism which the poem espouses [...] not only can revolutionary commitment not share a common ideological space with the 'strong black consciousness' which might be assumed from the title, but it must also override it. (1989: 12)

Rosegreen-Williams also considers that the line in "Mujer Negra" "Ahora soy" ("Now I am") suggests the Revolution becomes an "absolute panacea" for the subject of the poem: the black woman finds her own identity in the historical process whose culmination is the Revolution, but this same Revolution also entails the loss of her identity in the homogenising body politic promoted by Castro's regime: "The egalitarianism claimed, or implied, by the reference to other heirs of the revolution as "iguales míos" further serves to disseminate the myth that the end of the class struggle is simultaneous with the end of racial prejudice and discrimination" (Rosegreen-Williams 1989: 12). Dellita Martin-Ogunsola suggests that in its vacillation between Africanity and revolution, "Mujer negra" evidences a "dialectic of ambivalence" (1999: 239) and I would argue that it also presents a subversion of that dialectic. We cannot forget where and when Nancy Morejón writes; the influence of post-revolutionary Cuban society is going to be obvious in her poetry. Her loyalty to the Revolution is evident as she also tries to reconcile what she thinks is important for her own poetry. The topics of negritude, race, gender, and African traditions are always present in Morejón's writing. Thus, despite the Revolution's claims to have achieved racial equality among Cubans, it is clear that Morejón continues to lend great importance to questions of ethnic and gender identity. According to Paula Sanmartin, Afro-Cuban women poets can identify simultaneously with a unified black consciousness of the African diaspora as well as with a transcultured black identity within a Cuban national ideology (2006: 70). The Revolution's vision of *cubanismo* establishes that with the elimination of social class, discussion of racial and gender discrimination will not be necessary. All Cubans are racially mixed and therefore to talk about racial differences is a way of creating divisions and disrupting national unity. Notwithstanding the Revolution's lack of patience with questions of racial identity, Morejón has managed to incorporate in her work the fundamental role of

Afro-Cubans in building Cuba as a post-colonial nation. Morejón has affirmed the specificity of her work through being black and a woman, whilst simultaneously subscribing to the official discourse of *cubanidad* (Morejón 1996: 7).[7]

Morejón's 1993 poem "Ana Mendieta" (1993) stands out, not only because of its concept of the nation as culturally hybrid but also because it extends the meaning of the nation to embrace those who have left Cuba, who live in the diaspora of the North, and who, albeit at a distance, still belong to the Cuban nation. In this aspect, Morejón's poem veers away significantly from official revolutionary discourse. In an interview, Morejón stated that "the diaspora cannot be in any way divorced from the phenomenon of the nation" (Morejón 2000: 163). In the 1990s, and in response to the hardships of the so-called "special period", the pattern of migration changed dramatically in Cuba as people tried in droves to leave the island as *balseros* (rafters). The *balseros* left the island primarily for economic reasons rather than ideological ones. The topic of migration is like an open wound in Cuban culture and, according to Juanamaría Cordones-Cook, even though Morejón decided to remain on the island and to be loyal to the ideals of the Revolution, "el problema de la separación de las familias cubanas, el desarraigo, la nostalgia y la soledad se convirtió en una preocupación personal de esta poeta" (2009: 2).[8]

From the beginning of "Ana Mendieta", Morejón establishes an intimate tone between the poetic voice and the subject. The poem uses Mendieta's first name (Ana), which denotes familiarity and even a friendship. The use of the familiar "tú" form instead of "usted" reinforces that connection.[9] Such intimacy encourages us to think that despite being an immigrant living in the United States Mendieta is Cuban after all. That is emphasised further when Morejón uses the possessive plural in the line "Ana nuestra de la desesperanza" ("Our Ana of despair"). Miriam DeCosta-Willis reads the parity established between the poet and Mendieta here in terms of them both positing the creative artist as

[7] *Cubanidad, cubanismo*, and *cubanía* are terms used to describe the hybridity of Cuban culture: a mixture of European, African, and Asian influences. Such terms have been used to signify unity in Cuba under the Revolution and are intended to erase differences based on race.

[8] "The problem of the separation of Cuban families, of displacement, nostalgia and solitude became a personal preoccupation for this poet."

[9] Ana Mendieta traveled to Cuba in the 80s taking advantage of a thaw in the relationship between Cuba and the United States. Whilst there, Mendieta established a relationship with Angélica Hernández, Nancy Morejón's mother, and through her, Morejón became friends with the artist (DeCosta-Willis 2008: 246).

someone who negotiates space as a spiritual dimension (2003: 243). In Morejón's poetic evocation of her biographical subject, Ana is held to belong to Cuba, and not to the culture of the Unites States. In the same way that in her own work Mendieta attempted to erase the borders of national (together with racial and gender) identity, Morejón presents us with an idea of the nation that is inclusive and that incorporates those who belong to it spiritually, even though they do not live in the country.[10]

Mendieta's body and her body of work are inextricably linked in Morejón's poem. The physical fragility of Ana's body is emphasised, and it is also connected to the fragility (or impermanence) of her performance work. Moreover, the descriptions Morejón uses to approach her subject— "calcinada historia", "iluminada por las lluvias", "silueta de arena y barro" ("scorched story", "brightened by the rain", "silhouette of sand and mud")—are related to Mendieta's work as an artist. All these lines make reference both to Mendicta's body and to her life; however, they are connected to her work and the materials that she used in order to create the imprint of her body on the earth. Morejón's poem subtly elaborates on Mendieta's biographical data to achieve their coalescence with her work and to emphasise her longing for Cuba. Body, work, and life are all united within Ana and within Morejón's poem about her.[11] Thus, the poem mentions the balcony and the window from which Mendieta fell and it freezes her in her deathly flight through the Manhattan sky. However, this Manhattan landscape is one overwritten with images of Havana, its trees, its houses, its neighbourhoods, its Venetian blinds. On the other hand, the silhouettes Mendieta saw from her balcony are the crowds in New York, although those silhouettes brought to mind memories of her neighbourhood in Havana, according to Morejón's poem. Therefore,

[10] Miriam DeCosta-Willis also talks about the intimate tone in the poem and the changing of voices from "tú" to "nuestra." DeCosta-Willis's essay focuses on the connection between Morejón and Mendieta in the creation of a sacred space through their creative endeavour, a space imbued with spirituality. In that way, they both reproduce the idea of the artist as spiritual agent (2008: 243).

[11] Ediciones Vigía (a collaborative artisan press in Matanzas) produced an edition of the poem by Nancy Morejón (with an English translation by Linda Howe) which tries to recreate on the page some of the physical aspects of Mendieta's performances. It incorporates materials that Mendieta used in her own work, such as eggshells, sand, and feathers, and the book itself thus becomes a performance piece. Flora González has suggested that in *Paisaje Célebre* (1993), in which "Ana Mendieta" first appeared, Morejón "conflates the concepts of pictorial image with the simultaneity of time and space" (2005: 1002). The Ediciones Vigía text (produced in a print run of only two hundred copies) goes further still, attaching a new sensual experience to the content of the poem.

Morejón links Mendieta's silhouettes (her artistic work) with her desire to find her Cuban roots, her childhood in Havana, and a certain feeling of nostalgia for what could have been.

Whereas New York and Havana seem to merge in the poem, Morejón establishes from its beginning a dichotomy between Cuba and the USA. While the United States is associated with all that is negative (imperialism, isolation, the desert, hostility, the orphanage, death), Cuba is associated with all that is positive (roots, natural beauty, nobility). The desert, so different to the tropical landscape of Cuba, is what Ana finds both in the United States and in death. Hence, even though Ana is physically in the United States, the poem closely binds her artistic work to Cuba, which it posits as her true home. Morejón is unsparing in her use of negative connotations for the North: thus, the cities in the United States are "enardecidas de confort y espanto" ("blazing with comfort and terror"). Morejón's position, in this sense, is consistent with the representation by Cuban ideologues of the illusory and fictitious nature of promises held out by the American dream. Specifically, Iowa is presented as an inhospitable place, where the inclemency of the weather adds to the sense of isolation and morbidity, in explicit contrast with the tropical and fertile climate of Cuba.

Morejón also emphasises Ana's status as an immigrant in the United States. She is a swallow who has migrated, but since she left unwillingly her displacement is not labelled as a betrayal of the revolutionary cause. Through the character of Ana, Morejón takes possession of all the Cubans who left for the North; she takes possession of her as a Cuban woman, as a national symbol, and as a transnational subject whose life crossed and mediated borders. Ana comes to epitomise "peregrinos occidentales":

> Tus siluetas dormidas nos acunan
> como diosas supremas de la desigualdad,
> como diosas supremas de los nuevos peregrinos
> occidentales (2003a: 114) [12]

Later in the poem, Morejón not only refers to *Tree of Life* (Fig. 13-1), Mendieta's famous work (produced in 1977 in Old Man's Creek, Iowa) in which Ana's body appears covered with mud and standing up against a huge tree, but she also interprets the tree as the Cuban Ceiba (silk-cotton tree), an indigenous species which functions as a synecdoche for the nation: Ana, too, thus becomes a symbol for the Cuban nation. Additionally, the

[12] "Your sleeping silhouettes rock us / like supreme goddesses of inequality / like supreme goddesses of the new western pilgrims" (2003b: 115).

Ceiba is closely connected with Santería rituals and with Afro-Cuban spirituality:

> Ana, frágil como una cáscara de huevo
> esparcida sobre las raíces enormes de una
> ceiba cubana
> de hojas oscuras, espesamente verdes.
> (2003a: 114)[13]

In *Tree of Life*, woman and tree seem to form a unity, and the work has been interpreted as the essentialised image of woman. The identification of primitive cultures with nature is a common motif in ethnographic and imperialist descriptions. In the traditional Western binaries of man/woman, culture/nature, civilised/primitive, the second term is always devalued. In *Tree of Life*, moreover, we find the three "inferior" terms drawn together. Therefore, at first glance, it seems that this representation does not question the binaries of patriarchy and imperialism and even appears to re-assert them. However, as Jane Blocker suggests we can interpret this work from the point of view of ethnicity, and thus see that it goes beyond essentialising female identity, since the most evident visual aspect of this performance is precisely the colour of Mendieta's body, a dark brown. By marking colour in such an over-determined way, by constructing it as a kind of mask, Mendieta arguably questions the premises of race and colour and unveils them as constructions (Blocker 1999: 62).[14] At the same time, this image reproduces Mendieta's mestizaje, her production of an identity determined by race, and her affiliation with women of colour through the deliberate act of covering her body with the colour which whiteness reads as difference. Furthermore, this performance is connected to Santería

[13] "Ana, fragile like an eggshell / scattered over the enormous roots of a Cuban silk-cotton tree / with rich, dark green leaves" (2003b: 115).

[14] In opposition to the essentialised notion of Woman, which, arguably, for feminists of the 60s and 70s was evidently a white woman, Mendieta invites us to read the earth/nature binary opposition in terms of ethnicity and transforms the subject into a black woman, not only in this silhouette but in others where, for example, she imprints her figure in snow which, as it melts, uncovers the dark colour of the land underneath (Blocker 1999: 66). *Black Venus*, another of the silhouettes, also lends the earth an ethnic identity, as does *Encantación a Olokún/Yemayá* (1977), a work produced in Mexico which depicts a black figure inscribed in the earth and surrounded by green moss forming a protecting frame. In this work Mendieta simultaneously introduces to the interface between her body and the natural materials which represent it aspects both of Afro-Cuban cultural heritage and of race.

rituals. According to Mary Jane Jacob, in Santería there are trees associated with the orishas, and forests, which are considered to be sacred places. In light of this, Mendieta could also therefore be performing a religious ritual that connects her with African culture, and in which she would embody an orisha (Jacob 1996: 195). Thus, by incorporating in her poem a reference to *Tree of Life*, Morejón not only folds in the diasporic Ana, but also picks up the emphasis seen throughout her poetry on the importance of Afro-Cuban culture in any attempt fully to embrace the Cuban nation. Even though Mendieta was not black, her alignment with those rendered "other" by white hegemony, and her awareness of the constructed nature of race (which she performed in *Tree of Life*) serves Morejón doubly: it allows the poet to expand the concept of nation by including within it those who have left, and also to emphasise the role of indigenous and Afro-Cuban elements in the extended *cubanía* in which Mendieta now fits.

Finally, in the last stanza of the poem, Morejón presents us with the flight of Mendieta's silhouettes over the sky of Iowa until she finds her final resting place in her homeland, specifically in Jaruco, where Ana worked on her Rupestrian sculptures. The reference to Jaruco is important in that it signals the place of Taino culture within Cuban identity. During her stay in Cuba, Mendieta worked in Jaruco National Park creating sculptures of Taino goddesses in the earth:

> Tus siluetas, adormecidas,
> van empinando el papalote multicolor
> que huye de Iowa bordeando los
> cipreses indígenas
> y va a posarse sobre las nubes ciertas
> de las montañas de Jaruco en cuya
> tierra húmeda
> has vuelto a renacer envuelta en un
> musgo celeste
> que domina la roca y las cuevas del lugar
> que es tuyo como nunca. (2003a: 116)[15]

Through her poetry, Morejón moves Mendieta to the land where she was born. In these lines, Morejón again emphasises Ana's bodily fragility:

[15] "Your sleepy silhouettes / are raising the multicolored kite / which flees from Iowa along the native Cypress trees / and then settles on the steady clouds / of the mountains of Jaruco in whose moist soil / You have been reborn wrapped in a celestial moss / that covers the rock and the caves of the place / that is now yours as never before" (2003b: 117).

her silhouettes form a kite that not only soars, but flees from Iowa. The term "huye" ("flee") is much more emotionally loaded than "to emigrate", "to go on a pilgrimage", or even "to travel": running away suggests the desire to escape from danger and from the aridity of the United States. Mendieta's rebirth as a Cuban woman takes place when she creates her rupestrian sculptures in Jaruco. In addition to taking possession of Ana as a national symbol, Morejón also offers her the possession of the land of Cuba: the Jaruco caves belong to Ana in the same way that they belong to all Cubans. In Morejón's poetic tribute to Mendieta, Ana, the friend who moves among nations, the constant pilgrim, forced to inhabit the aridity of the United States, flies away with her work to her homeland; despite her constant movement Morejón recovers the involuntary exile as a piece of the Cuban mosaic, and as part of the artistic legacy which should be available to all Cubans.

WORKS CITED

Blocker, J. 1999. *Where is Ana Mendieta? Identity, Performativity, and Exile.* Durham: Duke University Press.

Cabañas, K. M. 1999. "Ana Mendieta. Pain of Cuba, Body I Am." *Woman's Art Journal* Spring/Summer: 12-17.

Castro Ruz, F. "Discurso pronunciado por el Comandante Fidel Castro Ruz, Primer Ministro del Gobierno Revolucionario, en el desfile efectuado en la plaza cívica, el 2 de enero de 1961." http://www.cuba.cu/gobierno/discursos/1961/esp/f020161e.html (Accessed 22 October 2010).

Cordones-Cook, J. 2009. "Umbrales de exilio en la obra de Nancy Morejón" *Mar Desnudo: Revista cubana de arte y literatura.* 14 http://mardesnudo.atenas.cult.cu/?q=exilios_nancy (Accessed 25 February 2010).

DeCosta-Willis, M. 2003. "An Aesthetic of Women's Art in Nancy Morejón's 'Ana Mendieta.'" In *Daughters of the Diaspora. Afra-Hispanic Writers*, ed. M. DeCosta-Willis, 240-248. Miami: Ian Randle.

Feldman, M. E. 1999. "Blood Relations. Jose Bedia, Joseph Beuys, David Hammons, and Ana Mendieta." In *Reclaiming the Spiritual in Art: Contemporary Cross-Cultural Perspectives*, eds. D Perlmutter and D Koppman, 105-116. New York: State University of New York Press.

Greeley, R. 2000. *Afro-Cuba, 'Woman,' and History in the Works of Ana Mendieta, María Magdalena Campos-Pons, and Marta María Pérez Bravo. Catálogo de exposición de The William Benton Museum of Art.* Storrs: University of Connecticut.

González, F. 2005. "Cultural Mestizaje in the Essays and Poetry of Nancy Morejón". *Callaloo* 28 (4): 990-1011.

Jacob, M. J. 1996. "*Ashé* in the Art of Ana Mendieta." In *Santería Aesthetics in Contemporary Latin American Art*, ed. A. Lindsay, 189-200. Washington: Smithsonian Institution Press.

Katz, R. 1990. *Naked by the Window: The Fatal Marriage of Carl André and Ana Mendieta.* New York: Atlantic Monthly Press.

Kuspit, D. 1996. "Ana Mendieta, Autonomous Body." In *Ana Mendieta*, ed. G. Moure, 35-63. Santiago de Compostela: Centro Galego de Arte Contemporánea.

Kwon, M. 1996. "Bloody Valentines: Afterimages by Ana Mendieta." In *Inside the Visible; an Elliptical Traverse of 20th Century Art in and from the Femenine*, ed. C. de Zegher, 165-171. Cambridge: MIT Press.

Martin-Ogunsola, D. 1999. "Africanity and Revolution: The Dialectics of Ambivalence in the Poetry of Nancy Morejón." In *Singular like a Bird: The Art of Nancy Morejón*, ed. M. Decosta-Willis, 223-242. Washington, DC: Howard University Press.

Mendieta, A. 1980. "Introduction." In *Dialectics of Isolation: An Exhibition of Third Word Women Artists of the United States* (Catalogue to exhibition curated by Kazuko and A. Mendieta), 1. New York: AIR Gallery.

——. 1996 "Personal Writings." In *Ana Mendieta*, ed. G. Moure, 167-219. Santiago de Compostela: Centro Galego de Arte Contemporánea.

Mendieta, R. "Childhood Memories: Religion, Politics, Art." In *Ana Mendieta*, ed. G. Moure, 223-228. Santiago de Compostela: Centro Galego de Arte Contemporánea.

Morejón, N. 1996. "Las poéticas de Nancy Morejón." *Afro-Hispanic Review* Spring: 6-9.

——. 2000. "Grounding the Race Dialogue." In *Afro-Cuban Voices: On Race and Identity in Contemporary Cuba,* eds. P. Pérez Sarduy and J. Stubbs, 162-169. Gainesville: University Press of Florida.

——. 2003a. "Ana Mendieta." In *Looking Within. Mirar Adentro. Selected Poems/Poemas Escogidos, 1954-2000,* ed. J. Cordones-Cook, 112, 114, 116. Detroit: Wayne State UP.

——. 2003b. "Ana Mendieta." Trans. G. Abudu. In *Looking Within. Mirar Adentro. Selected Poems/Poemas Escogidos, 1954-2000,* ed. J. Cordones-Cook, 113, 115, 117. Detroit: Wayne State UP.

——. 2003c. "Mujer Negra" In *Looking Within. Mirar Adentro. Selected Poems/Poemas Escogidos, 1954-2000,* ed. J. Cordones-Cook, 200-203. Detroit: Wayne State UP.

——. 2004. *Ana Mendieta*. Trans. L. Howe. Matanzas: Ediciones Vigía.

Moure, G. 1996. *Ana Mendieta*. Santiago de Compostela: Centro Galego de Arte Contemporánea.

Raine, A. 1996. "Embodied Geographies; Subjectivity and Materiality in the Work of Ana Mendieta." In *Generations and Geographies in the Visual Arts; Feminist Readings*, ed. G. Pollock, 228-249. New York: Routledge.

Rogoff, I. 1997. "In the Empire of the Object: the Geographies of Ana Mendieta." In *OutsiderArt. Contesting Boundaries in Contemporary Culture*, eds. V. L. Zolberg and J. Maya Cherbo, 159-171. Cambridge: Cambridge University Press.

Rosegreen-Williams, C. 1989. "Re-Writing the History of the Afro-Cuban Woman: Nancy Morejón's 'Mujer negra.'" *Afro-Hispanic Review* September: 7-13.

Sanmartin, P. 2006. "'National' Poetry? Diaspora and/or Transculturation in the Representation of National Identity in the Work of Black Cuban Women Poets." *MaComère* 8: 67-93.

CHAPTER FOURTEEN

THE FRACTURED FEMALE SUBJECT IN CUBAN CINEMA AT THE THRESHOLD OF CHANGE: THE CASE OF *MUJER TRANSPARENTE*

GUY BARON

In 1979, the Cuban film *Retrato de Teresa*, directed by Pastor Vega, caused a huge polemic in Cuba as it dealt very directly with domestic gender relations, and came only four years after the introduction of the 1975 *Código de la Familia* that attempted to legislate, amongst other things, for sexual equality. It opened up a national (perhaps even continental) debate on the subject of marital relations in general.[1] But the film has been criticised for aligning itself with a masculine perspective and for promoting a Marxist/modernising vision of gender relations in which women are seen from the point of view of class rather than sex, and where the paradigm of Cuban woman is depicted on screen (Burton-Carvajal 1994: 310).

It is argued here that this vision of "woman" within the Cuban Revolution changes quite abruptly from this fairly typical image in the space of only ten years, as the country entered a period of rapid and turbulent political and cultural transformation. As Kapcia argues, the 1989 crisis had been building for a number of years and many of the certainties of the past were being questioned at base level. This questioning produced a kind of collective postmodernism. Thus, as per Jameson's description of the postmodern condition of late capitalism in the West (1991: ix), a certain rejection of the linear trajectory of history was being articulated in a country with a still developing sense of its past but with a current crisis that would undoubtedly alter that perception. "If postmodernism can be defined as reflective of, and reacting to, crisis, then it is logical to suggest that crisis can in turn produce a collective postmodernism, leading to a

[1] The *Código de la Familia* (Family Code) was created in order to try and legislate for equality of the sexes within the home; an extremely bold attempt at taking the socialist Revolution into the private sphere. The code outlines the "rights and duties of husband and wife", where marriage must be underpinned by full equality and demands loyalty, consideration, respect, and mutual help (Azicri 1989: 458).

rejection of history as linear and purposeful" (Kapcia 2000: 215). This also created a divergence in the way images of women were both reflected and constructed, as the following analysis of the portmanteau film *Mujer transparente* (1990) will illustrate. But first it is worth considering the possibility that a specifically Cuban postmodernism was beginning to emerge towards the end of the 1980s.

Postmodernism was "largely resisted and contested" (Davies 2000: 103) in Cuba from both sociological and epistemological perspectives. Although Cuba has not developed a postmodern society exactly as described by Jameson and others, as Paul Ravelo Cabrera suggests a type of postmodernism has nevertheless developed in Cuba since the 1960s:

> Algo, sin duda, está aconteciendo en la realidad social contemporánea y, particularmente, en el campo de las ideas, la política, las ciencias, las artes, la literatura, y en la cultura contemporánea de los últimos tres decenios de este siglo [...] y que como ola expansiva tiende a replantear y reformular una historia cultural larga y compleja: la modernidad. (1995: 61)[2]

Part of this postmodern experience can be expressed through the idea of the fractured subject, of a breakdown in the order of things where subjectivity is concerned, that reflects the "'esquizofrénico' (según Lacan) espacio-tiempo posmoderno " that Ravelo Cabrera talks about (1995: 60) and that is oppositional to the totalising narrative of Marxism.[3]

Margarita Mateo Palmer asserts that Cuba has developed a particular postmodern culture. She discusses the subversive intent and diverse creativity of the *novísimos*; those writers born in Cuba in the 1960s and 1970s, and the audacious way they transgress and renew expressive codes (1995: 124). It is a re-thinking of the whole project of Cuban modernity, a new "espíritu epocal" ("spirit of the epoch") but one that does not lose touch with itself (Ravelo Cabrera 1995: 61). It is a type of self-reflexive, knowing modernity, and brings to mind the definition Tim Woods gives of postmodernism as: "a knowing modernism, a self-reflexive modernism, a modernism that does not agonise about itself [...] instead of lamenting the loss of the past, the fragmentation of existence and the collapse of selfhood, postmodernism embraces these characteristics as a new form of

[2] "Something, without doubt, is happening in contemporary social reality and particularly in the field of ideas, politics, science, the arts, literature, and in contemporary culture of the last three decades of this century [...] and that as an expansive wave, tends to reconsider and reformulate a long and complex cultural history: modernity."

[3] "'Schizophrenic' (according to Lacan) postmodern temporal space."

social existence and behaviour" (1999: 9). As we shall see, the representation of women in the five short films that make up the anthology *Mujer transparente* do not agonise about the past, but reformulate it for a new generation of thinkers. In the words of Mateo Palmer:

> El posmodernismo cubano se expresa a través de una amplísima gama de posiciones y matices ideoestéticos que [...] mantiene en general un empeño de subvertir y proyectarse en su contexto social, de promover el diálogo y la confrontación con la historia, de búsqueda de una nueva ética y de un proyecto de emancipación que se adecue a los nuevos tiempos. (1995: 123)[4]

So, toward the end of the 1980s, there began a resistance in Cuba to the totalising narrative of Marxism as Cuban society began to organise itself in a more fragmented and localised way. As Ravelo Cabrera says, what better term to use for this alteration of Marxist principles—"una condición o momento en que estaríamos repensando el (nuestro) proyecto de modernidad"—than postmodernism (1995: 66).[5] He adds that this crisis of modernity needs a critical theory:

> Que capte y problematice la tensionada modernidad social cubana de hoy: introducción y legitimación de prácticas del capitalismo, apertura de la economía al capital extranjero, erosión de la noción de 'sujeto socialista' con el aparecer de nuevos 'sujetos' asociadas a la apertura económica (1995: 66)[6]

The erosion of the so-called socialist subject and the fragmentation of female subjectivity can be seen in all of the short films considered here. In 1987 the Cuban Film Institute (ICAIC) divided into three groups, each under the tutelage of a senior director.[7] The group headed by Humberto

[4] "Cuban postmodernism is expressed across a wide range of ideo-aesthetic positions and nuances and [...] maintains in general a determination to subvert and project itself in a social context, to promote dialogue and confrontation with history, to search for a new ethics and an emancipation project suitable for the new times."

[5] "A condition or moment in which we would be rethinking the (our) project of modernity."

[6] "That captures and problematises Cuba's current strained social modernity: the introduction and legitimation of capitalist practices, the opening of the economy to foreign capital, the erosion of the 'socialist subject' with the appearance of new 'subjects' associated with the economic opening."

[7] The Cuban Institute of Cinematographic Art and Industry (ICAIC), was the first cultural body to be set up by the Revolutionary administration in March 1959.

Solás, one of Cuba's most esteemed directors (creator of the iconic *Lucía*, in 1968) was asked to produce fictional shorts that dealt with prejudice and taboos (Paranagua 1992: 24). The five directors concerned came up with five different films, each one of which has a woman as the main protagonist and represents daily lives of women in contemporary Cuba. The five films will be analysed separately, but they also must be considered in the context of one production, as an anthology that has its own voice within which exist the voices of five distinct elements. In this disjointed but integrated manner we can see from the outset a very distinctive fragmented style. The poster for the film clearly expresses this sense of unity and fragmentation working alongside each other (Fig. 14-1). The various graphic styles and the segmentation of the five letters in the word *"mujer"* (representing each of the five short films) create the postmodern sense of disjunction and fragmentation, while the continuity of colour links the fragments together within the one word.

The five shorts all examine certain conflicts within the reality of life in Cuba, and this is central to the film's postmodern style. As Scott Lash says: "The logic of postmodernism inheres in its problemization of the reality" (1990: 63). It is in this conflict, this questioning of previously established codes regarding the production and reflection of images of woman, where *Mujer transparente* differs from previous Cuban films that have a central female protagonist (such as *Retrato de Teresa*). In its denial of history via a reformulation of previously held ideas, and in order to make it relevant for a new generation of thinkers, *Mujer transparente* breaks new ground in Cuban cinema, and I will attempt to show how, through its postmodern aesthetic, it breaks with the paradigm of woman in Cuban cinema by deconstructing the individual woman's link to the Cuban national collective.

The first of the five short films that make up *Mujer transparente* is called "Isabel" and was directed by Héctor Veitía. Isabel (played by Isabel Moreno) works in a demanding job, is a mother of two grown-up children who make constant demands on her time, and wife of Luis, an evidently hard-working but uncaring husband who takes little interest in his wife's problems. There are echoes here of *Retrato de Teresa*, made some eleven years earlier, perhaps illustrating that the problem of developing equal rights for women in the private sphere has not yet gone away.

In *Retrato de Teresa* much of the focus is on Teresa's home routine and of her position in Cuban revolutionary society whereas Héctor Veitía's film, as Glenda Mejía suggests, concentrates on Isabel's journey of self-appreciation in a process of re-imagining. Her first words make plain the individualistic essence of the story: "Es verdad. ¿Qué soy si no un

fantasma, una sacacuentas, una madre melodramática que se despierta buscando oxígeno, como un puñetero 'goldfish' [...] ¿Por qué me habré metido en este lío?"[8] In *Retrato de Teresa*, the protagonist's desires are only hinted at; here, by contrast, Isabel has her desires elucidated more clearly as she rails against her domestic drudgery. At the end of the film Isabel rebels against her husband and children by walking away from them to a nearby park as the music of a popular song plays in the background. This harks back to the 1979 film by Pastor Vega and here, equally, the ending is left open. But, as Isabel says in angry voiceover that she would like to go off with the first man that passes, we are acutely aware of her inner thoughts and feelings:

> Ay como me subestiman, todavía no saben de lo que soy capaz. Café. ¡Mierda!, qué se jodan, qué se queda sin desayunar, qué se vaya a la escuela con la camisa sucia y ahora qué me busquen. Me voy con el primero que pase y soy capaz de cualquier cosa [...] Qué me vean con un pepillo de veinte años.[9]

It is possible to see Isabel as a nostalgic repetition of Teresa in the earlier film. The basic plot dilemma is much the same and some of the techniques are repeated. This gives a sense of a nostalgic view of past aesthetic experiences, but one in which Isabel represents a cinema of resistance to those experiences. Where *Retrato de Teresa* has a tendency to naturalise gender differences, this short film makes a bold attempt at reformulating the very notion of subjectivity by concentrating to a large extent on the central character's psyche and on her desire to re-create herself. In an ironic jibe at the very heart of the Revolution, as she puts on her make-up in the mirror she equates her reformulation with that of the process of rectification undertaken by the Communist Party.[10] "Me hice un

[8] "It's true, what am I if not a ghost, a bookkeeper, a melodramatic mother who wakes up needing oxygen, like a damned goldfish. Why would I have got myself into this mess?"

[9] "Oh how they underestimate me, they still don't know what I'm capable of. Coffee. Shit! Let them go fuck themselves, let them go without breakfast, let him go to school with a dirty shirt and now let them come looking for me. I'm going off with the first guy that passes by and I'm capable of anything [...] Let them see me with a twenty-year-old boy."

[10] In 1986, as the economy suffered increasingly from the tightening US blockade, and the Soviet Union entered *perestroika* and *glasnost*, a period known in Cuba as the "Rectification of Past Errors and Negative Tendencies" began (Kapcia 2008: 42). This was a process of "deep reassessment" that included an austerity programme, the reduction of permits given for private businesses, a denunciation

plan más duro que la plataforma del partido. Capítulo Uno: Rectificación."[11]

The supposed optimism of the 1979 film is replaced by a cynicism (towards family life and marriage) that forms part of a fragmented, postmodern cinematic aesthetic. The reality is that Isabel has nowhere to go. Her retreat to the street is a symbolic action, a simulacrum of Teresa's stride into emancipation. In this repetition, this simulacrum, the mask of Teresa's subjectivity is torn away and revealed to be false. The painting of Isabel's own face, in the form of her make-up and new hairstyle, shows us that she also wears a mask of subjectivity in a world where the very notion of the female subject is being deconstructed.

The second short film within *Mujer transparente* is "Adriana", by Mayra Segura, who went on to become assistant director on Tomás Gutiérrez Alea's *Fresa y chocolate* (1993). The edits between the five short films in *Mujer transparente* are seamless, thus demonstrating the need to observe the film simultaneously as a sequence of five separate entities but also as a complete and singular whole. As the closing music from one segment continues there is a cut to the following segment which is introduced with a simple intertitle. For example, as the closing music from "Isabel" continues, the film cuts from the park where Isabel sits alone, to an old and dark apartment where light enters as shards seen breaking through windows. As the camera moves around the apartment we hear the voice of a man talking to Adriana (Verónica Lynn). She wanders around her apartment and looks at old photos of herself as a child. She tries on a wedding dress, puts on make-up and looks at herself in the mirror. She calls the telephone engineers from her home phone (which is obviously in good working order) to ask for the engineer who had previously repaired it, to return, and specifically asks for the same young man who had called before. A Miss Haversham figure in her wedding dress, her home strewn with lighted candles, she imagines herself at a wedding reception married to the young telephone engineer, but she dances alone in the apartment. In her imagined scenario the guests look on asking her what she is doing and to look at herself. Four hours later the doorbell rings as the telephone engineer arrives. But Adriana does not answer the door. She has a flashback to her childhood, when she was shut inside whenever men were around; the engineer leaves and Adriana is left alone in the flat.

of the USSR's "betrayal of Marxism-Leninism, and an attempt to reinvigorate *conciencia* via an ideological purification of the population" (Bunck 1994: 18).

[11] "I made myself a plan tougher than the party platform. Chapter One: Rectification."

As Glenda Mejía argues (2005), Adriana's desires are clearly expressed in this short film: she fantasises about being married as she is probably a typical *solterona*, who had been prevented from marrying by her parents whose high standards were never met by any prospective partner. Thus, an old woman's fantasies are revealed in perhaps the least successful of the five shorts, although I disagree with Paranagua who believes the film is a failure (1992: 24). We see again here a woman who has suffered due to certain patriarchal constraints. A male voice is often heard, reining in Adriana's desires, reminding her of her age and telling her to act like a lady. The oppressive voice is no doubt the voice of her father, the authority who had repressed her desires in the first place. The mirror, as Mejía points out, acts as a window or "portal" to herself, her subjectivity. But this vision is merely an illusion, a false reality as she only sees superficial appearances. Here, then. the emphasis is on the construction of what it means to be a woman and not on providing any answer.

The film might, as Mejía suggests, attempt to explore the reasons behind Adriana's delusions but, ultimately, it appears to deny Adriana any possibility of achieving agency, and perhaps this is the real truth that is being hinted at. She can imagine what she might like to be—a subservient housewife in a traditional marriage—but there is nothing optimistic about this supposed search for the self. In Lacanian terms any image that Adriana sees in the mirror can only be a "misrecognition"; a false perception of self that can never approach any notion of truthfulness (Lacan 1977: 1-8). Her desires are elucidated but they neither illustrate a woman emancipated from the yoke of patriarchy, nor are they attainable. Drawing on Jean Baudrillard's *Seduction*, Mejía goes on to say that the mirror image Adriana sees can only be a deception, and that any image Adriana has of herself in the mirror is an objectified one:

> [A] woman, by looking at herself in the mirror, deceives herself because she only sees appearances, and illusions. Therefore, by looking at herself in a mirror, she is simply an object, because she cannot see her real self, thus she will never be a subject, she is just a simple simulation of that masculine truth of what it means to be a woman or, in other words, the 'imaginary' truth made real. (2005:10)

In the way Boggs and Pollard describe postmodern cinema (2003: viii), this film develops a cynicism, a dystopia, and a longing for an imaginary past that are common to postmodern films, in what was most certainly at the time in Cuba "a world in chaos." The nihilism they hold to be contiguous with postmodernism is evident in the film's denouement as

Adriana realises that any truth that may exist does not lie behind the mirror but in the sad reality of her own life, lived alone and, seemingly, without love.

While *Retrato de Teresa* stayed within the realms of the modernising, Marxist project, by producing a modern female socialist subject, this short film critiques that project through its elucidation of a fantasy that hints at the disavowal of any unified subjectivity. This crisis of subjectivity forms part of the Cuban postmodern revolutionary consciousness, and as such represents a critique of Marxism and its attempts at creating a unified female subject. Modernism's search for the self is disturbed here using an aesthetic that delivers an unstable and decentred subject who appears to have no real place in contemporary Cuban society. The darkness of Adriana's apartment and its contrast with the sunlight in the one scene shot outside, the contrast between her old age and the engineer's youth, both suggest a sad and nostalgic view of history as Adriana is left with nothing but faded memories and fantasy in a world that appears to have left her behind. Here, in Jameson's terms, we have an ephemeral depiction of a society "incapable of dealing with time and history" (1991: 117). The film's ephemerality, its inability to express itself clearly, and its lack of direct and obvious political motivation, form part of its postmodern aesthetic. As Harvey points out, whereas modernists could accept "the ephemeral and transitory as the locus of their art" (1990: 21), postmodernists accept the ephemeral without trying to define or explain elements within it. "Postmodernism swims, even wallows, in the fragmentary and the chaotic currents of change as if that is all there is" (1990: 44).

There is a sense of aesthetic disjunction in "Adriana" but it is a disjunction that sits neatly with the period of the late 1980s in Cuba, a time of enormous transition in the arts. The film has an almost gothic intent, a sublime mixture of the grotesque and the beautiful as Adriana puts on the wedding dress, the pain of her fantasy all too evident. This appears to suggest some kind of return to a classical romanticism while firmly locating the story in late 1980s Cuba. It is this kind of aesthetic disjunction that creates the film's ephemeral nature and, as such, has made it difficult for some critics, such as Paranagua, to categorise. It is precisely this lack of categorisation that illustrates a shift from a modernist to a postmodern aesthetic, where no answers, no definitions are sought.

The film, as Mejía rightly states, is as much about female desire as anything else, Adriana's desires being made evident through her wedding fantasy and her wish to see the young, good-looking telephone engineer return to her apartment. Ultimately her desires are never fulfilled, being

repressed by a patriarchal authority that historically has restricted the
expression of female sexual desire, particularly in a relationship between
an older woman and a younger man. At the end of the film she cannot find
the courage to resist the weight of traditional patriarchal oppression upon
her and she does not answer the door to the engineer. As Mejía comments,
she remains "abandoned" and cannot "break the stereotype of the 'good
father's daughter'" (2005: 12). The omnipresence of patriarchal authority
is too much for this elderly lady, still scarred by the marks of a pre-
revolutionary, bourgeois childhood. In this sense the film does not break
any new ground as it continues to locate this weight of patriarchy firmly in
pre-revolutionary times.

However, in its contradictory and dystopic view of female subjectivity
it does enter what might be considered a post-feminist terrain. Here, there
is no fixity of the female subject but there is a denial of what might be
considered the ideal socialist subject as seen, for example, in *Retrato de
Teresa* or in Sara Gómez's *De cierta manera* (1978). For Zalaweski (2000:
23), postmodern feminism comes directly out of the criticisms of
modernist feminist thought through a destabilisation of the category
"woman", exactly what is happening here. If modernists tried to fix an
identity of woman then here that notion is disturbed with the presentation
of yet another representation. Adriana exists as a woman, but it is what
constitutes her that is questioned. This story, then, does represent a critical
analysis of the power structure between male authority and woman. It
disturbs the authority of masculine power by creating some resistance,
however small and difficult to identify that might be. "Adriana", therefore,
forms part of the necessary multiplicity of discourses by and about women
in Cuban contemporary arts and, as such, adheres to the argument that
Cuban cinema in the late 1980s was developing a postmodern aesthetic
through its representations of women.

The third short film in the portmanteau is "Julia", by Mayra Vilasís,
and is a tale of divorce and female desire. As in the other segments, 'Julia'
takes a close-up look at the very intimate and personal side of a woman's
reality but also delves deep into the psyche of a divorced woman in
contemporary Cuba. Julia (Mirta Ibarra) has had a torrid relationship with
her ex-husband. As she embarks on an affair with a younger student, in
voiceover she articulates her sexual and other personal desires while
looking back on a failed marriage in which she was evidently
disempowered. Now, however, she is free to do as she pleases, turning the
tables on one of the primary forces within patriarchal society, that of the
sexual objectification of women. In one scene Julia comments: "Las

mujeres maduras sí sabemos disfrutar los amantes, ir más allá de los clichés, de los orgasmos panorámicos." [12]

Here, then, the contradictions inherent in any personal relationship are witnessed, further illustrating the development in Cuban cinema of the multi-dimensional Cuban woman, one not inextricably linked to the Marxist-socialist revolutionary process. Julia sexually objectifies her young lover, Carlos, but laments the failure of her marriage dream. She voices her sexual desires towards him but also admits to being subject to certain inexplicable forces that appear to prevent her from enjoying these pleasures entirely. As she sits at home, soon after her husband has left, she says: "Claro, siempre hay una cadena invisible que te ata a tu rol de mujer responsable, en tu casa, sola, esperando quién sabe qué." [13]

The film turns the tables on aspects of patriarchy, and fractures long-held myths of male and female sexuality. Here, in the Cuba of the late 1980s, female sexual desire is clearly elucidated in no uncertain terms. As Julia objectifies Carlos and makes pointed comments about sexual activity in Cuba generally, the comparison with *Retrato de Teresa* is again unavoidable. Whereas the 1979 film was unable to construct a female figure whose sexual desires could be clearly expressed, for fear of alienating the audience, only a decade later this fantasy could readily be presented on screen. [14] Therefore, times have changed. As we have already seen, Cuba was not detached from the emergence of a "postmodern condition" in the 1980s even though this was resisted and contested within the country by certain academics and critics. As Catherine Davies asserts, this particularly Cuban brand of postmodernism became evident and sex was one of its primary concerns.

> Postmodern aesthetics in Cuba privilege heterogeneity and subjectivity; a critical awareness of sexuality, sexual preference and sexual discrimination; a reassessment of existing "minority" cultures (women, gay culture); the creation of new styles ("freakies", roqueros); an engagement with

[12] "We mature women do know how to enjoy our lovers, we're more than just clichés, more than just panoramic orgasms."

[13] "Of course, there is always an invisible chain that ties you to your role as a responsible wife, at home, alone, waiting for who knows what."

[14] At the end of *Retrato de Teresa*, the lead character leaves her philandering husband with the outcome of her extra-marital affair left unresolved so that the viewer is left to make up his or her own mind about what happens. In an interview with the author in Havana (2005), the scriptwriter Ambrosio Fornet indicated that the film-makers did not feel they could clearly express that Teresa had definitely had an affair, for fear of alienating an audience steeped in its own macho prejudices.

concomitant issues (private sex life of individuals, domestic life, AIDS); a
reencounter with belief systems other than Marxism [...] a deconstruction
of sacred myths (2000: 112)

But "Julia" does not simply allow its protagonist a unified or complete
subjectivity or agency. It reveals a web of intricacies concerning both male
and female sexual desire, at the same time as understanding that female
subjectivity is a complex arena. Its open ending allows for two resolutions,
neither of which is ideal.

The fourth film, "Zoé", directed by Mario Crespo, is the only film of
the five without voiceover, the narrative depending instead on dialogue
between the two characters, a young student, Zoé (Leonor Arocha), and a
man she calls "El Acorazado Potemkin" ("The Battleship Potemkin",
played by Leonardo Armas) who has come to find out why she has been
missing her classes at university. Zoé leaves the young man alone in her
garage, and, hours later, she returns drunk, having completely forgotten
about him. They continue their sexual power-play and eventually they
sleep together. Afterwards, he gets up and leaves, not wanting to miss his
university class. As if distancing herself from such dogmatism, Zoé tells
him to leave as she has a lot to do and he does so with barely a word
spoken between them.

In its exploration of the relationship between the traditional, as
represented by "El Acorazado", and the new, as represented by Zoé, the
film examines the postmodern space of difference through the terminology
of sex and gender relations by questioning the givenness of heterosexual
relationships privileged by Marxism. If, in a machista society, men are
traditionally seen as the promiscuous seducers then this film complicates
that view. In "Zoé" both the male and female masculine subjects are
destabilised as traditional notions of masculinity are placed in opposition
to alternative notions of feminine subjectivity. However, this feminine
subjectivity is not presented as whole, fixed, or stable. Zoé reveals her
personal insecurities and yet she appears confident and in control. As in
the other films in the anthology the very notion of female subjectivity is
being questioned, thus undermining any universalising category of women.

The fifth and last short film of the portmanteau is "Laura". Directed by
Ana Rodríguez, it deals with another woman in an unhappy marriage but
the theme is somewhat different from the first film, "Isabel". Here, Laura
(Selma Soreghi) remembers her past in voiceover and by looking at old
photos of herself and of her friends, taken during the early years of the
Revolution, as she prepares to meet up with Ana, one of those old friends.
Ana left Cuba for Miami twenty years before and the film portrays the first
reunion of the two women since that time. The majority of the film takes

place in the hotel foyer where the stark differences between Cubans who stayed and those who left are revealed. As Laura enters the hotel she is told that she cannot go upstairs as Cubans are not allowed into the tourists' bedrooms. As she waits in the foyer contemplating seeing her friend again, she is surrounded by returning exiles bearing gifts for relatives, *jineteras*, and tourists trying to buy her a drink.[15]

Using photo stills from Laura's past, the film takes a nostalgic look at the early years of the Revolution through the eyes of Laura, even using footage from Tomás Gutiérrez Alea's 1968 classic, *Memorias del subdesarrollo*, to highlight this use of aesthetic and cultural memory. At first Laura wonders what she is doing in the hotel and decides to leave and forget the meeting with Ana. But she changes her mind saying that it would be easy to think of Ana as an enemy. She re-enters the hotel and takes a drink from the two tourists at the bar whose advances she had previously rejected, deciding to confront this part of what she calls "nuestra compleja realidad que es la historia efectiva de cada uno de nosotros."[16] Calling Ana on the phone she defies the restrictions to go up to the room and enters the lift as the film ends.

The audience is given an insight into Laura's treasured memories of her youth while at the same time being delivered a satire on a much-debated and extremely sensitive part of contemporary Cuban reality—the disjunction between Cuba as a tourist destination and Cuba as lived reality for Cubans. But once again, as in all the other films in this anthology, the personal is made very much political as Laura clearly expresses her private viewpoint about an aspect of Cuban contemporary life. Her distaste for the so-called tourist apartheid that became evident in Cuba at the end of the 1980s (when the US dollar was illegal for Cubans but used as the currency for tourists, and when those working in the tourist industry had access to material wealth while those outside this industry did not) is made very clear. Coupled with her nostalgic view of a lost past, plus an examination of the theme of exile, the film is about as politically daring as any film made at such a sensitive time in Cuba's history could be.

This crisis of subjectivity forms part of the postmodern trajectory of Cuba in the late 1980s as previous values, seen as absolute, are being eroded. The figure of Laura represents a postmodern disillusionment with a master narrative that has not produced the promised ideological utopia. In its obvious criticism of the possibility of delivering a socialist subject, the film, in Ravelo Cabrera's terms, captures and problematises the

[15] *Jinetera* is a term used to describe women who will spend time with, and sleep with tourists in exchange either for money or material goods.

[16] "Our complex reality that is the effective history of each one of us."

tensions within Cuba's contemporary social modernity, using a study of one female's experience of the economic opening to foreign capital (1995: 66). Since she seems to have no access to this capital, for Laura the experience is a negative one, and her nostalgia for happier times (within the Revolution) is made clear.

The films which comprise *Mujer transparente* all show various tensions at play in contemporary Cuban society. In all of them, the central character is a woman who has to live with the many complexities and contradictions of Cuba in the late 1980s. If there is a common thread in the five films it is one of a crisis of subjectivity—the fracturing of female identities. The self-reflection of "Isabel" as the protagonist questions her role as wife and mother; the sense of loss, despair and solitude created in "Adriana", a woman constrained by patriarchal traditions; the sense of confusion and anxiety over a woman's sexual desire created in 'Julia'; the chaos and difference as suggested in "Zoé"; and the sense of disappointment for a lost utopia in "Laura". If Jameson is right when he argues that the postmodern signifies the collapse of old certainties such as an industrial society that "no longer obeys the laws of classical capitalism, namely, the primacy of industrial production and the omnipresence of class struggle" (1991: 3), and that this, in turn signifies that: "Modernist history is the first casualty of the postmodern" (1991: xi), then these films pinpoint that casualty in a Cuban context where it is an epistemological one. The modernist search for truth as represented by Teresa is displaced by the knowledge that there is not one singular reality, but a series of fractured realities.

WORKS CITED

Azicri, M. 1989. "Women's Development Through Revolutionary Mobilization." In *The Cuba Reader. The Making of a Revolutionary Society*, ed. P. Brenner, 457-471. New York: Grove Press.

Boggs, C., and T. Pollard. 2003. *A World in Chaos: Social Crisis and the Rise of Postmodern Cinema*. Lanham, Md.: Rowman and Littlefield.

Bunck, J. 1994. *Fidel Castro and the Quest for a Revolutionary Culture in Cuba*. Philadelphia: Pennsylvania State Press.

Burton-Carvajal, J. 1994. "Portrait(s) of Teresa: Gender Politics and the Reluctant Revival of Melodrama in Cuban Film." In *Multiple Voices in Feminist Film Criticism*, eds. D. Carson, L. Dittmar, and R. Welsch, 305-317. Minneapolis: University of Minnesota Press.

Butler, J. 1990. "Gender Trouble, Feminist Theory, and Psychoanalytic Discourse." In *Feminism/Postmodernism*, ed. L. J. Nicholson, 324-340. London: Routledge.

Davies, C. 1996. "Recent Cuban Fiction Films: Identification, Interpretation, Disorder." *Bulletin of Latin American Research* 15 (2): 177-192.
——. 2000. "Surviving (on) the Soup of Signs: Postmodernism, Politics and Culture in Cuba." *Latin American Perspectives* 27: 103-121.
Harvey, D. 1990. *The Condition of Postmodernity.* Cambridge, MA: Blackwell.
Jameson, F. 1991. *Postmodernism or the Cultural Logic of Late Capitalism.* London: Verso.
Kapcia, A. 2000. *Cuba: Island of Dreams.* Oxford: Berg.
——. 2008. *Cuba in Revolution. A History since the Fifties.* London: Reaktion Books.
Lacan, J. 1977. *The Four Fundamental Concepts of Psychoanalysis.* Trans. A. Sheridan. London: Penguin.
Lash, S. 1990. "Postmodernism as Humanism? Urban Space and Social Theory." In *Theories of Modernity and Postmodernity*, ed. B. S. Turner, 62-74. London: Sage.
Mateo Palmer, M. 1995. "Literatura latinoamericana y posmodernismo: una visión cubana." *Temas* 2: 123-134.
Mejía, G. 2005. "Mujer Transparente: In Search of a Woman." In *Ediciones especiales, libros y tesis*, adjunct to electronic publication *Razón y Palabra.* http://www.razonypalabra.org.mx/libros/libros/mujertransparente.pdf (accessed 19 January 2008).
Mujer transparente. 1990. Dirs. H. Veitía, M. Segura, M. Vilasís, M. Crespo, and A. Rodríguez. Havana: ICAIC.
Paranagua, P. A. 1992. "Letter from Cuba to an Unfaithful Europe: The Political Position of the Cuban Cinema." *Framework* 38 (9): 5-26.
Ravelo Cabrera, P. 1995. "Posmodernidad y marxismo en Cuba." *Temas* 3: 58-68.
Woods, T. 1999. *Beginning Postmodernism.* Manchester: Manchester University Press.
Zalaweski, M. 2000. *Feminism after Postmodernism: Theorising Through Practice.* London: Routledge.

CHAPTER FIFTEEN

THE SCREENING OF CUBAN IDENTITY: MADRIGAL (2007) AND VIVA CUBA (2005)

JILL INGHAM

After four hundred years of Spanish colonialism, Cuba's recent history—marked by decades of intervention and antagonism from the United States, and a further fifty years of revolutionary government—has witnessed the country's sustained and consistent struggle to forge an identity for itself as an independent nation. Alongside the economic and physical hardships endured by Cubans in the face of the United States embargo, the country's sense of national identity has furthermore been undermined by emigration and the fact that a considerable proportion of its population either turned their backs on Castro's Cuba for political reasons or felt they had no choice but to leave because of poverty. More than two million Cubans now live in the United States.

It was twentieth century Cuban anthropologist Fernando Ortiz who coined the term *cubanía* to describe the search for a Cuban identity, yet a preoccupation with national identity goes back to well before this and is evident, for example, in the work of José Martí in the 1880s. Interestingly, Fernando Pérez, the director of one of the films I discuss below, has taken the life of Martí as the subject of a recent film project. It must be stressed, as Andrea O'Reilly Herrera argues in *Remembering Cuba: Legacy of a Diaspora*, that there is no such thing as one Cuban identity, but a plethora of positions (both on and off the island) nuanced by questions of age, class, race, and political allegiance. The point is also made by Juan Carlos Cremata, co-director (with Iraida Malberti Cabrera) of *Viva Cuba* (2005). Cremata has stated that there is not one monolithic experience of the Cuban Revolution, but a whole diversity of experiences (Stock 2006: 270).

In his 2007 film *Madrigal*, the much revered Cuban director Fernando Pérez departs from the direct portrayal of the rhythms of daily life which were evident in his 2003 documentary *Suite Habana*, to create a more bleak and escapist view of Cuban reality. In essence a doomed love story, the narrative includes none of the stereotypical scenes we might expect;

there is no flirtation on the Malecón, no sensual dancing to Afro-Cuban rhythms, and no shots of 1950s American cars or lush tropical landscapes. Instead, sound plays an important role in this film: there is a loud thunderstorm at the start, the constant sound of dripping water, and a repetitive, tolling background sound that exudes doom and foreboding, heaviness and inevitability. This is a cold, grey world from which one can only escape through the imagination. Cremata has made the intriguing comment that: "In the third world, and of course in my country, the conditions of life are so difficult that imagination is beyond necessary—it is urgent" (Arrington 2006: 2). In other words, one needs to be able to travel to another world in one's mind in order to be able to endure the world in which one lives physically.

Madrigal's opening sequences take place in a Havana theatre, where a play called *Los ciegos* is being staged. The gloomy opening song on the soundtrack refers to "heridos pasados" ("past wounds"), perhaps in reference to the conflict which preceded the revolution and to the post-revolutionary division of the Cuban people between those who stayed and those who left. As the lead actor Javier sings "nadie me ve" ("no-one sees me"), a group of men dressed as nuns in grey habits performs a robotic sequence of movements, the synchronisation of their movements suggesting uniformity and militarisation. We first see a person who appears to be a nun in profile view and the viewer may not realise the habit is in fact worn by Javier, the protagonist, and an actor in the theatre (see Fig. 15-1). This visual device subtly introduces the notion of deception.

The use of theatre space for the opening of *Madrigal* and the establishment of a dramatic context serves as a point of reference throughout the narrative inviting the viewer to infer that the lives of some Cubans are based on performance, on acting out a prescribed role, and that there is a lack of authenticity in their social interactions. As the film's opening scenes unfold, a poster advertising *Los ciegos*, the play within a play, comes into view outside the theatre. But who is blind? Is it that Cubans themselves are blind to the reality of their lives? The phrase "no todo lo que parece es" will recur throughout the film, inviting the viewer to reflect on the discrepancy between appearances and underlying realities.[1] Beat Borter draws attention to Pérez's fondness for the phrase "no vemos las cosas como son, sino como somos." [2] Ann Marie Stock contends that *Madrigal* reveals that appearances can be deceptive; the real

[1] "Not everything is at is seems."
[2] "We don't see things the way they are but rather the way we are."

and the imagined merge in the film as do fact and fiction, truth and deception, present and future (Stock 2007: 73). Borter suggests that Pérez wishes to emphasise "the importance of being aware of our own expectations and limitations, our own culturally defined attitudes" (1997: 157).

There is only one spectator in the audience for *Los ciegos*; this is Luisita, a young, rather overweight, and religious young woman who works in a mortuary. Javier follows her outside out of curiosity, but his view is obscured by smoke from a passing vehicle, another detail which emphasises concealment and bars to clear perception. Settings in this film are full of unexpected objects; for example, a pornographic magazine lies on the coffee table in Luisita's apartment, challenging the viewer's readiness to draw conclusions from incidental details or to infer judgements about a character from surface appearances. Javier's sexually liberated girlfriend, Eva, has given him an ultimatum to seduce Luisita, and then to poison her so that they can seize the large house she owns. This macabre plot underscores the scarcity of living space in Cuba.[3]

Settings in the film are mainly interior, with the outside world viewed in very limited terms, mainly through windows which offer no long distance views and which are often obscured. These elements of perspective reinforce a sense that whilst Cuba is available for close scrutiny for viewers in the world outside, for those within the confines of the Cuban island state, this outwards gaze is stymied and only an inner landscape can be contemplated. Furthermore, *Madrigal* follows in a line of Cuban creative work which makes reference to contemplation of the world beyond Cuba's borders, beginning with *Memorias del subdesarrollo* (and its telescope scene), through *Miradas* (Alvarez 2001) and pop duo Buena Fe's *Catalejo* (2009).

When Javier visits Luisita, he passes a couple copulating in a stairwell, and hears the sounds of others doing the same in adjacent rooms. The mechanical quality of these sounds alerts the viewer to the impersonal nature of sexual activity which has become little more than an escape from the tribulations of reality. Yet the interior scenes focussing on the relationship between Javier and Luisita are filmed in soft focus through a

[3] Many Cubans place housing at the top of their list of problems, and large extended families often live in cramped, shared conditions. Some Cubans are prepared to pay over US $10 000 (sent by relatives overseas) to secure a home, and others resort to divorces and marriages of convenience to expedite access to scarce accommodation. The lack of building materials (attributed by the regime to the embargo) means there is a huge black market in operation and a housing shortfall of half a million homes (Pressly 2008).

pink filter, lending a romantic ambience to the scene. Ann Marie Stock comments that the film in general exudes an atmosphere "saturated with gray tones and soft focus that is nothing short of stunning" (2007: 73). The constant rain outside creates a feeling of claustrophobia throughout the film and this is exacerbated by the way in which many scenes are framed. The inward-looking characters are tightly framed so that the focus is on their bodies and the mise-en-scène mirrors the theatrical space where the film opens so as to stage characters in each frame as static entities whose surroundings are closely defined like stage sets. There is no view through the windows to the external world beyond and many scenes take place at night when windows give on to nothing but darkness. Luisita refuses to open the window in her bedroom in another scene which conveys claustrophobia, isolation, and the sense of a national identity being played out as a conglomeration of disconnected private narratives rehearsed in *Klausurgespräch* or behind closed doors. The tightly framed plaza in one of the film's few scenes shot outside adds to the sense of enclosure and the impression that even when outside Cubans live their lives within four walls. Javier's caged doves provide another reminder about lack of freedom. Cuban identity in *Madrigal* seems to be defined by confinement and restriction: only the imagination—through drama, literature, and the cinema—offers an escape route.

The theatre is a narrowly defined, enclosed space, yet the performers have access in their own imaginations and through that of the dramatist to a whole world of possibilities. Cinema critic Myrto Konstantarakos maintains that space is not only recorded as a background stage—its very organisation implies political structure, revealing the ideology of the time (2000: 1). The claustrophobic spaces in *Madrigal* denote the isolation of the island and the bounded nature of its geographies, rather than the freedom suggested by the broad skies which are such an intrinsic part of Juan Carlos Cremata Malberti and Iraida Malberti Cabrera's *Viva Cuba* (2005), the other film I consider here. The theatre functions as a space which can transmit a message that is not communicable in real life. However, in *Madrigal*, given that there is only one spectator in the theatre, the message communicated in the play will not reach its intended audience.

Luisita's house retains an aura from its past as an upper class Catholic home; the plasterwork is ornate and the proportions of the rooms are large. The camera lingers on the chandelier in which Javier hides a ring. Luisita occupies only the top floor and the rest of the house is now sub-divided into flats, but there are frequent reminders of past wealth and decadence. Luisita wants to sell off a family heirloom, a jewelled necklace, to buy a harp she has seen in a shop window. This valuable necklace, together with

the house itself, reminds us of the radical changes which have taken place in Cuba since 1959 and the traces of these left in personal property marking the very different nature of life in post-revolutionary Cuba. Memories of what spaces used to be like persist in the minds of the women protagonists in *Madrigal* and *Viva Cuba*, thus perpetuating memories and geographies of past times through interior spaces and the recall which they trigger. British geographer Doreen Massey suggests that locations serve not only as theatres of progress and history but also as sites of nostalgia (1994: 168) and her observation offers some insight on the way space is tied to memory in recent Cuban cinema. Despite major social and political upheaval, and after several decades, it is impossible completely to erase former lives and times associated with some places and spaces, a situation reflected in *Madrigal* where it is clear that Luisita identifies strongly with her house and what it once represented. There is a radical disconnect between the texture and scope of her memories and the material remainder of the past. The only physical trace of the lifestyle which used to belong with the house is a necklace, which becomes a leitmotif for the past. The evocativeness of space not only for Cubans who remained on the island but also for those who left is highlighted by Carlos Eire in *Waiting for Snow in Havana: Confessions of a Cuban Boy* where he reflects on a life split by politics between a childhood spent in Cuba and teenage years and adulthood in the United States. Eire's memoir includes a chapter on the Castro regime's appropriation of space as a means of spiting its enemies; a swimming pool which had belonged to someone repudiated after the Revolution as a *gusano*, for example, was turned into the "Aquarium of the Revolution", now full of sharks (Eire 2003: 330).

Other elements in *Madrigal* point to the future; Javier has written a story set in 2020 and Luisita is desperate to know more about it. Set in 2020, Javier's fiction implies that all that will be left in human relationships is fiction, fabrication, deception, and carnal pleasure. The story within a story takes us to the Empire of Eros, an underground country in which citizens are instructed to engage in constant sexual activity. The couple in this part of the film, Javier's girlfriend from the theatre and another fellow actor, attend a lottery draw to try and win a ticket to leave the country. The last ticket is won by a young prostitute who leaves aboard a ship to restart her life, echoing the departure of Luisita's mother in the framing narrative of the film years before when she left Cuba for the United States. Originally a worker in a Havana factory, once in the United States she turned to prostitution. Luisita had imagined her mother working in a smart hotel, but this turned out to be an illusion. Survival and happiness in Javier's fiction depend on using the imagination,

whereas the two people in the film who leave Cuba are both portrayed as prostitutes (one a character in Javier's story and the other Luisita's mother in the film's metanarrative). A negative image is thus created of those who lack the imagination to stay, in that they literally sell themselves once they have left the island.

If Javier's story offers some hope for the future through the power of the imagination, his landlady Elvira provides a stark reminder about the hardships of Cuban life. She complains about not having money for food, and about the sameness of everything and the impossibility of change.[4] Elvira clearly desires Javier but his mannerisms indicate complete disinterest. Immediately after Javier has made this clear, the scene cuts to the mortuary where Luisita plunges a knife into a dead woman's body. Then the scene cuts back to Elvira's kitchen knife as she splits open the red melon she is preparing in the kitchen. Nothing will come of her wishful thinking focussed on Javier. There is no escape from the daily grind for this woman. Back in the mortuary Luisita stares at a corpse and considers whether it has a soul. Does the film present us with a version of reality in which Cubans have really lost their souls?

If Javier's dream is to write stories as a form of escapism, Luisita's dream is to be buried in her own house, indicating a desire to remain in her homeland, and referencing further a recent history of emigration and expatriation. It also suggests that staying in Cuba is tantamount to a living death. Luisita's desire to sell her necklace and buy the harp becomes so important that she will not grant Javier access to her bedroom until she has the jewel. The harp is being offered for sale by an old man who mends clocks for a living, no longer able to earn from his former career as a musician. There is no music left, he says, against the background of heavy ticking from the clocks. Here the soundtrack and the mise-en-scène suggest that for the Cuban revolution time is marching on and that the further it advances in age the more Cubans are left to ask where the rhythms and musicality of their lives have gone.

What is to be made of *Madrigal*? The film may leave the viewer asking whether for some life in Cuba is so bad that the only hope is the exit visa lottery, and taking up the random chance of being among those who win

[4] This provides an echo of Yailene Sierra's previous role, in Benito Zambrano's *Havana Blues* (2006), in which she played the embittered wife of a talented but hard up musician who is driven by lack of money and hope for a better future outside Cuba to take their children to live in Miami whilst her husband remains on the island.

the opportunity to leave the island.[5] This is, then, a pessimistic film from Pérez, who had previously made films of a less enigmatic nature, in which the rich tapestry of Cuban everyday life is celebrated. Is this bleak and negative picture the reality of life in Cuba now? The question is never blatantly posed, but there are plenty of pointers. Given that we are never sure what is real and what is symbolic here, and given the theatrical backcloth, the film operates in a terra incognita, in which reality is open to interpretation and in which people, like theatre performers, have to invent their own versions of life within strict limitations and boundaries, reflecting perhaps the very reality of Cuba today.

In contrast with *Madrigal*, *Viva Cuba* functions spatially and in a realm completely opposite to the one explored by Pérez's film. If spaces in *Madrigal* are claustrophobic, inward-looking and narrowly defined, in *Viva Cuba* spaces are outward-looking, enabling, and limitless. Spaces in both films, however, are self-reflective. *Viva Cuba* is a rarity in Cuban cinema in that it is filmed through the eyes of children. Indeed, the film is dedicated to all Cuban children.[6] Cuban directors had hitherto not followed the tendency in Spanish cinema of the 70s and 80s to view the world through the perspective of a child.[7] The child-centred focus of the film and the fate of one of the film's child protagonists to be leaving the island resonates with the real life drama which was played out in 2000 when six year old Elián González became the subject of a tug of war between the Unites States and Cuba following his survival after a perilous voyage which claimed the life of his mother and ten other *balseros*. Part road movie, with elements of magic realism, *Viva Cuba* deals with the temptation for Cubans to leave for what they perceive to be a better life overseas, a temptation for which the children in this film pay the price. They suffer great sadness and fear as decisions taken by their parents tear up the fabric of their lives.

Against a simulated soundtrack of war-time fighting, *Viva Cuba* shows us several children who are playing a war game in the streets, fighting the Spanish. This is a reference to Cuba's colonial history and especially the Spanish-American War of 1898. The girl, Malú, assumes the role of the Queen of Spain with the boys as her Cuban slaves such that Cuba's

[5] Lotteries for exit visas to the United States have taken place at regular intervals as part of the Special Cuban Migration Program.

[6] Stock also underscores that the production of this film coincided with "La batalla de ideas", a programme designed to assess and meet the educational needs of Cuban children (2006: 266).

[7] For a detailed exploration of Spanish films with a child protagonist see John Hopewell (1986: 134-144).

colonial history and its struggle to break free from foreign dominion are referenced in the film from the outset. Michael Chanan contends that the Cuban nation has been allegorised as a woman in cinema (2004: 490) and significantly the mothers of the two child friends in *Viva Cuba* hate each other with a vengeance, their adversarial positions clearly signalled by the ways in which they decorate the exteriors of their homes: one family's front door has been emblazoned with "Fidel", while the other's has been painted with the word "Dios". Malú's mother, now *déclassée* and a single parent, yearns to leave the island and join her friend overseas, though we are not told that he necessarily lives in the United States. She spends hours on the telephone, no doubt funded by remittances sent to her from abroad (and which constitute a significant portion of Cuba's income). The telephone is an interesting instrument of dependency and subjugation in the film; Malú's mother is tied by the telephone to her friend in another country, and pours into the receiver her complaints about the heat and lack of resources in Cuba, much to the discomfort of her daughter; for Jorgito's mother the telephone also channels suffering and she is pained every time the boy's father responds with Pavlovian alacrity to the summons of the telephone, quickly volunteering as a member of the party faithful and committing himself to more work.

Malú's father is the lighthouse keeper at La Punta de Maisí, at the eastern extremity of the island. Even though it does not appear on screen until the end, this location broadens the spatial scope of the film. The lighthouse keeper role also provides a hint of irony in that, like Malú's mother, her father also looks outwards and away from Cuba, yet unlike his ex-wife he has no desire to leave. In contrast, Jorgito's parents are loyal to the revolution, yet his father is an abusive husband and father, loathed by his wife, and feared by his son. While their parents represent polar opposites, Malú and Jorgito have a close friendship. Contrary to appearances the frequent arguments between the two children are not a symptom of deep-felt hostility; quite the opposite is the case and their closeness is not just psychological but is also physical and is apparent in the striking resemblance of their facial features. Once they embark on their journey they become real soul mates. A woman passing by notices their similarity, and, mistaking them for siblings, she tells the girl to look after her little brother (see Fig. 15-2).

Malú is distraught when she hears the desperation in her mother's voice and when she understands that she is determined to leave Cuba. She can only seek solace in her imagination—the twigs of the plant she is watering suddenly sprout yellow flowers, to the sound of a mournful solo cello. This foray into magic realism does not seem out of place in this

child's view of the world. Later in the film, she hatches a plan to run away and go and visit her father, to beg him not to sign the forms which would allow her mother to take her away with her from Cuba. The island is portrayed in this film as a paradise for children, where it is always sunny and where everything is colourful, with plenty of space and freedom to play. A spinning top is set on the ground against a background of blue sky with the city spread out beyond. The harmonious nature of childhood is conveyed through the comedy of scenes which intercut between the friends' preparations in their respective homes (at loggerheads in the politicised adult world). As the children busy themselves with their packing and earnestly perform their ablutions, *Viva Cuba* references and ironises in its diminutive would-be fugitives the clichés of the road movie genre.[8]

It features all the stereotypes one might expect: brightly coloured 1950s cars, a trip to the beaches of Varadero, a yacht moored out at sea, and feel good music. In sharp contrast with *Madrigal*, typical Afro-Cuban music creates an upbeat joyous atmosphere in this film. Here, space and distance are in the foreground; the journey made by the two children between Havana and the lighthouse foreshadows the greater distance which will separate them in the future, once the girl's mother takes her off the island. The rocky road trodden by the two children is a metaphor for the trials and tribulations Malú will experience, and for the gulf Jorgito will feel after his friend's departure. The need for new horizons for some marks for others the end of childhood.

Gaston Bachelard maintained that landmarks in space are more vital to the construction of memory than are chronological milestones. Domestic spaces, he argued, are especially complex psychologically since the home contains memories of the people by whom it was inhabited, of how they spoke and moved (1994: 14-15). The vitality of the domestic landscape and its crucial role in forming identity and memory can be seen in *Viva Cuba* and in Malú's instinctive reluctance to be torn away from her home. Even at the age of twelve, Malú realises the significance of her family home and does not want to abandon the place where her grandmother has recently died. The camera lingers over photographs of Malú's grandparents and other elderly relatives, emphasising family history and ties. As Malú recites her times-table to her grandmother, the film's editing replicates the grandmother's gradual loss of consciousness in an eerie but successful attempt to convey her dying moments. As she fades into

[8] The film brings to mind Ernesto and Alberto preparing for their epic trip in *Diarios de motocicleta* (Salles 2004), and of course the quintessential Cuban road movie *Guantanamera* (Gutiérrez Alea 1995).

unconsciousness the camera focus is blurred and the angle unsteady. The background sound of a slowing heartbeat accompanies the shot which lingers over family photographs of the weddings and baptisms of previous generations. Given that Cremata used his own grandmother to play the part of the old lady, the scene takes on greater poignancy. At the subsequent funeral the camera pans round the cemetery and the vast expanse of white gravestones emphasises the many generations which comprise a family's ancestry.

Once it becomes clear that the children have set off on their journey and disappeared, the mothers' panic reaction takes the shape of a spirited argument at a police station, whilst the children are pictured frolicking happily in the sea. At night they watch shooting stars as they lie cocooned and peaceful in a boat on the beach, before finally falling asleep in the moonlight in a beautifully filmed and poetic scene. The children's innocence and easy rapport makes for a stark contrast with their feuding mothers and the polarised politics of the adult world. It is the children who, in their absence, ultimately bring the warring mothers together, as the women's shared anguish leads them finally to seek solace in one another.

The focus on a child's perspective in *Viva Cuba* underscores how class and wealth differences are products of the adult world. Scenes of the two children at school convey a harmonious picture where all are happy, as the class recites poems extolling the virtues of sugar, the national crop. The continuing journey of the two children across the island provides a pretext for the cinematography to include the many large roadside hoardings proclaiming revolutionary slogans (not advertisements as one might expect to find elsewhere), and this in turn highlights the use of visual media in Cuba—slogans, official graffiti, and portraits in public spaces, as well as cinema—to articulate questions about and reflections on the national psyche. The fact that it is a child's fugitive impulse which opens up these vistas begs the question, furthermore, as to whether the director and screenwriter intend the hierarchy of nations, likes those of class and wealth, to be read as belonging appropriately to the idealised world of childhood or to the competitive and unjust world of adults. The two runaways join a school party on its way to an outdoor concert, in which the pupils wave the Cuban flag and sing patriotic songs with great enthusiasm. Malú fulfils her ambition to be a singer, and even appears on television, demonstrating that everything is possible in the world of the child.

Viva Cuba is dedicated to the *santería* deity Elegguá—the god of roads, and therefore an apt choice for this road movie. From the very start the viewer is reminded of one of the most fundamental and important features of Cuban cultural identity: *santería* and the syncretistic fusion of Afro-

Cuban deities with Catholic saints. Later, when the children reach a densely forested part of the island, they are warned by locals to beware of the local bogeyman, a frightening *santería* character on the loose in the forest. As well as integrating Cuba's distinctive religious beliefs within its scope, the children's journey also provides an opportunity for several poetic interludes which show off the flora and fauna of the island in their best light: a centipede, a butterfly, palm trees and birdsong, these are all part of Cuba's identity. The soundtrack of African song drives home the idea of ancient family ties. Even the bearded spelunker Malú and Jorgito meet on their journey looks clean and attractive, despite living rough in a small tent. Only the dead animal skull spoils the scene as the children begin to need water. However, the film stops short of adopting the aesthetics of a glossy travel programme promoting Cuba; the rural landscapes it shows us are beautiful but are not bathed in the artifice of commercial advertising.

By the end of the film, the emotive tones of the solo cello shift to a jarring cacophony as the reunited adult members of the two families argue over the decision reached by Malú's mother's to take her daughter off the island, and the two mothers at once hug with relief and chastise their offspring for running away. The cello now plays a sad elegy, interspersed with the ancient call of the ancestors evoked by the Afro-Cuban chant, as the inevitable departure of the girl and her mother looks set to happen with the father's reluctant acquiescence. This conclusion really ratchets up feelings of sadness and loss, since the girl, having just lost her grandmother, will now lose her country, her best friend, and her father. Happiness for one person, Malú's mother, comes at a steep price for others in the family. The film ends with the children looking out to sea, their contemplation of the dilemma of emigration emphasising the reach of the split between families and communities which has been such a feature of the country's national identity since the 1960s.[9]

Though made within two years of each other *Madrigal* and *Viva Cuba* could hardly be more different. Reality in *Viva Cuba* is firmly grounded in the universal experience of childhood friendships and in Cubans' own day to day experience of life on the hyphen and of the disconnections caused by the ever present lure and possibility of physical emigration. *Madrigal*, on the other hand, deals with another kind of migration: the flight into fiction and drama, into discourse and the imagination. A parallel reality, or internal migration, is sought in *Madrigal* by means of the theatre and the

[9] The ending also references *Fresa y chocolate* in which Diego and David are posed in a similar manner (Gutiérrez Alea 1994).

story written by Javier, within a film narrative that self-consciously acknowledges its own artifice. Whilst the sounds and colours in *Madrigal* are sombre and subdued, in *Viva Cuba* they are clear and vibrant. Where settings in *Madrigal* are internal and claustrophobic, in *Viva Cuba* they are external and open. And while *Madrigal* deals with Javier's internalised feelings of guilt over duping Luisita, the two children in *Viva Cuba* epitomise the openness, innocence, and freedom of childhood. The use of language can also be seen to reflect this dichotomy: the occasionally enigmatic nature of the actors' dialogue in *Madrigal* contrasts with the natural and deliberately unscripted scenes featuring the two children in *Viva Cuba*. Both films, however, avoid making any overt political references, whilst at the same time addressing the theme of the desire for escape, *Viva Cuba* in a familiar, conventional way, and *Madrigal* in a stylised, symbolic way.

Whereas in *Madrigal* Cuban identity seeks refuge in an internal migration facilitated through sexual escapism and imaginative flights of fancy curtailed by a pessimistic vision of the present and future where relationships are based on material gain (and where even sexual pleasure is compulsory and mechanical), in *Viva Cuba* Cuban identity is situated in history, landscape, and music, and in the heart of the family, which, like the Cuban nation, has been rent asunder by the dogmatic politics of the last 50 years. Even if families have been geographically split, or divided by divorce or separation, for their offspring it is their very family heritage that forges their identity in tandem with the geography, history, and culture of the island. Stock contends that the overarching message in *Viva Cuba* is one about adolescence and the ability of friendship to overcome adversity (2006: 269). Yet the many references to ancestry (the grandmother, the cemetery, *santería* gods) would seem to indicate that family ties are paramount despite geo-political divisions. The film's children represent what the adults are leaving behind: friends, family, ancestral ties, and a much loved island landscape and its music and folklore.

WORKS CITED

Arrington, V. 2006. '*Viva Cuba* movie by Juan Carlos Cremata' in *Havana Journal*. 30 January. http://www.havanajournal.com/culture/entry/viva_cuba_movie-by_juan_carlos_cremata (Accessed 22 June 2009).

Bachelard, G. (1994). *The Poetics of Space*.Trans. Maria Jolas. New York: The Orion Press.

Borter, B. 1997. 'Moving to thought: the inspired reflective cinema of Fernando Pérez.' In *Framing Latin American Cinema: Contemporary Critical Perspectives*, ed. A. M. Stock, 141-161. Minneapolis: University of Minnesota Press.

Chanan, M. 2004. *Cuban Cinema*. Minneapolis: University of Minnesota Press.

Eire, C. 2003. *Waiting for Snow in Havana: Confessions of a Cuban Boy*. London: Simon & Schuster.

Hopewell, J. 1986. *Out of the Past: Spanish Cinema after Franco*. London: British Film Institute.

Konstantarakos, M. 2000. *Spaces in European cinema*. Exeter: Intellect Books.

Massey, D. 1994. *Space, Place and Gender*. Cambridge: Polity Press.

O'Reilly Herrera, A. 2001 *Remembering Cuba: Legacy of a Diaspora*. Austin: University of Texas Press.

Pérez, L. 1999. *On Becoming Cuban*. Chapel Hill: University of North Carolina Press.

Pressly, L. 2008. "Cuba's Housing Crisis". In *Crossing Continents*. Radio 4. 29 December. London.

Stock, A.M. 2005. "Abriendo nuevos caminos para el cine cubano." In *Cuba: cinema et revolution,* eds. J. Amiot-Guillouet and N. Berthier, 265-271. Lyon: Le Grimh-LCE-Grimia.

——. 2007. "Imagining the Future in Revolutionary Cuba: An Interview with Fernando Pérez." *Film Quarterly* 60 (3): 68-75.

PART IV
CHILE AND ARGENTINA

CHAPTER SIXTEEN

DIFFRACTION AND PROFANATION: NEW FORMS OF PUBLISHING IN ARGENTINIAN LITERATURE

SOLEDAD PEREYRA

In *Los libros de la guerra*, an anthology of his journalism published in 2008, the controversial Argentine writer Rodolfo Fogwill describes how it was commonplace in the 70s to read work by other Argentine authors in Xerox format using copies which reached him in various and complex ways. In that dark and undemocratic period in Argentina's history, Fogwill was a young writer and publicist who shared with many writers and readers the desire to stay abreast of new and original developments in their contemporary literary environment. However, during the dictatorship of 1976-1983 the parameters which determined what could be written and published in Argentina were strictly controlled by the government. Censorship and other more violent forms of repression meant that many literary works remained unpublished including those which were judged later on to be the best endeavours from those years.

Government control over literature in the dictatorship years lead to the pursuit of unofficial strategies developed in order to ensure the publication, circulation, and distribution of literature and books during those troublesome times. Parallels can be drawn between these strategies and the ones which evolved in literary and publishing circles in the years immediately preceding and following the 2001 Argentine economic crisis. The emergence of these innovative and creative ways of publishing and disseminating literature in the shadow of challenging political and economic circumstances reveals a striking symbiosis between the material aspect of literature—the book itself with its concrete visual appearance—and the historical conditions in which it is created, one which calls into question the conceptual boundaries which define literary production today.

From a sociological perspective, Pierre Bourdieu has pointed out the structural parallels between literature and publishing, as well as the displacement of literary texts so that they have become symbolic goods within a highly commercialised publishing environment (1999: 242-245). Although autonomy of the literary and publishing spheres may be a thing

of the past, as the Argentine experience shows, this does not mean of itself that the inevitable result is submission to the transnational market and to the political structures which uphold it. The recent history of traditional and alternative publishing in Argentina uncovers fluctuations in the parallels between structural and symbolic economies. In the last ten years, as in the 70s and during the dictatorship, there emerged several independent and alternative publishing projects which evidence a successful struggle against external conditions like globalisation and economic crisis. Eloísa Cartonera, a publisher of books made by hand and from salvaged materials, represents one of the best examples of such projects. In this chapter I examine how, in the middle of a period of economic turmoil, Eloísa Cartonera succeeded in redefining literature and I look especially at the role of the visual and material aspects of its books in accomplishing this.

THE 90S: MENEMISM, POVERTY, AND CARDBOARD PICKERS

From the mid 80s and throughout the 90s Argentinian publishing experienced changes in line with those which were being felt across the world as a result of the increased commodification of literature: there was more emphasis on best-sellers, a concentration on just a few authors who were heavily marketed and sold as media personalities, a fast churn or turnover of titles, small print runs, the taking over of editorial organisation by multinational enterprises, and displacement of local idiosyncrasies in favour of the norms of so-called world fiction (Saitta 2004: 250; Casanova 2001: 225-226). The neoliberal policies pursued during his presidency (1989-1999) by Carlos Saúl Menem also favoured the consolidation of Argentina's publishing industry by multinational enterprises. The national publishing industry, as well as all the other resources and companies in the country, ceased to be locally owned and managed, instead becoming investments in the hands of foreign shareholders. By the late 90s, however, it was clear that neo-liberalism had not lived up to its sales pitch. By 2002 more than half the population had fallen below the poverty line and in Buenos Aires alone, 20 percent of the population was considered to be living below the bread line.[1]

For Argentinians, the new millennium heralded the worst economic crisis in the country's history. In the last decade of the twentieth century more than 80 percent of the country's public sector had been privatised;

[1] This percentage equates to 638 000 Buenos Aires inhabitants living in poverty, 171 000 of them in conditions which could be regarded as indigent (Dirección General de Estadística y Censos 2005).

the railway system was devastated, while the oil and mining industries were broken up and sold off. National media outlets, including radio, had been sold as well as sections of the country's coastline and 60 percent of Patagonia (Massuh 2003: 58-59). Malena Botto suggests that in the same time frame Argentina's publishing sector underwent a seemingly paradoxical process of both concentration and polarisation (2006: 210-232). On the one hand, concentration came about as a result of denationalisation and saw the control of the market by a few publishing houses under foreign management. What emerged as an effect of this new publishing market was in essence a monopoly: a handful of companies took ownership of 75 percent of the market for books with the consequent decimation of the independent domestic publishing industry (Botto 2006: 210-213; CEP 2005: 62-63; De Diego 2007: 38). On the other hand, some independent publishing houses, such as Beatriz Viterbo, Simug, and Adriana Hidalgo, did succeed in re-merging in the early 90s, however, and Botto's analysis accounts for this in terms of polarisation, an indirect and unexpected effect of the monopolisation of publishing by foreign multi-nationals. To consolidate their limited but real space in the book market, these new independent publishers had to appeal to the symbolic value associated with certain authors or titles that were not published by the big publishing houses.

The economic crisis of 2001 saw the price of paper go up by 300 percent and a large number of the businesses associated with paper manufacture went bankrupt. The end of dollar parity and convertibility not only caused the collapse of the sectors traditionally associated with the book industry, but also led to a sharp increase in the price of the raw materials and supplies for manufacturing books. According to reports produced by Argentina's Ministry of Economy and Production, by 2002 publishing had contracted by 25 percent and would not recover from this until 2004 when there was an increase both in new titles and in print runs. Surprisingly, after the crisis of 2001, the publishing houses which experienced the most significant percentage growth were not the dominant conglomerates but the small imprints with turnover of less than half a million pesos per year (CEP 2005:63; Vanoli 2009: 169-170). At the same time, there are critics like Malena Botto and Hernán Vanoli who point out that in step with this process there was an increase in the sale of books by Argentinian authors. Thus, in tandem with the process of economic recovery, there is first a growth in small publishing houses, many of which are independent, and secondly there is a higher inclusion and diffusion of contemporary Argentinian authors within that national publishing market.

From the 90s on, there is a shift not only in the content of literary works but also in the material aspects of their production, publication, and distribution. The 2001 economic crisis served to galvanise the already existing groups and projects which conceived themselves as alternatives to the traditional publishing market.[2] And in the years since 2001 there has been a proliferation of these alternative publication channels which, together with the resurgence of the independents, may account for the recovery of overall volume since the contraction of the sector's output. Within this picture what stands out is the growth of entities which are markedly different from traditional publishing enterprises in their organisation, in the way that they conceive the look and feel of a book, and in their perception of literature. Strikingly, these new enterprises are also much less profitable than the big companies.

A NEW CONCEPT IN PUBLISHING

The increase in the price of paper together with the growth of unemployment as a consequence of the 2001 crisis increased the number of *cartoneros*, people who try to make a living as cardboard pickers and who have become a feature of modern-day Argentina. Whole families work in this way and in the capital alone there are now more than 100 000 *cartoneros*. A small group of artists in Buenos Aires which was innovative, progressive, anti-hegemonic, and political, came up with a new publishing concept which connected with the rise in cardboard picking. Called Eloísa Cartonera, the project was founded by Fernanda Laguna, a visual artist, Javier Barilaro, a designer and painter, and Washington Cucurto, a writer. Timo Berger, a German poet and translator, and also a partner in the project, describes its beginnings:

> Se trataba de mucho más que libros. Sin embargo, nadie habría imaginado aquella tarde de otoño del 2003 que un simple bricolaje en una biblioteca de Buenos Aires sería el inicio de una fructífera red continental de editoriales. El escritor argentino Washington Cucurto me llamó aquella tarde para decirme que tenía que ir a la "Casa de la Poesía". No me explicó por qué. Sólo añadió: "¡Vamos a crear "algo nuevo"! [...] En el patio

[2] It is essential to make a distinction between independent publishing houses and new alternative publishing projects. Following Vanoli I term the projects studied more closely in this chapter alternative publishing projects or alternative publishing houses. Lumping the more radical projects together with formats already familiar from the market in independent publishing would be to over-simplify the evolution which occurred in the Argentinian publishing scene as a result of the crisis.

estaba el escritor y pintor Javier Barilaro, junto a la primera tapa pintada de un libro de Eloísa Cartonera. Con témperas de colores transcribía el título y el nombre del autor en el cartón marrón, invitándome a participar. (Berger 2009:11)[3]

From these modest beginnings in an obscure library in Buenos Aires, Eloísa became the first *cartonera* publisher, and consolidated itself not as a market leader but as a beacon for a range of alternative publishing projects not only in Argentina but across Latin America. Today Eloísa Cartonera is based in a shop called "No hay cuchillo sin rosas" ("There is no knife without roses") and, as Timo Berger suggests, its new publishing model grew from the cooperative's original aims and ambitions.

To make its book covers Eloísa uses material bought from *cartoneros* and pays the cardboard pickers above the going rate for this supply.[4] The social aspect of the project extends to giving the *cartoneros* the opportunity to be involved themselves in the manufacture of the books. This participation provides them with an activity that is not only economically rewarding but also motivational as each book is crafted and painted by hand. Readers benefit from the project too since it offers them books at a lower price than those made and distributed by conventional publishers.[5] As unlikely as it sounds, Eloísa Cartonera's hand made books are less expensive than conventionally mass-produced books. This is because the press does not have large overheads associated with marketing and publicity. Furthermore, it works either with titles whose copyright has been donated to the project or with others to which copyright restrictions do not apply (Fig. 16-2).

[3] "It was about much more than books. But nobody would have imagined on that afternoon in autumn 2003 that a bricolage group in a Buenos Aires library would be the start of a highly productive network of publishing houses across the South American continent. The Argentinean writer Washington Cucurto called me that afternoon to tell me I should go to the Casa de la Poesía. He didn't tell me why. He just added 'We're going to create something new!' [...] The writer and painter Javier Barilaro was in the patio with the first painted Eloísa Cartonera cover. He was painting the title and the name of the author with poster paints on a brown cardboard panel, and suggested I join in" (Berger 2009:11).

[4] Initially Eloísa Cartonera paid pickers ARS $1.50 per kilogram of cardboard, well above the going rate at the time of thirty cents per kilogram.

[5] Originally, the text block for Eloísa's books was made using photocopies. Today, people working on the project have improved the quality of the type pages by using an old German printing machine that was donated to the publishing project (Ruiz Guiñazú 2009).

With no ties to any political party and no subsidies, Eloísa also enjoys a structural independence while its cooperative framework allows traditional hierarchies to be eschewed and for all its workers to have a say in how the company is run. This in turn encourages the egalitarian distribution of goods and tasks. With parallel means of distributing its books it also sidesteps the more traditional marketing pathways used by the publishing conglomerates. Texts are distributed without intermediaries like publishing agents and publicists, and are sold directly to readers in bookshops and at events like concerts, political rallies, and fairs. Similarly, the same people who manufacture the books also select catalogue titles and deal with copyright permissions. Rights are not purchased from writers but are instead donated to the project. Eloísa Cartonera's structure dispenses with the traditional roles of editor, critic, and publicist, and also with the notion of the writer as the owner of a text, thus rejecting (in common with other groups in contemporary Argentina) the nineteenth and twentieth century model of a literary establishment.

While easily recognisable as a book, a text published by Eloísa Cartonera nevertheless stands out visually on account of being made by hand and decorated in a process that ensures each and every copy produced by the imprint is unique (see Fig. 16-1). As well as being hand painted, covers may be adorned with glitter and with other found materials, like bottle tops, to create a book which evokes the discourses of appliqué work and of recycling, as well as those of literature. The unity established by the project between the material object and the artistic content is one which was to be emulated by other cooperative groups in Argentina. From the outset, the project had in mind the publication of alternative titles by less well know and even unknown writers, as well as more familiar texts which had become hard to obtain. An offer of this kind favours the successful circulation of the "tradición-otra" (counter culture, or alternative culture) through material objects whose manufacture itself also breaks with hegemonic paradigms. Books produced from material considered as refuse thus become a platform for textual content which is similarly marginalised, unfairly ignored, or neglected within the dynamics of the Argentinian literary field. Form and content mirror each other in the production of Eloísa's volumes. As participants in the project put it:

> Eloísa Cartonera es un proyecto social y artístico en el cual aprendemos a trabajar de manera cooperativa. La idea del proyecto es generar trabajo genuino a través de la publicación de libros de literatura latinoamericana contemporánea. Para esto ideamos una manera de trabajar muy sencilla que consiste en la fabricación de libros de cartón. El libro de cartón es el

producto de nuestro trabajo. Pero lo más importante es descubrir una nueva
manera de trabajar. (Cucurto and Joly 2007:4)[6]

As mentioned previously, the publishing concept worked out by Eloísa
Cartonera was taken up by other groups, both in Argentina and abroad,
leading to the setting up of several *cartonera* publishing houses in cities
across Latin America. Other groups did not necessarily copy Eloísa
Cartonera's model exactly, but sought to emulate its creative responses, or
diffraction, when faced with an economic crisis and a publishing sector
which had become set in its ways.[7]

SPREADING THE WORD: NEW FORMS OF PUBLISHING IN ARGENTINA

In a series of talks organised by the independent publisher Interzona in
2008, the Argentinian writer Alan Pauls said:

> Me parece que lo que hace unos diez o quince años se vivía aquí como una
> especie de catástrofe, que era la captura de las editoriales argentinas por las
> corporaciones editoriales españolas o planetarias; eso, que en ese momento
> fue vivido como una catástrofe como la pérdida de un capital histórico
> argentino, yo creo que empezó a dar frutos en un sentido impensado,
> inesperado—que son, me parece, los mejores frutos que pueden dar las
> cosas, sobre todos los procesos catastróficos—, y es la proliferación, ya no
> de escritores, si no [sic] de editoriales independientes que empezaron a
> funcionar con la misma lógica—o con una lógica muy parecida—que
> hicieron grandes a las editoriales argentinas en los años 40 o 50. Es decir,
> tratar de aprovechar aquellos intersticios que el mercado, el gran mercado,
> el Mercado con mayúsculas, de las Editoriales con mayúscula, no explotan,
> desdeñan, ignoran. (Pauls 2008)[8]

[6] "Eloísa Cartonera is a social and artistic project in which we learn to work in a
co-operative way. The idea of the project is to generate genuine employment
through the publication of contemporary Latin American Literature. For this we
came up with a very simple way of working that consists in the manufacture of
cardboard books. The cardboard book is the product of our work. But the most
important thing is discovering a new way of doing things" (Cucurto and Joly
2007:4).
[7] I take the idea of diffraction as a metaphor from the concept in physics which
describes the phenomenon which occurs when sound and light waves ripple and
curve their paths around an obstacle. The Latin root of the word "diffraction"
means to crack or break apart and so the metaphor also aptly describes the
dynamics by which these alternative publishing paradigms emerged and spread.
[8] "It seems to me that the acquisition of Argentinean publishing houses by Spanish
or planetary publishing corporations, which was perceived here about ten or fifteen
years ago as a catastrophe and as the loss of Argentinean historical capital, began, I

Pauls's own experience in the field of Argentinian publishing over the last twenty years and his first hand knowledge of the market lends authority to his viewpoint. Nevertheless, his assessment speaks to a binary and polarised view of the Argentinian publishing market place, one torn in his view between massive and standardised commercialisation on the one hand and independent small scale producers on the other. This leaves out another significant element in the publishing scene today, i.e. publishing and distribution through new paradigms that bring together an innovative business model and formal and material experimentation.

For the independent Argentinian publishers which became established during the 50s and 60s, economic considerations were just as important as achieving an effective intervention in the cultural field. By contrast, for the new ventures that emerged after the 2001 crisis in Argentina, cultural questions outweighed economic ones. However, as Hernán Vanoli points out, while the notion of commercial gain was displaced by the economic crisis and the alternative projects to which it gave rise, the concept of the division of labour (and consequently ideas about commercialisation and economic interest) is present in all these projects, albeit with reduced significance (2009: 174-176). Two features set apart these new kinds of publishing venture. On the one hand, the nominal question: while a finished book may be the end result of a co-operative group's work, members choose not to categorise themselves narrowly as publishers. On the other hand, there is the material question, the nuts and bolts of the production of a text, the new arrangement of which interrogates literature's status within these projects. The question of a formal or material aspect should not be underestimated, or minimised, or naively left aside, because it not only concerns those who write or produce books, but also makes itself felt in readers' relationships with the book, and consequently outlines a renewed vision of the literary world and of reading practices.[9]

believe, to bear fruit in unforeseen and unexpected ways—and it seems to me that this is the best sort of fruit that can come from things, especially from catastrophic developments—namely the proliferation, no longer of writers, but of independent publishing houses that began to work with the same logic—or with a very similar logic—to the one that made Argentinean publishing houses in the 40s and 50s great. That is, to try to take advantage of those interstices that the market, the large market, the Market with a capital M and Publishers with a capital P, do not exploit, the ones that they scorn, of which they are ignorant" (Pauls 2008).

[9] As Ana Mazzoni and Damián Selci suggest with reference to poetry issued by non-conventional presses: "The first thing that comes to mind about this poetry

We can divide recent Argentinian publishing into two strands on the basis of the kinds of material and the platforms which are used. Firstly, there are ventures which use new technologies and web applications as publishing platforms. We could also group here talking book imprints like "Voy a salir y si me hiere un rayo", personal blogs (for example, Cecilia Pavón's *Once Sur*) and E-zines and online magazines such as *El Interpretador*. Secondly, there are ventures which embrace the traditional concept of the printed book up to a point, but which also deconstruct it in ways that go against traditional publishing. This group of publishing projects includes Eloísa Cartonera, Belleza y Felicidad, Plush, Tsé-Tsé, Junco y Capulí, Carne Argentina, Clase Turista, Chapita, and Editorial Vox. The names of these ventures alone is indicative of their desire to set themselves apart from the hierarchy and gravitas of traditional publishing and canonical literature, and as Ana María Porrúa suggests, the names also point to an appropriation of mass culture and its elements of banality, charm, and fleetingness (2003: 85). The extension, diversification, and multiplication of the Argentinian publishing market can be seen as a migration of Eloísa Cartonera's original concept to other groups or publishing projects which looked for well defined alternatives in publishing in order to ensure the preservation of literature as a real and social object.

CONCLUSION

As Rodolfo Fogwill suggests, photocopies and informal lending libraries were only some of the ways of circulating literature under the military dictatorship; in the current climate of economic crisis, the book—and therefore literature—is looking for other ways of assuming its form and in doing so, it diffracts. Like a ray of light, it avoids obstacles and finds alternative paths by which to travel. When this happens, the book ceases to be a sacred object worshiped by a select group: instead it evolves and in doing so it recalls the earliest moments in the history of the book as a profane object. In Roman times, profanation was an act through which what was hitherto considered available only to deities or divine beings was transformed and became available to every man, to the *legos*: "E se conacrare (sacrere) era il termine che designava l'uscita delle cose dalla

isn't the way it is written, but the materiality of the object-book that supports it. Curious designs, formats fairly far removed from 'proper' books [...] everything makes us wonder 'But, what is this?'" (2006).

sfera del diritto umano, profanare significava per converse restituire al libero uso degli uomini" (Agamben 2005:83).[10]

As Giorgio Agamben points out, profanation results from contact with something considered profane, or through the inappropriate use or re-use of the sacred. A good example of this last kind of profanation would be the games children play for fun and which make a neutral use of something which was primarily conceived for other purposes, in another sphere. When playing games, a typical political activity, people take things which were not meant to be originally for them; they make them their own, enjoy them, re-use them, and through that game or object-game there is still a reminder of the original article's sacred aura which, even after its profanation, distinguishes it from the ordinary: "Pura, profana, libera dai nomi sacri, è la cosa restituita all' uso comune degli uomini. Ma l'uso non appare qui come qualcosa di naturale: piuttosto a esso si accede soltanto attaverso uma profanazione" (Agamben 2005:83).[11]

The economic crisis in Argentina turned literature into a luxury for those who write it as well as for those who read it. Arduous economic circumstances have fostered new and highly creative forms of the book that are produced outside the ambit of the publishing establishment. Cardboard books' visual characteristics, like the circumstances of their production, question established definitions of literary practice and consumption. Eloísa Cartonera's books *profane* literature by publishing it between covers made of cardboard picked from the streets: a material considered garbage by most people is fused with the aim (shared with conventional publishers) of creating books and literature. Here, the material aspect of the book becomes the visual cue to the profanation of literature. Today, literature has come back in the form of a profane book to reach those to whom it had been denied: people who want to write literature, people who want to read it.

[10] "And if 'to consecrate' (*sacrare*) was the term that indicated the removal of things from the sphere of the human law, 'to profane' meant, conversely, to return them to the free use of men" (Agamben 2007:73).

[11] "The thing that is returned to the common use of men is pure, profane, free of sacred names. But use does not appear here as something natural: rather, one arrives at it only by means of profanation" (Agamben 2007:73).

Works Cited

Agamben, G. 2005. "Elogio della profanazione" In *Profanazioni*, 83-106. Roma: Nottetempo.
——. "In Praise of Profanations." In *Profanations*. Trans. J. Fort, 73-92. New York: Zone Books.
Berger, T. 2009. "Un prólogo". In *Mehr als Bücher. Anthologie Mit texten von Kartonbuchautoren/ Más que libros antología de escritores cartoneros*, ed. A. Navarro Millet, 11-13. Berlin: Lalarva/ Papper LaPapp.
Botto, M. 2006. "1990-2000. La concentración y la polarización de la industria editorial." In *Editores y políticas editoriales en Argentina, 1880-2000*, ed. J. L. Diego, 209-248. Buenos Aires: Fondo de Cultura Económica.
Bourdieu, P. 1999. "Una revolución conservadora en la edición." In *Intelectuales, Política y Poder*, 223-264. Buenos Aires: EUDEBA.
Casanova, P. 2001. *La República mundial de las Letras*. Barcelona: Anagrama.
CEP [Centro de Estudios para la Producción, Secretaría de Industria, Comercio y de la Pequeña y Mediana Empresa, Ministerio de Economía y Producción]. 2005: "La industria del libro en Argentina", *Síntesis de la economía real* 48 (March): 51-82.
Cucurto, W. and J-B Joly, eds. 2007. *Kein Messer ohne Rose. Geschichte eines lateinamerikanischen Verlages und Anthologie junger Autoren*. Buenos Aires / Stuttgart: Eloísa Cartonera / merz&solitude.
De Diego, J. L. 2007. "Políticas editoriales y políticas de lectura." *Anales de la educación común* 6 (July): 38-44.
Dirección General de Estadística y Censos, 2005. "Pobreza e Indigencia en la ciudad de Buenos Aires." *Informe de resultados* 249 (25 April).
Fogwill, R. 2008. *Los libros de la guerra*. Buenos Aires: Mansalva.
Massuh, G. 2003. "Arte de la crisis = Krisiaren artea: crisis del arte = Artearen krisia." *Zehar: revista de Arteleku-ko aldizkaria* 51: 58-63.
Mazzoni, A. and D. Selci. 2006. "Poesía actual y cualquierización." *El interpretador* 26 [electronic publication].
Pauls, A. 2008. "Talando Árboles: ¿Somos muchos más que dos? Charla/Debate." *Hablando del asunto* [blog], http://www.hablandodelasunto.com.ar/?p=742. (Accessed 21 February 2009).
Porrúa, A. M. 2003. "Lo Nuevo en la Argentina: Poesía de los 90." *Foro Hispánico, La literatura Argentina de los años 90* 24: 85-96.
——. 2008. "Poesía argentina en la red." *Punto de vista* 90: 18-23.
Ruiz Guiñazú, M. 2009. "Cada libro cartonero es un tesoro." *Diario Perfil*, 31 May. http://mehralsbuecher.blogspot.com/2009/06/cada-libro-cartonero-es-un-tesoro.html (Accessed 3 June 2009).
Saitta, S. 2004. "La narrativa argentina, entre la innovación y el mercado (1983-2003)." In *La república y su sombra*, eds. M. Novaro and V. Palermo, 239-256, Buenos Aires: EDHASA.
Vanoli, H. 2009. "Pequeñas editoriales y transformaciones en la cultura literaria Argentina." In *Apuntes de Investigación del CECYP*, No 15, 161-185.

CHAPTER SEVENTEEN

VISUAL DIALOGUES: STREET ART AND GRAFFITI IN ARGENTINA AND CHILE

GUDRUN RATH

The anonymous protagonist of Julio Cortázar's short story "Graffiti" is constantly covering the city's walls with drawings. His visual expressions are responses to a censorious regime which methodically expunges murals, and they also reference a more general political oppression. Unexpectedly, someone has the heart to respond; other sketches begin to appear next to the original graffiti, beginning a dialogue with them. However, this illicit form of communication suddenly comes to an end when the female graffiti artist who had begun to respond to the protagonist's graffiti with her own designs, is arrested. Once again, the drawings done by the protagonist of Cortázar's story become a monologue, while his former female dialogist, after being tortured by the police, tells him in a final timid drawing that he should continue. Cortázar's story unfolds in the midst of an anxious city, which implicitly mirrors the Argentinian dictatorship. The images on the walls remain, despite being swept away:

> En el tiempo que transcurría hasta que llegaban los camiones de limpieza se abría para vos algo como un espacio más limpio donde casi cabía la esperanza. Mirando desde lejos tu dibujo podías ver a la gente que le echaba una ojeada al pasar, nadie se detenía por supuesto pero nadie dejaba de mirar el dibujo, a veces una rápida composición abstracta en dos colores, un perfil de pájaro o dos figuras enlazadas. Una sola vez escribiste una frase, con tiza negra: A mí también me duele. No duró dos horas, y esta vez la policía en persona la hizo desaparecer. Después solamente seguiste haciendo dibujos. (1980: 130) [1]

[1] "In the time that passed before the cleaning trucks arrived something like a cleaner space opened up for you where there was almost room for hope. Looking from afar at your drawing you could see people casting a glance at it as they passed by. Of course nobody lingered but nobody could resist looking at the drawing either, a quick abstract duo-chrome sketch, sometimes the outline of a bird, or of two intertwined figures. Only once did you write a phrase, in black chalk: It hurts me, too. It didn't last more than two hours and the police themselves made it

Clandestine inscriptions in and on the urban space exist in opposition to the censorship of mural art by totalitarian systems, and thus they subvert official codes, and enact the quest for intersection and for silent yet visible dialogue as Cortázar describes in his short story. Graffiti, like street art, inscribes itself into the urban space, and it does so by transgressing the established order. In the Latin American context of military dictatorships, different forms of transgression and different forms of communication emerge, similar to the dialogical structures Cortázar referred to in his text. In this chapter, I want to ask how political graffiti and street art evolved in this context, and to consider the form and shape they assumed as acts of resistance. To what extent are the territorial limitations of political graffiti valid for other types of street art? In this chapter I look closely at two instances of urban art—one in Argentina and the other in Chile—seen within the context of totalitarian systems and of post-dictatorial memory.

GRAFFITI ART COMES TO LATIN AMERICA

In places like metropolitan New York where significant resources were dedicated to the renaissance of urban areas, graffiti proved to be persistent and subway trains coated with tags continued to circulate around the urban space, populating the city's surface with garish designs. As Nestor Canclini suggests in *Hybrid Cultures*, the graffiti of New York's suburbs and the graffiti which mushroomed in the Paris of 1968 together form the two principle cornerstones of what became modern graffiti (2005: 250). Tania Cruz Salazar traces the journey of New York-style graffiti to Mexico City (and thence to other sites across Latin America) via Los Angeles, Tijuana, Guadalajara, and Nezahualcóyotl (2008: 144-145). Along this pathway, graffiti assumed peculiarly Latin American idioms as it spread across big cities and fragmented into a diversity of styles and techniques. The evolution within Latin American graffiti of unique characteristics means that it has now outgrown European or North American prototypes and that its geographically distinctive iterations have become *sui generis*. Today, stencil graffiti in Argentina, Brazil's *pichaçao*, and urban mural art in Chile, have themselves become a rich source of urban art forms with an influence that extends across the globe.

Although graffiti styles from New York and Paris were catching on as early as the 1960s and 1970s in Latin American cities like Río de Janeiro and the Mexican capital, the street gangs who painted them would not

disappear. After that you stuck to drawings." Cortázar's story was first published in a catalogue of Antoni Tàpies's work (Holmes 2007: 71).

begin to use the term "graffiti" for their work until the late 1980s or the early 1990s: until then, in Mexico, for instance, this kind of street art was referred to with terms like *pinta* and *pintada*, or, in the north of the country, *placas* and *placazos* (Cruz Salazar 2008: 143).[2] *Pinta* and *placa* referred equally to unauthorised protest graffiti as well as to monochromatic political propaganda and the original shared nomenclature illustrates the vicinity of Latin American graffiti to the political graffiti of 1960s France.

Leaving aside the influence of American and French graffiti, another originating moment has to be taken into account when we consider the Latin American context. Political paintings, and Mexican muralism especially, continue to influence contemporary Latin American graffiti and the convergence of these two forms of expression is indicative of the powerful connection which exists between arts and politics in Latin America, and distinguishes its graffiti from the varieties to be found on other continents. In Chile, especially, Mexican muralism has had a great influence on urban art: referring to the 1950s and 1960s Ronald Palmer suggests that, in the context of politically motivated art within the reach of all "Mexican muralist ideals of collaborative artistic action were realised with greater vigour and urgency in Chile than in Mexico itself" (2008: 8) and he goes on to detail the painting of the Capuchins Bridge in Viña del Mar in 1964, an act which was carried out by a team officially approved by the city's socialist mayor. When opponents of the left destroyed the resulting design, which pictured the children of a future Chile and a world held aloft by a worker, Pablo Neruda "broadcast a tirade on the radio: on the mural itself as pioneering Latin American propaganda, and its *freísta* destroyers as colonial fascists" (Palmer 2008: 8).

In Mexico, as in the US, the emergence of graffiti in the 1970s was strongly connected to the socio-economic situation of the country (Cruz Salazaar 2008: 145).[3] The modernisation and industrialisation of the big cities, and especially of the capital, was accompanied by a social and spatial segregation and youth unemployment, where graffiti turned into a mode of expression and identification for youth. The territorial marking of districts with tag graffiti by the *chavos banda* or by the chicano "cholos", and the practice of crossing out graffiti painted by a rival *banda* (crew),

[2] This type of graffiti is usually referred to as hip hop graffiti on account of its ties to hip hop music and the use of various colours (Kozak 2004: 25).
[3] In Argentina, by contrast, the absence of hip hop graffiti is striking. Its late emergence in the 1990s is probably related to the socio-economic, as well as to the political situation of the country. The political situation, however, led to urban art forms that differ from the usual transgression in graffiti.

demonstrate the strong relationship that ties graffiti to urban space.[4] As Néstor García Canclini suggests, graffiti in this case becomes a "territorial writing of the city designed to assert presence in, and even possession of, a neighbourhood. The battles for control of space are established through [groups'] own marks and modification of the graffiti of other groups" (2005: 249).

The crews' signatures or a writer's tags are spread out to achieve the maximum coverage of a given urban space. The appropriation of the word from the margins of the city becomes a form of symbolic appropriation of the urban space. The writer's individual identity, however, dissolves in the collective identity of his crew and within the relative anonymity of a generic tag. Graffiti resists the dominant order, flooding surfaces with apparently meaningless signifiers—"Kool Guy" or "Crazy Cross"—which, exactly because they oppose being reduced to one interpretation, do not correspond to the logics of the hegemonic denomination system (Baudrillard 1978: 26).

Contemporary graffiti continues to resist being reduced to the rebellious expression of youth or to a simple act of resistance to the hegemonic order. The blurring of boundaries between graffiti and other forms of expression has taken a new turn, however, in that its sub-cultural origins have been appropriated by the discourse of consumerism and advertising. According to García Canclini, modern graffiti has to be approached as something which exists on a hybrid, liminal line between elite and mass culture, between the popular and the cultured (2005: 249).[5] This hybrid genre discussed by García Canclini traverses not only class stratification; as a fusion form it also approximates image and text, sometimes to the point where text becomes image and vice versa.

Since its beginnings, the illegal status of graffiti has as a matter of course politicised art and aestheticised politics. Thus, as a form of expression which underscores the inseparability of politics and art it articulates another kind of border elimination which mirrors the tendency of graffiti to erase the dividing line between image and text. Forms of resistance in Latin American graffiti have caught up with this contemporary dilution of limits. The bond between arts and politics that applies to graffiti also affects street art, and both involve practices of resistance, protest, and collective memorial that indicate new directions in urban aesthetics.

[4] For cholo-graffiti, usually painted only in black and making use of religious symbols like the Virgen de Guadalupe, see Borjórquez's 2009 article "Los Angeles 'Cholo' Style".

[5] Canclini, however, does not take into consideration graffiti-advertisements.

Urban art's immediacy turns it into a quick and participatory medium, as was seen, for example, in Oaxaca in 2006. When teachers in the Mexican city went on strike to demand "higher pay, better working conditions and [...] the resignation of governor Ruiz" (accused of election fraud), three people were shot dead by the police (Nevaer 2009: 8-9). In the conflict which ensued, graffiti became one of the principal forms for staging resistance, with the walls becoming a space of clandestine communication for the citizens. However, the dialogic structure witnessed during these events can be observed elsewhere, and has become a characteristic of the examples of Latin American graffiti and street art which I explore in this chapter.

ACCOMPLICES' DIALOGUES: SANTIAGO DE CHILE

In 1983 an urban intervention in Santiago de Chile by CADA (Colectivo de Acciones de Arte / Art Action Collective) expanded and gave a further twist to the use of graffiti as a forum for anonymised public dialogue and debate. Ten years after the imposition of the military dictatorship, CADA collaborated with co-operative art groups from all across the city to paint the phrase "NO +" as widely as possible in the metropolitan area. The graffiti was conceived as bipartite, a dual construction, the other half of which would be completed by the city's inhabitants, thereby initiating mute nocturnal dialogues between artists and citizens turned accomplices by their common graffiti endeavour (García Navarro 2008: 353). Under cover of night, this collaboration between artists and anonymous individuals produced slogans like "NO + tortura" ("No more torture") and "NO + muerte" ("No more death"), as well as "NO + familia" ("No more family"), "NO + desempleo" ("No more unemployment"), and even "NO + porque somos más" ("No more because we're more"). This last phrase—"No más porque somos más"—spread across the city and became synonymous with the Chilean movement towards democratic government. The writer Diamela Eltit, who was a principal member of the art collective which instigated the "NO +" campaign, observes:

> Ese lema fue la gran consigna que acompañó el fin de la dictadura. Fue apropiado por la ciudadanía y más tarde por las organizaciones sin nuestra intervención, y esa "pérdida" autoral fue de una radicalidad extrema pues nos desalojó de nuestra propia creación, o más bien nos convertimos en un signo político sin cuerpo, sin firma. La relación arte política alcanzó su máximo espesor. (qtd in García Navarro 2008: 359)[6]

[6] "This slogan was the great watchword that accompanied the end of the dictatorship. It was taken up by citizens and later on by organisations as well,

Instead of delimiting territory in an act of closure, the graffiti belonging initially to the CADA intervention opened up a space for communication. In the case of the "NO +" campaign, the dialogic character that often emerged unexpectedly between different graffiti led not to the crossings-out which were characteristic of the early tag graffiti wars, but instead to an invitation to make additions, to supplement, and thus to participate, making readers into writers. By means of graffiti, the walls of Santiago de Chile took on a leading role in the expression of a civic dialogue between like-minded subjects, or accomplices, who had theretofore been rendered silent.

While the "NO + " formula continues to be cited in contemporary Chilean street art—for example, in 2006 in the work of the PEKA and TOKO crews (Palmer 2008: 21)—the full impact of the ties between arts and politics in Chilean urban art were at their most visible in the socialist mural-brigades that first emerged in the 1960s and have since developed over time and across the country's expanse (Palmer 2008: 8-11). BRP (Brigada Ramona Parra) and BEC (Brigada Elmo Catalán), the two best-known mural painting brigades (the first of which is still active today), have introduced a particularly Mexican influence to their style of mural-painting and have made the art form into a major influence on contemporary street art.[7] In the case of the brigades, where every member had a clear part to fulfil—from planner to outliner—the mural's massive and memorable visuals created a pictorial language that operated on the basis of rapidly recallable codes. In the late Pinochet era, when the brigades participated in resistance to the dictatorship, the BRP appropriated the star of Chile which had until then been exclusively an emblem of the Right (García Navarro 2008: 11). In this instance visual dialogue takes place through the symbolic re-appropriation of signs. Through the brigades' murals, this process of re-appropriation assumed more extensive proportions within the city's symbolic order.

without our intervention, and this authorial 'loss' was an extremely radical one since it turned us out of our own creation, or, rather, we became a disembodied political sign without a signature. The relationship between art and politics gained its greatest density."

[7] BRP was named after a nitrate-worker killed at a rally. There were several BRPs (in 1970 up to one hundred and twenty such groups) working around Chile (Palmer 2008: 9).

CLAIMS FOR JUSTICE: STREET ART IN BUENOS AIRES

In the case of Argentina, the fusion of arts and politics as a means of expressing resistance to the oppressive system in government can be traced back to an intervention which took place during the military dictatorship. Starting in 1983, the *Siluetazo* was carried out on two subsequent occasions. It was conceived by the artists Rodolfo Aguerreberry, Julio Flores, and Guillermo Kexel, who suggested its use to the Madres de la Plaza de Mayo (Longoni and Bruzzone 2008: 7).[8] In the *siluetazo* interventions, life-sized silhouettes were cut out and pasted on the walls around the Plaza de Mayo in Buenos Aires during the second Marcha de la Resistencia (Resistance March). "Aparición con vida" ("Sighted Alive") was one of the principal demands held out by Argentine mothers of the disappeared and by symbolically reclaiming the lives of the missing with silhouettes, the action made for a very present absence. The intervention was widely supported by everyday people, and as in the case of CADA's "NO +" campaign, silhouettes immediately spread around the city. The action has been cited in other interventions and continues to be until the present day. Once more, aesthetics and politics merged, and made resistance visible on the walls:

> En lugar de disolver el arte en la política, la Siluetada evidencia que lo estético es una dimensión inseparable de la política a la que acompaña. Su autonomía radica, precisamente, en efectuar la indistinción de lo político y lo estético [...] pero reteniendo la potencia de lo estético como motor de la resistencia. (García Navarro 2008: 343) [9]

Like graffiti, the *Siluetazo* effects a fusion of arts and politics together with the appropriation of urban space. It is, furthermore, an expression of the territorial claim established over the Plaza by the protests led by mothers of the disappeared (García Navarro 2008: 349-350). If the symbolic appropriation of space, and especially of the Plaza de Mayo by anti-dictatorial protestors, remains as a durable legacy it is in part as a result of interventions like the *siluetazo*. The symbolic and performative act of giving human physical form ("poner cuerpo") to the disappeared— which was what the artists and protestors achieved by acting as models to

[8] Some critics prefer the term *Siluetada* to *Siluetazo* because of the phonic analogy with revolutionary actions like the *Cordobazo* (García Navarro 2008: 339).

[9] "Instead of dissolving art within politics, the Siluetada proves that the aesthetic is an inseparable dimension of the politics which runs parallel to it. Its autonomy lies precisely in effecting a lack of distinction between politics and aesthetics [...] while retaining the power of aesthetics as an engine for resistance."

symbolise the absence of the missing—became a defining moment in the dialogue between arts and politics in Argentina, and it continues to be a reference for contemporary interventions.

Urban interventions in Argentina, ultimately deriving from the *Siluetazo*, have combined forms of resistance with forms of collective memory. By the 1980s the graffiti crew "Secuestro" were reflecting on Argentina's more recent past. With slogans like "Yo secuestro, tú secuestro" ("I kidnap, your kidnapping"), and "El colegio es una institución de secuestro" ("College is a kidnapping institution") they highlighted the violence of the preceding years as well as the oppressive character of society in more general terms (Kozak 2004: 210-211). In the last few years, the symbolic occupation of public space initiated by the *Siluetazo*, has shifted to performative memorial practices which have been linked to claims for justice with respect to the dictatorship's genocide. In a 2004 intervention titled "Blancos móviles", referring to recent "security" discourses and police violence, the GAC (Grupo de Arte Callejero) street art collective re-deployed the silhouettes, this time fragmented by a target drawn across the body to state that, "lejos de estar a salvo seguimos siendo 'blancos'. Blancos móviles. Muestran la manera en que la normalidad perversa actual se instala: convirtiéndonos en blancos en una ciudad que se vuelve fortaleza. Como en las viejas épocas feudales, el 'afuera' es tierra de nadie, y los espacios interiores prometen 'seguridad'." (Grupo de Arte Callejero 2008: 428).[10]

The symbolic occupation and marking out of urban space has, then, been one of the main objectives of urban art in Argentina and Chile since the 1990s. Various groups have repeatedly used street art and graffiti to claim justice from a military regime whose decision-makers are only now being brought to trial. In a collaboration between H.I.J.O.S (Hijos por la Identidad y la Justicia, contra el Olvido y el Silencio / Sons and Daughters for Identity and Justice, and Against Forgetfulness and Silence), a collective of children of the disappeared, and art collectives like the Grupo de Arte Callejero and Étcetera, graffiti has been embedded in the "escrache" (see Fig. 17-1 and Fig. 17-2), a term drawn from Lunfardo (the Buenos Aires argot which originated in the underworld), and which means "sacar a la luz lo que está oculto" ("to bring to light what is hidden" (GAC 2009: 57). Using paint-bombs and modified street signs such "escraches" sought to make visible the houses belonging to the military regime's

[10] "Far from being safe, we continue being 'blank'. Movable targets. They show the way in which the current perverse normality installs itself, making us targets in a city become a fortress. As in the feudal times of long ago, the 'outside' is a nomansland, and interior spaces promise 'security'."

torturers (Zuckerfeld 2008: 437-438; 440-441). Throwing a red paint bomb at a wall to identify a torturer's residence is a practice copied from demonstrations in Chile, where visiting members of the Étcetera group learned of this action art form as a means of denunciation and as a way to raise consciousness among citizens (Zuckerfeld 2008: 438). The interventions generated much controversy, and, like other urban art forms, the police sought to suppress them on various occasions (Zuckerfeld 2008: 444).

In the kind of political-artistic interventions I have discussed above, different urban practices converged. In one of the campaigns carried out by GAC since 2001, alongside demonstration and performance, street signage was re-purposed to indicate the whereabouts of clandestine prisons which had operated during the military dictatorship (Grupo de arte callejero 2009: 82-83). This kind of intervention not only posits public space as staged but also inscribes in urban space the demand that what has been concealed in the political past should be made visible. In this instance, the territorial marking of graffiti serves to denounce injustices that had been accepted in the city by mutual agreement. Having become an element within a number of strategies, graffiti's scope as a genre has been broadened. This extension of graffiti's range has enabled a performative approach to urban space (Schindel 2008: 411-412), where interventions extend to the whole surface and are connected to the desire to reach as many observers as possible in public space.

Urban art no longer serves to delimit territories, as in the case of hip hop graffiti, but highlights and claims the visibility of the political past in urban spaces. In urban interventions of the kind I have discussed in this chapter, resistance is performed in an aesthetic and political hybrid form which demands a space and a place for collective memory. In Argentina and Chile, art works as installations and interventions have successfully harnessed the transgressive potential of graffiti to articulate a form of public expression which sites both the denunciation of past crimes and the demand for a visible collective memory in the urban landscape. Notwithstanding such success, however, the process of reclaiming the streets is one which is never fully accomplished.

WORKS CITED

Baudrillard, J. 1978. "Kool Killer oder der Aufstand der Zeichen." In: *Kool Killer oder der Aufstand der Zeichen.* Trans. H.-J. Metzger, 19-38. Berlin: Merve.

Bojórquez, C. 2009. "Los Angeles 'CHOLO' Style Graffiti Art." http://www.graffitiverite.com/cb-cholowriting.htm (accessed 20 June 2009).

Cortázar, J. 1980. "Graffiti." In *Queremos tanto a Glenda,* 129-134. Madrid: Alfaguara.

Cruz Salazar, T. 2008. "Instantáneas sobre el graffiti mexicano: historias, voces y experiencias juveniles." *Última década* 16 (29). http://www.scielo.cl/scielo.php?script=sci_arttext&pid=S0718-22362008000200007&lng=es&nrm=iso&tlng=es (doi: 10.4067/S0718-22362008000200007) (Accessed 20 June 2009).

García Canclini, N. 2005. *Hybrid Cultures. Strategies for Entering and Leaving Modernity.* Trans. C. Chiappari and S. López. Minneapolis: University of Minnesota Press.

García Navarro, S. 2008. "El fuego y sus caminos." In *El Siluetazo*, ed. A. Longoni and G. Bruzzone, 333-364. Buenos Aires: Adriana Hidalgo.

Grupo de Arte Callejero. 2008. "Blancos móviles." In *El Siluetazo*, ed. A. Longoni and G. Bruzzone, 427-433. Buenos Aires: Adriana Hidalgo.

——. *GAC: Pensamientos, prácticas, acciones.* Buenos Aires: Tinta Limón.

Holmes, A. 2007. *City Fictions. Language, Body and Spanish American Urban Space.* Lewisburg: Bucknell University Press.

Kozak, C. 2004. *Contra la pared. Sobre graffitis, pintadas y otras intervenciones urbanas.* Buenos Aires: Libros del Rojas.

Longoni, A. and G. Bruzzone, eds. 2008. *El Siluetazo.* Buenos Aires: Adriana Hidalgo.

Nevaer, L. E. V. 2009. *Protest Graffiti Mexico. Oaxaca.* Intro. L. Downs. New York: Mark Batty.

Palmer, R. 2008. *Street Art Chile.* London: Eightbooks.

Schindel, E. 2008. "Siluetas, rostros, escraches" In *El Siluetazo*, ed. A. Longoni and G. Bruzzone, 411-423. Buenos Aires: Adriana Hidalgo.

Zuckerfeld, F. 2008. "Continuidad de la línea en el trazo: de la Silueta a la Mancha." In *El Siluetazo*, ed. A. Longoni and G. Bruzzone, 435-452. Buenos Aires: Adriana Hidalgo.

CHAPTER EIGHTEEN

RECOBRANDO LA IDENTIDAD: CHILEAN CINEMA AFTER PINOCHET

VERENA SCHMÖLLER

Are there typical Chilean features or collective characteristics, which could be combined into what we could call *chilenidad*? Can we speak of one single Chilean culture, something that really corresponds to *lo típico chileno*? Chilean filmmakers have repeatedly asked—and tried to answer—these questions, often with recourse to the key concept of a collective memory. Nevertheless, it is questionable whether there can be such a thing as a single and monolithic Chilean identity, since Chilean society was torn into two parts with the military coup in 1973. But it is not only political polarisation that marks today's Chile; there is also a fundamental social and topographical divide: between the poor and the wealthy, and between metropolitan areas and the countryside. In contemporary Chilean cinema, no other topic is more frequently projected onto the screen than that of national identity. As I have outlined elsewhere (Schmöller 2007 and 2009), many recent Chilean films look for a collective identity through a focus on traditions and rituals, political history, Chilean topography, or through an emphasis on the number of children orphaned by the vicissitudes of the country's history.[1]

Another strategy filmmakers use for grappling with the issue of identity is narrating the experiences of foreigners and returnees who visit Chile or migrate to the Andean country, getting to know its contemporary face. Both types of protagonists in these narratives are outsiders: they have lived—their whole lives or many years—in other parts of the world and, therefore, meet the Chileans and their mentality with a certain amount of

[1] In *Madres y huachos: Alegorías del mestizaje chileno* (1993), Sonia Montecino argues that for centuries Chile's history has been marked by the presence of orphans and of lost children: the children of Spanish conquerors, the children who lost their fathers in the aftermath of the military coup in 1973, or *los hijos de la transición* who live in a society which does not yet know which path to follow. These children, *los huérfanos y perdidos*, often feature in leading roles in Chilean cinema of the 90s and became one if its most salient characteristics (Cavallo, Douzet, and Rodríguez 1999: 58-60).

reservation. Unconsciously or consciously, they focus their gaze on everything that seems strange, unfamiliar, or different. The outsider status of the main characters in these films allows them to pose basic questions about the identity of the typical or average Chilean, and to query the recent fate of the country. These characters are used intentionally to register Chile's here and now with alien or alienated eyes.

In what follows, I will examine the quest for national identity in Chilean cinema by close analysis of one example drawn from a clutch of films with foreigner and returnee protagonists. My thesis is that those narratives which focus on the point-of-view (POV) of outsiders and returning exiles are especially effective in trying to convey core aspects of contemporary Chilean identity, and more so than stories represented from the perspective of characters who are already at home in the country. Turning on the country the alien or alienated gaze permits the observation, detection, and unveiling of what remains invisible from within.

My focus is on the visual structure of the film I wish to study here and is informed by contemporary narrative theories. I examine firstly characters' perspectives on Chile by analysing the visual POV structures. In a second step, I look more closely at the importance of mise-en-scène to my interpretation. Among titles from recent Chilean cinema which stand out for their creative use of POV and mise-en-scène are Sergio Castilla's *Gringuito* (1998), Juan Vicente Araya's *No tan lejos de Andrómeda* (1999), and Raúl Ruiz's *Cofralandes* (2002).[2] My analysis will focus mainly on *Gringuito*, as this film's narrative incorporates both a character who is a foreigner as well as one who is a returning exile. First of all, however, I offer a short summary of the relationship between the country's film sector and Chilean society and politics.

CHILEAN FILM, SOCIETY, AND POLITICS

Reactions to Augusto Pinochet's death in 2006—an event celebrated by many in Chile, lamented by some others—demonstrated the country's abiding divisions. In common with many other aspects of Chilean history, the story of the country's film industry reveals the extent of these divisions.

[2] Further films that incorporate foreign or returnee protagonists are Ricardo Larraín's *La Frontera* (1991), Sebastián Alarcón's *Los agentes de la KGB también se enamoran* (1991) and *Cicatriz* (1996), Miguel Littín's *Los náufragos* (1994), Alex Bowen's *Campo minado: nadie vuelve intaacto* (1998), Luis Vera's *Bastardos en el paraíso* (2000), Fernando Lavanderos's *Y las vacas vuelan* (2004), and Rodrigo Gonçalves's *Horcón, al sur de ninguna parte* (2005).

During the 60s and the early 70s, the so-called Nuevo Cine Chileno (New Chilean Cinema) was closely associated with the Allende regime. Filmmakers working at the time in Chile fully supported the Allende government, and the state supported the film industry by funding film studies departments and film schools as well as the production of many films (Bolzoni 1974: 36). As Aldo Francia has shown in his retrospective assessment of the period, the Viña del Mar film festivals in 1967 and 1969, and the coalescence around them of the New Latin American Cinema, established a milestone which was important not only for the continent's film industry, but also for the unification of the Latin American continent through cinema (1990: 17). However, in 1973 Chile's film sector was destroyed in the aftermath of the *coup d'état*. And it remained almost non-existent during the Pinochet administration: the regime burned copies of films and closed film schools; the leading production company, Chile Films, was occupied by military force; left-wing filmmakers were persecuted and therefore many of them went into exile (Ruggle 2008: 63; Hübner and Recabarren 1976: 64). Zuzana Pick refers to one aspect of the outcome of these processes as the "Chilean-cinema-in-exile phenomenon" (1990: 109).

After 1990, when Chile returned to democratic government, it was, above all, the cinema that began to uncover what had occurred during the Pinochet regime: terror, human rights violations, and an experience of collective amnesia. Documentary film became an important platform for those who sought openly to discuss what had gone on in the preceding fifteen years and to expose the people responsible. Later, the dictatorship and related topics, such as freedom of speech, the sense of guilt, Chile's fractured identity, and the *desaparecidos* became significant for fiction film as well as for documentary. Moreover, filmmakers are increasingly looking for a Chilean identity that would unify the "two Chiles". Some directors, like Andrés Wood, have been trying to achieve this by using filmic *costumbrismo*, that is, by providing detailed, realistic descriptions of Chilean society and its daily life from an insider's perspective. Other directors like Sergio Castilla, Juan Vicente Araya, and Sebastián Alarcón have chosen not to approach Chile and the Chileans from an insider's perspective, but rather to come at the issues they wish to address from the viewpoint of the outsider or the foreigner.

If immigration and the return of exiles to their home country have both been such popular subjects for contemporary Chilean cinema this is because they are also fundamental to the Chilean experience. The view of the outsider—be it the foreigner's or the returning exile's perspective—is one which figures prominently in the history of the Chilean arts. On the

one hand, as sociologists point out, Chile has always been open and hospitable to foreigners, integrating several waves of immigrants during the past centuries. On the other hand, many Chileans, especially those with left-wing political opinions, were forced into exile, among them a good number of artists, academics, and politicians. Since the transition to democracy many expatriates have returned to Chile, bringing with them a plenitude of experiences and memories of their lives abroad (Correa et al. 2001: 64-66, 312-14).

GRINGUITO

Directed by Sergio Castilla in 1998, *Gringuito* tells the story of eight-year-old Iván, the eponymous diminutive *gringo* who has to move with his mother and father (who are expecting another child) from New York to Santiago de Chile. During the dictatorship Iván's family decided to leave Chile because their opposition to the Pinochet regime had already cost the life of the child's grandfather. Years later the family decides to return to Chile. Iván is very upset by this change in his life and rejects his new home from the very beginning. After a few arguments with his parents, he runs away from his new home in Santiago and starts to discover the city on his own. While strolling through the capital he makes new friends but soon learns that he needs to be very careful and not to trust people indiscriminately. After several minor adventures, some of them dangerous, Iván ultimately finds his way back home and arrives just after his sister's birth.

Iván is the prototype of someone born outside the country who is taken to Chile against his will. Unlike tourists or guests, who enjoy discovering the country, Iván—in common with several other protagonists in Chilean cinema—has many negative ideas about the country.[3] The night before they leave for Chile he asks his father: "But what if we get bored?" Another anxious thought, which he shares with his best friend, is "I'm worried I'm gonna disappear in Chile." This resentment towards the family's repatriation, however, also serves the purpose of lending verisimilitude to Iván's scrutinous and cautious perspective towards his new home. From the outset, he studies his surroundings carefully; nothing seems to escape the thorough gaze of these eyes.

[3] Another example is Ana in *Horcón, al sur de ninguna parte*. Although she resents having to go to Chile, Ana fulfills her father's last wish, taking his ashes to the Pacific coast. She ends up staying, getting to know the country better and bonding with her father's friends.

Although Iván seems to reject everything his parents tell him, he still learns from what they say and do. For instance, when the family arrives at Santiago's airport, his father, Jorge, is startled at the sight of a police officer talking on the phone. Iván takes notice and asks his father why he was staring at the policeman, but Jorge answers evasively and tries to reassure his son. Iván will remember that scene when he strolls through the city and encounters two policemen. He has seen and felt his father's fear, and, from that moment on, Iván will never trust the police. Instead, he confides in the most unlikely people: a gang of small-time criminals, prostitutes, and a down-at-heel fruit seller. This man, Flaco, steals the boy's money and leaves him alone in a brothel; nonetheless, in the end Flaco becomes Iván's new best friend.

By accompanying Flaco, Iván gets to know a Chile that is totally different from the one in which he lives with his middle-class parents. Flaco carries fruit and vegetables in a huge cart that is moved by man power.[4] He lives in a poverty-stricken suburb, a so-called *población*.[5] He takes Iván with him to his shack, shows him how to dance the *cueca*, the Chilean national dance, and invites him to partake in an *empanada*, a traditional dish. Consequently, Flaco's world is characterised as simple, if not poor, reminiscent of the rural way of life—in contrast to the well-to-do standard of living enjoyed by Iván's family.[6] And it is with Flaco that we see Iván smile and laugh for the first time. He even speaks Spanish with Flaco, something he had refused to do before, even when his parents begged him. In fact, he had insisted he never wanted to speak Spanish again: "I don't speak Spanish. I forgot it. I will never speak Spanish."

Gringuito would be the ideal film to promote the beauty of Santiago de Chile, as seen through the eyes of an eight-year-old discovering the city for the first time. Indeed, the film has been read as homage to the city; Verónica Cortínez categorises the film as belonging to the "cine de la

[4] The so-called *carretonero* has been a very typical image in Chilean cinema; a famous example is found in a scene in Patricio Guzmán's documentary *La batalla de Chile*, in which the camera follows a *carretonero* along the Alameda, the main street in Santiago's city centre.
[5] The Chileans call the poor residential areas at the edges of a city *poblaciones*. Orlando Lübbert's film *Taxi para tres* (2001) paints an extensive portrait of a *población santiaguina*.
[6] Orlando Lübbert points out that the *cultura campesina* still informs people's day to day reality in the Chilean countryside and in the *poblaciones* which skirt the bigger cities (Unsigned 2001: 5).

ciudad" (2001: 122).[7] The camera—in what often feels like documentary footage—moves slowly through the streets of the metropolis and documents the city centre, the suburbs as well as the bars and brothels of Santiago's nightlife. Like a travelogue, the film presents the main sights of the city such as the Santa Lucía Hill.[8] It registers the daily routines of the La Vega market as well as the upper class neighbourhoods. And because it covers so many different parts of Santiago, it represents the most detailed filmic portrait of the city in contemporary Chilean cinema. Not only does it offer overseas spectators a detailed visual impression of the city, but it also presents the citizens of Santiago with an opportunity to recognise their capital anew and, moreover, to discover new parts of it.[9] Of course, *Gringuito* is neither a travelogue nor a documentary about Santiago. It is the story of a little boy discovering a city that is new to him, as well as the story of a father getting to know his native city again.

GRINGUITO'S POV STRUCTURE

Contemporary Chilean films that incorporate foreigner or returnee protagonists very often present their stories through characters' perceptions. In the case of *Gringuito*, the plot is presented—to a great extent—through Iván and Jorge's visual perception using mostly classical POV shots. A good example is the scene that shows Iván and the fruit seller playing in Flaco's garden. The first shot is focused on Iván glancing at an object; the second one is focused on the object, in this case Flaco, who is dancing the *cueca*.

In a second example, we observe Iván following his father's glance towards a police officer. The first shot shows the perceiving subjects, Iván and Jorge, the second one reveals what they perceive: a policeman talking on a public phone. The shot is followed by an over-the-shoulder shot showing the policeman and another shot of Jorge. However, instead of cutting and assembling these two shots directly, the film uses a dissolve to connect them. For a very brief moment, we can see both the policeman and the startled Jorge in the same frame (see Fig. 18-1). The following shot, again, makes us comprehend that what we see corresponds with

[7] "Cinema of the city." *Gringuito* is one of many films based in Santiago. Other examples are Patricio Kaulen's *Largo viaje* (1967), Raoul Ruiz's *Palomita blanca* (1973), and Ricardo Amunategui's *Cesante* (2003).

[8] Santa Lucía Hill is a landmark frequently used in Chilean films to represent the city as, for example, in *Los agentes de la KGB también se enamoran* and *36 Veces*.

[9] This may have contributed to making *Gringuito* one of the most successful Chilean films since 1990: in Santiago de Chile, where the film ran in theatres for 17 weeks, it attracted over 100 000 spectators (Cortinez 2001: 116).

Iván's perception. As the boy follows his father's look, he catches a glimpse of the police officer's gun holster. The film cuts from Iván to the holster, which is shown in a close-up shot, and back to Iván, who is then moving closer to his father. Later on, during the encounter with two other policemen, we observe a very similar POV shot. The first shot shows Iván's glance; the second again presents another close-up of a gun holster worn by the first policeman before panning to the other's truncheon; the third shows Iván's reaction: he starts running and escapes from the policemen.

The first part of the film reveals in tandem both Iván's and Jorge's perception, whereas in the second part the two channels of perception are treated more discretely. After Iván runs away, the plot line divides into two: while the thread which shows Ivan's odyssey across the city is naturally focused on Iván's perception, the thread concentrating on the search for the child exposes Jorge's perception. Since the first part of the film intercuts both characters' perceptions, it indicates that Iván learns from his father; he imitates his father's way of looking and learns from him how to see his surroundings, something which is played out more obviously in the second part of the film.

That the exposition of the film's narrative often unfolds from Iván's perspective is important in two ways: first of all, it is Iván who discovers a totally new world. By looking through Iván's eyes, we get to know not only the domestic setting of the family story, in other words, the home environment of a relatively wealthy family, but we also gain a very extensive picture of the city. Iván approaches a diversity of characters and enters the most dangerous of places, as well as poor neighbourhoods and rundown areas. These places also belong to contemporary Chile; and without the use of Iván's perspective, we probably would not know them. His parents almost certainly would not have visited La Vega market, and they would never have accompanied Flaco to his home. Through Iván those socially divergent worlds within Chile are connected, at least, that is what the ending suggests, when Iván wishes to introduce Flaco to his family: "Te tengo que presentar a mi familia. [...] Nos vamos juntos, tú eres mi amigo."[10]

Secondly, the use of Iván's perspective to filter the narrative is important because it establishes that someone who has not personally lived through the horrors of the military coup and its aftermath can nevertheless still pick up on the sense of fear that continues to exercise a hold over contemporary Chilean society. Of course, Iván knows about the

[10] "I have to introduce you to my family [...] We'll go together, you're my friend."

dictatorship from his parents, and he learns how to react from observing their behaviour, as I suggested previously. However, he also seems immediately to feel a sense of fear, when he looks at a police officer for the first time. What is important is that Iván does not consider the police as a source of succour for those in difficulty, but rather as a sign which connotes danger. Iván does not look into the faces or the eyes of the policemen, but stares instead at the symbols of their power, the gun and the truncheon. This becomes obvious through the visual POV. In summary, then, while it facilitates the bringing together of usually dislocated parts of Chilean society—the rich and the poor, the metropolis and the provincial—Iván's perspective cannot be so easily reconciled with the forces of law and order.

GRINGUITO'S MISE-EN-SCÈNE

Paying close attention to the mise-en-scène of the film, it is obvious that Castilla also seeks to portray reconciliation between the strata of Chilean society which are opposed politically. That reconciliation is already anticipated by the image which shows Jorge and the policemen at the very beginning of the film. The integration in one frame of characters who could be considered representatives of the two Chiles suggests that a reunification of the two parts of Chilean society could be possible. Later on in the film, while looking for his missing son, Jorge gets the help which he needs at a police station.

Another example in the film of the narrative working to reconcile political opposites is found in the relationship between Jorge and his mother-in-law, Teté. As a consequence of holding very different political views they have a rather frosty relationship. As mentioned previously, Jorge comes from a family of those who were vigorously opposed to the Pinochet regime. Teté, on the other hand, belongs to the pro-Pinochet part of society. In their argument, the continuing divisions within Chilean society become manifest:

Jorge	Usted no me conoce a mí, señora.
Teté	Y no tengo ningún interés en conocerte, pobrecito retornado del exilio.
Jorge	Usted no tiene derecho a hablar de eso. Usted no conoce lo que es el dolor.
Teté	No, ustedes son los únicos que han sufrido.
Jorge	Ustedes siempre se las arreglaron para pasarlo bastante bien, señora.

Teté ¿Qué sabes tú de mi? ¡Huevón insensible egoísta! [11]

At the beginning of the conversation each character is framed separately: they argue while driving, shouting across at each other through open windows, in a shot/countershot sequence. During the argument the cars stop and Jorge leaves his car to talk to Teté more directly. He tries to calm her down and apologises: "Teté, perdóname [...] tiene razón [...] no nos conocemos."[12] Although both characters are now presented together in one medium close-up shot, they are still separated physically from each other, as Jorge is outside Teté's car while she remains seated on the inside. Moreover, she winds up the window, which further emphasises their disconnection. Visually, the separation between the characters is underscored by a dark, thick line representing the frame of the vehicle (see Fig. 18-2). Later in the film, however, we see that Jorge and his mother-in-law have been reconciled. They have had a drink in a bar, talked extensively and walk home arm in arm. Again, it is the mise-en-scène that emphasises this newfound proximity, as there is neither a visual line nor any physical space separating the characters. Instead, they touch each other.

CONCLUSION

Analysing *Gringuito* in terms of the POV structure and *mise-en-scène* suggests that Sergio Castilla wishes to represent the possibility of a reconciliation of the two opposing parts of Chilean society. Other films, such as *No tan lejos de Andrómeda*, directed by Juan Vicente Araya, however, see little chance for such a rapprochement between the two Chiles; Araya's protagonist is far from being happy. Instead of integrating him within Chilean society after his return to the country, the director has him die in the end. In Sebastián Alarcón's *Cicatriz*, on the other hand, hope seems to reside in the new generation, as children occupy most of the final scenes in that film. As Ascanio Cavallo, Pablo Douzet, and Cecilia Rodríguez suggest: "La función que cumplen los niños en *Cicatriz* es aún más amplia [que la de otros 'niños perdidos' que protagonizan en el cine chileno de los noventa] y tiene que ver con su sentido final. No solo hay

[11] "*Jorge* You don't know me, madam; *Teté* And I have no interest in getting to know you, poor returned exile that you are; *Jorge* You have no right to speak of that. You don't know what pain is; *Teté* No. You're the only ones who suffered; *Jorge* Your kind always fixed everything so that you had a comfortable existence, madam; *Teté* What do you know of me? You insensitive selfish twit!"

[12] "Teté, forgive me [...] you're right [...] we hardly know each other."

numerosas secuencias donde aparecen niños, sino que éstos ocupan una gran proporción de los planos finales" (1999: 225).[13]

Gringuito's incorporation of characters with an outsider perspective, above all, Iván, who is foreign to the country and knows only bits and pieces about it—mostly gleaned from what his parents have told him—allows Castilla to give a multifaceted impression of what contemporary Chile—or more precisely, Santiago de Chile—is like. Tethering the film's perspective to Iván's vision presents a number of opportunities for the narrative to examine post-dictatorship Chile: the young protagonist is not only foreign, but is a curious child who likes to explore and to go on adventures. Furthermore, Iván does not want to go to Chile in the first place, and therefore is a very critical and observant pair of eyes; we learn about his view of Chile through the visual POV. Wandering through the capital, he gets to know what would otherwise be socially disconnected parts of the city.

Integrating a returning exile into his narrative allows Castilla not only to show the possibility of a socially united Chile but also to open up a space for discussion of the problematic abyss which still divides the opposing camps in Chile's national politics. When he arrives in Chile, Jorge is still full of resentment. He does not trust the police—something which we get to know though the director's strategic use of POV, a technique which is also manifest in a later scene when Jorge cannot really look into his mother-in-law's eyes. However, having spent several days looking for his missing son, he begins to notice that everybody is willing to help him: the police and even Teté. By means of the visual POV as well as the film's mise-en-scène it becomes clear that a friendly co-existence of the two elements of Chilean society represented by the previously fractured family is—in the film at least—not only possible, but worthy and desirable.

[13] "The role played by children in *Cicatriz* is even greater [than the one played by other 'lost children' protagonists in Chilean cinema of the 90s] and has to do with its final meaning. Not only are there numerous scenes where children appear but these occupy a great proportion of the final shots."

WORKS CITED

Bolzoni, F. 1974. *El cine de Allende*. Valencia: Fernando Torres.

Cavallo, A., P. Douzet and C. Rodríguez. 1999. *Huérfanos y perdidos: el cine chileno de la transición 1990-99*. Santiago de Chile: Grijalbo.

Correa, S., C. Figueroa, A. Jocelyn-Holt, C. Rolle and M. Vicuña. 2001. *Historia del siglo XX*. Santiago de Chile: Sudamericana.

Cortínez, V. 2001. *Cine a la chilena: las peripecias de Sergio Castilla*. Santiago de Chile: RiL.

Francia, A. 1990. *Nuevo cine latinoamericano en Viña del Mar*. Santiago de Chile: CESOC/Ediciones Chile-América.

Hübner, D. and E. Recabarren. 1976. "Das Kino der Unidad Popular." In *Kino und Kampf in Lateinamerika: Zur Theorie und Praxis des politischen Kinos*, ed. P. B. Schumann, 41-67. Munich and Vienna: Hanser.

Montecino, S. 1993. *Madres y huachos: Alegorías del mestizaje chileno*. Santiago de Chile: Cuarto Proprio/CEDEM.

Pick, Z. M. 1997. "Chilean Cinema in Exile". In *New Latin American Cinema, Volume Two: Studies of National Cinemas*, ed. M. T. Martin, 423-440. Detroit: Wayne State University Press.

Ruggle, W. 2008. *Welt in Sicht. Filmische Reisen durch Lateinamerika, Afrika und Asien*. Ennetbaden: Edition Trigon-Film.

Schmöller, V. 2007, "Vergessen, andeuten, ansprechen, sich erinnern: Vergangenheitsbewältigung im chilenischen Film". *Impuls* 1: 20-21.

——. 2009. *Kino in Chile – Chile im Kino. Die chilenische Filmlandschaft nach 1990*. Aachen: Shaker Media.

Unsigned. 2001: "¿Volante o maleta?" *The END—esto recién comienza* 11: 4-7.

CHAPTER NINETEEN

THE POLITICAL DIALECTIC OF
VIOLETA PARRA'S ART

LORNA DILLON

Like so many of her contemporaries, Violeta Parra viewed the class struggle as a polarised field: a political landscape in which the needs of the masses were directly at odds with those of the ruling classes. This attitude comes across clearly in the lyrics of the song "Mazúrquica modérnica" where Parra conveys the power of Latin American committed art and the challenge it poses to authority:

> Me han preguntádico varias persónicas
> si peligrósicas para las másicas
> son las canciónicas agitadóricas
> ay qué preguntica más infantílica
> sólo un piñúflico la formulárica
> pa' mis adéntricos yo comentárica.
> (2005: 77)[1]

Rebellious, indignant and utterly anti-establishment, the lyrics epitomise Parra's un-nuanced representation of politics. Her visual art, like her music, was part of a movement which sought to redress social injustice. The bedrock of her oeuvre is this drive to address the inequities suffered by disadvantaged sectors of society. In this chapter I will examine the way Parra's politically engaged ethos is embedded in the narratives of her art.

Firstly, I will consider the artistic context for Parra's work. I shall then explore the relationship between politics, artistic context and aesthetics in her artistic production. After examining the overall aesthetic of Parra's art, I will explore the narrative content of her work. I propose that this narrative content was informed by a neo-indigenist drive that was itself

[1] "Various people have asked me if agitative songs are dangerous for the masses. Oh, what an infantile question, which only an idiot would ask, let me say from my guts." [Translated for sense only. Parra inserts suffixes—mostly augmentatives and diminutives—within or at the end of words throughout the lyrics. This gives the impression of mocking the subjects with whom the song is in dialogue. The linguistic device also creates the sense of mock authority.]

part of a process of decolonisation. I will examine those works which, like the song "Mazúrquica modérnica", are fuelled by rancour at the hypocrisy she perceived in the work of politicians and bureaucrats. Some of Parra's politically engaged works, such as those which broach the subjects of inequality, torture, and genocide, for example, were radical for her time, but others followed the archetypes of historical paintings. Parra's historical works sought to unite Latin American people by representing their shared history. I will look finally at Parra's representation of some of the human rights abuses that were occurring during her lifetime and I suggest that in works which address contemporary themes Parra´s binary perspective is particularly evident. The overall intention of the chapter is to outline the political dialectic which defines Parra's art and to trace the way that this is re-iterated across the different creative media in which she worked.

The global folk movement of the twentieth century coexisted with "the growth of increasingly politicised song movements (usually far left of centre)" (Pring Mill 1990: 7) and, in the visual realm, with politically-engaged styles and movements. Parra was driven not by one art form, but by the need to engage in an enabling way with the poor. While she is often presented as an isolated genius, Parra was in fact part of the global counter-culture of the 1950s and 1960s and, as was the case with many artists of her generation, a global political conscience merged with the need to redress years of colonial subjugation at a more local level. As Valerie Fraser explains, the shared experience of "colonial oppression [and] its twentieth-century legacy of continuing external interference and exploitation" resulted in "the persistent concern of Latin American creative artists to give authentic expression to their own voices, to locate their own cultural identity" (1989: 2). This concern was not an entirely new one and there is a history of such movements in the Chilean arts. Take, for example, the Tolstoyan Colony of 1904, which was formed, "en la devoción de postulados sociales y que agrupaba a escritores y pintores, que iban a los barrios pobres a enseñar arte y descubrir talentos" (Ricardo Bindis 2006: 176).[2] Likewise, the Generation of 1913 was formed by artists who came from the working class and who valued Chilean popular ceremonies and customs (Ricardo Bindis 2006: 176). As a result of the increasingly inclusive perspective of the art world, and of projects such as the Tolstoyan Colony, the demographic make up of Chilean artistic society changed. This early twentieth century development, which Ricardo Bindis

[2] "Out of a commitment to social issues and which brought together writers and painters who went to poor districts to teach art and to discover talent."

describes as the "ascenso del proletariado" ("rise of the proletariat") (2006: 196), went hand in hand with increasingly left-wing movements in the arts. While these movements were growing, technological advances in printing simultaneously were revolutionising the process of mass communication. The Chilean political parties of the left were quick to seize upon this opportunity, incorporating graphic and mural art into their campaigns, as an effective means of getting their message across to as many people as possible. As a result, these liberal movements in Chile helped consolidate the relationship between certain types of aesthetics and left-wing politics. Eduardo Castillo Espinoza explores this relationship in *Puño y letra: movimiento social y comunicación gráfica en Chile* (2006) and I shall return to Espinoza's study in order to look at the crossover between Parra's aesthetic and that of the mural and graphic artists.

Socially inclusive nationalist art in Chile grew at the same time as similar art movements were taking shape across Latin America. Artists became "animated by a common desire to break away from academic rigidity and the dictates of the European schools and to forge a national expression that would harmonise traditions, social needs, and even political formulas geared to the twentieth century" (Castedo 1969: 222). The building of this type of art upon a discourse of stock images is exemplified in Parra's work. She created widely accessible images that were structured around simple and universally recognisable forms. As Catherine Boyle observes of Parra's poetic language, it deploys "stark oppositions, recognized symbols and everyday realities and languages that are, in many ways, as available to everyone as they are to the privileged sensibility of the poet" (2009: 74). Boyle's description is as applicable to Parra's visual art as it is to her lyrics. Symbols such as guns, doves, and crosses combine to form a visual language that is readily understood. Each element is like a glyph which builds the overall narrative of the image. In common with the muralists, Parra produced narrative conceptual images with bold outline forms. This type of art has an aesthetic clarity which owes a lot to Russian art. Parra visited the Soviet Union several times and the Soviet aesthetic can be seen in some of her images. This aesthetic, which stems from the binary techniques used by graphic artists, is one that was employed widely by Latin American political campaigners of the mid twentieth century. For example, in the mid 1940s the mural artist Fernando Marcos designed posters for the Chilean socialist party including one with the title *La tierra para él que la trabaja* (*Land for the one who works it*), which depicts a broad shouldered man holding an area of green land in his large hands. The man's physique suggests that he is a manual worker and the hat he wears is a sign that he is a *campesino*. Although Marcos's poster

contains text, the didactic nature of the various components in the image, like those in Parra's images, would also have been accessible to the illiterate. Marcos has clarified the constituent elements of his poster by using blocks of colour within clearly defined shapes. This style, known as hard-edged painting, also figures in Parra's work. Within her embroideries, in particular, the individual components that I have previously described as glyphs, are created using flat, even values and colours. Parra adds further clarity to her embroideries by delineating these components with thick bands of stitching.

The embroidery *El hombre* exemplifies this style. The image depicts a man walking with a llama. The man has indigenous physiognomy. His broad physique, the sloping posture of a weary manual worker, and the type of clothes he wears, all signal that he is a *campesino*. Superficially the humble *campesino* is a simple depiction of a farm worker, but more intrinsically the representation of the *campesino* is a sign which intersects with the politics of the time and represents the value of the manual worker. Every aspect of the image is ideologically charged. Take the man's large hands and feet, for example: the artistic technique of disproportionately enlarging these parts of the body, to emphasise physicality, is one which is used widely in the Americas. It has figured prominently in left-wing art throughout the twentieth century. Indeed the epithet *patagones* was applied to the Chilean muralists "por la tendencia a exagerar la escala de caras, pies y manos" (Castillo Espinosa 2006: 61).[3] Fernando Marcos's mural *Homenaje a Gabriela Mistral* typifies this trend. In Marcos's mural, as in *El hombre,* the manual workers are depicted as having large hands.

Often this type of art includes images of working animals. Marcos has included donkeys in the mural *Homenaje a Gabriela Mistral* and Parra has included a llama in *El hombre.* The llama functions symbolically within the embroidery: through it emerges the concept of working the land. A certain amount of equivalence is presented between the man and the animal: both must use their strength for agricultural labour. Despite the emphasis on the strength of the manual worker, Parra's embroidery also implies that the worker is of a pacifist disposition. This is conveyed through his unobtrusive posture; by his smiling yet peaceful expression and by his indirect gaze; the man does not confront the spectator but looks down at the path in front of him.

As well as creating works replete with a politically engaged aesthetic, Parra also created images which depicted specific political issues. The dialectic of Parra's work follows a paradigm of binary oppositions, one

[3] "On account of the tendency to exaggerate the scale of faces, feet and hands."

that was crystallised by the muralist movement. With reference to the murals of Diego Rivera, Leopoldo Castedo notes that they "reiterate an invariable dialectic in which evil is the enslaving Spaniards and good the downtrodden Indians' (1969: 225). This paradigm is also at the crux of Parra's work. Amongst her embroideries, *Los conquistadores* offers the clearest example of this dichotomised view of politics and history.

Los conquistadores is a dramatic embroidery that portrays a scene from the collective Chilean imaginary. In the late nineteenth and early twentieth century this collective imaginary was shaped by what Dawn Ades terms a "historicist indigenism" which grew from the need to protect and conserve the vestiges of pre-Hispanic culture (2006: 35). Indigenous art and writing address the need to counteract negative stereotypes generated by the Indianism (a style characterised by fanciful representations of Native American people) of the previous centuries. In Chile, Indianism perpetuated the stereotype of a weak and savage native, who was easily overthrown by the Spanish forces. Works such as *Los conquistadores* discredit such notions by depicting the barbaric acts of the Spaniards and by reiterating popular tales of heroic native warriors. These warriors already enjoyed some notoriety as a result of their portrayal in *La Araucana*, a poetic trilogy by the Spanish nobleman Don Alonso de Ercilla, which takes the form of a series of *cantos* and is considered to have been one of the first literary works in the new world. The three parts of *La Aruacana*, written in *ottava rima* and published in 1569, 1578, and 1589 respectively (Scarpa de Roque 1982: 8), detail the war between the Spaniards and the Mapuche people. De Ercilla went to the Americas as part of the conquest and thus *La Araucana* purports to be his eye witness account of scenes from the invasion of Chile. His work is held in great esteem by Chileans, and, as Lisa Flora Voionmaa Tanner observes: "Los héroes araucanos, [...] Lautaro, Caupolicán Tucapel y Colo Colo entre otros inmortalizados en *La Araucana* de Alonso de Ercilla, se convertieron en emblemas nacionales" (2005: 40).[4]

In *Los conquistadores* Parra celebrates one of these national emblems: the Mapuche leader Galvarino. Parra's embroidery is a narrative image which tells the story of the captive Galvarino being tortured by the Spaniards. In the tale, which is widely told in Chilean popular culture, the governor García Hurtado de Mendoza sent orders for Galvarino's hands to be amputated. Parra's image depicts the moment after the first hand is removed when, according to legend, Galvarino fearlessly placed his other

[4] "The Araucanian heroes [...] Lautaro, Caupolicán, Tucapel and Colo Colo among others, who were immortalised in Alonso de Ercilla's *La Araucana*, all became national emblems."

hand in front of the axe. After enduring this act of savagery, Galvarino allegedly asked the Spaniards to kill him; they refused and he was released. Due to the valiant nature of these acts, Galvarino has been immortalised in Chilean collective memory. Parra's representation uses clear iconography to relate Galvarino's tale—the man on horseback wears ballooning Elizabethan-style trousers and carries a halberd, an outfit that has come to symbolise the Spanish conquistadores:

> Mention the word 'conquistador' and in most people an image pops immediately to mind. He wears a shining breastplate and rather oddly shaped helmet, usually with plumes. His sleeves and trousers are puffed, padded and of gaudy color combinations, but he wears no-nonsense gauntlets and tall leather boots. At his side is a slender rapier and in his hands a fancy ax with a ten-foot handle. (Munson 2006)

This image of the conquistadors bears little resemblance to historical reality since the Spanish army did not have a uniform at the time of the conquest and each soldier provided his own clothing, which was usually a long sleeved shirt, trousers (but not the ballooning trousers associated with the conquistadors) and sandals. Nonetheless, Parra uses this instantly recognisable iconography because it communicates so effectively. Tropes such as this have a symbolic value and are part of popular collective memory.

The other figures in the image are also presented symbolically and somewhat stereotypically; the priest is identifiable by the cross hanging around his waist; the native by his bare skin, and the henchman by his axe. Parra has reduced her image to include only those constituent elements which can represent the key aspects of the narrative; there are no superfluous details and each aspect of the image informs the spectator of some part of the storyline. It is through the augmented plasticity of the axe, for example, the only extra-textual detail in the image, that our attention is drawn to the central meaning of the narrative. The axe has been created by winding wool around a piece of cardboard which has subsequently been glued to the surface of the image. It is a sign whose function transcends its denotative meaning: superficially it represents the implement used by the conquistadors to amputate Galvarino's hand; its true value, however, is in its connotative meaning that the Spaniards were violent.

Parra's representation of Galvarino draws attention to the savagery of the colonial army. The result of this is that the image counteracts the suppression of indigenous Latin America by colonialism which sought to forge a static framework for the culture of the colonial subject. This framework, based upon the presumed supremacy of the culture of the

colonisers, relies upon the belief that the host culture can improve only by adopting the culture of the colonisers. Parra seeks to redress this by providing an alternative model in her representation of the brave and heroic figure of Galvarino. Like much of her work, *Los conquistadores* is neo-indigenous. Neo-indigenism is an ideological and aesthetic position which "proposes an internal view of indigenous values with the purpose of legitimizing and preserving their intrinsic features" (Marquez 1997: 65). While the majority of colonial art presented the natives as weak, Parra's work seeks to glorify their strength: it pays homage to the Mapuche fighters who, despite their eventual defeat, prevailed in a number of battles against the Spaniards. At the same time Parra discredits the notion that the Spaniards were civilised by depicting their acts of savagery: the inclusion of the priest in *Los conquistadores* serves as a reminder that religion was crucial to the success of the colonial project. As Eduardo Subirats underscores in *Three Visions of America*, the Spaniards' destruction of existing civilisations in the Americas was justified by the premise that the natives were lost souls:

> The Catholic state assumed the role of Christendom's chosen people in order to forcibly impose its value system upon the entire globe [...] Its ultimate meaning was directed toward the territorial possession of the New World and the exploitation of its immense wealth, but only as an instrument for the forced conversion of its native peoples, and the political construction of a Christian world, the first modern, internationalist utopia. (2001: 29)

By aligning the priest with the soldiers as they savagely mutilate Galvarino, Parra foregrounds the ideology upon which the conquest was based. Superficially, the depiction of Galvarino's stoic act conveys the strength and courage of the native warrior. On a more symbolic level, however, this gruesome vision of the indigenous leader's tortured body acts as a metaphor for the devastation wrought against Latin America by the Spaniards.

As a folklorist, Parra constantly sought to re-claim traditional practices and to re-configure them so as to generate a sense of cultural identity based on popular traditions; ultimately, this could usurp the position of supremacy held by the culture of the coloniser. In his analysis of Parra's songs, Reiner Canales proposes that the success of Parra's project was found in the way she was able to integrate into the strata that engaged in these popular cultural practices:

Violeta Parra no opera con una comunidad / nación imaginada por otros desde arriba, sino con una comunidad recordada, buscada y puesta al día. Ella participa y hace participar de y en la modernidad desde estas raíces, desde un *sueño de niños* y de *una historia de brujos*, como asevera en *Escúchame, pequeño.* Por lo mismo es que en la obra de Violeta aparecen aquellos postergados en la construcción identitaria guiada a sangre y fuego por el Estado: los campesinos, los pobres, los indígenas, las mujeres, los ancianos. Es la cultura *desde abajo*, es el gesto profundo del *desenterrar.* (2003: 9)[5]

The easiest way to comprehend Parra's attitude to her indigenous subject is through her own words. The following is an extract from the song "Arauco tiene una pena":

> Un día llega de lejos
> huescufe conquistador,
> buscando montañas de oro,
> que el indio nunca buscó,
> al indio le basta el oro
> que le relumbra del sol.
> Levántate, Curimón.
> (2005: 19)[6]

In these lyrics, Parra establishes a polemic between native Chileans and the Spanish colonisers. Linked by the concept of gold, the two nationalities are also juxtaposed. The natives are presented in a positive light: "Al indio le basta el oro; que le relumbra del sol," while the Spaniards are presented negatively by linking them to the quest for material wealth: "Un día llega de lejos Huescufe conquistador, buscando montañas de oro." This process of decolonisation was central to neo-indigenist works. Canales compares the essential dialectic of Violeta Parra's work to that evidenced in the work of José Martí, and by Pablo

[5] "Violeta Parra does not work with a community / nation conceived from above but rather her work is rooted in the drive to seek out, remember and re-generate a traditional community. She participates in modernity and brings people into it from these roots, from *a children's dream* and *a story of witches*, as she insists in *Écoute moi, petit.* Furthermore, in Violeta's work we find those who were last in line when it came to the construction of identity by the state: i.e., peasants, the poor, the indigenous, women, the elderly. This is the creation of culture *from below*, it is the profound gesture of *unearthing.*"

[6] "One day Huescufe the Conquistador arrived from afar, looking for mountains of gold, gold that the Indian had never sought, because for the Indian the gold shining from the sun was enough. Arise, Curimón."

Neruda in *Alturas de Machu Picchu*. Canales notes that in their works the three authors "obedecen a la necesidad de reactivar la potencialidad liberadora de la historia propia, de reanudar, como en un primer ademán emancipador, el hilo roto por los efectos destructivos de la colonización" (2003: 65).[7]

While I agree with Canales that Parra is using Chile's indigenous past as a way of undermining the effects of colonialism, there is also a paradox inherent in *Los conquistadores*; since it depicts scenes in which the native leaders are subordinate to the invading army, their value in the attempt to reconstruct a sense of Chilean identity is diminished. Nonetheless, Parra has chosen these images because the leaders are heralded as heroic in the Chilean imaginary as a result of the sacrifices they made in the struggle against the colonial power; her embroideries reiterate this heroism by re-telling these popular tales. This link between culture and politics is well established. As Edward Said observed "culture is a sort of theatre where various political and ideological causes engage one another" (1993: xiv). Parra adds her own inflection to the popular tales she revisits in her embroidery and thus demonstrates an acute awareness of the convergence described by Said. As we have seen, *Los conquistadores* venerates native warriors at the same time as it emphasises the brutality of the Spaniards. It exemplifies the drive of the neo-indigenist project. Said notes that "stories are at the heart of what explorers and novelists say about strange regions of the world; they also become the method colonised people use to assert their own identity and the existence of their own history" (1993: xiii).

The political dialectic of Parra's work transcends the dichotomy of colonised subject and colonising agent. In the song "Arauco tiene una pena" Parra applies this binary paradigm to Chilean society itself:

> Arauco tiene una pena
> más negra que su chamal,
> ya no son los españoles
> los que les hacen llorar,
> hoy son los propios chilenos
> los que les quitan su pan.
> (2005: 19)[8]

[7] "Follow the need to reactivate the liberating potential of local history and re-tie as a first emancipatory gesture, the thread broken by the destructive effects of colonisation."

[8] "Arauco has a grief darker than his chamal. No longer is it the Spaniards that makes them cry. Now it is the Chileans themselves that deny them their bread."

The main premise of "Arauco tiene una pena" is that there has been a continuum of power and exploitation stretching from the era of colonisation to Parra's own time. To underscore this point, I would like to explore the way the binary perspective evident in Parra's depiction of historical scenes (such as the fabled capture of Galvarino), recurs in her representation of contemporary events. *Mitin 2 de abril* is a visual depiction of the turmoil which occurred in Santiago on 2 April 1957 and which had begun in response to a decree authorising an increase in the fares charged by transport providers in cities. The first to react were the students in Valparaíso. The movement subsequently spread to Concepción and Santiago. In Santiago the protest ended with ferocious violence involving the army and a state of national emergency was declared. As Pedro Milos explains:

> El centro de la capital se vio convulsionado por uno de los principales movimentos populares de su historia. El gobierno reprime enérgicamente a los manifestantes. Sin embargo, la policía es sobrepasada, retirándose del centro. Un par de horas más tarde el ejército se hace cargo de la situación, restableciendo el orden. Los muertos llegan casi a la decena. Se declara el Estado de Sitio. Al día siguiente hay nuevos enfrentamientos y nuevas muertes. La calma comienza a restablecerse, lentamente, a partir del día jueves [...] El lunes 8 de abril se ha recuperado la normalidad. Han sido doce días en que han ocurrido hechos de violencia inusitada en una sociedad fuertemente institucionalizada como la chilena. Las cifras oficiales hablan de 20 muertos y centenares de heridos. No obstante su magnitud, el movimiento no produjo ningún cambio institucional. (2007: 5)[9]

With this image Parra moved beyond the neo-indigenist programme to express her concerns about current affairs. Parra was in Chile in 1957 and it is likely that she participated in the protests. In the song "La carta" she refers to a letter that she received informing her that her brother had been

[9] "The city centre was shaken by one of the biggest popular uprisings in its history. The government energetically suppressed the demonstrators. Nevertheless, the police were overwhelmed and retreated from the centre. A couple of hours later the army took charge of the situation, re-establishing order. Deaths numbered in the tens. A lockdown was declared. The following day there were more confrontations and further deaths. Calm slowly began to be restored from Tuesday onwards [...] by Monday 8 April things were back to normal. There had been twelve days when violence of a sort unknown in a strongly institutionalised society like Chile's broke out. Official figures put the number of deaths at twenty and the number of injuries in the hundreds. In spite of its huge scale, this movement did not bring about any institutional change."

arrested. Parra expresses her support for the protest and decries the fact
that her brother was arrested for participating in it:

> La carta dice el motivo
> Que ha cometido Roberto:
> Haber apoyado el paro
> Que ya se había resuelto,
> Si acaso esto es un motivo,
> Presa voy también, sargento sí.
> (2005: 55)[10]

The image as a whole echoes Francisco de Goya's oil painting *El tres de
mayo de 1808*. In both *Mitín 2 de abril* and *El tres de mayo de 1808* the
state forces are shown on the right of the image and the protesters to the
left. The structure of the two paintings is almost identical, with the barrel
of the gun, the shape of the soldiers and the protestors forming a circular
composition. Both paintings have a white figure as their focal point. Most
of the protesters appear to be startled and crushed to the ground, but the
white figures stand resolutely in front of the armed troops.

That Parra, like Goya, has chosen to depict a central figure in white
indicates her political position; the colour imbues the protestor with an air
of innocence. A further sign that this protestor is a pacifist is the inclusion
of a dove, the universal symbol for peace, on the banner held aloft by the
figure. Moreover, by choosing to depict these violent scenes at night Parra
and Goya have created great contrast in the paintings and, as a result, the
spectator's eye is naturally drawn to the white figure. In Goya's image the
posture held by the white figure echoes the Crucifixion; in Parra's version,
the forces are depicted in red and are identified by the barrels of their guns.
As I mentioned at the beginning of this chapter, Parra's work is un-
nuanced; in *Mitín 2 de abril* we once again encounter her binary aesthetic:
there is no middle ground—the authorities are depicted as tyrannous while
the protesters are depicted as peaceful and defenseless. While this may
have been the case in the protests that occurred in 1957, other
confrontations in Chile at the time were more complicated. Nevertheless,
the perspective which informs Parra's work inspired by the transport riots
recurs right across her artistic praxis. What she thus failed to acknowledge
was the increasing number of armed groups who protested against the state
in the late 1950s and particularly in the 1960s following the success of the
Cuban Revolution. Nonetheless *Mitín 2 de abril* has the political edge that

[10] "The letter states that Roberto's crime was to have supported the strike which
had already been resolved. If that's the crime then Sergeant take me prisoner too."

Parra is renowned for as a musician: "Las canciones políticas de Violeta Parra [...] presentan una visión marcada por la claridad de los advenimientos históricos del país, sobre todo por su referencia a la degradación de los derechos del pobre y del socialmente perseguido" (Agosín 1988: 131).[11]

The structure of *Mitín 2 de abril* is reiterated in the papier-collé work *Genocidio*, in which once again we encounter troops attacking the masses. However, this image shows increasing violence: the central figure is now inverted as it is hurled upon a heap of bodies. In *Genocidio*, Parra has used green oil to paint the military forces while the people who are being killed are presented using papier-mâché. Her use of papier-mâché in this work is atypical of her collages in general because one of the scraps of paper in this image includes a photographed face. This face, which has been cut from a magazine, has been applied over the raised surface of further layers of papier-mâché to create a three dimensional head shape with life-like features. The face, which is about the size and shape of a Sindy doll head, both blends with the mass of bodies and emerges with haunting realism due to its enhanced plasticity. There is no scope for debate about the message in this collage work; once again the armed forces are depicted as murderous while the protesters are depicted as innocent and defenseless. As Parra writes:

> Miren como se viste cabo y sargento
> Para teñir de rojo los pavimentos.
> [...]
> Miren como le muestran una escopeta
> Para quitarle al pobre su marraqueta.
> (2005: 81)[12]

What is clear from Parra's political images and songs is that she has taken on the role of human rights campaigner. By capturing the atrocities perpetrated by the state forces in both visual and verbal media, Parra provides a voice for the oppressed. It is through this voice that she seeks to engage with and embolden the victims of such atrocities and therein is the activist element of Parra's art. As Carla Pinochet-Cabos suggests:

[11] "Violeta Parra's political songs [...] offer a clear vision of the milestones in the country's history, above all in their reference to the degrading of the rights of the poor and of the socially marginalised."

[12] "Look how corporal and sergeant get dressed to stain the pavements red [...] Look how they show the pauper a rifle to steal his loaf of bread."

Para Violeta Parra, la tarea de despertar al mundo popular de su letargo de injusticia implica hacerles conscientes de su condición de sujeto. Esto significa ser capaz de observar su propia situación de pobreza, pero más allá de eso, implica darse cuenta de su condición de dominados (2007: 29).[13]

To conclude, I would like to return to the bold aesthetics of Parra's art. I have argued that her work, like her political outlook, was a product of the counter-culture of the 1960s, a time when art was transformed by the techniques of graphic artists and when posters and mural art became a potent means through which to communicate with the public. Parra's hard-edged figurative works evince an aesthetic that is inextricably linked to her milieux. Both the symbols and the un-nuanced style of her work are part of a language whose currency transcends the usual subject matter of the embroideries and sculptures in which we find them.

At the same time, Parra's visual narratives follow the broad decolonising trend of neo-indigenism, a trend which sought to reclaim and legitimise Latin America's indigenous past and transform its cultural agency into a unifying device. By depicting tales from the collective Chilean imaginary, Parra taps into popular mythology and employs it as a means of usurping Chile's colonial hegemony. Parra replaces a historical memory premised on a civilised and ecclesiastically motivated imperial body with icons from indigenous history such as the Mapuche hero Galvarino. These iconic figures act both as emblems of the strength of the indigenous fighters and as tropes for the destruction wrought on the continent by the invading army.

I have also argued—and herein lies the idiosyncrasy of these works of art—that Parra applied the binary paradigm that arose from neo-indigenism to works in which she addressed current affairs. In doing so she articulated her conception of the way in which the litany of abuse that began with colonisation was perpetuated by the regimes that followed. Furthermore, Parra's representations of state violence serve as activist images which make visible the human rights abuses of her era and call the perpetrators of such abuses to account.

[13] "For Violeta Parra the task of stirring ordinary men and women from their lethargy of injustice implies making them conscious of their condition as subjects. That means them becoming capable of seeing the poverty of their situation. Moreover it means them becoming aware of their condition as dominated subjects."

WORKS CITED

Agosín, M. and I. Dölz-Blackburn. 1988. *Violeta Parra: Santa de Pura Greda: Un estudio sobre su obra poetica.* Santiago: Editorial Planeta Chilena.

Bindis, R. 2006. *Pintura Chilena doscientos años: despertar, maestros, vanguardias.* Santiago de Chile: Origo Ediciones.

Boyle, C. 2009. "Gracias a la vida: Violeta Parra and the Creation of a Public Poetics of Introspective Reflection." *Hispanic Research Journal* 10 (1): 70–85.

Canales, R. 2003. Violeta Parra y la cultura nacional a partir de dos valses en francés. Diss., Universidad de Chile.

Castedo, L. 1969. *A History of Latin American Art and Architecture: From Pre-Colombian Times to the Present.* London: Pall Mall Press.

Castillo Espinoza, E. 2006. *Puño y letra: movimiento social y comunicación gráfica en Chile.* Santiago: Ocho Libros Editores.

De Goya, F. 1814. *El tres de mayo de 1808.*

Fraser, V. and O. Bradley. 1989. *Drawing the Line: Art and Cultural Identity in Latin America.* London: Verso.

Marcos, F. 1939. *La tierra para él que la trabaja* (printed poster).

——.1939. *Homenaje a Gabriela Mistral* (mural).

Marquez, I. 1997. "José María Arguedas." In *Encyclopedia of Latin American Literature,* ed. V. Smith, 65–67. Chicago: Fitzroy Dearborn Publishers.

Milos, P. 2007. *Historia y memoria: 2 de abril de 1957.* Santiago de Chile: LOM Ediciones.

Munson, R. "Conquistador Clothing." *National Park Service* [website]. http://www.nps.gov/cabr/historyculture/conquistador-clothing.htm (Accessed 28 February 2010).

Parra, V. 1962. *El hombre* (embroidery).

——. 1963-1965. *Genocidio* (papier-mache on pressed wood).

——. 1964. *Los conquistadores* (embroidery).

——. 1964. *Mitin 2 de abril* (oil on cloth).

——. 2005. *Cancionero Violeta Parra.* Santiago de Chile: Fundación Violeta Parra.

Pinochet Cabos, C. 2007. Violeta Parra. Hacia un imaginario del mundo subalterno, diss., Universidad de Chile.

Pring-Mill, Robert. 1990. *'Gracias a la vida' The Power and Poetry of Song.* London: Queen Mary and Westfield College.

Scarpa Roque, E. 1982. Prologue to *La Araucana* by A. de Ercilla, vii-viii. Santiago de Chile: Editorial Andrés Bello.

Subirats, E. 2001. "Three Visions of America." In *A Twice Told Tale,* ed. S. Juan-Navarro and T. R. Young, 29–35. London: Associated University Presses.

Voionmaa Tanner, L. F. 2004. *Escultura Pública: Del monumento conmemorativo a la escultura urbana Santiago, 1792-2004.* Santiago de Chile: Ocho Libros Editores.

PART V
COLOMBIA, BOLIVIA, AND VIRTUAL SPACES

CHAPTER TWENTY

CHILDHOOD AND ITS REPRESENTATIONAL USES: CINEMATIC EXPERIENCE AND AGENCY IN VÍCTOR GAVIRIA'S *LA VENDEDORA DE ROSAS*

DEBORAH MARTIN

The place of the child in Latin American film has not been sufficiently interrogated in the light of recent developments in theories of childhood and cinema, nor has it been in terms of the child's role in the politics of culture more generally.[1] This chapter looks at *La vendedora de rosas* (Víctor Gaviria, 1998), a film which takes street children, played by natural actors, as its subjects. The film, the second in Gaviria's "Medellín trilogy" is an extremely naturalistic, almost anthropological portrait of children living on the margins of Colombian society. Set on Christmas Eve, it follows a group of homeless girls as they prepare for the night of celebrations, dreaming of or avoiding family members, and selling roses to make a living.[2]

This chapter argues that whilst the child often features as the subject of discourses which deny it agency, this film, which exposes myths of childhood through its very subject matter, is torn between a privileging of the child's disruptive agency, and a cinematic language which is still partially beholden to myths of childhood as a "time and space apart" (Lebeau 2008: 40). The film's non-traditional representations of the journey undermine dominant cinematic narrative and associated myths of progress and teleology, whilst also evoking aspects of childhood perception and experience. Ultimately, the question remains as to whether the child in *La vendedora de rosas* really escapes from what Nira Yuval-

[1] Laura Podalsky (2008: 144) and Karen Lury (2005: 314) point to a need for further consideration of children and youth in Latin American cinema.
[2] The other films in the trilogy were *Rodrigo D: no futuro* (1994), and *Sumas y restas* (2005).

Davis calls the "burden of representation", and which dominant culture so often has it bear.[3]

The street child as filmic subject is frequent in Latin America, where neo-realist techniques and thematics have been influential.[4] *La vendedora de rosas* takes female street children as its focus, providing an incisive critique of the gendered power relations striating urban space. However, it is not just gender difference which is dealt with. More subtly, Gaviria also undermines universalist notions of childhood by focusing on the differences between the values and attitudes of street children and (non-homeless) poor children. The film has two protagonists, Mónica, who has been on the street for some time, and Andrea, who runs away from home in the first scene but returns at the end of the film, spending only a night or two on the street. The narrative functions assigned them, and the film language surrounding them, serve to indicate their distinct ideological insertions.

In his influential *Centuries of Childhood*, Philippe Ariès claims childhood to be a cultural construction of the modern era, invented alongside ideas of family, home, and privacy. Furthermore, as Sharon Stephens argues, the difference between child and adult serves as a means of creating hierarchical structures both in terms of social and conceptual organisation:

> The 'hardening' of the modern dichotomy of child/adult, like the modern distinction female/male, was crucial to setting up hierarchical relations between distinct domains of social life—the private and the public, consumption and production [...] upon which modern capitalism and the modern nation-state depended. (1995: 18)

The Romantic idea of the child places her/him firmly on the nature side of the nature/culture binary. It has been argued that the childhood domain

[3] Nira Yuval-Davis argues that "women especially are often required to carry this 'burden of representation' as they are constructed as the symbolic bearers of the collectivity's identity" (1997: 45). Sharon Stephens urges that the same scrutiny that has been applied to the structural role of gender in modern society should be applied to the role of children in culture and society, for example, as "symbols of the future and of what is at stake in contests over cultural identity" (1995: 6).

[4] *Los olvidados*, Buñuel's surrealist take on Mexico City's street children, is the most famous example of this, but the thematic has continued to preoccupy filmmakers in Latin America. Geoffrey Kantaris (2003: 177-189) traces the trajectory of socially excluded youth in Latin American film through *Pixote* (Babenco, 1981), *Pizza, birra, faso* (Caetano and Stagnaro, 1997), *La vendedora de rosas* and *Amores perros* (González Iñárritu, 2000).

of play, imagination, innocence, and emotion is a Romantic fantasy which serves as ground for the realities of work and discipline (Stephens 1995: 6). On the one hand, Latin American reality—extreme poverty, prevalent child homelessness and the dissolution of the nuclear family—all of which are themes of *La vendedora de rosas*, exposes such myths of childhood. But Latin America is ideologically indebted to European constructions of childhood, and its cinema structurally indebted to traditional visual representations of the child, such that the film treads a wavering path between extreme radicalism in its bid to allow child agency, and a more conventional use of the child: as (national) allegory/symbol within the Latin American narrative tradition of mobilising the child-figure as a means of highlighting exploitation, marginalisation, and racism whilst denying the figure real agency (Browning 2001: 18). As such, Gaviria's film embodies Browning's view that the child-figure has both subversive and conservative representational potential. On the one hand, s/he embodies the future of the nation, whilst on the other, s/he is able to "push social and linguistic boundaries", thus representing rebellion (Browning 2001: 4).

European notions of childhood were exported as part of the colonial project and its formation of social actors (Stephens 1995: 16). Post-independence, the idea of the child has been ideologically bound-up with the emergence of the nation state, and etymologically "nation" in English, like "nación" in Spanish, derives from the Latin *nasci*, to be born (Levander 2006: 7). Browning sees the (literary) figure of the child as a particularly important one in cultures where the notion of illegitimacy—political and personal—is all-pervasive (2001: 3) The illegitimate offspring of "Mother America" and "Father Europe" is also discussed by Gerald Martin who proposes that the "Latin American cultural hero", the *mestizo* whose quest for identity allegorises the national one, is a structuring trope in Latin American narrative (1989: 3). Film criticism, too, produces readings which centre around the child's narrative importance as the allegorical repository of national identity or destiny: David Ranghelli focuses on films which, like *La vendedora de rosas*, take young girls as their subject, and in particular the girl-child's prostitution. *Iracema*, for example, allegorises "el uso que se ha hecho de Brasil y de su gente" (1998: 5).[5] Deborah Shaw also sees the child as repository of national pessimism or optimism, when considering Babenco's *Pixote* and Salles's *Central Station*. In these films, she argues, children represent opposing national visions: corruption, immorality, and hopelessness in *Pixote*,

[5] "The use that has been made of Brazil and of its people."

versus spiritual and moral redemption and a sense of national renewal in *Central Station* (2003: 142). For Laura Podalsky, "youth have [sic] served as a symbolic repository for ambivalent feelings about the fall of past Mexican social models" (2008: 146).

Turning to visual culture more widely, we find that the modern idea of the child also emerged alongside modern technologies of vision. In *Cinema and Childhood*, Vicky Lebeau explains that "our modern commitments to the idea of the child are inseparable from its representation in visual form" (2008: 10), that cinema "institute[d] itself with and through the child, bringing into renewed focus the visual dimension of the 'myth' of the child, that modern commitment to the *difference* of childhood as a time and space apart" (2008: 40). And so, to echo Lebeau, we must ask ourselves: "What is the child *for* [Latin American] cinema? What does [Latin American] cinema *want* of the child?" (2008: 12). Karen Lury has claimed that, within Italian neo-realism (an explicit influence on Gaviria's filmmaking), as well as in other cinemas, "the child's primary function is to act symbolically [so that] the child, the actual body, agency and living-ness [...] disappears and instead the child-figure, the child as convenient symbol takes his or her place" (2010: 10, 6).[6] Gaviria himself has addressed the inevitable allegorical readings of the film, stating that "[en] mis películas [...] la alegoría es accidental. [...] La vendedora de rosas tampoco es la patria sino una niña abandonada con frío y con algo que decir. Si se producen resonancias alegóricas es sólo como un agregado al realismo que intentamos" (2003: 103).[7] Whatever the director's intention, it is difficult for this film to escape from a traditional narrative colonisation of the child, a requirement for the *child*, as "convenient symbol" to mobilise the viewer politically.

In examples such as these, the figure of the child enshrines the discourse or fantasy of the future which Lee Edelman sees as the ground for modern political discourse. As Edelman puts it: "We are no more able to conceive of a politics without a fantasy of the future than we are able to conceive of a future without the figure of the Child" (2004: 11). The repressive nature of discourses enshrined by the child is part of what Edelman terms "reproductive futurism" in which the child serves "as the

[6] Gaviria's earlier film *Rodrigo D: no futuro* (1994), which deals with male youth cultures in Medellín, was so named in homage to Vittorio De Sica's *Umberto D* (1952). Jáuregui and Suárez trace the similarities and divergences between Gaviria's work and neo-realism (2002: 371-3).

[7] "In my films [...] allegory is accidental [...]The rose seller isn't the country but a cold abandoned girl with something to say. If there are allegorical resonances then these are just in addition to the realism which we were aiming for."

repository of variously sentimentalised cultural identifications [and] has come to embody for us the telos of the social order and [...] to be seen as the one for whom that order is held in perpetual trust" (2004: 11) We might posit, then, that a radical cinema of childhood is one in which the child is agent rather than simply subject of discourse, and in which the child-symbol is not exploited for its "futurity". Gaviria's experimental methodology grants the child radical agency, yet his choice of a narrative which allegorises the child's story and employs the child's futurity/death as political symbol ensures that, on one level at least, the child remains consigned to bearing the "burden of representation", and the film cannot resist participating in the romanticisation, sentimentalisation and what Emma Wilson calls the "pictorial angelicization" of childhood (2005: 334).[8] This is particularly true of the depiction of Mónica when she is in her drug-induced reveries (discussed further below). Attempts to evoke what Lury calls "the child, the actual body, agency and living-ness" are also an important part of Gaviria's aesthetic, however (2010: 6).

Debates around the child in cinema are often framed in terms of agency. Lury indicates that it is film which shows "the disruptive, impossible, unintelligible aspects of the child" which allows the child agency (2005: 308). As has been well-documented by Jáuregui (2003) and Kantaris (2003: 184-5), the film's highly unusual pre-production phase, in which the director and crew worked with the street children in something akin to a social project, and its long shoot, in which the children improvised scenes and used their own language, led to the production of what Carlos Jáuregui calls an "enunciación colectiva" ("collective enunciation") (2003: 72), a process and a film ethically commited to its child subjects. The filmmaker has spoken and written at length about the process of working with these children, and comments that "[su] rebeldía, tan combatida en una sociedad de consumistas conformes, es lo único que los preserva de la desintegración absoluta, y los salva de ser [...] objetos y cosas inservibles" (1998: 40).[9] Gaviria also allows the spectator to enter the (street) child's perceptual world, adopting low camera angles from which we see tall buildings from the perspective of tiny people, thus effecting a challenge to the politics of visual representation, denying any

[8] Wilson contrasts "the pictorial angelicization of working children" such as that of Scorcese's child prostitute in *Taxi Driver* (1976) with Lucas Moodysson's *Lilya-4-ever* (2003), which, she argues, emphasises film as more than a visual medium, through strategies of movement and tactility (2005: 334).

[9] "[Their] rebelliousness, so embattled in a society of conformist consumers, is the only thing that saves them from falling apart completely, and keeps them from becoming [...] objects and useless things."

masterful gaze which would induce spectatorial complacency or control. In one important scene, the viewer is placed, with Mónica and her boyfriend Anderson, on the steps outside a bourgeois family home. Inside, we see the family's Christmas celebration, and a cosseted, well-fed bourgeois child who catches sight of the pair of vagabonds, who quickly flee. The double positioning of the spectator is interesting here: our gaze is aligned with that of the social other, positioned outside the bourgeois family home, yet the play of gazes taking place between inside and outside and the sharp focus on the bourgeois child's surveillance of the pair also points self-reflexively to our own cinematic gaze on the street children, leading the viewer into a self-reflexive contemplation of the way social space is ordered and controlled through looking, including cinematic looking.

The film also nuances the representation of children's subjectivities, through its focus on different types of journey. Movement through the city space is one of the film's central motifs, as the director points out: "[Los] niños de la calle [...] se la pasaban todos los minuciosos días del año *caminando de un lado a otro como hormiguitas*" (Gaviria 1998: 40, emphasis added).[10] Films about childhood often narrativise individuation, and both Mónica and Andrea symbolise this process in their own ways. As Phil Powrie argues: "The defining feature of representations of preadolescent children is that they are poised on a threshold, an in-between space" (2005: 348). Andrea, aged ten, leaves home in the film's first sequence after an argument with her mother, and returns home twice over the course of the film, eventually to reconciliation. Andrea's frustration with the other children's inability either to keep promises or to carry out plans is constant throughout the film. She has not been socialised in the ways of the street children, that is to say, to accept the haphazard, the nonsensical. She acts as a guide, a narrator-witness, to this other world: in the film's first sequence, we follow her from the relative safety of home to the underworld inhabited by the other children, experiencing their lives through her first-time gaze. The child-as-witness is an important neo-realist trope, discussed by Gilles Deleuze, who stresses the passivity of the child, in what he describes as "a cinema of the seer and no longer of the agent" (2005: 2).

Constantly crossing the threshold between home and the outside world, Andrea also telephones home once during her first absence, and we are party to the comical conversation in which she tries to assert her

[10] "[The] street children [...] lived out every single day of the year *scurrying about like little ants.*"

independence. This back-and-forth movement is also seen by Annette
Kuhn as a common one in films taking children as their protagonists.
Following Freud's formulation, she describes it as "a fort/da, a repeated
back-and-forth from safety to danger and back again" (2005: 410) a
movement shared with the many children's games which entail the leaving
and rejoining of security.[11] This back-and-forth movement is, Kuhn claims,
characteristic of children's psychic relationships with their transitional
objects (blankets, soft toys, and the like), a "psychical ebb and flow"
(2005: 401) which can be experienced by adults through aesthetic
experiences like that offered by cinema. Kuhn is drawing here on
Winnicottian object-relations theory in her development of a theory of
cinema which relates it to preconsious states (rather than unconscious
ones). She states that "cinema can be, or be like, a transitional
phenomenon. This is the secret of cinephilia" (2005: 414). Thus, the film
narrativises—through children's journeying—that psychic negotiation of
inner and outer reality which is most intense at a preconscious stage,
which is characteristic of children's experience of and relation to the world,
and which Kuhn claims we replay as adults through aesthetic experiences
like cinema viewing.

Mónica's journeys follow a different pattern. She has been on the street
for some time, and though there is a clear psychic anchor to existing or
remembered family members (mother figures) and home places, she and
the other street girls also form new kinship patterns and home places
amongst themselves. Their journeys are haphazard, circular, and
incoherent, involving multiple bases and a nomadic relationship to space.
Deleuze defines neo-realism as an "art of encounter—of fragmentary,
ephemeral, piecemeal, missed encounters" (2005: 2), an appropriate
description of the movement of Mónica and the other street girls. Their
activity is pointless, repetitive, circular and full of broken promises and
unfulfilled errands, and the spectator experiences the narrative as such.
Diego Del Pozo describes the film's narrative structure as little more than
a "collage de secuencias [en que] apenas hay una línea argumental que
soporta ligeramente la sucesión de tipos sociales" (2003: 93).[12] This
challenge to traditional narrative is nowhere more evident than in the
many representations of Mónica's journeys through the city space.
Although at any one time these journeys may have a specific purpose

[11] In "Beyond the Pleasure Principle", Freud theorises his grandson's game of
throwing an object out of the cot and pulling it back towards him to be a way of
managing anxiety about the absence of his mother (1920: 15-16).
[12] "Collage of sequences [in which] the bare bones of a plot just about support the
series of social types portrayed."

(fleeing from Zarco, the film's villain; returning to relatives in *barrio* Miramar; stealing money to buy crude fireworks to celebrate Christmas), taken together they represent a disjointed, repetitive, and haphazard whole, and are frequently interrupted or cut short, or change course unexpectedly. Karen Lury, discussing Dimitris Eleftheriotis's monologue, *Cinematic Journeys*, claims that such mobility

> Should be set against the trope of the mobile subject in certain well-known genres of Western film in which people travel, such as the road movie. In these films, characters conventionally traverse landscapes and go to particular places to appreciate the world as spectacle (or as "scenery") and they often make the journey to learn about themselves. (2010: 10)

In contrast, Lury suggests that in the child-centred films she discusses, movement "has an ontological rather than an epistemological dimension" (2010: 10). Journeys in *La vendedora de rosas* reveal the incoherent, inconsequential and truncated nature of the children's street lives. They are a challenge to teleological views of history (which, as we saw earlier, may be enshrined by the child) and also to concepts of progress, if, as García Canclini would have it (2005: 19-35), the various paths to modernity—democratisation, expansion, secularisation—have, in Latin America, been interrupted, or have become contradictory.

These "nowhere journeys" can also be read as examples of Gaston Bachelard's characterisation of childhood experience and especially experience of space. His "poetics of reverie" has recently been used to theorise children's geographies, and can be useful as part of a phenomenological approach to the analysis of childhood in film. Although Bachelard has been criticised by Chris Philo for his romanticisation of childhood "reverie" (2003: 13), his emphasis on the child's absorption in so-called directionless, seemingly meaningless, activity illuminates our reading of *La vendedora de rosas* with its continual "meaningless" journeying, its absorption in ultimately directionless activity. This continual travelling, whilst leading nowhere, speaks of a lack of social insertion, whilst its narrativising constitutes a critique and subversion of dominant ideology and linear narrative.

There is a further element which has yet to be explored by critics, however, and this is the attempt by Gaviria to represent a *childish* relation to space. As Powrie suggests, "we could [...] characterize the social position occupied by children as one of idleness (rather than leisure) and [...] propose that their spaces are *deviant heterotopias*. [...] In such spaces, a Bakhtinian contestation of order flourishes" (2005: 351). Although Powrie is discussing the representation of first world childhood—a very

different kind to that depicted in *La vendedora de rosas*—there is still a sense in Gaviria's film in which the "idle" or so-called "meaningless" activity of children is foregrounded alongside attempts to evoke this lack of direction aesthetically (moving the camera from right to left, for example) which can be seen as a move towards the filmic subjectification of childhood experience.

The second type of journey of relevance here is effected through the device of the *sacol*-induced trip, described by the director as "un viaje hacia los afectos" (Jáuregui 2003: 97).[13] Through this device the spectator experiences, and is invited to identify with, the reveries of Mónica, in which she sees her lost grandmother, and her wishes for family and affection are fulfilled. With an intensity heightened by the use of saturated colours, Gaviria re-creates for the viewer the hallucinatory quality of childhood, in the sense of its closeness to the imaginary realm, signalled by daydream sequences induced by inhaling glue. Whilst this is a common activity for street children in many cities of Latin America, Mónica's three visions (all involving her grandmother) also present a filmic opportunity for Gaviria to experiment with moulding the medium to the childhood perception, showing the childhood reverie Bachelard calls "*seeing*". He writes that "when we are children, people *show* us so many things that we lose the profound sense of *seeing*. Seeing and showing are phenomenologically in violent antithesis" (1969: 127). Lury posits that the kind of seeing which children do is linked to the imaginary realm, directionless, timeless, and, further, that cinema in general enables us to experience childlike seeing, reverie being part of what children offer as protagonists (2005: 313). As Kuhn puts it, "through its organization within the frame of space, time stillness and motion, film is capable [...] of replaying or re-evoking certain states of being which are commonly experienced as inner" (2005: 407), and *La vendedora de rosas* is a film particularly concerned with such an evocation, both through the obsessive to-ing and fro-ing of the journey of individuation made by Andrea, and through the subjective childlike reveries of Mónica.

Kuhn has suggested that the so-called magic of cinema, lies in "the ebb and flow of losing and re-finding oneself in space-time" which we experience as viewers, and which, she says, "evokes the oscillation between clinging and going exploring that characterises the child's relationship with its [transitional] objects".[14] The magic of cinema is never

[13] "A journey towards affect."

[14] Annette Kuhn outlined these ideas in her presentation "Cinematic experience, film space, and the child's world" given on 21 January 2009 at Queen Mary, University of London. She draws here on Winnicottian object-relations theory.

given a more arresting diegetic form than when it is framed by the child's gaze at the cinema screen. As Lebeau says: "The image of the child's enraptured gaze at the screen is a recognisable motif in cinema" (2008: 44) and Mónica's enraptured gaze during the three visions, which the spectator experiences through her point of view, are a variation on this motif, representing the childlike seeing processes of the cinematic spectator. In a recent talk Alberto Moreiras spoke of freedom as "an ability to scorn images" possessed by Rosario Castellanos's indigenous women in *Balún Canán*, and the characters Rachel and Decker in *Bladerunner*.[15] Like Mónica, these figures carry around with them images that they know not to be real, but upon which they rely, acting, perhaps, as a symbol of the individual in the "society of the spectacle". Furthermore, Mónica's dependence is not just on images, but, like that of the cinematic spectator, on the "unregulated [...] timeless and ahistorical" gaze of the child (Lury 2005: 314), a gaze which (ironically) she facilitates through drug use.

François Truffaut commented that "making a child die in a picture [...] is a rather ticklish matter; it comes close to the abuse of cinematic power" (quoted in Lebeau 2008: 154-55). Like Andersen's *Den Lille Pige med Svovlstikkerne* (*The Little Match Girl*), on which the film's story is based (Jáuregui 2003: 96), *La vendedora de rosas* ends with the death of its child protagonist. Mónica is murdered by El Zarco, the film's villain, who earlier on has stolen a watch from her (setting the story on Christmas Eve enables Gaviria to emphasise the fever of accumulation which takes place across the different social classes in different ways, but exists nevertheless: Zarco is excited that he has stolen a watch that will enable him to give a Christmas gift to his nephew). When she dies Mónica is entering the third of her visions of her grandmother, and the moment of death is paralleled in the fantasy with the moment of being embraced, finally, by the older woman.

How are we to interpret the death of the child in the film and what related questions does it raise in terms of emotion, ethics, and the spectator? As Lebeau puts it: "The child's body—in pain, in death—[is] a type of limit to an aesthetic committed to acts of social transformation" (2008: 136). On the one hand, Gaviria permits the viewer no sentimental delusion about the immunity of children from violence and death, and the death of the protagonist is clearly a device for political mobilisation of the spectator through an appeal to the spectator's desire to protect the child. The use of

[15] These ideas were part of a lecture given by Alberto Moreiras, entitled "Idolatrous Dwelling: On the Limits of Transculturation", on 23 April 2009 at Cambridge University's "New Approaches to Latin American Popular Culture" Symposium.

the suffering child in film has been critiqued, however, for its shoring up of the adult/child division, and consequent reinforcement of adult power, through provoking in the adult spectator the "pleasurable emotions of tenderness and compassion" (Patricia Holland quoted in Wilson 2005: 331). This very conventional aspect of Gaviria's representational use of the child can be seen, then, as a partial undermining of the very radical agency which his filmmaking practice attempts to facilitate.

The almost photographic stillness of Mónica's death provides the visual counterpart to the music accompanying the final credits. The lyrics are pertinent and worthy of interpretation: "Rosas/que sembraste allá en el huerto/en el jardín de tu casa".[16] Here, the use of the rose image sheds further light on childhood in the film. It coincides with the Romantic notion of childhood as close to nature, as inhabiting a garden, temporally and spatially separate from the adult domain. On closer inspection, however, we remember that roses also facilitate the girls' own crude insertion into capitalist mechanisms of exchange in the film and are the subject of several disputes amongst those who sell them. The double allegiance of the image—at once nostalgic for myths of childhood and expository of them, which employs conventional representational uses of the child whilst also attempting to move beyond these by offering a filmic subjectification of childhood experience—captures well the impulse(s) of the film as a whole. Through these lyrics, the rose seller, her friends, and ultimately her death are linked with the insertion of them all into dominant (capitalist) ideology. The insistent use of the second person singular becomes accusatory in its implication of the viewer in the sowing of the seeds that germinate outside the house (society) and its institutions, in the production, flowering, and dying, of the roses on the periphery. As Gaviria himself puts it: "La ciudad, con sus industrias y desarrollo produce no sólo mucho dinero sino *afueras* de su prosperidad" (quoted in Jáuregui 2003: 97).[17]

Gaviria employs the trope of the child in traditional ways: to highlight marginalisation and social problems. He relies heavily on the child as symbol of the future in the film's two narrative strands (a symbol of optimism in the case of Andrea's story, of pessimism and a call to action in the case of Mónica's). Although it has been argued that such representational uses of children deny them agency, and, in the case of the representation of the suffering child, that such portraits simply reinforce dominant power structures, Gaviria also experiments with different ways

[16] "Roses that you sowed there in the garden of your house."
[17] "With its industries and development the city produces not only a lot of money but also *outskirts* to its prosperity."

of evoking childhood experience, allowing the children's language and experience to shape the film, but also giving filmic shape to childlike movement and perception, the filmic rhetoric exhibiting both a rebellious directionlessness which undermines dominant ideology, and a need for or scorn of the images through which it reaches us. He effects, in the end, a double positioning of the spectator, who is simultaneously placed as the subject of a kind of narrative colonisation of childhood, whilst having her adult perceptual world disrupted through being made to re-experience the motile and psychic experience of the child. It is a film which at once confirms and denies, then, the easy separation of, and the power relations between, on-screen child and adult spectator.

WORKS CITED

Ariès, P. 1973. *Centuries of Childhood*. Trans. R. Baldick. Harmondsworth: Penguin.

Bachelard, G. 1969. *The Poetics of Reverie: Childhood, Language and the Cosmos*. Toronto: Grossman Publishers.

Browning, R. 2001. *Childhood and the Nation in Latin American Literature*. New York: Peter Lang.

Deleuze, G. 2005. *Cinema 2: The Time Image*. Trans. H. Tomlinson and R. Galeta. London: Continuum.

Del Pozo, D. 2003. "Olvidados y re-creados: la invariable y paradójica presencia del niño de la calle en el cine latinoamericano." *Chasqui* 32 (1): 85-97.

Edelman, L. 2004. *No Future: Queer Theory and the Death Drive*. Durham: Duke University Press.

Eleftheriotis, D. 2010. *Cinematic Journeys*. Edinburgh: Edinburgh University Press.

Freud, S. 1920 (1955). "Beyond the Pleasure Principle." In *The Standard Edition of the Complete Psychological Works of Sigmund Freud* 18, ed. J. Strachey, 7-64. London: Hogarth Press.

García Canclini, N. 2005. *Imaginarios urbanos*. Buenos Aires: Eudeba.

Gaviria, V. 1988. "Los días de la noche." *Kinetoscopio* 45 (9): 40-42.

Jáuregui, C. 2003. "Violencia, representación y voluntad realista: entrevista con Víctor Gaviria." In *Objeto visual: Imagen y subalternidad: el cine de Víctor Gaviria*, 91-104. Caracas: Cinemateca nacional de Venezuela.

——. and J. Suárez. 2002 "Profilaxis, traducción y ética: la humanidad 'desechable' en *Rodrigo D: no futuro*, *La vendedora de rosas* y *La virgen de los sicarios*." *Revista iberoamericana* 68: 367-92.

Kantaris, G. 2003. "The Young and the Damned: Street Visions in Latin American Cinema." In *Contemporary Latin American Cultural Studies*, eds. S. Hart and R. Young, 177-89. London: Arnold.

Kuhn, A. "Thresholds: Film as Film and the Aesthetic Experience." *Screen* 46 (4): 401-14.

Lebeau, V. 2008. *Childhood and Cinema*. London: Reaktion Books.

Levander, C. 2006. *Cradle of Liberty: Race, the Child and National Belonging from Thomas Jefferson to W.E.B. Du Bois*. Durham: Duke University Press.

Lury, K. 2005. "The Child in Film and Television: Introduction" *Screen* 46 (3): 307-14.

——. 2010. "Children in an Open World: Mobility as Ontology in New Iranian and Turkish Cinema." *Feminist Theory* 11 (3): Forthcoming.

Martin, G. 1989. *Journeys Through the Labyrinth*. London: Verso.

Philo, C. 2003. "To go back up the side hill." *Children's Geographies* 1(1): 7–23.

Podalsky, L. 2008. "The Young, the Damned and the Restless: Youth in Contemporary Mexican Cinema." *Framework* 49 (1): 144-60.

Powrie, P. 2005. "Unfamiliar Places: 'Heterospection' and Recent French Films on Children." *Screen* 46 (3): 341-52.

Ranghelli, D. 1998. "Las niñas en el cine latinoamericano: cuatro historias." *Kinetoscopio* 48 (9): 3-6.

Shaw, D. 2003. *Contemporary Cinema of Latin America: Ten Key Films*. New York: Continuum.

Stephens, S. 1995. *Children and the Politics of Culture*. Princeton: Princeton University Press.

Wilson, E. 2005. "Children, Emotion and Viewing in Contemporary European Film." *Screen* 46 (3): 329-40.

Yuval-Davis, N. 1997. *Gender and Nation*. London: Sage.

CHAPTER TWENTY-ONE

THE ONLINE ANTI-REGGAETON MOVEMENT:
A VISUAL EXPLORATION

MICHELLE M. RIVERA

While recent studies have cited rising rates of broadband adoption and Internet usage among US native and foreign-born Latinos (Livingston et al. 2009), research is sorely lacking on the ways in which Spanish-language dominant Internet users assert themselves as interactive subjects online. This chapter critically examines a thriving online participatory culture of Internet users whose dominant language is Spanish and who are anti-fans of reggaeton music.[1] These anti-fans actively assert their disdain for this genre of Latin pop music in user-generated content that includes anti-reggaeton images circulated on blogs, social networking sites, and online music forums. Together these digital venues support a growing web-based anti-reggaeton movement.

In what follows I wish to analyse digital visual culture as it relates to the anti-reggaeton movement by focusing on nine images drawn from a cross section of multiple Web sites. By employing Gillian Rose's critical visual methodology (2007: 12-13) I seek to address the following questions: What has been fuelling the online anti-reggaeton movement since the global crossover of this popular music form?[2] What does the

[1] Henry Jenkins defines a participatory culture as one in which "Fans and other consumers are invited to actively participate in the creation and circulation of new content" (2006: 290). Jonathan Gray defines anti-fandom as "the realm not necessarily of those who are against fandom per se, but of those who strongly dislike a given text or genre, considering it inane, stupid, morally bankrupt and/or aesthetic drivel" (2003: 70). While I use Gray's understanding of anti-fans in this study, I also expand his definition to encompass the role of cultural resistance to a particular genre or text.

[2] I deploy the term *crossover* to reference the process described by Garofalo "whereby an artist or a recording from a 'secondary' marketing category like country and western, Latin, or rhythm and blues achieves hit status in the mainstream or 'pop' market. While the term can and has been used simply to indicate multiple chart listings [...] its most common usage in popular music history clearly connotes movement from margin to mainstream" (1993: 231). My interest is in the movement of reggaeton from underground to mainstream status.

circulation of this digital visual culture online signify in the post-crossover context for reggaeton? How are these digital images being created and deployed on anti-reggaeton sites?

To begin to answer these questions, I critically examine the digital visual culture that anti-fans of reggaeton produce in response to the many channels of music, media representations of Latinidad, and other products of the culture industry that infiltrate their daily lives. While processes of globalisation enable these circuits of culture and capital to flow transnationally, it is too often the case that these processes are taken for granted and the responses to them ignored. As a controversial and provocative musical genre being sold as one of the more recent "hot" Latin global commodities, reggaeton presents an ideal case study for investigating how a global audience and interpretive community of anti-fans grapple with discourses of authenticity tied to the marketing of Latin music and the commodification of Latinidad. One of the ways reggaeton has been marketed is as a Latin urban musical genre targeted at "one of the fastest growing demographics in the US—bilingual, bicultural Hispanics ages 14 to 30" (Holt 2006). I contend that reggaeton artists have been used by the culture industry to promote and sell Latin urban authenticity as a tenable media representation of Latinidad or Latinness particularly for that target market. [3] Iconic reggaeton artists, such as Daddy Yankee, are at the forefront of the commercial incarnation of the genre, selling everything from "urban" music to a line of "urban" hair gel[4]. These marketing ploys have provoked a rejection of the genre they exploit as anti-fans strongly assert their resistance to an urbanised Latin authenticity. In this instance, they reject their interpellation (in Althusser's sense) as the audience for reggaeton solely based on demographically defined features, such as a shared language. The use of homogenised, conflated, and grossly

[3] I define *Latin urban authenticity* as a discourse that is a by-product of the Latin urban marketing construct used by the music industry to reach a bicultural, bilingual youth-driven Latin(a/o) market. Latin urbanness is often invoked alongside coded imagery, and words such as barrio or streets, to associate a putatively real or true Latin(a/o) identity with a particularly urban aesthetic.

[4] Zaire Zenit Dinzey-Flores has pointed to the ways that reggaeton artists call attention to critical public policy issues affecting poor urban communities through the "urban spatial aesthetics" with which they infuse their song lyrics. In her words: "Reggaetoneros have done what political figures haven't been able to do; they restore hope, '*en la disco o en el residencial*' [in the disco or the public housing project] to the beat of reggaetón" (2008: 61). I argue that it is equally important to be attentive to how those same Latin urban aesthetics ascribed to reggaeton and reggaetoneros are often deployed as a means to target fashionably urbanised consumer products to poorer urban consumers.

essentialising representations of Latinidad to market to US Latinas/os and a Latin global market abroad has only emboldened this imagined community of consumers, or interpretative community of anti-fans, in their response. The online participatory anti-fan culture around reggaeton offers more nuanced discussions not only of the genre but also of the complexities of Latina/o identity. In my analysis, I explore how the online visual culture of the anti-reggaeton movement challenges the culture industry's invention of the Latin audience for reggaeton as an undifferentiated mass. It is important to examine these spaces of online production—as I aim to do in what follows— because they illustrate how anti-fans create a means for destabilising the discursive authority of commercialised representations of Latinidad and thus resist the commodification of Latinidad and Latina/o identity.

This chapter aims to bring together scholarship in new media studies, visual culture studies, fan studies, popular music studies, and Latina/o communication studies. By creating a conversation between them, I set forth a theoretical framework for analysing the negotiation of global media texts like popular music mediated through anti-fan produced content like digital visual culture that circulates globally via the Internet. An interdisciplinary approach is called for in order to address the challenges posed by increasingly global audiences, fan/anti-fan communities, and cultural texts that are seen, read, heard, and interpreted internationally thanks in large part to the dynamic means of communication and channels of distribution that are facilitated by the Internet.

I contend that the realm of digital visual culture can work to challenge the representational authority of the culture industry, the commercial media, and, in this particular case study, mainstream media representations of Latinidad. These are alternative spaces carved out by anti-fans online where they make their arguments visible and audible, gather information, commune with those of shared interests and debate with those of disparate interests, and, ultimately, share alternative discourses to those disseminated by corporate media.

REGGAETON GOES GLOBAL

For over two decades, reggaeton has been a touchstone for younger generations in Puerto Rico. More recently, reggaeton has been used as a marketing tool to promote everything from toothpaste to politicians' campaigns in the US, the Caribbean, and in parts of Latin America. While the social and political relevance of reggaeton has often been questioned, those who have grown along with the genre can speak to its cultural relevance beyond a musical form. After reggaeton experienced a crossover

into the mainstream popular music market in the latter part of 2004, there was an increased presence of the genre on the radio, in films, on television programmes, award shows, magazines, and other entertainment platforms. Reggaeton's popularity was parlayed into reggaeton/urban themed clothing lines, merchandising and advertising deals, a bustling ringtone market, and various Internet sites devoted to news about the genre and to music/video streaming. In the midst of the reggaeton marketing blitz, radio broadcast and satellite stations changed their programming around the US and abroad to reflect an *hurban* format (a neologism formed from combining the words Hispanic and urban) with some venues playing reggaeton songs round the clock (Hinckley 2005; Navarro 2005). Increased visibility provided a newfound commercial viability for the genre, which, aside from lining the pockets of industry executives and merchandisers, created a continuing and forceful backlash against reggaeton.

Arguably, the backlash against reggaeton emerged out of a reaction against particular media representations around the genre that became conflated with Latinidad. While reggaeton was billed as a niche market, it became the hot new sound in the Latin music market and began outselling *música regional Mexicana*, which has a longstanding history as the top-selling genre in this sector. Resistance to the perceived invasion of reggaeton was immediately visible on the Internet. There was a strong and immediate reaction from the anti-reggaeton crowd against the media construction of "Reggaetón Latino" as a catch-all avatar for the Latin community in all its diversity in the US and overseas.[5] This rejection of the genre derived, in part, from the deviant image associated with Puerto Rican *underground* music, which is considered a precursor to reggaeton (Santos 1996; Marshall 2009). Scholars have traced how reception to *underground* was fraught with tension from the mid-1990s in Puerto Rico, when state interventions imposed censorship and bans on underground music, videos, and dance (Negrón-Muntaner and Rivera 2007; Santos 1996, Rivera 2009). And more recently there have been reports from the Dominican Republic of censorship imposed on reggaeton songs, videos, and performances (Unsigned 2006). Earlier bans of *underground* were premised on the alleged obscenity, sexism, and misogyny of the music

[5] María Elena Cepeda critically analyses the music video for "Reggaetón Latino (Chosen Few Remix)," which purports to offer a unified construct of pan-Latinidad, and instead reveals the contested terrain of "inter-Latino youth dynamics." Such findings demonstrate that complex negotiations over cultural texts like reggaeton also speak to the contested nature of Latinidad (2009: 565).

videos, and the explicit lyrics of songs held to be rife with sexual content and allusions to drugs and violence (Báez 2006: 64; Baker 2005: 111; Negrón-Muntaner and Rivera 2007: 36; Santos 1996: 219). The more recent censorship of reggaeton in the Dominican Republic cited similar offenses. Hence, to imply that reggaeton was the most popular Latin music form after its mainstream crossover was offensive to those who did not identify with its repetitive sonic structure, its lyrical content, its visual dimension, or its performative aspects.[6] In turn, issues of representation were at the fore in the anti-reggaeton stance. Many Latinas/os and Latin Americans did not identify with reggaeton and studying the online visual culture of the anti-reggaeton movement helps us to understand why.

COMMODIFIED LATINIDAD AND LATIN MUSIC AUDIENCES

My analysis draws upon a rich body of literature in Latina/o Communication Studies that has laid a critical framework for analysing the discursive construction of pan-ethnic Latina/o identity in the media (Calafell 2007; Valdivia et al. 2008). This analysis traverses anti-fan digital visual culture spanning the extension of the Hispanophone and the Anglophone globe and thus seeks to extend this literature by examining how media and market constructs of Latinidad are also being read and interpreted outside of the US context. I suggest that the music industry is currently deploying the Latin urban construct in ways that draw upon the many tropes (Shohat and Stam 1995: 138-139) and tropicalisations (Aparicio and Chávez-Silverman 1997: 1-15) that scholars have pointed to and problematised thus far within the global marketing of Latinidad. Aparicio asserts that "contemporary constructs of Latinos/as remain obedient to a long history of stereotypes of Latin America textualised through media, literature, historical texts, popular music, and folklore" (Aparicio 1997: 198-199) and Dávila observes that advertisers segment Latinos as "part of the same undifferentiated market" regardless of differences in ethnicity, class, lifestyle, taste, age, or race (2001: 8). Accordingly, it is against the music industry's grossly homogenising construction of Latinidad that I observe anti-fans of reggaeton reacting and reasserting their hybrid and intersectional identities as well as their musical tastes.

In many ways, Latin popular music seeks to interpellate a manufactured Latin global audience. Deborah Pacini-Hernández identifies

[6] I focus my attention on the underrepresented research area of reggaeton visual culture in this study. Ethnomusicologist Wayne Marshall has written extensively about the sonic structure of reggaeton music.

the problem very clearly:

> By lumping the diverse musics made in the US with musics produced and
> consumed within Latin America as well as in the Iberian peninsula into a
> single category, Latinas/os are equated with Latin Americans and
> Spaniards, thus perpetuating the exclusion of US Latinas/os from US
> cultural citizenship; the implicit message is that those who perform and
> consume 'Latin' music are foreign, and therefore not 'American'. (2007: 51)

Furthermore, the music industry has used these same categories to
expand its audience base around a shared language among US Latinas/os,
Latin Americans, and Spaniards. However, as Pacini-Hernández goes on
to explain: "Clearly, the language-based constructions of Latinidad by
both the Latin and mainstream music industries were inadequate to
describe the multidimensional experiences of US Latinas/os" (2007: 54). I
engage this dilemma by examining how these language-based categories
of Latinidad are read and rejected by those who are targeted as the
audience for Latin music. The music industry draws up neat categories like
"música regional Mexicana," "rock en español/alternative," "tropical," and
in doing so alienates fans of music forms that fall outside these
mainstream categories. These narrow forms of representation for Latin
music fans set up a hierarchy that structures which kinds of Latin music
are deemed marketable, profitable, and more likely to be consumed by
Spanish dominant and bilingual/bicultural audiences. Therefore, these
privileged forms relegate alternative music like heavy metal and rock
hybrids to the margins. This creates an ideal context in which marginalised
fans can establish a binary opposition between cultures of alternative
musical taste and more commercially viable forms, like reggaeton, sold
under the Latin music umbrella. From this opposition comes the creation
by anti-fans of a global online movement to ban reggaeton.

METHODS FOR EXPLORING ONLINE MUSIC FANDOM AND ANTI-REGGAETON DIGITAL VISUAL CULTURE

Fan studies is attuned to the shifting balance of power between media
producers and fans, and more recently current concerns within the
discipline have queried how fans "are embedded in the existing economic,
social, and cultural status quo" so that "taste hierarchies and structures
among fans themselves are described as the continuation of wider social
inequalities" (Gray 2007: 6). While recognising the importance of framing
studies of fans around a discussion of the structural hierarchies by which
they are constrained, I also underscore the importance of examining the

carving out by fans of their own spaces where complex hybrid and intersectional identities are negotiated as they mediate texts they hate and love. There is a tendency in work on online music fandom to polarise fans around these two approaches. Either they are controlled by corporations/advertisers who use digital delivery systems (like Rhapsody or iTunes) to data-mine, atomise, monitor, and automate them, and impinge on their privacy (McCourt and Burkart 2007: 261-68) or they are empowered via their tech savvy functionality as "amateur experts" in music/artist/band promotion (Baym and Burnett 2009). This area of fan studies has yet to engage an intersectional analysis of the way music fans/anti-fans bring their cultural, ethnic, gender, racial, class, sexual, religious, and political identities to bear on their negotiations of the musical taste cultures they privilege and disdain. The analysis I propose of the anti-reggaeton movement requires both an intersectional and an interdisciplinary approach in order to examine these multidimensional layers of mediation, in particular, the complex way in which pan-ethnic identity is constructed and read through reggaeton.

Anti-reggaeton fans use the Internet to distribute the visual culture they create as a means to negotiate further the media texts they love to hate. New media scholars have addressed the myriad ways that Internet and digital technologies have enabled widespread distribution of content to consumers by media industries (Jenkins 2006). At the same time, fan cultures have benefitted in kind from the same technologies as a means of circulating their user-generated content online. Social networking sites, video sharing sites like YouTube, and various computer-mediated communication venues have provided instantaneous online platforms for fan communities to go digital and global at the same time, leveraging their technological acumen to challenge the culture industry's control over their favourite or most hated texts. While fan studies scholars have addressed ways by which fans/anti-fans reassert their control over media texts, far fewer studies have investigated actual fan produced texts like the digital visual culture examined here. Without fan/anti-fan user-generated content (videos, links, songs, mashups, articles, visual images, online discussions and debates) Internet-based movements like the global anti-reggaeton one would cease to exist.

Prior to 2004, using an online search engine to look for the term reggaeton produced zero results. After 2004, when reggaeton had crossed over as a mainstream popular music form, the same search engine query produced results numbering upwards of hundreds of thousands—all user-generated content. While fan studies and new media studies scholars have taken an interest in the growing amount of fan-generated content online,

this is an area that visual culture studies should examine more closely. Fan-produced content extends to various textual, visual, and hybrid forms and is imbued with many layers of social and cultural meaning that have yet to be examined.

While the Internet provides a decentralised site where users from all parts of the globe converge, new media scholars (Baym 2007; Baym and Burnett 2009) have pointed out issues of social incoherence when fans are not concentrated in one location online and instead form chaotic communities and networks dispersed across many different sites, a feature which indeed applies to the circulation of visual culture produced by reggaeton's anti-fans. Thus, a challenge in approaching this material is to keep track of images spread unevenly across a range of online spaces that are constantly changing, from social networking sites, to blogs, to music streaming sites. In this study, I focus on a sample of the digital images that have circulated in various modified forms among anti-fans of reggaeton online. On 25 June 2009, I took a snapshot of images which recurred across various anti-reggaeton sites using Google's advanced image search function to provide access to all digital images tagged "anti-reggaeton". I collected fifty digital images from the 7,536 search results garnered from English and Spanish language sites. I reduced the sample to nine images by looking for the most prominent and recurrent themes and by considering their cultural significance as well as the power relations articulated through their production. I also considered hyperlinks between pages where these images appear to address the role cross-referencing plays in communicating between anti-fandom nodes.[7]

REGGAETON: NATIONAL AND GLOBAL INVASION!

In his foreword to the anthology *Reggaetón*, Juan Flores writes about his late friend Johnny Ramirez, who considered reggaeton mere noise and called it "racketon" (2009: ix). Flores grappled with his friend's disdain for reggaeton stating, "the sonic *intrusion* he feels is the *invasion* of generational degeneration, the moral decline of young people "que no valen ná" ["who are worthless"] (2009: x, emphasis added). Here, Flores highlights the framing of the genre as an invasion and hones in on the role played by generational differences in forging distinctive tastes in music. Reggaeton has been discussed with similar terminology in the popular

[7] This study follows the ethical decision-making criteria outlined in the recommendations of the Association of Internet Researchers and thus only assumes fewer obligations vis a vis protecting individual privacy where publicly accessible Web sites are under investigation (2002: 7).

press and mainstream media. In news articles everywhere from *BBC News Online* (Wells 2005) to various *Associated Press* reports (Unsigned: 2006b), reggaeton has been described as an explosion, a revolution, mad hot, taking over, coming up, ruling, rising, and as a craze. Reggaeton is seen as an invasion due to a crossover success not seen since the worldwide penetration of salsa music in the 1990s, and a *New York Times* article referenced it as: "The Conquest of America (North and South)" (Caramanica 2005). Among anti-fans of reggaeton, the invasion is anything but welcome. Reggaeton's active anti-fans appear across the gamut of Internet platforms and their blog posts, for example, describe feeling bombarded by the genre as well as irritated at having to hear it in nightclubs, on the street, on buses, on the radio, and on television.

In my sample of anti-reggaeton images one of the most frequently recurring themes is reggaeton as threat or invasion, on both a national and global scale. Among the most commonly circulated images is one which uses the simple device of striking through the term reggaeton. This graphic representation of the wish to ban reggaeton has been altered in various ways and even embellished at times with visual flairs like blinkies, but the particular images referenced here render explicit national and global symbolism. For instance, the images in Fig. 21-2 represent only a few of the multitude of signs circulated online that express a desire to rid the world or a specific country of reggaeton.

The three images in Fig. 21-2 which refer to "alianza" [alliance] call for "a Venezuela, Mexico, and a world without reggaeton." The two very similar triangular devices represent a Venezuelan alliance against reggaeton (X-2 left), and a worldwide alliance (X-2 right). Between these two iterations, only a few elements have been modified by the anti-fan designer(s). The image for the Venezuelan alliance uses red, yellow, and blue colours and seven stars, which are symbols culled from Venezuela's national flag. The colours of the worldwide alliance are red, white, and blue, but other examples of the same design have been posted online with variations in the colour scheme or adapted to represent Mexico, Ecuador, and Peru. The image of the Mexican alliance against reggaeton (Fig. 21-2 centre) uses the eagle, serpent, and cactus from the Mexican national flag. This image is not as easily modified as the simpler triangular one and so does not circulate with the same frequency. Images like these are ideal for reggaeton's anti-fans online, because they are simple, bold statements that can work to mimic the representational strength of national or global symbolism that is similarly achieved with national flags. These images help to construct the appearance of a national and global movement against reggaeton and can be easily transferred to an offline setting: some

have been used as t-shirt decals, for example. The smaller pixellated strike-through globe (Fig. 21-2 centre) is the picture for a user profile on social networking site MySpace, his location given as Mexico City and his space identified as the headquarters of AMAR, the Asociación Mundial Anti-reggaetón [Worldwide Association Against Reggaeton]. While it is hard to pinpoint the creative origin of and motivation behind these images, the texts which surround the sites where they are reused and repurposed often provide insight into how and why particular images are being presented. For example, the owner of the AMAR MySpace profile where Fig. 21-2 appears writes in a public comments forum:

> ¿Que [sic] opinais [sic] acerca de la decadencia del ya deprimente y absurdo genero [sic] del reggaetón, basura del desperdicio acaso? [S]i el reggaetón desde su inicio a [sic] sido mierda las difusoras y los "diyeis" de los putridos antros dedicados a dicho genero [sic] se han asforzado [sic] en difundir este genero [sic] mas [sic] pestilente que nunca y al parecer (por fin!!!) esta mierdera [sic] plaga de lobotomizados que gustan de dicha "musica (¿?)" [sic] poco a poco va empobreciendo en numero [sic]... opinen opinen!!! Senkoe!! (Jose Antonio y compañia: 2007) [8]

Thus, the AMAR member uses a profile image that coincides with his low opinion of the genre. Using a discourse of reggaeton as a pestilential scourge, this anti-fan clearly reacts against the popularization of reggaeton as something he sees as forced on those in dance clubs by DJs. Hence, the theme of reggaeton as invasion marries the image and the accompanying commentary. The digital image serves as a visual representation of the AMAR member's text and its forceful stance against reggaeton.

Fig. 21-2 (left) appeared on a Facebook profile page dedicated exclusively to the alliance against reggaeton in Venezuela. This profile page has 159 members and all content is public, as recruitment of other Facebook members appears to be the intended goal. On the wall of the profile page, beneath a statement about the alliance and in the field 'Who I'd like to meet', there is an appeal to the likeminded:

> Personas sabias e inteligentes, xD ... Rockeros, Emos, Poperos, Hadcore

[8] "What do you think about the decline of the already depressing and absurd reggaeton genre, just wasteful trash, perhaps? If reggaeton since its inception has been shit the broadcasters and deejays in the putrid clubs devoted to this genre have dedicated themselves to spreading this more-pestilent-then-ever genre. Apparently (finally!) the shitty plague of lobotomised people who enjoy such so-called "music (?)" is little by little shrinking in number...have your say!!! Senkoe!!

[sic], Techno, Electro, Drum And Bass, lo que sea... Menos Reggaetóneros!! Ni plataneros, Ni tierruos ni X, Caramelos de Cianuro Talento Naciona!! =) [sic] (Unsigned 2007)[9]

Here, the Venezuelan alliance not only uses the triangular image to appeal to anti-fans of reggaeton, but as the statement on the profile page suggests, this group seeks to target a particular set of anti-fans. The statement uses Venezuelan colloquialisms like "tierruos" and "plataneros," which connote repudiation of rappers and producers of tropicalised musical forms, such as merengue, and salsa. This group considers these musical forms as culturally inferior compared with rock and electronic dance music forms.

The worldwide variation on the anti-reggaeton alliance image (Fig. 21-2, right) links to a blog created by an anti-fan in Granada, Spain, and the design is embedded next to a strike-through device that reads: "no mas [sic] reggaetón" ("no more reggaeton.") The Spanish anti-fan's blog includes a poll gauging readers' opinion of the genre: 77 percent of those who responded expressed hate, 11 percent said they loved the genre, and another 11 percent did not much care for it. This blog, which invites a range of perspectives about reggaeton, contrasts with other sites which discount the music completely based on taste differences alone. This blog also demonstrates how fans and anti-fans can interact with one another in virtual spaces, using them as platforms to debate and express divergent opinions.

The Mexican alliance image (Fig. 21-2, centre) is hyperlinked to an anti-reggaeton forum dedicated to posting, exchanging, and trading similar images. This site functions as a central point where anti-fans can upload newly modified images or download them for their own blogs, profile pages, social networking sites, or other anti-reggaeton sites. Issues of copyright and monetary concerns are not a priority here. Communication, rather than making money, drives the way these images are exchanged and illustrates the workings of the Internet gift economy as anti-fans of reggaeton constantly modify and exchange free content logos and icons. Collaboration is also valued in this gift economy and is a feature of the way virtual fans organise. As Richard Barbrook suggests:

> Unrestricted by physical distance, [fans] collaborate with each other without the direct mediation of money and politics. Unconcerned about

[9] "Wise and intelligent people, xD ... Rockers, Emos, those into Pop, Hardcore, Techno, Electro, Drum And Bass, whatever ... Anyone but Reggaetoneros! Or plataneros, or tierruos or X, Cyanide National Talent Sweeties!! =)"

copyright, they give and receive information without thought of payment. In the absence of states or markets to mediate social bonds, network communities are instead formed through the mutual obligations created by gifts of time and ideas" (1998).

Barbrook's analysis of fans' behaviour seems equally pertinent to the free circulation and online exchange of logos and images by active reggaeton anti-fans who create a visual culture around a shared cause.

Herbert Gans defines *taste culture* as one which "results from choice; it has to do with those values and products about which people have some choice" (1974: 12). Gans argues that there is a constant struggle over the prioritisation and representation of one's particular interests, tastes, and content in the mass media (1974: 112) which creates a taste hierarchy in which high culture is always privileged over low culture. Creating this hierarchy relies upon drawing out conflict and relegating certain tastes to the margins and alienating those who identify with interests perceived to be low culture tastes. This power struggle extends to popular music especially, where standards of high and low tastes are often debated. And reggaeton is no exception. Gans's modelling of taste conflict and hierarchy helps to explain the vigorous exchange and refashioning of images used online in support of and against reggaeton. The web-based anti-reggaeton movement not only survives but thrives on the activity of a sizable number of reggaeton's anti-fans and fans who exchange counterarguments both textually and visually. Fig. 21-1 illustrates how digital images based on a common core design are modified and then circulated online by both fans and anti-fans as they repurpose them to serve their particular interests and tastes.

The type of attention and visibility that reggaeton has received in the mainstream media has raised concerns for anti-fans who feel compelled to form national and global alliances against it and demarcate their own spaces online where they can celebrate their musical taste cultures.[10] The images in Fig. 21-2 include only a cross-section of the Latin American countries represented in the online anti-reggaeton movement. Between

[10] Grossberg et al. discuss taste cultures as a market type and assert that: "producers operating with an understanding of the audience as taste cultures construct media products according to their understanding of the features of the product that hold the taste culture together, rather than according to their image of a particular demographic group of consumers" (2006: 225). I argue, conversely, that not only are anti-fans of reggaeton constructed as a market type based on shared demographics, but that they reject the Latin urban construct and in doing so reassert their choice in musical taste cultures.

2004 and 2006, the top spots in the Latin music charts became a competition between the previously dominant *música regional Mexicana* and reggaeton which was becoming more and more popular in the US. In addition, the peak of reggaeton's success coincided with a format change that affected Spanish language radio programming across the US. Several stations switched from rotating traditional salsa, merengue, norteño, and tejano music to a programme which accommodated more youth-friendly *hurban* formats such as reggaeton, hip hop, bachata, and contemporary cumbia hybrids. Thus, reggaeton posed a threat to other musical genres' slice of the airwaves. Many reggaeton anti-fans devote web sites and online media to rejecting reggaeton and embracing other genres considered alternative Latin music forms, such as heavy metal and rock, and other musical taste cultures, such as emo culture. Arguably, the drive to create alternative sites online slamming reggaeton and supporting heavy metal, for instance, derives in some way from the lack of visibility and representation given to these genres and to taste cultures that are not commercialised, marketed, and packaged in the same ways that propelled reggaeton to more mainstream success. However, what is being silenced in these debates is that even though alternative Latin music genres and musical taste cultures are not as visibly highlighted by the mainstream, they are still just as much products of the culture industry as the commercialised form of reggaeton. Hence, the battle of conflicting musical taste cultures wages on as reggaeton continues to be the mainstream target for these anti-fans.

ANTI-CONSUMERISM AND REGGAETON

Because reggaeton is often discounted as a musical form it is certainly not considered a cultural form in the eyes of anti-fans. After the crossover of reggaeton, there was a strong reaction against its commercialisation. In particular, reggaeton superstars, such as Daddy Yankee and Don Omar, were singled out for attack by anti-fans. Fig. 21-3 shows an image of Daddy Yankee that was posted on an anti-reggaeton discussion forum and also an image of Don Omar found on an anti-reggaeton Web site created by an anti-fan from Nuevo León, Mexico, who appears, on the other hand, to be a fan of heavy metal band Iron Maiden. Here, the anti-fan(s) add a Joker face layer to a photograph of Daddy Yankee, so that he resembles a clown, and caption the new image "Daddy Yankee el payaso capitalista" ("Daddy Yankee the capitalist clown"). Arguably, they label Daddy Yankee as a capitalist clown because not only is he the genre's top-earner—thanks to platinum sales of his reggaeton albums—but he has also received a film deal and multiple lucrative endorsements globally. After

Daddy Yankee endorsed John McCain's bid for the 2008 US presidential elections, rap artist Fat Joe publicly referred to the reggaetonero as a sell-out (Reid 2008). Daddy Yankee is well known for the conspicuous consumption evidenced in his fur-lined clothing and bling-bling diamond jewellery, which has many anti-fans up in arms. The same grievance underpins the image (Fig. 21-3) in which artist Don Omar's head is held in the clutches of a monstrous figure alongside a crudely cut and pasted reproduction of the shiny and large bling-bling chain that Omar often wears. The monstrous figure in the image appears to have been pasted from art work typical of record sleeves for heavy metal bands like Iron Maiden. The collage design solicits: "Muerte al reggueton [sic]" ("Death to reggaeton") and this could arguably also be calling for the cessation of the conspicuous consumption practices flaunted by reggaeton's most fashionable and notable icons. A text layer added to the image of Daddy Yankee in Fig. 21-3 says: "DESPIERTA!!! Esta Sanguijuela solo te quiere chupar el dinero…y aparte te tiene perreando como un imbecil", framing Daddy Yankee as a capitalist bloodsucker exploiting fans for personal gain.[11] *Perreando* refers to the reggaeton dance style and the word in Spanish is formed from the noun signifying dog. An adapted clip art image of two dancers in Fig. 21-4 mimics and critiques the grinding pose that is typical of reggaeton's dance style. This image, found on a Spanish MySpace user's public comment board, repurposes a sign with the warning "Prohibido perrear en esta zona…por un mundo sin reggaetón."[12] Further text added to the image reads:

> Esse [sic] ritmo es bailado por hombres y mujeres ignorantes, hambrientos de sexo, manipulados por el consumismo. ¿A quién se le ocurre que una mujer debe ser gasolinera y fácil?[13]

The anti-fan's attack is waged on two fronts. One critique is waged against the sexually charged dance of reggaeton, and the other targets the commercialisation of the genre through mass consumption practices. Thus, in both Fig. 20-3 and Fig. 20-4, the *perreo* dance is associated with ignorance, foolishness, and sexual depravity. In particular, the woman who dances *perreo* is read as submissive and sexually available, creating a

[11] "WAKE UP!!! This leech just wants to bleed you dry of your money… and aside from that he's got you dancing around doggy-style like an imbecile."

[12] "Doggy style dancing forbidden in this zone…for a world without reggaeton."

[13] "This beat is one which ignorant, sex-hungry men and women dance to, and they're manipulated by consumerism. Who thinks women should be gold digging pushovers anyway?"

discourse which also polices female sexuality. *Gasolinera* references Daddy Yankee's number one song and crossover hit "Gasolina", thus defining women in terms of a particular track, the lyrics of which, furthermore, have been a source of debate on account of being rife with double entendres and sexual innuendos. Thus, the construction of the image in Fig. 21-4 crystallises reggaeton's role as a site for debates over indecency, sexual provocation, and moral corruption. The image's critique of the *perreo* dance echoes moves to censor *underground* in the 1990s and later reggaeton in Puerto Rico and the Dominican Republic. The discourse of reggaeton as a corrupting influence particularly targets women within a punitive patriarchal narrative about sexuality and decency in public spaces (only the woman, the *gasolinera*, is reduced to definition by the "Gasolina" song though both a man and a woman are shown dancing to it in Fig. 21-4). As a dance style found in clubs and parties, *perreo* has provoked moral panic for decades and yet is not so different from other Caribbean forms of dance, such as whining or even hip hop grinding or juking. *Perreo* has been debated not only by reggaeton's anti-fans but enthusiasts of the genre too. But the online anti-fan visual culture uses digital cut and paste to make opposition to sexism and consumerism on the one hand, and enjoyment of reggaeton on the other, seem mutually exclusive. The target is not only reggaeton music, but those who dance to it as well. Here, anti-fans conveniently ignore the pleasure derived from dancing and depict reggaeton as a corrupting influence and those who dance to it as the corrupted. Hence, the anti-reggaeton images created, modified, circulated, exchanged, and posted online reveal some of the ways in which anti-fans also negotiate the boundaries of sex, gender, taste, ethnic and cultural identity as they mediate reggaeton.

CONCLUSION

The online circulation of images analysed in this chapter highlights how these images are able to perform a signifying function in the web's anti-reggaeton environment. The images we have looked at serve as a signpost for identity as well as a way to make an argument visually. Their significance is two-fold in that they not only allow anti-fans to speak back to popular culture representations they do not identify with, but they also demonstrate the function of anti-fans as cultural producers in the digital realm. The purpose of reggaeton anti-fan sites is in some ways to circumvent the culture industry's gatekeepers. Ironically, several images I have analysed here espouse arguments based on essentialist high/low culture arguments of aesthetic taste even though they wage their arguments by creating amateur low-resolution renderings of visual culture

that would not be considered high art by the very standards they seek to uphold.

Because these online sites and spaces are often associated with low aesthetic worth and little visual cultural capital, they can easily be ignored by academics. Yet, arguably, they are a central location of identity negotiation and formation as well as an alternative public sphere where anti-fans speak back to, interact with, and produce images and text that resist the apparatus that seeks to define them. These are spaces of rampant controversy, debate, and conflict as well as of solidarity, community, and fan culture; and the producers and users of these spaces are underrepresented as cultural producers on the Internet. The anti-fans I examine are resistant to commercially produced genres like reggaeton, and yet they cling as fans to other commercial genres and rework images from popular culture to make their case. There are levels of containment and static, closed, and essentialist notions that work against, and with, flexible, malleable, changing, fragmented, and negotiated identities. These are creative and expressive spaces that should continue to be critically examined. Without a doubt, the anti-fans studied here have claimed these spaces by using digital production and representation for their own ends and as I have aimed to demonstrate in this chapter, the realm of digital visual culture can be used to challenge the representational authority of the culture industry as well as the constructs of commodified difference that work to constrain heterogeneous representations of Latinidad within mainstream media and popular culture.

WORKS CITED

Aparicio, F. R. 1997. "On Sub-Versive Signifiers: Tropicalizing Language in the United States." In *Tropicalizations: Transcultural Representations of Latinidad*, eds. F.R. Aparicio and S. Chávez-Silverman, 194-212. Hanover: University Press of New England.

Aparicio, F. R. and S. Chávez-Silverman, eds. 1997. *Tropicalizations: Transcultural Representations of Latinidad*. Hanover: University Press of New England.

Báez, J. M. 2006. "'En mi imperio': Competing Discourse of Agency in Ivy Queen's Reggaetón." *CENTRO: Journal of the Centre for Puerto Rican Studies* 18 (11): 63-81.

Baker, E. 2005. "Preliminary Step in Exploring Reggaetón." In *Critical Minded: New Approaches to Hip Hop Studies*, eds. E. M. Hisama and E. Rapport, 107-23. Brooklyn: Institute for Studies in American Music.

Barbrook, R. 1998. "The High-Tech Gift Economy." *First Monday* 3 (12). http://www.cybersociology.com/files/5_barbrook.html (Accessed 4 August 2010).

Baym, N. K. 2007. "The New Shape of Online Community: The Example of Swedish Independent Music Fandom." *First Monday* 12 (8) http://firstmonday.org/htbin/cgiwrap/bin/ojs/index.php/fm/article/view/1978/1853 (Accessed 9 September 2010).

——, and R. Burnett. 2009. "Amateur Experts: International Fan Labour in Swedish Independent Music." *International Journal of Cultural Studies* 12 (5): 433-449.

Calafell, B. M. 2007. *Latina/o Communication Studies*. New York: Peter Lang.

Caramanica, J. 2005. "The Conquest of America (North and South)." *New York Times,* 4 December. http://www.nytimes.com/2005/12/04/arts/music/04cara.html (Accessed 4 August 2010).

Cepeda, M. E. 2009. "Media and the Musical Imagination: Comparative Discourses of Belonging in 'Nuestro Himno' and 'Reggaetón Latino." *Identities: Global Studies in Culture and Power* 16 (5): 548-572.

Dávila, A. 2001. *Latinos, Inc.: The Marketing and Making of a People*. Berkeley: University of California Press.

Dinzey-Flores, Z. Z. 2008. "De la Disco al Caserío: Urban Spatial Aesthetics and Policy to the Beat of Reggaetón." *CENTRO Journal of the Center for Puerto Rican Studies* 20 (2): 34-69.

Ess, C., and the Association of Internet Researchers. 2002. "Ethical Decision-Making and Internet Research: Recommendations From the Aoir Ethics Working Committee." http://aoir.org/reports/ethics.pdf (Accessed 4 August 2010).

Flores, J. 2009. "Foreword: What's All the Noise About?" In *Reggaeton*, eds. R. Z. Rivera, W. Marshall, and D. Pacini Hernández, ix-xi. Durham: Duke University Press.

Gans, H. 1974. *Popular Culture and High Culture: An Analysis and Evaluation of Taste*. New York: Basic Books.

Garofalo, R. 1993. "Black Popular Music: Crossing Over or Going Under?" In *Rock and Popular Music: Politics, Policies, Institutions*, eds. T. Bennett, S. Frith, L. Grossberg, J. Shepherd, and G. Turner, 231-248. London: Routledge.

Gray, J. 2003 "New Audiences, New Textualities: Anti-fans and Non-fans." *International Journal of Cultural Studies* 6 (1): 64-81.

Gray, J., C. Sandvoss, and C. L. Harrington, eds. 2007. *Fandom: Identities and Communities in a Mediated World*. New York: New York University Press

Grossberg, L., E. Wartella, D. C. Whitney, and J. Macgregor Wise. 2006. *Mediamaking: Mass Media in Popular Culture*. Thousand Oaks, CA: Sage.

Hinckley, D. 2005. "Reggaeton Gets Solo Tryout on Station Formats." *New York Daily News*, 27 July. http://www.nydailynews.com/archives/entertainment/2005/07/27/2005-07-27_reggaeton_gets_solo_tryout_o.html (Accessed 4 August 2010).

Holt, C. 2006. "Worldwide Reggaetón." *Millimeter*, [electronic publication] 1 April http://digitalcontentproducer.com/dcc/revfeat/video_worldwide_reggaetn/ (Accessed 4 August 2010).

Jenkins, H. 2006. *Convergence Culture: Where Old and New Media Collide*. New York: New York University Press.

Jose Antonio y compañia. 2007. *asociación mundial anti-reggaeton*. MySpace Pages. http://www.myspace.com/yoodioelreggaeton (Accessed 4 August 2010).

Livingston, G., K. Parker, and S. Fox in co-operation with the Pew Research Centre. 2009. *Latinos Online, 2006-2008: Narrowing the Gap*. http://pewhispanic.org/reports/report.php?ReportID=119 (Accessed 4 August 2010).

Marshall, Wayne. 2009. "From Música Negra to Reggaeton Latino: The Cultural Politics of Nation, Migration, and Commercialization." In *Reggaeton*, eds. R. Z. Rivera, W. Marshall, and D. Pacini Hernández, 19-76. Durham: Duke University Press.

McCourt, T., and P. Burkart. 2007. "Customer Relationship Management: Automating Fandom in Music Communities." In *Fandom: Identities and Communities in a Mediated World*, eds. J. Gray, C. Sandvoss, and C. L. Harrington, 261-281. New York: New York University Press.

Navarro, M. 2005. "Mad Hot Reggaeton." *New York Times*, 17 July http://www.nytimes.com/2005/07/17/fashion/sundaystyles/17reggaeton.html?_r=1 (Accessed 9 September 2010).

Negrón-Muntaner, F., and R. Z. Rivera. 2007. "Reggaeton Nation." *NACLA Report on the Americas* 40 (6): 35-39.

Pacini-Hernández, D. 2007. "The Name Game: Locating Latinas/os, Latins, and the Latin Americans in the US Popular Music Landscape." In *A Companion to Latina/o Studies*, eds. J. Flores and R. Rosaldo, 49-59. Malden, MA: Blackwell.

Reid, S. 2008. "Fat Joe Calls Daddy Yankee a 'Sellout' for Endorsing John McCain." 28 August. http://www.mtv.com/news/articles/1593771/20080828/yankee_daddy.jhtml

(Accessed 4 August 2010).

Rivera, R. Z.,W. Marshall, and D. Pacini-Hernández, eds. 2009. *Reggaeton.* Durham: Duke University Press.

Rose, G. 2007. *Visual Methodologies: An Introduction to the Interpretation of Visual Materials.* London: Sage.

Santos, M. 1996. "Puerto Rican Underground." *CENTRO: Journal of the Center for Puerto Rican Studies* 8 (1-2): 219-231.

Shohat, E., and R. Stam. 1995. *Unthinking Eurocentrism: Multiculturalism and the Media.* London: Routledge.

Unsigned. 2006. "No Reggaeton en D.R." *Associated Press.* 9 April. http://www.ahorre.com/reggaeton/musica/music_business/no_reggaeton_en_dr / (Accessed 4 August 2010).

Unsigned. 2006b. *Associated Press.* "A un paso de develarse ganadores de Billboard Latinos." 25 April. http://msnlatino.telemundo.com/search_results?search_web=1&s=A+un+paso +de+develarse+ganadores+de+Billboard+Latinos (Accessed 4 August 2010).

Unsigned. 2007. *Alianza para un Venezuela Sin Reggaeton.* http://www.myspace.com/venezuelasinreggaeton (Accessed 4 August 2010).

Valdivia, A. N., ed. 2008. *Latina/o Communication Studies Today.* New York: Peter Lang.

Wells, M. 2005. "Puerto Rico Shakes to a New Beat." *BBC News* 7 March. http://news.bbc.co.uk/2/hi/americas/4304185.stm (Accessed 4 August 2010).

CHAPTER TWENTY-TWO

T. IFOR REES:
A WELSH DIPLOMAT IN LATIN AMERICA

DIANA LUFT

[*This chapter arises from a public interview I conducted with Morfudd Rhys Clark to mark an exhibition of her father's photographs entitled* T. Ifor Rees (1890-1977): From Bronceiro to Bolivia *which was part of the* Fractured Identities; Resiting Hispanic Visual Cultures Conference *held at Cardiff University, 3-4 July 2009. Much of the information which follows derives from that interview and from the preliminary discussions with Mrs. Rhys Clark which preceded it.*]

The photograph in Fig. 22-1 shows a small girl, with a big bow in her hair and wearing a pretty white dress. She sits in a lush garden on a small wooden chair and frowns resolutely into the bright sun. The photographer's head makes a shadow against the grass. In her hands the girl holds a book, *Cymru'r Plant* (Children's Wales), a Welsh-language journal aimed at children.[1] The girl is a young Morfudd Rhys Clark, and the photographer is her father, T. Ifor Rees. The photograph was taken in the family's garden in Managua, Nicaragua, while Rees was employed at the British Consulate there between 1921 and 1926. As a photograph it is full of ambiguities and raises many questions. What is this little girl doing reading *Cymru'r Plant* in a Nicaraguan garden? How did the girl, and the book, arrive there from Wales? How did Rees manage to keep hold of his Welsh identity and to pass it on to his children while working in the very British surroundings of the British Consulate, in Latin America? And how did he come to be working in such an environment in the first place? This chapter will attempt to answer some of those questions based on an examination of Rees's writings and photographs, his career, and information supplied by members of his family, especially his daughter, Morfudd Rhys Clark.

[1] This popular journal was founded by the historian, author and educator O. M. Edwards in 1892 and ceased publication in 1987.

T[homas] Ifor Rees is a figure who is known to many in Wales already, but mostly as an author and translator. Many Welsh readers will be aware of his work from the illustrated travel books he published in the 1960s, *Sajama: Teithiau ar Ddau Gyfandir* (1960) and *Illimani yn nhiroedd y Gorllewin* (1964); others will know him as a translator of French and Spanish novels,[2] and still others will know him for the beautiful printed editions of some of his translations which he published in Mexico City in the 1940s, the first—and perhaps only—Welsh-language books to be published in Mexico. His translation of Thomas Gray's "Elegy Written in a Country Churchyard" is probably the most widely known of these.[3] Rees's work as a diplomat has not been investigated until recently, and his photographs, many of which have appeared in his two illustrated books— *La Paz; album fotográfico* (1948), and *In and Around the Valley of Mexico* (1953)—are relatively unknown in Wales, at least when compared with his literary output. As is the case with many authors who have chosen to work through the medium of a minority language, his work is not well known beyond the borders of his own country.

In many ways T. Ifor Rees is an anomaly. Unlike most Welsh-language writers, Rees did not stay within his own square mile. Despite his dedication to writing and publishing in Welsh, he spent his working life abroad in Europe and Latin America. His choice to follow a career in the civil service was unusual for someone of his background, and his extraordinary success at that career, rising from Vice-Consul in the Consular Service, to Ambassador in the Diplomatic Service, acting as the first British Ambassador to Bolivia, also marks him out. Rees's unique position as a Welshman from a relatively humble background who worked at the highest levels of the British civil service in Latin America is enough to inspire an interest in him. Add to this the extraordinary record of his time in Latin America in the form of his collection of photographs and his travel writing, and a truly unique picture emerges.

[2] These include *Rousille: neu, y Tir yn Darfod* (1933), a translation of René Bazin's *La Terre qui meurt*; *Y Campwaith Coll a straeon eraill* (1954), a collection of translations of short stories by Honoré de Balzac; *Y Meirw ar y Mynydd* (1965), a translation of Henri Troyat's *La Neige en Deuil*; and *Pan Gwympodd y Mynydd* (1968), a translation of Charles Ferdinand Ramuz's *Derborence*.
[3] Rees's translation of Gray's "Elegy" was published as *Marwnad a ysgrifennwyd mewn mynwent wledig* (1942). The other two volumes are *Rubaiyat* (1939), a translation of Edward Fitzgerald's English version of *Rubayait Omar Kharim*, and *Taith o amgylch fy ystafell* (1944), a translation of Xavier de Maistre's *Voyage autour de ma Chambre*.

T. IFOR REES: DIPLOMAT

T. Ifor Rees was born in the small farming village of Bow Street, mid-Wales in 1890 and graduated from University College Wales, Aberystwyth, in 1910.[4] He sat the civil service exam in 1912, despite the fact that Welsh was not recognised as a subject for these exams until 1936 (Williams 1997: 386-87). It may be that Rees benefited from the reform in the civil services that took place under the new Liberal government, when even the mandarin Foreign Office was forced to overhaul its recruitment methods to bring them in line with the rest of Whitehall, getting rid of the practice of nomination, and recruiting staff through examinations instead (Hennessey 1989: 55). Despite not fitting the traditional aristocratic profile of the Foreign Office (and suffering from a heavy cold at the time), Rees passed the exam and spent some months serving in London before receiving his first overseas posting, to Marseilles, in 1913. He was appointed Vice-Consul for Caracas, Venezuela, in 1914, and describes in his 1964 travelogue, *Illimani: yn nhiroedd y Gorllewin* (*Illimani: In the Western Lands*) how he heard of the outbreak of World War I while at sea and on the way to take up this post:

> Mordaith ddeudydd oedd o Trinidad i La Guaira—pellter o tua phedwar can milltir. Sylwais, fel eraill o'r teithwyr, fod y llong yn hwylio yn agos iawn at y glannau, y rheiny yn ymgodi'n serth a choediog i gryn uchder. Bore Awst y pumed cefais wybod gan y Capten fod Prydain Fawr bellach yn y rhyfel, ac mai'r rheswm ei fod yn cadw mor agos at y tir oedd iddo dderbyn gorchymyn i ofalu cadw'r llong y tu mewn i ddyfroedd tiriogaethol Venezuela, h.y. o fewn tair milltir o'r lan, rhag iddi syrthio'n ysglyfaeth i'r llong ryfel Almaenaidd y *Karlsruhe*, y gywddid ei bod yn y parthau hynny. (1964: 3)[5]

[4] Details about Rees's career can be found in *The Foreign Office List and Diplomatic and Consular Year Book 1949* (London: Harrison and Sons), p. 327. See also my article in *Y Traethodydd* (2010), "Teithiau ad Ddau Gyfandir: T. Ifor Rees, Llysgennad a Llenor, yn America Ladin."

[5] "It was a two-day journey from Trinidad to La Guaira—a distance of some four hundred miles. I noticed, along with some of the other travellers, that the ship was sailing very close to the shore which rose up, steep and wooded, to a great height. On the morning of the fifth of August I was informed by the Captain that Britain was now in the war, and that he was keeping so close to the shore because he had been ordered to keep the ship within Venezuelan territorial waters, that is, within three miles of the shore lest it fall prey to the German warship *Karlsruhe* which was known to be in the area."

Rees spent the entire First World War in Venezuela, and was appointed Consul for Managua, Nicaragua, in 1921 (see Fig. 22-2). He was involved there in protecting the working rights of British Overseas Territories citizens in the Caribbean, especially in the wake of the upheavals in the sugar industry that characterised this period (McLeod 1998). While stationed in Venezuela he returned to Wales to marry his childhood sweetheart, and Morfudd and her siblings, while born in Wales, spent their early years in Nicaragua and Spain. Rees returned to Europe in 1926 when he was appointed Consul in Bilbao, in the Basque country, but returned to Latin America in 1932 when he was appointed Consul General for Mexico City.

It was in Mexico that Rees published his first book, *Rousille: neu, y Tir yn Darfod* (1933), a translation of René Bazin's *La Terre qui meurt*. He began working on the translation in 1928, with the intention of submitting it to the National Eisteddfod (the literary and cultural festival held yearly in Wales), but did not complete it in time. In 1934 his work took him to Havana, Cuba, where he was promoted to the post of Consul General (see Fig. 22-3). His career becomes much easier to follow at this point, because he became responsible for filing reports on the political and economic situation of the countries in which he was stationed. These reports, referred to as *Confidential Prints*, were published for internal circulation amongst Government offices, British consulates and embassies. Before this point we must rely on his travel books, *Sajama* and *Illimani*, which act as memoirs of his time in Latin America. In 1937 Rees was transferred to Milan, Italy, once again at the rank of Consul General, but his stay there was to be short-lived. In 1938, after less than a year in Italy, he was called back to Mexico City as Consul General and *chargé d'affaires* (that is, the person temporarily in charge of a consular mission in the absence of a higher authority).

The circumstances of Rees's return to Mexico are interesting in that they serve to illustrate how important he had become in the British consular service in Latin America, and in Mexico in particular. According to his daughter, while he was disappointed to be called back from an exciting new post (he had learned Italian in preparation for it), he was very pleased to be returning to Mexico, the country where he felt most at home, and had the most friends. It is also the country where he was able to be the most creative: all of the translations Rees produced abroad were written in Mexico. Nevertheless, his recall had a serious purpose. In 1938 Mexico nationalised its oil industry, a move which was opposed by Britain since many of the oil companies operating in Mexico were British. As a result, diplomatic ties between the two countries were broken, and the British

ambassador and his staff were called home. The consular staff, however, were permitted to stay. On the eve of the Second World War, Britain was eager to mend ties with Mexico and to prevent it from selling to the Axis powers oil and other materials vital to the munitions industry such as copper and tin (Halperín Donghi 1993: 235). Rees was sent back to Mexico to look after the Embassy and its records but also to attempt to thaw diplomatic relations, evidently because of the ties he had formed in his years there in the 1930s. By using consular as opposed to diplomatic staff Britain could attempt to resume diplomatic relations with Mexico surreptitiously while preserving the charade of a diplomatic rift on the surface and thus avoid angering British citizens whose property had been confiscated during the nationalisation.

An incident Rees describes in his travel book *Illimani, yn nhiroedd y Gorllewin* illustrates how his literary interests came to his aid in this mission. He was eager to get to know the Mexican foreign secretary at the time, a man by the name of Eduardo Hay, but official channels were closed to him. In the end, he persuaded a friend to hold a dinner party to which both men were invited. Rees describes the atmosphere as being rather frosty until Rees happened to mention that he had read Hay's Spanish translation of Edward Fitzgerald's English version of the *Rubáiyát of Omar Khayyám*. Rees praised the translation, and mentioned that he was attempting to translate the same poem into Welsh. With this the ice was not only broken but melted in a torrent, and Hay insisted that Rees publish his book in Mexico, apparently tickled by the idea that this would be the first Welsh book published in Mexico (Rees 1964: 82-3; Edwards 1977: 7). According to Morfudd, Hay also insisted that Rees use the rather flamboyant woodcuts that he had had made for his translation. Rees took up the first suggestion but not the second, and his translation of the *Rubáiyát*, complete with wonderfully restrained woodcuts by his friend Robert Hesketh, appeared in 1939, the first Welsh book to be published in Mexico, to favourable reviews. The printing was especially praised by the reviewer G. J. Williams, who compared it with the products of the Gregynog Press, a small publishing house run by Gwendoline and Margaret Davies out of their house in mid-Wales (Williams 1941: 100).

Rees claims (probably not altogether seriously) that this was the incident which led to the eventual resumption of diplomatic ties between the two countries. Whether or not this is an exaggeration, Rees's diplomatic skills—his ability to make the right contacts and tread carefully—are evident here. Interestingly, this incident is recorded rather differently in the report Rees sent back to his superiors at the Foreign

Office. There, in his "Report on the Leading Personalities in Mexico" (27 June 1939), Rees gave the following description of Eduardo Hay:

I have found him friendly and ready to be helpful, but unfortunately he carried little or no weight in influential circles. He is not considered to be a man of great intelligence, but is sympathetic, cultivated, salonfähig and reputed honest. Unkind rumour attributes his inclusion in the Cabinet to a desire to demonstrate the inferiority of the white intellect as compared with the brown. He claims descent from the Erroll family, speaks excellent English, and has published a competent Spanish version of Fitzgerald's rendering of *Omar Khayyam*. (Great Britain. Foreign Office 1989-92: [A6711/5026/26]).

Rees's transaltion of *Rubáiyát* was followed by two more beautifully produced books, similarly adorned with Hesketh's woodcuts: *Marwnad a ysgrifennwyd mewn mynwent wledig*, a translation of Thomas Gray's "Elegy Written in a Country Churchyard", published in 1942, and *Taith o amgylch fy ystafell*, a translation of Xavier de Maistre's *Voyage autour de ma Chambre*, which appeared in 1944. This last book was also entered into competition for the National Eisteddfod and, despite the praise it received from the judges, did not win.

Rees made the jump from the consular to the diplomatic service in 1943 when he was appointed British Minister to Bolivia. In the meantime, his children had attended school in Wales, and Morfudd, having graduated from St. Hugh's College, Oxford, went out to join her father in Bolivia in 1946 (see Fig. 22-4). Rees was made ambassador to Bolivia in 1947, the first British ambassador to serve in that country. Once again, he seems to have been there at a difficult time. The offices of the Embassy were located in the same building as the newspaper *La Razón* and were caught up in an attack on the paper by members of the Movimiento Nacionalista Revolucionario in May of 1946. Rees surmises that the popularity in recent elections of the Independent candidate Guillermo Gutiérrez—the former editor of the paper—was the cause of the attack (Great Britain. Foreign Office 2000: [AS 2861/9/5]). He and Morfudd also witnessed the bloody overthrow of President Gualberto Villarroel in July 1946, and its aftermath. Rees does not mention this incident in the short account of his time in Bolivia in *Illimani*, but his report on the events for the Foreign Office makes gripping reading, describing the siege of the Presidential Palace by an angered populace, the resignation of the President, the deaths of Villarroel along with his aide-de-camp and private secretary, and the desecration of their bodies by the mob: "Thus fell a Government which, whatever its faults, was a constitutional one, and one which, according to

its lights, darkened lights maybe, had endeavoured to serve the interests of the nation" (Great Britain. Foreign Office 2000: [AS 4608/9/5]).

Rees retired in 1949 and returned to the town, indeed to the house of his birth, Bronceiro, in Bow Street, where he actively pursued his literary interests, publishing a further eight books. Along with the two travel books —*Sajama* and *Illimani*—he published six translations of French and Spanish works, including some short stories by Balzac and *Platero a minnau* (a translation of Juan Ramón Jiménez's *Platero y Yo*), as well as two books of photographs. He was active in the chapel, Capel y Garn, teaching Sunday school, and he maintained his interest in walking, hiking, and travel. T. Ifor Rees died in 1977 at the age of 87.

T. IFOR REES: PHOTOGRAPHER

Rees's interest in photography began as a child, long before his travelling days. It was sparked by a local photographer in Bow Street who had apparently set up shop to take portraits of tourists. According to his family Rees was a terrible diarist: he would start out on a trip with the best of intentions of writing a diary, keep at it for a few days, and then entirely neglect it. His photographs were his diary, and he never travelled without bringing at least one, and more often two cameras with him. While his landscape shots are very accomplished, it is in the images of people that Rees's photos really come alive. It is unfortunate that many of the photographs chosen to accompany his travel books are landscape shots. The extensive collection of photographs kept by his family contains a host of more personal photographs, including candid images of street scenes like the one taken in Caracas (Fig. 22-5), or in Mexico (Fig. 22-7), as well as portraits of individuals he met on his travels, such as the Tzendal man and his son (Fig. 22-8), the Bolivian family (Fig. 22-9), and the Mexican woman on the train (Fig. 22-10).

Rees collected photos as well as taking them, and he made up albums in which to keep them, complete with captions. While sometimes informative—containing information on the individuals and places pictured—very often they are more circumspect. The photograph of the three boys in a cart pulled by a goat is simply labelled "Goat taxi", for example, with no indication of where or when the photograph was taken (Fig. 22-6). Rees also included in his albums commercially produced postcards alongside his own photographs. These postcards, especially when portraying native people, tend to be anthropological in nature, representing the subjects as types rather than as individuals (Fig. 22-11). The postcard depicting "Indios de 'Tenango'" found in one of Rees's albums, for example, is an anthropological view. Each man looks straight

into the lens without smiling. No hint of individuality emerges: the photograph is of a type, not of individuals. Rees's photos largely avoid this tendency, even when they are posed, as his photograph of a group of Tzendal men shows (Fig. 22-12). It is posed, like the postcard, but not rigidly so. Individuals look in different directions, some smiling and some laughing. If the photographer has set up this scene, he does not control it.

This photograph, like the photograph of the Tzendal man and his son was taken by Rees on a trip through Chiapas in 1943 which he describes in *Illiamni*. After reaching Tuxtla Gutiérrez, Rees and his travelling companion visited the old state capital of San Cristóbal de las Casas. There they paid a visit to the city's mayor, who offered to take them on an excursion to see some of the nearby Tzendal villages, as he was a Tzendal himself (Rees 1964: 63-6). This explains much of Rees's apparent rapport with his subjects: he was travelling with someone who could communicate with them. The interest in people that characterises Rees's photographs is also apparent in his writings. In both his travel writing and his official reports, Rees's primary interest is in the people that he meets along his journeys. While his primary duty in Mexico may have been to secure the interests of the former British owners of the nationalised oil companies, he was acutely aware of the situation of the Mexican people who had formerly worked for those owners. In his report on the nationalisation crisis, written in December 1938, he observes:

> Foreign companies operating in this country have been too much inclined in the past to treat their Mexican employees as beings obviously inferior, and incapable of efficient service unless supervised by foreigners. It would probably not be an exaggeration to say that this attitude has been responsible to no inconsiderable extent for the difficulties that have of recent years beset the said companies. (Great Britain. Foreign Office. 1989-92: [A 84/84/26])

T. IFOR REES: WELSHMAN

Despite living and working far from home, Rees was a Welshman through and through. He remained connected to the cultural life in Wales, entering his writings into competition in the National Eisteddfod, and celebrating St David's Day wherever he happened to be stationed. He had the latest Welsh-language publications sent to him wherever he was in the world from a bookseller friend in Aberystwyth. And he ensured that Welsh was the language of the home. While the children spoke Spanish and English with others, they spoke only Welsh with their father.

Rees was obviously proud of being Welsh. He chose to write and publish in Welsh—a natural choice in Wales, but more difficult to keep up

when working overseas. And the language had its uses in the consular service as well. Rees records in *Sajama* that one of his first duties upon taking up his post in Managua was to find an ex-pat who could act as consul at Bluefields. Rees was informed that there was a British man in Bluefields who might be suitable for the job: a man by the name of Edmund Owen Rees, who had come to Nicaragua some twenty years earlier to start a tanning business. "'Cymro yn ddiau!' meddwn wrthyf fy hun, a llawen iawn oeddwn i ddeall nad cam-arweiniol yr enw" (Rees 1964: 36). [6] Edmund Rees turned out to be a Welshman from Carmarthenshire, who spoke, read and wrote perfect Welsh. This came in very handy as, Rees explains, Bluefields had no code-book at the time. To keep the consular correspondence from being intercepted, it was all carried out in Welsh.

In many ways T. Ifor Rees is an anomaly: a Welsh author publishing in Mexico, a farm boy from mid-Wales operating at the highest level of the British diplomatic service, and a writer who chronicled his own life through the medium of photographs. These photographs are unique in many ways. More than capturing important places, historic events, and peoples and ways of life that have long past, they depict prosaic corners— a Cerveceria in Mexico—, everyday occurrences—a horse collapses on a street in Caracas—, and individuals—a woman and her child on a train.

[6] "'Definitely a Welshman!' I said to myself, and was very happy to find out that the name was not misleading."

WORKS CITED

Balzac, H. 1954. *Y Campwaith Coll a straeon eraill.* Trans. T. I. Rees. Cardiff: Gwasg Prifysgol Cymru.
Bazin, R. 1933. *Rousille: neu, y Tir yn Darfod.* Trans. T. I. Rees. Aberystwyth: Gwasg Aberystwyth.
Edwards, H. 1977. "Y Gyfrol Gyntaf Gymraeg i'w Hargraffu ym Mecsico." *Y Casglwr* 2: 7.
Gray, Thomas. 1942. *Marwnad a ysgrifennwyd mewn mynwent wledig.* Trans. T. I. Rees. Mexico City: American Book & Printing Co.
Great Britain. Foreign Office. 1949. *The Foreign Office List and Diplomatic and Consular Year Book 1949.* London: Harrison and Sons.
——. 1989-92. *British Documents on Foreign Affairs: Reports and Papers from the Foreign Office Confidential Print,* Part II, Series D, Latin America 1914-1939, eds. G. Philip and K. Bourne. Bethesda MD: University Publications of America.
——. 1999. *British Documents on Foreign Affairs: Reports and Papers from the Foreign Office Confidential Print,* Part III, Series D, Latin America 1940-1945, eds. P. Preston and M. Partridge. Bethesda MD: University Publications of America.
——. 2000. *British Documents on Foreign Affairs: Reports and Papers from the Foreign Office Confidential Print,* Part IV, Series D, Latin America 1946-1950, eds. P. Preston and M. Partridge. Bethesda MD: University Publications of America.
Great Britain. Public Record Office. 1969. *The Records of the Foreign Office, 1782-1939.* London: Her Majesty's Stationery Office.
Halperín Donghi, T. 1993. *The Contemporary History of Latin America,* ed. and trans. J. C. Chasteen. Durham NC: Duke University Press.
Jiménez, J. R. 1961. *Platero a minnau.* Trans. T. I. Rees. Cymdeithas Lyfrau Ceredigion: Aberystwyth.
Khayyám, O. 1939. *Rubaiyát Omar Khayyám.* Trans. T. I. Rees. Mexico City: American Book & Printing Co.
Luft, D. 2009. Interview with Morfudd Rhys Clark. *Fractured Identities: Resiting Hispanic Visual Cultures Conference,* Cardiff University, 4 July.
——. 2010. "Teithiau ad Ddau Gyfandir: T. Ifor Rees, Llysgennad a Llenor, yn America Ladin." *Y Traethodydd:* 64-81.
Maistre, F. X. 1944. *Taith o amgylch fy ystafell,* trans. T. I. Rees. Mexico City: American Book & Printing Co.
McLeod, M. C. 1998. "Undesirable aliens: race, ethnicity, and nationalism in the comparison of Haitian and British West Indian immigrant workers in Cuba, 1912-1939." *Journal of Social History:* 599-624.
Rees, T. I. 1948. *La Paz; album fotográfico.* La Paz: Librería Selecciones.
——.1953. *In And Around the Valley of Mexico.* Published by the author.
——.1960. *Sajama: Teithiau ar Ddau Gyfandir (Mécsico, Nicaragua, Peru, Bolivia).* Aberystwyth: Cymdeithas Llyfrau Ceredigion.

———.1964. *Illimani yn Nhiroedd y Gorllewin: Teithiau ac Atgofion*. Aberystwyth: Cymdeithas Llyfrau Ceredigion.

Rhys Clark, M. 2007. "Bletchley Park a La Paz: Atgofion Morfudd Rhys Clark." In *Atgofion Amser Rhyfel*, 2-8. Aberystwyth: Cymdeithas Lenyddol Capel y Garn.

Troyat, H. 1965. *Y Meirw ar y mynnyd*. Trans. T. I. Rees. Llyfrau'r Dryw: Llandybie.

Williams, G. J. 1941. "Rubaiyat Omar Kyahham." *Y Llenor* 20: 100.

Williams, J. G. 1997. *The University of Wales 1839-1939*. Cardiff: University of Wales Press.

PICTURE CREDITS

Figure 1-4 is used with the kind permission of Clara Holgado on behalf of María del Mar Bonet. Figure 2-4 is used with kind permission of Rafael Gordon. Figures 3-1 and 3-2 are used with permission of the British Film Institute. Figure 6-1 is used with the permission of the National Gallery of Art, Washington DC. Figure 6-2 is used with permission of Museo del Prado, Madrid, and Art Resource, NY (photo by Erich Lessing). Figures 10-1, 10-2, and 10-3 are used with permission of the Museo de Arte de la Universidad Nacional Mayor de San Marcos, Lima, Peru. Figures 11-1, 11-2, 11-3, and 11-4 are used with permission and are © Banco de México Diego Rivera Frida Kahlo Museums Trust, Mexico City / Artists Rights Society (ARS). Figure 13-1 is used with the permission of Galerie Lelong, New York and is © The Estate of Ana Mendieta Collection. Figures 14-1, 15-1, and 15-2 are used with kind permission of the Instituto Cubano de Arte e Industria Cinematográficos, Havana, Cuba. Figures 17-1 and 17-2 are used with permission of GAC (Grupo de Arte Callejero). The image in Figure 21-2 ("Alianza para una Venezuela sin reggaeton") is used with permission of alias 'Slavetothepc'. The images in Figures 22-1 to 22-12 are used with the kind permission of Morfudd Rhys Clark and Osi and Hilary Rhys Osmond. The illustration on the front cover is a still from *Teresa Teresa*, used with kind permission of the film's director, Rafael Gordon. The illustrations on the back cover are of T. Ifor Rees (left) and the Parícutin volcano in Mexico shortly after its eruption in 1943 (right) and are used with the kind permission of Morfudd Rhys Clark and Osi and Hilary Rhys Osmond. Every effort has been made to obtain permission to reproduce copyright material in this volume where copyright holders have been kind enough to acknowledge and reply to correspondence. If any oversight has been made the editors and contributors apologise in advance and welcome copyright holders informing them of errors or omissions.

Electronic manuscript preparation and cover design: R. Prout.

NOTES ON CONTRIBUTORS

DOLORES [LOLY] ALCAIDE RAMÍREZ is an Assistant Professor of Hispanic Studies at the University of Washington, Tacoma. She has published several articles on Latino-Caribbean women writers such as Mayra Montero, Loida Maritza Perez, and Irene Vilar. She is especially interested in the representation of violence and identity in the works of Latin American women artists of African descent, and the connections with the rituals and the aesthetics of Santeria. Her recent work is on Afro-Cuban artist Maria Magdalena Campos Pons.

GUY BARON is a lecturer in the Department of European Languages, Aberystwyth University. Guy's research centres on gender in Cuban cinema and in Spanish and Spanish American film, and on masculinity and feminism in Cuba.

KEITH BUDNER is a graduate research student at Berkeley, University of California.

MAURICIO CASTILLO is a graduate student at Columbia University. His research interests include twentieth century Spanish American and Brazilian literature and culture, colonial cultural production, the Latin American Left, and post-colonial theory.

TALÍA DAJES is a PhD candidate at the University of Michigan. Her research interests include women's studies, popular culture in contemporary Spain and Latin America, and film and literature.

LORNA DILLON is completing her PhD at King's College, London. Lorna's research focuses on Violeta Parra's embroideries, collages, and paintings and examines the political dialectic of Parra's work to situate it within the growth of neo-indigenism, the global counter culture, and the expansion of the Latin American political left. Lorna's work on Parra has appeared in *Identity, Nation, Discourse: Latin American Women Writers and Artists*, ed. Claire Taylor (2009).

SILVIA GRASSI is a graduate of the University of Milan and a PhD candidate at Cardiff University where she is working on the representation of minority identity in Catalan and Spanish soap operas. She has presented her work at the annual conferences of the Anglo Catalan Society and WISPS and has contributed teaching on Spanish film and Catalan Culture to the undergraduate programme at Cardiff's School of European Studies.

JILL INGHAM's previous publications include "Gangsters, Gays, and Policemen: Arrested Masculinity in the Cuban Novel Fifty Years Ago" in *Antes y después del Quijote* (2005). Jill's PhD thesis was on "The Function of Physical Space in the Cuban Novel of the 1950s" and examines the role of geography in revealing hitherto undetected currents of opposition and issues of gender identity.

NASHELI JIMÉNEZ DEL VAL is Lecturer in Spanish and Latin American Studies at the University of Stirling. Nasheli's teaching and research interests are centred on Latin American Cultural Studies, particularly Latin American visual cultures. Her main focus is on the relationship between images and power. More specific research areas include visual cultural studies, colonial visual discourse analysis, postcolonial theory and methodology, and contemporary debates in Latin American art and art theory.

M. GRAZIELLA KIRTLAND GRECH is a PhD candidate at the University of Calgary.

ALEJANDRO LATINEZ is an Assistant Professor at Sam Houston State University. His research includes work on adolescence and hybrid and androgynous identity and its relationship to development in Latin America. He is the recipient of an Enhancement Grant for Professional Development from Sam Houston State University in support of his work on Abraham Ángel.

DIANA LUFT is a Research Fellow at the School of Welsh, Cardiff University. Diana studied for her PhD at Harvard and is a graduate of the University of Toronto. Her main research interest is Welsh prose literature, especially that of the medieval period. Besides Welsh travel writing, Diana's previous publications have addressed the history of translation, antiquarianism and the reception of medieval literature, and digital humanities.

DEBORAH MARTIN is Lecturer in Latin American Studies at the University of Bath. Deborah's PhD, entitled "Gender, Politics and Aesthetics in Colombian Women's Cultural Production 1940-2005: Débora Arango, Laura Restrepo and Women's Documentary" emphasised theories of the visual and theories of gender and sexuality in delineating the emergence of a feminine cultural production in Colombia. She has published on Latin American literature and documentary film, and her other interests include Latin American contemporary art. She has taught at Cambridge, Anglia Ruskin, and London Metropolitan Universities.

CELIA MARTÍN-PÉREZ lectures in nineteenth century and modern Spanish culture at Birkbeck, University of London. Her research focuses on the relations between gender, history, and politics, with particular interest in the visual representations of historical subjects. Celia's PhD thesis was published in 2005 as *Representaciones culturales en torno a la figura de Mariana de Pineda, heroína liberal*. Her current research focuses on the overlooked area of historical house museums as key elements in the shaping of identities.

SOLEDAD PEREYRA has studied and taught at the Universidad Nacional de La Plata and in Freiburg, Germany. She has taught courses on Argentinian Literature and Spanish Medieval Literature, and completed her doctoral thesis in 2010. She is now based in La Plata where she is researching literature of migration in the Comparative Literatures Department of the Universidad Nacional.

ESTHER PÉREZ-VILLALBA is Lecturer in English Studies at the University of Zaragoza. Her book *How Political Singers Facilitated the Spanish Transition to Democracy, 1960-1982: The Cultural Construction of a New Identity* was published by Edwin Mellen in 2007. She is currently working on British and American Cinema, fields in which she has published a number of journal articles and book chapters.

JAIME PORRAS was born in Oaxaca, Mexico. He holds a Ph.D. in political science from the Université de Montréal. He has published on the relation between politics and artistic expression, with particular reference to cinema and literature. He presently works at the College of the Americas (Inter-American Organization for Higher Education), and is also a contributor to radio programs and Latin American print media.

RYAN PROUT is Lecturer in Hispanic Studies at Cardiff University. He has published on Spanish and Latin American writing and film and his most recent work has been on adoption and identity in Spanish autobiography, disability in Spanish film, and on diglossia and the epistemology of the closet in the work of Juan Pinzás. His book *Angles on Iberia* is forthcoming as is an edited dossier on The Last Film for *Jura Gentium Cinema*.

GUDRUN RATH is a scientific assistant and Phd candidate at the Universities of Heidelberg and Vienna.

MICHELLE RIVERA is Teaching Assistant and DFI Fellow at the Institute of Communications Research, University of Illinois at Urbana-Champaign. Michelle's research interests focus on pan-ethnic constructions of Latina/o identity in popular culture, music fandom, and digital representations online. Michelle serves as a journal referee for *CENTRO: Journal of the Center for Puerto Rican Studies*.

ANTONIO SÁNCHEZ is a Lecturer at the School of Languages, Cultures and Religions in the University of Stirling. His research interests include immigration and cultural identity, the cultural representation of collective memories and traumas and the construction of space in cinema Spanish cinema. Among his publications is *Postmodern Spain: A Cultural Analysis of 1980s-1990s Spanish Culture* (2007). At present he is working on a volume on the representation of space in modern Spanish cinema.

VERENA SCHMÖLLER is an Assistant Professor in the Roman Literatures and Cultures Department at Passau University, where she teaches literature, cultural and film studies. She is on the board of *cineforum e.V.* and founder of the *¡muestra! Iberoamerikanisches Filmfest* Passau. Verena is currently completing her doctorate on narrative structures in contemporary film. Her book *Kino in Chile—Chile im Kino. Die chilenische Filmlandschaft nach 1990* was published in 2009.

INDEX OF NAMES